# The Center Seat:
# 55 Years of *Star Trek*

## The Official Companion Book to the
## Hit Documentary Series by the Nacelle Company

By Peter Holmstrom

Foreward by Brian Volk-Weiss

# CONTENTS

# INTERVIEWS TAKEN FROM
*THE CENTER SEAT: 55 YEARS OF STAR TREK:*

LEONARD NIMOY (actor, "Spock," *Star Trek*)

WALTER KOENIG (actor, "Chekov," *Star Trek*)

RICK BERMAN (executive producer, *Star Trek* franchise, 1987–2005)

NICHOLAS MEYER (director/uncredited screenwriter, *Star Trek II: The Wrath of Khan*)

RONALD D. MOORE (screenwriter/executive producer, *Star Trek* franchise, 1990–2000)

JERI TAYLOR (screenwriter/executive producer, *Star Trek: The Next Generation*)

DOROTHY FONTANA (story editor/screenwriter, *Star Trek*)

BRANNON BRAGA (screenwriter/executive producer, *Star Trek* franchise, 1990–2005)

MANNY COTO (executive producer, *Star Trek: Enterprise*)

BRENT SPINER (actor, "Data," *Star Trek: The Next Generation*)

WENDY NEUSS (co-producer, *Star Trek: The Next Generation*)

DENISE CROSBY (actress, "Tasha Yar," *Star Trek: The Next Generation*)

MARK A. ALTMAN (creator, *Pandora*; author, *The Fifty-Year Mission*)

ROB KLEIN (pop culture historian/archivist)

TOM GILBERT (author, *Desilu: The Story of Lucille Ball and Desi Arnaz*)

JOHN TENUTO (*Star Trek* historian, startreknews.net)

MARY JO TENUTO (*Star Trek* historian, startreknews.net)

LARRY NEMECEK (author, *Star Trek: The Next Generation Companion,* podcast host, *The Trek Files*)

MARC CUSHMAN (author, *These Are the Voyages*)

ANDREW PROBERT (production illustrator, *Star Trek: The Motion Picture*)

JOE D'AGOSTA (casting director, *Star Trek*)

ANDRE BORMANIS (screenwriter, *Star Trek: Enterprise*)

DAVID GERROLD (screenwriter, *Star Trek* "The Trouble with Tribbles")

MICHAEL OKUDA (scenic art supervisor, *Star Trek: The Next Generation*)

DENISE OKUDA (art department, *Star Trek* feature films)

RALPH SENENSKY (director, *Star Trek* "This Side of Paradise")
SANDRA LEE GIMPEL (stunt actress, M-113 Creature, "The Man Trap")
LARRY NIVEN (science fiction author, *Tales of Known Space* series)
LUCIE SALHANY (president, Paramount Domestic Television 1985-1991)
AARON HARVEY (author, *Star Trek: The Official Guide to The Animated Series*)
FRED BRONSON (publicist, *Star Trek: The Animated Series*)
BOB KLINE (art designer, *Star Trek: The Animated Series*)
RICH SCHEPIS (author, *Star Trek: The Official Guide to The Animated Series*)
BILL REED (director, *Star Trek: The Animated Series*, Season 2)
HAROLD LIVINGSTON (story editor, *Star Trek: Phase II*)
DAVID GAUTREAUX (actor, "Xon," *Star Trek: Phase II*)
PRESTON NEAL JONES (author, *Return to Tomorrow – The Filming of Star Trek: The Motion Picture*)
JOHN DYKSTRA (special photographic effects supervisor, *Star Trek: The Motion Picture*)
ROBERT SALLIN (producer, *Star Trek II: The Wrath of Khan*)
KEN RALSTON (special visual effects supervisor, *Star Trek II: The Wrath of Khan*)
DAVID LIVINGSTON (director, *Star Trek* franchise)
LOLITA FATJO (pre-production coordinator, *Star Trek: The Next Generation*)
MERRI D. HOWARD (producer, *Star Trek: The Next Generation*)
HERMAN ZIMMERMAN (production designer, *Star Trek: The Next Generation*)
MICHAEL WESTMORE (makeup supervisor, *Star Trek* franchise, 1987-2005)
JOHN DE LANCIE (actor, "Q," *Star Trek: The Next Generation*)
ROBERT BLACKMAN (costume designer, *Star Trek: The Next Generation*)
DAVID CARSON (director, *Star Trek: The Next Generation*, "Yesterday's Enterprise")
CIRROC LOFTON (actor, "Jake Sisko," *Star Trek: Deep Space Nine*)
LISA KLINK (screenwriter, *Star Trek: Voyager*)

PENNY JOHNSON JERALD (actress, "Cassidy Yates," *Star Trek: Deep Space Nine*)
ANDREW ROBINSON (actor, "Garek," *Star Trek: Deep Space Nine*)
NICOLE DE BOER (actress, "Ezri Dax," *Star Trek: Deep Space Nine*)
ROBERT PICARDO (actor, "The Doctor," *Star Trek: Voyager*)
TIM RUSS (actor, "Tuvok," *Star Trek: Voyager*)
ROXANN DAWSON (actress, "B'Elanna Torres," *Star Trek: Voyager*)
JOHN BILLINGSLEY (actor, "Doctor Phlox," *Star Trek: Enterprise*)
DOMINIC KEATING (actor, "Malcolm Reed," *Star Trek: Enterprise*)
*STAR TREK* TIMELINE

## TELEVISION SERIES

*STAR TREK* (TOS) 1966–1969
*STAR TREK* (TAS) 1973–1974
*STAR TREK: PHASE II* (Unproduced, yet often discussed)
*STAR TREK: THE NEXT GENERATION* (TNG) 1987–1994
*STAR TREK: DEEP SPACE NINE* (DS9) 1993–1999
*STAR TREK: VOYAGER* (VOY) 1995–2001
*STAR TREK: ENTERPRISE* (ENT) 2001–2005
*STAR TREK: DISCOVERY* (DISCO) 2017–PRESENT
*STAR TREK: SHORT TREKS* 2018–PRESENT
*STAR TREK: PICARD* (Picard) 2020–PRESENT
*STAR TREK: LOWER DECKS* (Lower Decks) 2020–PRESENT
*STAR TREK: STRANGE NEW WORLDS* (SNW) (TBD)
*STAR TREK: PRODIGY* (PRODIGY) 2021
*STAR TREK: SECTION 31* (TBD)

## MOTION PICTURES

*STAR TREK: THE MOTION PICTURE* (TMP) 1979
*STAR TREK II: THE WRATH OF KHAN* (Khan) 1982
*STAR TREK III: THE SEARCH FOR SPOCK* (Search for Spock) 1984
*STAR TREK IV: THE VOYAGE HOME* (Voyage Home) 1986
*STAR TREK V: THE FINAL FRONTIER* (Final Frontier) 1989
*STAR TREK VI: THE UNDISCOVERED COUNTRY*

(Undiscovered Country) 1991
*STAR TREK: GENERATIONS* (Generations) 1994
*STAR TREK: FIRST CONTACT* (First Contact) 1996
*STAR TREK: INSURRECTION* (Insurrection) 1998
*STAR TREK: NEMESIS* (Nemesis) 2002
*STAR TREK* (Trek 09) 2009
*STAR TREK: INTO DARKNESS* (Into Darkness) 2013
*STAR TREK BEYOND* (Beyond) 2016

"I don't believe in a no-win scenario." ~James T. Kirk

"Remember to look up at the stars and not down at your feet. Try to make sense of what you see and wonder about what makes the universe exist. Be curious. And however difficult life may seem, there is always something you can do and succeed at.
It matters that you don't just give up." ~Stephen Hawking

"In science fiction, we dream." ~Ray Bradbury

Frasier: Noel... *Star Trek* is just a TV show.
Noel: So was *Brideshead Revisited!*
Frasier: ...You're angry, so I'm going to ignore that.
~Frasier Crane, *Frasier* episode, "Star Mitzvah"

# QUARANTINE TO THE STARS
Foreword by Brian Volk-Weiss

When the COVID-19 crisis began and it became clear that it was starting to spread around the world, I made the decision to evacuate our headquarters. February 29, 2020 – it was early, compared to other companies, and even countries. If it were just about the employees, it'd be an easy solution – they simply don't come to the office, and work from home. But for a production company, it's more complicated than that. We had to move editing bays and color-correcting machines to dozens of employees' homes spread out over an 80-mile radius, and some of these things weigh over a thousand pounds. This was all being done while the city of Los Angeles and the state of California were talking about shutting down the entire city. We were rushing, very quickly, and we had a lot of people who stayed in the building working 12-to-18-hour shifts getting all our equipment disconnected from power sources and 7-figure data towers. They had to pack everything up, ship the equipment to people's homes, and then unpack and fit it all to the new remote environments. Sometimes the equipment was so powerful (in terms of needing electricity) that we had to bring in external power sources to their houses.

After 13 days of the entire company working around the clock to make all of this succeed, I received an email from the head of our post-production team: We had completed the evacuation of our head-quarters – the staff as well as our equipment. This meant we were able to keep working. We had five series in production at that time, and be-cause of everyone's hard work, we didn't miss a beat. All the equipment was officially moved between Friday and Sunday, and on Monday, the entire company was fully operational from people's homes.

So, if you're wondering why I'm telling this story at the beginning of a book about *Star Trek*, it's because after our head of post-production had sent that email letting us know we had successfully evacuated, all I could think of was a moment from *Star Trek II*.

I took a screenshot from *TWOK* in which the computer screen read "Nominal" and sent it to the whole company. And even though some

of them may not have understood what I meant, any *Star Trek* fan will. Basically, it meant that all our systems – even though they were barely functional – *were* functional. Many production companies, including ones owned by friends of mine, had shows that were canceled and a myriad of other things go wrong. I am relieved to report that we didn't. So, that's a good way to segue into the most powerful moment for me while directing *The Center Seat*.

We interviewed Nicholas Meyer, and it was absolutely fantastic, and very powerful. We got some great stuff that you'll read about in the book, but at the end of the interview – unfortunately, while the cameras were still rolling – I tried saying something to him that I'd always wanted to say in a casual way; "Hey man, the words you wrote in *Star Trek II*, '*I don't believe in the no-win scenario*' – those words changed my life. Everything I have done in my whole career, and even in my life." Or something like: "Thank you for writing the words that will *literally* be on my tombstone." But as I started saying it, I just broke down. It was embarrassing, and the cameras were still rolling, but I started crying and could barely get the words out.

And then the craziest thing happened. I noticed he wasn't saying anything, and when I looked up, he was tearing up too. Here you have two grown-ass men talking about some science fiction movie from 40 years ago, and they're crying like babies. At the very least, now you understand why I have started this book with a COVID story, but it should serve as no greater story than to demonstrate the importance of *Star Trek* to my life and to what this company stands for. (Some of you may have noticed the company is even named after a term I learned from *Star Trek*.) I simply thought it was a fitting way of explaining how *Star Trek* affects people and changes lives. At the very least, my life.

Lastly, I want to thank Gates McFadden from the bottom of my heart. Gates, who I did not know even two years – maybe even 18 months – before *The Center Seat* was greenlit. We had developed a good relationship while working together on her podcast, *InvestiGates*. I really didn't know her that well, but I liked working with her. I fully admit it was surreal every time I would see her on my caller ID, or

when I would get a text from her, but that wore off eventually. When we got the good news that *The Center Seat* was greenlit, I called her and said, "Hey Gates, we got this show greenlit. Would you be interested in being an executive producer?" And she said yes. She'll probably be mad at me for telling this part of the story, but our contract with her was as simple as it could be – it may have been just *one or two* pages. It required me to do a lot of things and didn't require much from her. But I trusted her, and boy…did she reward my trust. She worked insanely hard to book some of the people that you saw in the show and will read about in this book. If anyone enjoys the show, book, or podcast (*shameless plug*), a lot is due to what Gates accomplished and how hard she worked, from booking talent, to the voiceover, to the insight she gave; I have never in my life made anything where one of my co-producers was actually *there* for a lot of the story. So many people helped make all of this possible, but I wanted to give a special shout-out to Gates.

Finally, I wanted to thank all of you for buying this book, and I hope you enjoy it. I'm on social media; let me know if you did or didn't! I want to hear why!

~ Brian Volk-Weiss
Los Angeles, June 23, 2022

# DEFINITELY NOT SICKBAY
Author's introduction by Peter Holmstrom

*"Someone once told me that time was a predator that stalked us all our lives. I rather believe that time is a companion who goes with us on the journey, and reminds us to cherish every moment, because it will never come again. What we leave behind is not as important as how we've lived. After all Number One, we're only mortal."* ~Jean Luc Picard, Star Trek: Generations

Some say the minds of children hold the secrets of the universe. For in those minds, children dream of worlds beyond – beyond the adult concerns of property tax, electric bills, and understanding the pesky new home screen on streaming services. Nights are filled with possibilities, with each new skill and piece of information adding to the puzzle and wonder of existence. Others say children only want to eat poo. Go figure.

It was in one of these childlike states (the first one, not the second) that my first real memory of *Star Trek* begins. Well, that's not quite true. *Star Trek* was always in my life – from before memory could take hold. On the TV screen, Channel 12 KPTV, 6 pm *Star Trek: The Original Series*, 7 pm (my favorite) *Star Trek: The Next Generation*, five nights a week. There, I dreamed. But this day was not a dream. It was early in the morning of April or May, 1993 – I was a shy and reclusive boy with glasses and probably wearing a dinosaur shirt. Standing across the pre-op room at the Oregon Health and Sciences University in Portland, Oregon, was a nurse, here to take me inside for corrective eye surgery. Memory recalls the nurse as being brunette/blonde and in her early 20s. She saw I was nervous and tried to calm me down by asking the question which made me love her for all time… "Are you a fan of *Star Trek*?" Keeping my suave demeanor, I said, "YES!!!" She smiled and said, "Well, this is something like you'd see in *Star Trek*." Instantly, my imagination dreamed of entering sickbay of the U.S.S. Enterprise, to find Dr. Beverly Crusher warmly smiling with a hypospray and a quick-fix for all my problems through the wonderous cures science had achieved. Or perhaps finding my way into the sickbay of the classic Enterprise, where Leonard "Bones" McCoy would pat me on the

shoulder and complete a somewhat more complicated surgery, but I would nonetheless be back on duty, exploring strange new worlds with James T. Kirk in no time.

In childhood, we dream...

I follow the nurse, say goodbye to my parents, and eagerly leap to the "sickbay" my mind had created beyond. And I discover the "*Star Trek*-like" thing the nurse was referring to is a breathing apparatus attached to a balloon – the conduit for dispensing the anesthesia. Of course, even my four-year-old mind knew this rubbery face mask had nothing to do with *Star Trek*, but still, it was nice of her to try. As I breathed into the apparatus, and sensed air turn to clearly not air, I felt myself drift off to sleep, final thoughts of how this was definitely not like sickbay. A few hours later, I woke up at home in bed to see that my parents had bought me the Transporter Room set from Playmates. Man, did that get some use.

In those fleeting moments in the operating room, the seed for this book was planted. (Well, not really. I was four...)

When Nacelle Publishing came to me with the offer to write a companion book for their TV documentary series on the history of the *Star Trek* franchise, I leapt at the opportunity. While there have been many books written about the behind-the-scenes journey of the franchise, few have taken a bird's-eye view of the franchise as a whole – and illuminated how interconnected *Star Trek* was to both itself and the television landscape as a whole. *I Love Lucy*, *The Brady Bunch*, *War of the Worlds*, *Battlestar Galactica* – a web of connections; remove one, and the web crumbles.

The story of the *Star Trek* franchise is a story of Hollywood, a story of dreamers, a story of connections. Within these pages, we feature extended and exclusive interviews from the documentary series, *The Center Seat: 55 Years of Star Trek,* and paint our own picture of the franchise through snapshots of key events and episodes. A story unfolds, based on memories. It must be noted that memories often tell

differing and contradictory stories. Memory is fallible — based on past and current subjectivity, bias, and perception, rather than a film reel of objective truth. I remember the nurse as brunette/blonde and in her 20s — she may have been completely different. Rather than hide the Rashomon-style of history, this book will lean into it, presenting the various perspectives on events and allowing you, the reader, to decide. And even then, the truth may never be known.

In this book you'll read the words of dreamers, workers, technicians — people for whom *Star Trek* was the height of their lives, and others who felt it was just a job. *Star Trek* connects dreams with reality, and reality to dreams. A boy is wheeled into surgery, a nurse recalls a TV show, years later that boy writes a history of *Star Trek*. A former soldier-turned-screenwriter in 1965 dreams of space, the final frontier… And the rest is history.

Let's see what's out there…

~ Peter Holmstrom
Los Angeles, June 10, 2021

# LUCY LOVES *STAR TREK*
Development, *The Cage, Where No Man Has Gone Before*

*"You either live life — bruises, skinned knees and all — or you turn your back on it and start dying." ~Captain Christopher Pike*

*September 8, 1966; December 7, 1979; June 4, 1982; June 18, 1990; December 9, 2002. Dates that live in the minds of die-hard* Star Trek *fans as well as their high school graduation or wedding day. They have their stories — they remember where they were the first time they watched "The Man Trap" on NBC Thursday night television, or standing in line to watch* The Motion Picture — Star Trek's *glorious return after a ten-year absence. Sitting on the edge of their seats as Commander William Riker utters the words, "Mr. Worf... Fire." Thus ending Part I of the greatest two-parter in* Star Trek's *history. For all of these dates, few would count December 8, 1957, as particularly significant in the* Star Trek *mythos. However, without the events surrounding that date, it is very likely we would never have heard the name "Enterprise." This was the date that two successful actors-turned-producers, Desi Arnaz and Lucille Ball, purchased RKO studios for three million dollars.*

**ROB KLEIN (pop culture historian/archivist):** When you talk about '60s *Star Trek*, you have to give credit to Desilu. And you cannot mention Desilu without mentioning Lucille Ball and Desi Arnaz.

**TOM GILBERT (author, *Desilu: The Story of Lucille Ball and Desi Arnaz*):** Lucy absolutely is the reason *Star Trek* exists. She wasn't particularly involved with the development of it, but she made the decision to go ahead with it. And it's paid off in spades for Paramount.

**RICK BERMAN (executive producer, *Star Trek* franchise, 1987–2005):** I love Lucy.

**JOHN TENUTO (*Star Trek* historian, startreknews.net):** Lucille Ball has never received the credit that she's deserved. Desilu was a studio owned by Lucille Ball and Desi Arnaz, and then after their divorce, solely by Lucille Ball. She becomes the first woman to own a studio. But they were known for, and very successfully known for,

making sitcoms. They made *The Danny Thomas Show, The Andy Griffith Show,* and, of course, Lucille Ball's own television shows. They had really pioneered the way we use cameras on sitcoms. Marc Daniels, who would go on to work on *Star Trek,* worked on many of the early *I Love Lucy* episodes.

**LARRY NEMECEK (author, *Star Trek: The Next Generation Companion*, podcast host, "The *Trek* Files"):** It's only been the last few years that people even realize the pivotal role that Lucy [had with *Star Trek*]. People have appreciated her business smarts. People have appreciated the decisions she made after Desi, who was the business guy. But what she did with the studio afterward and trying to get out of the easy path of just doing the sitcoms, just doing her show — she really tried to build a studio into something more. It's only been recent that we've learned the story of the board voting to not pursue a network contract and Lucy pulling her executive veto to say, "No, I want to do these two series, *Star Trek* and *Mission Impossible.*"

*The beginning of* Star Trek, *as much as anyone can actually say there is a "beginning" to anything, can be traced back to October 15, 1951, and the premiere of a new half-hour comedy television series starring struggling actress, Lucille Ball, and her husband, Desi Arnaz. The show was a culmination of nearly two years of work, which began with the formation of Desilu studios in 1950, and the intention of Lucille Ball and Desi Arnaz to produce an adaptation of Lucy's successful radio show,* My Favorite Husband, *for television. Not just wanting to star in the show, Lucy and Desi sought creative control over the project as well. Studio space was rented, equipment secured, and the writers of* My Favorite Husband *were brought over for the adaptation.* I Love Lucy *not only shifted the paradigm for the television comedy landscape, but utterly revolutionized the way that television shows were produced and consumed.*

**TOM GILBERT:** Lucille Ball was a phenomenal TV star of the 1950s. She and her husband, Desi Arnaz, created a show called *I Love Lucy,* which became a Number One show six months after it premiered in 1951. It would stay at the top of the ratings for its entire seven-year run, and then it went into hour-long specials. *I Love Lucy* enabled them to create their own production company, Desilu, which

became the largest independent television producer in Hollywood.

*Lucille Ball was born in Jamestown, New York, on August 6, 1911. An early interest in acting led to jobs as a model in New York before she moved to Hollywood in 1932. She became a contract player for RKO Pictures, and earned a number of small roles, though she found it difficult to break through to stardom. In early 1940, she signed with MGM, but her struggles with stardom continued.*

**TOM GILBERT:** After a few years, MGM dropped her option, because she wasn't really breaking through. So Lucy kicked around in freelancing for a few years and started doing comedy. She got a radio show on CBS called *My Favorite Husband,* which was performed in front of a live audience in a radio studio. She would read her script – the writers would notice that her facial expressions were getting a huge response from the audience. It made them realize that this would be ideal for television. CBS network was just starting a TV division, and they wanted Lucy to go to television with this show. Lucy said she would, but by then she had been married for ten years to a Cuban band leader, Desi Arnaz. Desi would tour the country with his band, and Lucy wanted him home so they could have a married life. So she said to CBS, "I'll only do the TV show if you cast Desi as my husband." CBS didn't like the idea of a Cuban being married to a red-blooded American gal, so they resisted the idea. So Desi said to Lucy, "Let's try this out on the road." So they performed as a married couple on stage, and the audience loved it. That was enough to convince the network to do a pilot in early '51, and Phillip Morris bought it as a sponsor, and the show went on the air in the fall.

*The creative team from* My Favorite Husband *was brought over by Lucy and Desi to create* I Love Lucy, *with many of the early episodes straight adaptations of the radio show. Not unusual for shows of the time. But what did make the show unusual was how the show was to be shot.*

**TOM GILBERT:** Once the network accepted Desi, then the question was, "When are you moving to New York?" At that time, everything came live from New York. Very few things were put on film. All the big network shows were shot live out of New York. This

was a stumbling block because Lucy wanted to stay in Hollywood. She wanted a family and a home there. So Lucy put her foot down and said, "We don't want to. We want to do it from here." And the network said, "You can't do it from here." At that time, there was no cross-continental cable – anything that aired in New York had to be rebroadcast, but with a Kinescope, which was a film of a television monitor. If you saw a show, while it was live, it was being filmed for rebroadcast on the West Coast. That was because there were fewer people on the West Coast. The East Coast was the population center so they had to have the best quality. The advertisers were all on the East Coast, so they wanted to see the top quality. Then Desi said, "What if we film it in front of a live audience?"

**MARC CUSHMAN (author, *These Are the Voyages*):** Desilu invented the reruns. Desi Arnaz invented the reruns. When they were doing, *I Love Lucy*, CBS wanted to shoot it like they were shooting *The Honeymooners*, which filmed in New York, in front of an audience with video cameras. It goes out live. On the West Coast, they film it off of a TV screen and they rush that episode to the lab, get it developed, bring it back and air it on the West Coast, three hours later. That would be called a Kinescope. That's how everything was. The reason why Kinescope looked so bad is because they were filmed off of a TV screen, which was round back then. Desi Arnaz and Lucille Ball didn't want to do that. They lived in Los Angeles and they wanted to stay here. They wanted to be able to film in Los Angeles.

CBS said, "We're not going to pay for you to film that. Three video cameras can do it so much cheaper live from the East Coast. You're going to film from three cameras and then edit it? My God! On TV? Why???" And Desi Arnaz said, "I'll pay the difference, if you give me the rights to the reruns." Harry Ackerman [executive producer] at CBS — and I confirmed this with Harry Ackerman, by the way — said, "What's a rerun?"

*With Lucy and Desi taking a salary cut of $1,000 per week in order to stay in L.A., filming began for* I Love Lucy *on studio space rented by Desilu Productions at General Service Studios. The show premiered on October 15, 1951.*

*The gamble paid off, with the Hollywood Reporter writing in its review of the pilot the following day: "Every once in a rare great while, a new TV show comes along that fulfills, in its own particular niche, every promise of the often-harassed new medium."*

**TOM GILBERT:** When *I Love Lucy* debuted on October 15, 1951, it got good reviews. People didn't know what to expect. She wasn't that well known. But by February it was Number 1. It was huge. Sixty-seven million people are watching this. At the time, not everyone owned a television set. People were watching at appliance stores or they'd gathered around the window to see television.

**MARC CUSHMAN:** A year later, *I Love Lucy* is Number 1 in the ratings, and CBS doesn't want to stop airing it in the summer. So they come to Desi Arnaz and say, "Can we have those reruns?" So CBS had to pay Desi Arnaz a million dollars to get those reruns back for the summer. And more beyond that.

**TOM GILBERT:** Lucy has said this many times in interviews – Desi was the one pulling the strings. He was the brains behind the whole thing. He was the one who built the studio, he was the genius on that end of it. He had an innate business quality, and he was a gambler. Wasn't afraid to take chances.

*By 1953, Desilu Productions was in a position to upgrade their soundstages. They leased the Motion Picture Center at 846 Cahuenga Blvd. in Hollywood, renaming it Desilu Studios, and subsequently began acquiring other locations in and around the Los Angeles area. Quite a big step up for the actress who just six years before was struggling to find work in B-movies.*

**TOM GILBERT:** Once *I Love Lucy* was off and running, they had all of this equipment that they had purchased to shoot *I Love Lucy* just sitting in a corner waiting for the next week. They shot the shows on Thursday nights and then they didn't use it again until it was time for the camera rehearsals on Wednesday the next week. [The equipment] was all languishing and money was to be made if they could come up with another show so that they can use the cameras on another production and make some more money. So what they ended up doing

was *Our Miss. Brooks*. Produced by Desilu and shot by Desilu.

*As more revenue came in from the increasingly successful* I Love Lucy, *Desilu began producing and distributing several other television shows, including,* The Life and Legend of Wyatt Earp (1955-1961), December Bride (1954-1958), The Untouchables (1959-1963) *and* Westinghouse Desilu Playhouse (1958-1960), *an anthology series which would famously be the launching pad for the future hit show* The Twilight Zone (1959-1964).

**TOM GILBERT:** As Desilu grew, Desi realized they needed to get bigger if they were going to survive. At this point, the major movie studios who had stayed away from television because they were afraid of the competition, were starting to get into it. When RKO Studios — which had been owned by Howard Hughes, languished in the '50s, and was sold to General Tires — was barely getting by, Desi was in the right place and found out that it was available. So he bought it. This came as a shock to Lucy, but she okayed it – she was the vice president of the company.

*Thus, on December 8, 1957, Desilu Studios bought RKO, which included two studio lots in Culver City and Hollywood, respectively. The Hollywood location would ironically sit right next to the future* Star Trek *owners, Paramount Pictures.*

**TOM GILBERT:** Once they had RKO, they had to fill it up and get the stages working. Once they got rolling, then they had to go public. The company got big enough to where it was not just a mom-and-pop thing anymore, they had stockholders. And then the pressures on Desi became great, because they had to answer to people, and he became unhappy. During this time, Lucy and Desi divorced. Desi kept running the company, and Lucy went to Broadway.

*By this point,* I Love Lucy *had come to an end, and Desi Arnaz and Lucille Ball had divorced. Tensions between the two were fierce, but they attempted to keep the studio they formed going. However, without the cash cow that was* I Love Lucy, *Desilu began to flounder. The first solution was for Lucille Ball to return to Hollywood and give CBS what they wanted – a new show starring*

*Lucille Ball.*

**TOM GILBERT:** Desilu needed Lucy to come back to prop the studio up – they had to have a Lucy show. If they had nothing else, she was a guaranteed sale. CBS would snap her right back up. She came back and did *The Lucy Show* with Vivian Vance [former co-star on *I Love Lucy*]. It was kind of like *I Love Lucy*, but there were no husbands. *The Lucy Show* was a big hit, Number 1. [Meanwhile], Desi had disintegrated into a lot of drinking. He'd be drunk at the studio, people talked, it was a bad image for the company. Lucy and Desi had a "buyout agreement" and if one invoked it, the other had to sell. Lucy invoked the buyout agreement and Desi had to sell his part to her. Desi reluctantly agreed. This was at the end of 1962. He sold for three million dollars.

*While* The Lucy Show *was a Number 1 hit for CBS, Desilu's revenue from other programs was slim. Lucy realized Desilu needed some new blood to keep the company afloat.*

**TOM GILBERT:** With Desi gone, Lucy needed someone to sell programs. She needed some network guns. So she brought on Oscar Katz, a CBS finance executive, and he brought on Herb Solow, who was an NBC daytime programmer. Herb Solow was ambitious in wanting to make it in prime time. He's really the key. Oscar Katz not so much. They would bring in producers to pitch, and Herb brought in Gene Roddenberry. He had an idea for three shows.

Every year, Lucille Ball would threaten to leave [*The Lucy Show*]. And CBS would go, "What do you want? What do you want?" Because she was a big tentpole for them on Mondays and they needed her. So she got a development fund. She took money from the development fund to develop *Star Trek* and *Mission Impossible*.

Herb Solow had a big ego. He wanted to get places in Hollywood. He said when he got to Desilu, it was, like, moribund. It was Lucy's camp, and they made their little *Lucy Show*, and everything else was just bereft. Rundown, depressing, and nothing happening. They didn't

really have any reputation left. Desilu was washed up. Herb Solow was able to get things going. He brought Gene Roddenberry and other projects. This was putting them back on the map.

Lucy was pretty much oblivious. I mean, she had to make decisions, but she wasn't interested in that aspect of it. She wasn't interested in running a studio, but she had to. She inherited it. When she finally signed off on *Star Trek*, she wasn't sure what it was. "Oh, *Star Trek* is the show about the movie stars traveling around the world selling war bonds?" Star. Trek. (laughs)

**MARC CUSHMAN:** Desi Arnaz had taught Lucille Ball that the key to being a success is to own the property, as they owned *I Love Lucy*, the reruns. They had divorced at this point; he was in poor health and he gave up the presidency of Desilu. She became the reluctant president. She's doing her own sitcom there, which he helped launch. They still had a wonderful relationship. They just weren't husband and wife anymore. So she had Herb Solow and Oscar Katz, her two lieutenants at Desilu, to go out and find some properties that the studio can own. Their stages were very busy filming everybody else's shows. But she wanted to own it.

**JOHN TENUTO:** Lucille Ball, and her executives as Desilu, were facing a struggle. Television was changing, it was moving away from sitcoms and into the world of dramas. They wanted to show that Desilu was capable of producing not only drama, but exceptionally difficult dramas. Drama shows that the major studios would have trouble making. And that's why they purchased *Star Trek* and *Mission Impossible*.

Lucille Ball likes *Star Trek*. Likes the challenge of making *Star Trek*. And produces it. She was hands-on. There are stories that she was on the set while making "The Cage," and she's helping sweep up the set. That type of hands-on. This wasn't just for Gene Roddenberry; this was something that could affect Desilu's future.

*As Herb Solow and the people at Desilu began their search for hour-long drama projects in the mid-1964, one prominent writer who came to their*

*attention was Gene Roddenberry. Roddenberry had previously written for the hit TV western,* Have Gun, Will Travel *[1957-1963], as well as creating the short-lived military drama,* The Lieutenant *[1963-1964], for MGM and NBC.*

**JOHN TENUTO:** Eugene Wesley Roddenberry was born on August 19, 1921, in El Paso, Texas. He was the son of Eugene and Carol Roddenberry. He was a sickly boy. Quite often he would be trapped inside because of his illness. He would find his escape inside of books — science fiction books, adventure books, the stories of Jules Verne, and H.G. Wells. And that would be the genesis of *Star Trek*, if you forgive the pun for *Star Trek II*.

He would eventually take an opportunity that the government gave to all male civilians in the United States to learn how to fly an airplane. He does an amazing amount of flying during World War II. He flies in 89 combat missions during World War II and wins numerous awards, including the Distinguished Flying Cross. After the war, he becomes a pilot for Pan Am. Later, he decides to become a police officer in Los Angeles, in the tradition of his father, who had also been a police officer.

All the way through this whole process — through the military, through his police — Roddenberry was writing. He was writing his own work, he was writing PR for the newspaper, he was writing speeches for his bosses, he never gave up his love of writing.

**LARRY NEMECEK:** Gene Roddenberry had always been a fan of Jonathan Swift, and of a lot of early science fiction. It's in the '40s and '50s, and here's Gene, who's a World War II bomber pilot, civilian pilot for Pan Am, who famously had a crash plane in the desert, saved all of his passengers, got them to safety. Winds up writing speeches for Tom Parker at LAPD, after being a motorcycle cop. Then kind of gravitates over to writing [TV] scripts. A cop script as a cop advisor for *Dragnet*. That was his entree to TV. But now he's on his own. He wants to do his own series. He's doing something he knows — the military [in the series, *The Lieutenant*]. But he's in trouble for writing this [script

tackling racism in the military]. So he's like "Fine guys, fine. I love science fiction. I'll do my messages."

*The "trouble" in question was a conflict that had arisen during Roddenberry's show,* The Lieutenant, *where an episode confronting racism committed by the military was frowned upon by the U.S. military. The same U.S. military who supported the show and allowed it to film at Camp Pendleton – a major cost-saving measure. As the military removed their support, the network lost faith in the show, and* The Lieutenant *was canceled after one season.*

**LARRY NEMECEK:** March 1964, Roddenberry finally puts his ideas to paper. He's going around selling it to the network – he gets turned down everywhere. NBC, CBS. He actually gets a meeting at Desilu. Lucille Ball at that time is the queen of TV. Desilu rents stages to *Hogan's Heroes, My Three Sons* – but she's hungry for some one-hour shows. She wants some income.

**DOROTHY FONTANA (story editor/screenwriter, *Star Trek*):** Well, the television industry at the time, remember, you had three channels — you had ABC, NBC, and CBS. That was all you had to sell to. And so the prospects were daunting. Gene took it out there and a number of people, MGM, turned it down. Think about MGM now? How many times did they kicked themselves around the block for saying no to *Star Trek*? That just kills me every time. But ultimately, Herb Solow and Oscar Katz at Desilu said, "Yes, let's do this." And convinced Lucille Ball that this is one we should take a chance on. At least for the pilot. Then they had to sell it to a network and it went to NBC.

*The concept that Roddenberry developed was for a science fiction TV show, titled* Star Trek. *Described as "Wagon Train in Space"* Star Trek *would feature the crew of the U.S.S. Enterprise (Yorktown, early in the show's development) as it traveled to strange new worlds on its mission of exploration. Per the episodic format and high episode counts for seasons at the time, numerous stories were conceived to pitch the show to networks. Together, Roddenberry and Herb Solow began pitching the show to the big three networks – ABC, CBS, and ultimately, NBC. The first two turned the show down immediately, which left NBC – former distributor for* The Lieutenant.

*In May of 1964, Herb Solow and Gene Roddenberry arrived at NBC for a meeting with Grant Tinker, vice president of programs, West Coast, and Jerry Stanley, program development vice president. As described by Herb Solow in the book* Inside Star Trek: The Real Story, *by Herb Solow and Robert Justman, "I asked Gene to explain. He did, very succinctly, describing the premise of 'The Menagerie.' NBC was not convinced of the potential of the series, but just as Roddenberry and Solow were about to leave, Solow said, "If you give us a commitment for a ninety-minute script instead of one hour, and we make the pilot, you can always run it as a TV special and recoup your investment if it doesn't sell as a series. Besides, I'm not leaving this room until you give us a script order." NBC agreed to produce a pilot for* Star Trek, *based on the "Menagerie" story (later retitled "The Cage.")*

**MARC CUSHMAN:** It's interesting to know the reason why NBC wanted *Star Trek*. There were only two reasons. One is because *Voyage to the Bottom of the Sea* was on the air at this point [through ABC] and winning its time slot, CBS had just ordered *Lost in Space* from Irwin Allen, and they wanted to get into the science fiction game. That's one reason. The other reason is they wanted to do business with Lucille Ball because Lucille Ball was CBS's golden girl. That's the network that carried *I Love Lucy*, currently was carrying *The Lucy Show*. She was the feather in their cap. If NBC could get Lucy to give them a show?

*As development for* Star Trek's *pilot, "The Cage," continued through 1964, work shifted to the design and look of the sci-fi series. While previous genre shows were populated with rockets on rickety wires with not-very-convincing flames coming out the back, Roddenberry wanted to push the look of the future into new territory, starting with the design of the flagship, the U.S.S. Enterprise. Art director and production designer for* The Cage *and the subsequent series was Matt Jefferies.*

**JOHN TENUTO:** Walter Matt Jefferies had a lifelong passion for design. Particularly aeronautic design. He served in World War II, and came back from the war, as many people did, haunted by his experiences. He decided he wants to design — he wants to create, not destroy. Jefferies really is the person who took Roddenberry's ideas and turned

them into something concrete and believable. He is the designer on not only the Enterprise external, but the Enterprise internal. He brings his wartime experience and his design and aeronautic experience to *Star Trek*. He was so good at what he did, the military would come and walk around the bridge of the Enterprise, because it was a model of efficiency. You put the captain at the center, you surround him with the most important officers, and the most important functions. Everything that he did set the design aesthetic for *Star Trek* through all the versions of *Star Trek*.

**ANDREW PROBERT (production illustrator, *Star Trek: The Motion Picture*):** Starships [in most sci-fi movies/shows] back in the day were all these rockets that even used blow torches out the back of these models to make you think they were flying. It was pretty horrible. But then the Enterprise came along and there were no rockets. This thing flew faster than light, and it had a shape like one I've never seen before.

The original shape [of the Enterprise], one of Matt Jefferies' original designs, rather than having a saucer, had a sphere out front, and then a straight piece coming off of that with the nacelles, pretty much the way they ended up looking. Then that got changed to a saucer, but the saucer was on the bottom of the engineering part. But Gene, or someone, took that and flipped it.

**DOROTHY FONTANA:** The Enterprise itself was a real work in progress [as pre-production continued] because Gene didn't want it to look like those rocket ships everybody knows. He wanted it to be different. Matt Jefferies, in the art department [who would later become the art director for the series proper] was responsible for designing the look of the Enterprise. He himself had been a World War II pilot, flying in Europe. He later flew privately and even owned one. So he was very well acquainted with flying machines, and he kept coming up with different aspects to what the ship should look like. Sam Peeples [prolific screenwriter and creator of *The Tall Man*] provided a large number of old science fiction magazines that had space ships on the cover. Different looks, different designs. Roddenberry would look at them and go,

"How about we try this, but do this with it?" And Matt would come up with something. Ultimately, Matt came up with the saucer shape and the undercarriage, if you will, which supports the two engines.

**MARC CUSHMAN:** On the original drafts for "The Cage," the ship was called the U.S.S. Yorktown. By the time they filmed it, it had been changed to Enterprise. Gene liked to name all the ships after famous U.S. battleships, usually aircraft carriers. You see in different episodes of *Star Trek* – you have the Lexington, you have the Potemkin – all these names came from aircraft carriers. But the Enterprise was the biggest, and the most modern of the aircraft carriers to that point, in the 1960s. Nuclear powered. So when they started thinking about the propulsion system of the starship Enterprise, it just seemed like that was the better name. Because in the consciousness of America at that point – you didn't get bigger and better and newer than the Enterprise. So Yorktown got changed to Enterprise, and we're all happy about it.

*Operating the Enterprise was the crew of Starfleet, a pseudo-militaristic organization which sourced from Roddenberry's own history in the United States military.*

**MARC CUSHMAN:** Gene wanted to pattern Starfleet after the U.S. Navy. That's why the uniforms have a slight naval style to them. He wanted the terminology. He wanted an "ensign" at the helm. Because you could have a lieutenant in the Army, but you could only have an ensign in the Navy. Commodore. Things like this. The reason is he was an ex-military man. He felt that as Americans, we could relate to this. Keep in mind, this is 1964 when he's putting *Star Trek* together, is less than 20 years since World War II, a war that half of all American men had fought in. So the military was very much something that Americans were conditioned to.

**JOHN TENUTO:** I think it's fair to say that part of the reason *Star Trek* felt so real and felt so authentic — even though it was set in the world of the 23rd century and also dealt with issues that people were concerned with — was because many of the core group who creates *Star Trek*, Gene Roddenberry, Gene L. Coon, Matt Jefferies, were all

people who had served in war. And they knew what war was like. That's one of the reasons *Star Trek* has always had a bent towards diplomacy and towards peace rather than war. So *Star Trek* became a way for Roddenberry to take all the joy that he had had as a little boy, reading the science fiction stories, and to make commentary using science fiction.

*With filming on "The Cage" soon to commence, attention turned to the casting of the show. No, this is not the era of James T. Kirk and Doctor McCoy – the starship Enterprise would first be captained by Christopher Pike. While numerous actors were considered, from Lloyd Bridges* (Sea Hunt [1958-1961]) *to Howard Duff* (the voice of Sam Spade on the radio), *to Jack Lord* (Dr. No [1962], Hawaii Five-O [1968-1980]), *and Leslie Nielsen* (Forbidden Planet [1956], The Naked Gun *trilogy) – Jeffrey Hunter was ultimately chosen for the role. Hunter had recently starred in the biblical epic* King of Kings (1961) *as Jesus, and had previously co-starred with John Wayne in* The Searchers (1956), *and was largely considered an up-and-coming movie star.*

*The most significant casting for "The Cage" – with the possible exception of Majel Barrett, future wife of Gene Roddenberry, as Number One – was of Leonard Nimoy as the science officer, Mr. Spock. Leonard Nimoy, born March 26, 1931, in Boston, Massachusetts, had been a character actor for over ten years in Hollywood – securing roles in* Dragnet (1951-1959), Perry Mason (1957-1966), *and sci-fi features like* Zombies in the Stratosphere *(1952) and* THEM! *(1954).*

**LEONARD NIMOY (actor, "Spock," *Star Trek*):** There were times early on [in the pursuit of acting] when it was particularly difficult. It got gradually better. Gradually. It was a slow process, from the time I first acted on film to the time I got the *Star Trek* role was over 15 years. I had an agent, when I first started out in the business, who said to me, "It can take six months or 15 years." I didn't quite understand how that would work. But he was right. The six months thing was because in those years the studios were signing people to long-term contracts. So you would be signed to a seven-year contract with six-month options. They could drop you at the end of any six-month period. The six months thing is for people who have a certain look at a

certain time in the business and you'd be paraded around to the studios and somebody would say, "Right, sign him or her." If you had that, if you were of the kind they were looking for at that particular period of time. I was not. So I went to the 15-year route. It takes 15 years.

*While the search for Captain Christopher Pike was an arduous one, the search for Spock (no pun intended) was much easier.*

**LEONARD NIMOY:** It took about five minutes. I had acted in an episode of a series called *The Lieutenant* that was produced by Gene Roddenberry. And I didn't even meet him when I was cast in that role. He was out of town or something. I met the director Marc Daniels, wonderful guy. And he cast me in this role. I did the job, week or two later, my agent called me and said, "Gene Roddenberry has now seen the show" — I guess he came back in town and saw the footage — "he's interested in you for the science fiction pilot that he's going to produce, sometime in the future." I put that on the back burner because he's going to produce a pilot. You might be cast in it. It might be sold and it might go on the air — you know, as all those maybes. So I was sophisticated enough by then not to get too excited. But sure enough, about three or four weeks later, maybe a month or so, my agent called me again and said, "He wants to see some other footage on you to find out what your range is." So we sent him a performance that I had done in a *Doctor Kildare* episode and the word came back. It was very flattering. He said, "I remember seeing that and being impressed by it, but I had no idea it was the same actor. The range was so different, performance was so different. Come in and see us." I went to meet Gene and he said, "Come with me." And he walked me through the various departments. He showed me where they were making the props. He showed me where the sets were being designed, the design for the Enterprise ship. And I realized that he was selling me on this job.

**WALTER KOENIG (actor, "Pavel Chekov," *Star Trek*):** There was nothing special about us as actors, it's just that we were the ones playing the part. Except for Spock, because anybody playing Spock, he would be performing a role. Leonard was Spock. Leonard was Spock

all the time, offstage, behind the camera, at lunch — he was Spock. He wasn't making believe. Unless you're prepared to do that, you cannot acquire that level of involvement as a performer.

**JOHN TENUTO:** In 1963 and '64, Gene Roddenberry was a showrunner on a show called *The Lieutenant.* An episode called "In the Highest Tradition" features an actor named Leonard Nimoy. During the filming of the show, Roddenberry would occasionally visit the set, and Nimoy keeps noticing that Roddenberry is looking at him. Roddenberry eventually approaches Nimoy and introduces himself as the creator of the show, and says, "I've been looking at you. I'm writing a concept for a show, and I'd like for you to play an alien on that show. I want to put a bald cap on you, I want to paint you red, and give you funny ears." This is about a year or so before they're filming "The Cage." Leonard Nimoy has never had a steady job at that time, he's picked up roles here and there and supplemented his income by driving cabs. Even though Roddenberry considered people like Martin Landau and even DeForest Kelley for the role, he always had Nimoy in mind. Eventually, Nimoy convinced him there were too many elements for the role – the red skin, bald – and they'd scale that back with the great work of Fred Phillips, the makeup artist on the original *Star Trek*. But Nimoy always said that showed him what sort of person Roddenberry was – he said he was going to call Nimoy, and he did.

**LEONARD NIMOY:** I'm an actor. You do the job. You find a way to find your way into this role through dialect or makeup or wardrobe or posture or attitude or something. You're supposed to be able to change. I always considered myself a character actor. I'm wanting to be able to do different kinds of people, all different kinds of people. And that's why I took the job on *Mission Impossible*. For two years, I played all different kinds of people. I played Eastern European dictators. I played South Americans. I played Asians. I played all kinds of people. I had a wonderful time for two years. And then I thought, "Well, I've done them all. I'm going to leave."

*With casting complete on "The Cage," the vote of confidence Desilu made on this strange science fiction show was about to be put to the test. Robert*

29

*Butler, who had previously directed seven episodes of the Desilu show* The Untouchables, *as well as two episodes of* The Lieutenant, *was hired to direct the pilot, from a script by Gene Roddenberry. Bob Justman joined the pilot as associate producer, beginning his long association with the franchise.*

**JOHN TENUTO:** Desilu begins filming the pilot of *Star Trek*, known as "The Cage," on November 27, 1964. Of course, the only actor that would eventually appear on *Star Trek* is Leonard Nimoy, who plays a very young Spock.

**LEONARD NIMOY:** The script [for "The Cage"] was very good. I didn't quite understand how it was going to work as a television show because it was so unique. It was really quite special, but it was a very intelligent script. It had layers of ideas in it that you didn't often get in television. The story was thoughtful, unusual, somewhat erotic, but not easily identifiable as a science fiction television episode.

*The story for "The Cage" begins as the Enterprise receives an old distress signal from the U.S.S. Columbia — lost in unknown regions over 18 years ago. Captain Christopher Pike, weary of command and the responsibilities over human life it entails, transports with a landing party to the surface of Talos IV in search of the distress signal's source. While there, Pike is captured by the inhabitants of Talos IV and presented with three illusions that represent the life he "wants" rather than command. Rejecting these as illusions, Pike learns the Talosians have orchestrated the illusions in hopes of tricking Pike into staying on Talos IV to keep the sole survivor of the Columbia company — a human woman now medically unfit to be removed from the planet. Pike rejects their illusions, accepting his place as captain as where he truly belongs. With a renewed sense of purpose, Pike rejoins the Enterprise to travel to their next adventure…*

**JOHN TENUTO:** [The pilot of "The Cage" was] very expensive. In fact, Desilu extends the runtime of the episode so that it could be released as a movie, or as a television movie, if it doesn't sell as a pilot. This is why the episode is slightly longer than an hour if you watch it in its original format.

*NBC was not impressed with the expense and rejected the pilot for* Star

Trek. *However, in an unprecedented move, NBC requested that a second pilot be produced. This pilot, "Where No Man Has Gone Before," would be the thing that ultimately sells the network on* Star Trek.

**MARC CUSHMAN:** [Herb Solow and Oscar Katz bring Lucy] *Star Trek*, they brought her *Mission Impossible*, and they brought her *Mannix*. All three of those shows sold and became Desilu shows. The problem was, a couple of these properties were very expensive. So the old guard at Desilu, the board of directors, tried to talk Lucy out of doing *Star Trek*. They fought her when she did the pilot, they fought her when NBC rejected the pilot and ordered a second one – which never happened before. That first pilot cost $600,000, which is near $6 million today. That could have crushed Desilu right there. And then NBC says, "No, it's too cerebral. It's not action/adventure enough. We love it. But it's not quite right. We can't use this to sell it to advertisers because it's not reflective of what we would want the series to be. Will you make a second pilot?" The old guard tried to talk her out of doing that, but she went forward anyway. That one costs about $400,000 because most of the sets were already built. And then NBC ordered 16 episodes, the first half of the first season.

**JOHN TENUTO:** They film the episode ["The Cage"]. They showed it to the NBC executives and so the story goes that the NBC executives didn't like it, but they wanted to try again. What appears to have happened was, the NBC executives did like it, but they didn't like elements of it. Primarily they thought it was too slow. They were promised something action-oriented, but it was much more thoughtful, more *Twilight Zone*, a classic piece of science fiction. They liked Jeffrey Hunter, but didn't like a female first officer, nor did they like the ratio of men to women officers. They wanted more men, less women. So there were serious changes NBC was looking for. But the idea of doing a second pilot was really not common and still isn't very common. A lot of that was due to an executive at Desilu named Herb Solow. He was both creatively important to *Star Trek*, but he really believed in *Star Trek*. He used his salesman's ability to get NBC to take another pace. "Look, we can reuse a lot of these sets. It's not going to be as expensive. Let's not waste what we have." NBC agreed.

Roddenberry jokingly says that he had to cut either Spock or Number One. And so he decided to cut Number One because he could marry her and keep Spock, and he didn't want to do it the other way around. Of course, he's being tongue in cheek.

*As Roddenberry and Desilu began pondering a second pilot more in line with NBC's wishes, a major change occurred in relation to the series lead. Jeffrey Hunter would not be returning as Christopher Pike.*

**LEONARD NIMOY:** Jeffrey Hunter was very good. And a nice guy. I felt a loss when I heard he was not going to do it.

**JOE D'AGOSTA (casting director, *Star Trek*):** Jeffrey Hunter was a movie star. I mean, he'd only been in movies. I don't think he'd ever done television. When he took the show, his wife, I'm told, hated the fact that he was doing television. It was such a breakdown of his career. So my understanding is, she wanted him out. He wanted out. Even if the network wanted him, it was too big an issue. So they released him.

*With only the two fixtures of Mr. Spock and the U.S.S. Enterprise remaining, work began on the second pilot for* Star Trek *in 1965.*

**RONALD D. MOORE (executive producer, *Star Trek: Deep Space Nine*):** It is crazy that they got a second pilot. Networks just don't do that. They give you one shot, you take your shot; it doesn't work, they cancel it and move on. It's really unheard of for a show to get a second stab at a pilot. And it's difficult for a studio to want to do it too, because the studio has already spent all the money on the first pilot – that money's gone – now they're going to do a second pilot, and there's still no guarantee the pilot will go to series. So you're asking them to risk even more money. NBC takes a lot of bashing for *Star Trek*, but they clearly saw something in that series, that they believed in it strongly enough that they were willing to take another shot.

*Six hundred thousand dollars spent on the first pilot, a lost lead, and an unhappy network would give anyone pause. However, Desilu and Gene*

*Roddenberry were committed to the project. A key ingredient that ensured the opportunity for a second pilot was even possible was Lucille Ball.*

**TOM GILBERT:** Herb Solow took *Star Trek* to NBC, where he had a relationship, and NBC did not like the first pilot. It was very rare for there to be a second pilot made, but he arranged for there to be a second pilot and for NBC to look at it again. So he went back to Lucy and said that they didn't like it and he wanted to remake it. Lucy had a development fund that she was able to reach into. It was at her discretion, this extra money, which she had leveraged out of her deals to come back to CBS every year. So she gave [Solow] the money to do the new pilot. I don't know if NBC had any money in the second pilot, but I don't think so.

**LARRY NEMECEK:** How did Herb Solow not only sell this crazy show in 1964 to NBC, but then to sell it again? It's several factors. One was they had spent the money — all these sets and costumes, the ship model, I mean, everything. So they had some money invested. He was a super slick salesman. He knew all the guys at NBC from past associations. Believe it or not, there was actually a kick at the time to have more diversity in casting and to sell color TV sets. Parent company [of NBC was] RCA [the developer of color television].

**LEONARD NIMOY:** I got a phone call from Herb Solow, who was running Desilu at the time, and he's the one who said to me, "We're going to make another pilot, and we'd like you in it." I was working pretty good, my career was moving along nicely. So it was another job, as far as I was concerned. I said, "Okay. Fine."

*With the exception of Leonard Nimoy as Mr. Spock, a new cast was required for the second pilot.*

**JOE D'AGOSTA:** Many of the actors we brought in for the second pilot of *Star Trek*, we had cast in *The Lieutenant*. Nichelle Nichols was a true discovery, because I had seen her do a scene in an acting class. So I brought her in, and she was cast as a guest star in an episode of *The Lieutenant*. Gary Lockwood was the lead of *The Lieutenant*,

and obviously knew Gene, so when Gene was hiring for the pilot, he probably wrote the role for him. The easiest place to go was people we were familiar with from *The Lieutenant*.

*While Nichelle Nichols' character of Uhura would not appear until the series proper, several other leads like George Takei and James Doohan were cast as physicist-soon-to-be-helmsman Mr. Sulu and engineer Montgomery Scott, respectively.*

**JOE D'AGOSTA:** We must have cast the second pilot in a matter of two weeks. Just enough time to come up with the major cast – which was primarily made up of people from *The Lieutenant*. James Doohan, to my knowledge, was Gene's secretary's boyfriend. George Takei was on *The Lieutenant*.

*The most significant addition to the cast was the new series lead role of Captain James Kirk. Roddenberry wanted to do away with the tired, weary lead perception given to Christopher Pike and create a virile, energetic captain who could nevertheless contemplate the philosophical side of life. Into this mold, came Canadian-born actor William Shatner. Before landing the role in* Star Trek, *Shatner, born March 22, 1931, had found some success with roles in* Alfred Hitchcock Presents, Judgment at Nuremburg (1961), *and the landmark episode of* The Twilight Zone, *"Nightmare at 20,000 feet."*

**JOE D'AGOSTA:** William Shatner was being groomed to be the next big movie star – exactly the same way Robert Redford's career was developed.

**ROB KLEIN:** William Shatner just has a huge work ethic. When you struggle as an actor, you don't take anything for granted. That's why still today, he's almost 90 and he's still going. I think the thing that illustrates this the most is he was living in a camper after *Star Trek* had gone off the air. I'm sure people probably thought, "Oh, this guy's a millionaire," but that just wasn't the case. He didn't really get comfortable until several of the feature films were produced.

**MARC CUSHMAN:** One of the great things about the character

of Kirk, especially as played by Shatner, is that he was a flawed hero. He had insecurities, he had an ego, he had a temper, and we saw that displayed in *Star Trek: The Original Series*. Roddenberry wanted to show that nobody was perfect, because he wasn't perfect. He hated the fact that TV shows and movies tried to portray heroes as someone perfect.

**RONALD D. MOORE:** Kirk was my childhood hero. I mean, he made me want to be that man, he made me want to act like he did. He was smart, he was courageous, he had a sense of humor and had a sense of modesty. He had a sense of his own limitations. At times he could admit failings. In the "Errand of Mercy" episode, he could end up in a place where he felt bad because he was arguing for war, and he's a man that didn't want war. [He could] be blinded by his own quest for vengeance in a show like "Obsession" or in "Conscious of the King." So he's aware of his failings, but he was this action hero.

*"Where No Man Has Gone Before" entered production on July 19, 1965, at the Culver City Studios of Desilu. Despite the reuse of sets and effects, the pilot still had an enormous budget for the time – which did little to temper the fears of the executives at Desilu. Final numbers estimated at $435,000.*

*The plot of the second pilot sees James T. Kirk and the crew of the Enterprise discover an artifact from a 200-year-old starship – a flight recorder that tells a tale of terror that began with the ship encountering a magnetic storm. The Enterprise subsequently encounters the same magnetic storm, damaging the ship, and causing two crewmen to begin exhibiting heightened ESP abilities. Kirk and Spock debate what to do with these new godlike beings – even as the growing powers of one, Kirk's old schoolmate Gary Mitchell, tend toward wicked results. Kirk attempts to maroon Mitchell on a remote planet, but Mitchell discovers this and retaliates with startling power. Only through the combined might of Kirk and Dr. Elizabeth Dehner (the other super-powered human) is Gary Mitchell defeated.*

**LARRY NEMECEK:** Sam Peeples does the script for "Where No Man Has Gone Before," which ends with a good ole fistfight. Kirk has defied through ESP his old school friend Gary Mitchell. It's challenging, it's a very entertaining premise, and it's more hands on. It's recast.

The paint job is more vibrant because NBC is now owned by RCA, and they're selling color TVs and they want a look that will totally change the look of prime time. And the other thing that changed was a guy named William Shatner takes over the captain's role, now named James T. Kirk.

**RONALD D. MOORE:** "Where No Man Has Gone Before" is a little more network TV – there's a fistfight, there's a phaser rifle, it's got more action/suspense to it. However, I think it's *Star Trek* for the first time as we know it. "The Cage," for all of its glories, is a little cold. I think a lot of that has to do with Jeffrey Hunter. He's a good actor. But Hunter is very internal, and he wasn't the captain I wanted to see week after week. That's not the captain of the Enterprise. That's a tired, tortured man. Granted, that's the story, but Hunter brings that to Pike. There's a sadness behind Hunter's eyes, there's a tormented quality to him, there are dark shadows back there. And his interactions with the crew on the bridge and on the surface – he's not that captain you want to follow. Kirk is. Shatner brings life. Shatner steps into that role and he is the captain. The relationship between Pike and Spock is nowhere close to what it is between Kirk and Spock. Kirk and Spock, right out of the gate in the opening scene of "Where No Man Has Gone Before" and they're playing chess, there's a relationship and banter there that speaks volumes about the men and the ship they serve on. Pike was not the kind of captain that would have made the show successful. Ira Behr once said, "Shatner plays Kirk as what every little boy imagines a starship captain should be. A really good version of what every little boy imagines a ship captain should be." And I think that's right. There's a certain romantic heroism, the twinkle in the eye, getting the girls and drop-kicking the bad guys, and there's a joy to him. When you watch "The Cage," Pike is tormented and angry, but there's no life to him. I don't want to go boldly places with Pike. I do with Kirk.

**MARC CUSHMAN:** In the second pilot for *Star Trek,* "Where No Man Has Gone Before," we have a phaser rifle. In the breakdown of the script, it was called a "laser rifle," and they got memos from Forest Research and the RAND Corporation and NASA, saying that, "We don't think they'll be using lasers by that point. Because we're using

lasers now. They'll be using something new." Matt Jefferies came up with the name "phaser."

**ANDRE BORMANIS (screenwriter, *Star Trek: Enterprise*):** I thought ["Where No Man Has Gone Before"] established Kirk as a very strong leader, the Kirk/Spock relationship, and Spock's inability to processes human emotion. I like the fact that Spock was a little more cold-blooded in that pilot. As opposed to later on when he became much more of a humanitarian – he just didn't show his emotions, but he had some form of empathy. I liked the cold-bloodedness of Vulcans, and that's something I tried to put into the Vulcans of *Enterprise*. Cold logic is basically, "If you have to kill ten people to save a thousand, you kill ten people." And there's not a lot of debate. That's probably how a race that doesn't have emotions and favors cold logic would operate.

**JOHN TENUTO:** The second pilot would be written by Samuel A. Peeples, who would go on to write one of the drafts of *The Wrath of Khan*. Samuel A. Peeples wrote "Where No Man Has Gone Before," which takes us a quantum step forward towards the *Star Trek* that we know, primarily because the captain, Christopher Pike, is replaced by the captain that we know, James T. Kirk. We have Spock, we have Scotty, we have Sulu, we have the characters that we know and love – still not all, but we're getting there. And that sells, because that's much more of almost a western story in a way. It gave NBC what it wanted, so they go ahead and pick up *Star Trek* for a whole season. But one of the recommendations is, "Make it even more colorful," so the costume design changes and slight design changes to take advantage of the color TV.

*With the second pilot a success, NBC ordered the series* Star Trek *for 16 episodes from Desilu Studios for broadcast in the fall of 1966.*

## CITY ON THE EDGE OF BROKE
*Star Trek: The Original Series,* Seasons 1–3

*"Where I come from, size, shape, or color makes no difference… and nobody*

*has the power." ~Captain James T. Kirk*

*Preparation for the first season of* Star Trek *began in May of 1966, with William Shatner, Leonard Nimoy, James Doohan, and George Takei returning to star. Gene Roddenberry hired newcomer John D.F. Black as associate producer in charge of story and scripts, while Robert Justman continued with the series and took on the role of producer to handle the details of production.*

**DAVID GERROLD (screenwriter, *Star Trek*):** Bob Justman made that show run. You couldn't do *Star Trek* without Bob Justman. He invented the job. Because he could read a script and say, "Okay, we can do this, we can do that. That goes, we can't do this."

*Fred Phillips returned as the head of makeup effects, Matt Jefferies as art director and production designer along with Rolland Brooks, and Jerry Finnerman took on the role of director of photography.*

**DAVID GERROLD:** One of the stories with "Trouble With Tribbles," I was at the studio every day watching the dailies and hanging out on the set. One day, Matt Jefferies is sitting behind me, and says, "Oh, you're David Gerrold?" I said yeah. I had turned in a first draft that was 80 pages, it ran long. And he said, "We can't shoot it." "You can't shoot it?!?!" He says, "Yeah, too many sets. I can't afford to shoot all those sets. You know how much a foot of corridor costs?" I said, "What if I combine the bar with the trading post? One less set, one less actor." He said yes.

**JOHN TENUTO (*Star Trek* historian, startreknews.net):** *Star Trek* needed to be a very colorful show. That's one of the reasons *Star Trek* sold. and sold to NBC. NBC was owned by RCA, and RCA wanted shows that highlighted color – and *Star Trek* was actually used in advertisements for RCA TVs to sell color televisions. That's why William Theiss's designs were so bright in terms of the costuming, and that's why the bridge is so bright. Because it was going to be one of the first shows that would begin in color. There were many shows at the time that were color, but most shows started in B&W and transition to color, like *The Andy Griffith Show*. Even if you watch color

episodes of *The Andy Griffith Show*, it still looks like it's in black and white – the colors are very muted – it was still made with the idea that most people would have a black and white television. But by the time you get to *Star Trek*, as a full-out color television show, they want to take advantage of that. Matt Jefferies was brilliant with the way that he designed both the paneling on the bridge of the Enterprise, and also the back panels in sickbay, because they're not only colorful, but they're understandable. They helped enhance the story, and any good set design enhances the story.

*With the series going forward for a 16-episode minimum order, it would need a casting department and the ability to bring in large numbers of actors on short notice. However, the job wouldn't just be for* Star Trek, *it would be for every Desilu Studios show –* Star Trek, Mission Impossible, Mannix, *and* The Lucy Show. *This intensive job would go to Joe D'Agosta.*

**JOHN TENUTO:** One of the unsung heroes of *Star Trek* is a Joseph D'Agosta or Joe D'Agosta. He was the casting director. He worked on many Desilu projects. In fact, for television fans, he was also the casting director on *The Brady Bunch*. He was responsible for casting everyone on *The Brady Bunch* except for Florence Henderson, who was already cast by the producers of the show. One of the great things that Joe D'Agosta contributed to *Star Trek* was his ability to bring in diverse actors to play the roles. *Star Trek* was representing society in a way that many other television shows didn't. At the time, it was very common to watch whole runs of television shows and the 1950s and '60s, and see only one type of person. That wasn't true on *Star Trek*. Admirals, doctors, scientists. Many of the problems that existed in America in the 1960s and beyond would be solved by that time, and it was the job of Joe D'Agosta to go and make that happen.

**MARK A. ALTMAN (creator, *Pandora*; author, *The Fifty-Year Mission*):** Given the fact that *Star Trek* is now over half a century old, it's easy to lose perspective on how significant and groundbreaking the casting of *Star Trek* was at the time. In a medium in which there was a virtual monopoly on roles played by Caucasian actors and actresses, Gene decided to forgo conventional thinking. It's a testament to Gene

Roddenberry that his vision of the future reflected a diverse future in which he populated his future ensemble with African American and Asian actors. But perhaps even more importantly than that, and a fact that often gets overlooked, is Gene's casting of women and people of color in guest roles who were often the superiors and commanding officers of Captain Kirk. Remember this was an era where a black person was usually cast as the housekeeper. Whether it be Commodore Stone played by the great Percy Rodriguez in "Court Martial" or the brilliant, if ultimately unhinged, William Marshall as Professor Richard Daystrom in "The Ultimate Computer," this is perhaps Gene's greatest contribution to *Star Trek* and his enduring legacy which later series would subsequently build on with the casting of actors like Avery Brooks, Kate Mulgrew, and Ian Alexander.

**JOE D'AGOSTA (casting director, *Star Trek*):** Working at Desi-lu, where *Star Trek* was filmed, was like working with your family. Herb Solow, who ran the studio, was a guy's guy. When the second pilot of *Star Trek* sold, Gene went to Herb Solow and said, "We need a casting department." I had to have a personal interview with Lucille Ball, because I'd also be casting for *The Lucy Show* along with *Star Trek*. I went to her office, waited for a long time. Lucy sat in the corner in the dark. Gary Morton, her husband, sat at a desk. He was raised up high, I was down low. I couldn't figure out why he was interviewing me – even though I knew she was there, in the dark. Gary was a second-rate comedian who knew nothing about anything. But I did what I did and answered the questions. Then at the end of the interview, Lucy spoke up. She said, "Lucy is a tough broad, and she needs strong men around her to make her look feminine." And I said, "No problem." Then I asked her a question, "What if I bring in women that are prettier than you?" She just looked at me and said… "Bring 'em in. I'll eat 'em alive." I was approved. They gave me an offer and I accepted.

*Key additions to the series came with the casting of Nichelle Nichols as communications officer Uhura, and DeForest Kelley as Dr. McCoy.*

**JOE D'AGOSTA:** I brought Nichelle Nichols in because Gene said to me that he wanted a woman in the command structure. Gene

had worked with DeForest Kelley on a police show and had developed a working relationship. Walter Koenig came later. Gene came up with the idea of wanting someone who looked like the Monkees. When the script came out and it showed Chekov was a Russian, I had worked with Walter on a show that had Walter playing a Russian student, at MGM.

**WALTER KOENIG (actor, "Pavel Chekov," *Star Trek*):** Joe D'Agosta is responsible for my career. We both did an independent movie together – he was still an actor at that time. We both went in for parts. It was "supposed" to be a very candid portrayal of homosexuality, called *Strange Lovers*. He played a guy who had a fight with his wife and goes to a bar and meets a guy. Nothing was explicit. I played a young guy who at the age of 9 was raped by a guy, and then at age 14 – I played myself at 14, I was 26 at the time – my uncle comes home with a date and he's too drunk to perform, so she comes after me. (laughs.) Anyway, so we did this movie together, and a few years later, Joe had become a casting director, and he'd call me in for roles. He called me in for *Jericho*, he called me in for *The Lieutenant*, and I was one of two actors he called in for *Star Trek*.

**MARC CUSHMAN (author, *These Are the Voyages*):** One of the things Gene Roddenberry wanted to accomplish by doing an interracial cast on the original *Star Trek* was to bring a Russian on board. This didn't occur to him during the first season. Well, it did actually about halfway through the first season is when it first occurred to him that we need to have a Russian on the ship. He also wanted to have a "Davy Jones"-type character, because *The Monkees* was the only show that was getting more fan mail than *Star Trek* at that point. So he said, "Let's look for a Beatles-ish-looking guy like that young guy with an English accent on *The Monkees*," who was David Jones, and Walter Koenig kind of looks a lot like him, "and let's make him a Russian." This was huge for 1967.

**WALTER KOENIG:** They brought me in because I bore a resemblance to Davy Jones of the Monkees, and they were very successful with the pre-teen fans. Bear in mind, I was 31, married, and

not Russian, but the fans didn't know that. They thought I was really Russian. My mail reflected that. I got an enormous amount of mail. The reason to make him a Russian was to broaden out the international appeal and show that there would be a time in the future where we could all get together, where we could all love each other, and we could all have each other's back. Which was really what *Star Trek* was all about.

**DOROTHY FONTANA (story editor, screenwriter, *Star Trek*):** We had one of the most wonderful icons in Nichelle Nichols – not only African American, but she was also a woman. She was there on the bridge all the time. She was important. And there were some stations in the South that said, "Oh, you're having a black woman on the bridge, we're not going to show your show." And Roddenberry said a dirty word, "_____ you. Too bad. You lose." Later on, those stations came around and ran the show.

**DeFOREST KELLEY (actor, "Leonard 'Bones' McCoy," *Star Trek*):** How did I get picked for the role of Dr. McCoy on *Star Trek*? I really don't know... No, I had worked on the pilot for *Rawhide* with Clint Eastwood – got to know the producer on the show [CBS executive Robert Sparks]. I had done three or four western pilots and they all sold. Bob had become involved with Gene Roddenberry on a show called *333 Montgomery*, and had a lawyer in it. He had mentioned me to Gene. I went out to meet Gene and tested. So I had met Gene Roddenberry that way. That was around '59 or '60. Then when Star Trek came along, I had drifted back to doing a lot of westerns. Gene wanted me for the original, but NBC would not go for me, because I had played such bad guys all my life. So then they made the second pilot, and I had done another pilot for Roddenberry called *Police Story*. NBC saw that and said, "Well, he might be okay." So that's how I got it. I was not in either pilot, but I started with the first episode.

**DENISE OKUDA (art department, *Star Trek* feature films):** DeForest Kelley was always a gentleman. We worked with him on several of the *Star Trek* feature films. And he was always gracious. I guess the Southern gentleman always comes out. He was just pleasant to be

around and a true professional. He hit his marks the same way every time. I'm sure the editors loved him.

**NICHOLAS MEYER (director, *Star Trek II: The Wrath of Khan*):** DeForest Kelley was a lovely man. He was a joy to work with. He was a professional, he was an intuitive actor. I don't think he spent a lot of time analyzing – I think he understood, instinctively, who McCoy was. I don't think I ever had to spend a lot of time having to direct him or shape a performance. He had a kind of Henry Fonda-esque quality going. I don't think he ever got the chance to explore or exploit [his various] qualities.

**ROB KLEIN (pop culture historian/archivist):** The thing that really pulls me in is the relationship between Kirk, Spock, and McCoy. The writers have talked about it a lot, about how when they eventually added Dr. McCoy to the mix, they realized they could use him as a great foil, between the very cold and logical Spock and the more emotional Dr. McCoy, and Kirk being in between the two. The crux is the friendship between those two characters.

**NICHOLAS MEYER:** I think the three of them [Kirk, Spock and McCoy], are an interesting troika, with McCoy being all emotion and what some people would describe as a bleeding-heart liberal, Spock being a calculating machine, and Kirk straddling the divide. I'm also very interested as a citizen in what are the qualities of leadership. What are the qualities of a good captain? What are those qualities? I enjoyed the chance to explore some of those qualities when I had the chance to write Kirk.

**MARY JO TENUTO (*Star Trek* historian, startreknews.net):** Gene Roddenberry wanted DeForest Kelley for both pilots, but the studio told him no. Twice. That was because DeForest Kelley had over 10 years working as the heavy in westerns. He was frequently the bad guy. Gene had the idea that if he got a haircut, that would subliminally say "good guy" and the studio would come around. So he told DeForest Kelley to go see Jay Sebring, who was one of the leading male stylists in Hollywood. And the haircut was expensive. It cost $35 at the

time, but DeForest Kelley said he had faith in Gene Roddenberry. So he went and got the haircut and the studio approved. That haircut was based on John F. Kennedy.

*As pre-production on* Star Trek's *first season continued, the employees in front of and behind the scenes began to learn more about the show's creator, Gene Roddenberry.*

**JOE D'AGOSTA:** Gene Roddenberry was a guy's guy. He knew how to delegate. He knew how to laugh. He never pushed it. Gene Roddenberry was a team player. He would give people their due. Maybe the best boss I ever had.

**DAVID GERROLD:** Gene would sit down in the morning with a ream of paper and a bottle of scotch, and by the end of the day, the bottle of scotch was empty, but you'd have a *Star Trek* script. So Gene was a heavy drinker. He was creepy with women. There are stories that he tried to sleep with many of the actresses on the series. I know Nichelle has a story or two. In those days, producers were like feudal lords, and they took advantage of their position. Gene, for all his pretense of enlightenment… Great people have great virtues, but they also have great flaws.

**MARC CUSHMAN:** Gene was a paradox. He was a great pitchman. One of the best pitchmen I ever knew — on paper. He was a terrible pitchman in person. And his scripts were rarely perfect. He drank too much, but he came from the cocktail generation. His father was an alcoholic. He was not faithful to his wife, he was not faithful to his mistress. But he did not discriminate against you because of the color of your skin or your sex or your age. And he had such a creative mind. The first 13, 14 episodes of *Star Trek: The Original Series* for Season 1, he rewrote every one of those scripts. It's more than a 50 percent dialogue rewrite of every one of them. So he set the tone, he set everything for *Star Trek*.

**DAVID GERROLD:** Let me say it to you this way. 'Cause that first season of *Star Trek* had gravitas. That got lost somewhere in the

middle of the second season. Gene L. Coon loved doing adventures with a sense of humor, like *Wild Wild West*. That was why Roddenberry fired him. That first season of *Star Trek* had gravitas. I will tell you this, Roddenberry had a unique skill. He could take a bad script, run it through his typewriter and turn it into a good script. He also had a corresponding skill that he could take a great script, run it through his typewriter and deliver a good script. He had a very narrow box. He didn't have a sense of humor in his writing. He was not a great writer. And he was not always the best idea man. He was a good idea man on that first season of *Star Trek*, because he was working with a lot of great science fiction writers. Richard Matheson, Harlan Ellison, Robert Bloch, Theodore Sturgeon, Norman Spinrad, Max Ehrlich, and, of course, Dorothy Fontana. The best scripts on *Star Trek* did not come from Gene Roddenberry, which became a problem when we got to *The Next Generation*.

*A key element that would define* Star Trek *for the next 55 years, and was present since its early development, was its underlying sense of optimism for the future. In its early conception, this came from the mind of Gene Roddenberry. History remembers Roddenberry as a complex man with various agendas, moods, and personalities, but at this early stage of* Star Trek*, he wanted to produce a science fiction show that was different from the B-movie sci-fi/horror films and shows that were populating the airwaves at the time.*

**JOHN BILLINGSLEY (actor, "Doctor Phlox,"** *Star Trek: En-* **terprise):** I think you have to look at 1966. The mid-'60s was a fascinating period. If you go back and you look at the '60, there are two things that were colliding. One was the Civil Rights Act was passed, there was a sense of American possibility, we were trying to put a man on the moon. But also, Kennedy had been assassinated. At the same time, there were race riots, the Vietnam War was happening. There were forces in collision in American society. We tend to look back in the '60s from our lens as a time of positivism, but it was an extraordinarily complicated era in American history. I think *Star Trek* was aspirational in what it was trying to say about where we could go. I didn't think that *Star Trek*, or much television from that era, tends to view the world through as complicated a lens as it needs to. Gene Roddenberry pushed an

envelope as far as he could push it at the time, and he still kind of got in trouble. It's an inherent challenge in mass culture to put something out that doesn't offend too many sensibilities, because otherwise it'll get canceled. I appreciate the fact that *Star Trek* today is actually sort of trying to wrestle with some of that.

**MARC CUSHMAN:** Gene Roddenberry was – you couldn't peg him down if he was a Republican or a Democrat. I would call him a true moderate. But he was an optimist. He wanted to use *Star Trek* to try and help get us more civilized, and try and help us survive. He told me he didn't think we'd survive till the time of *Star Trek*. He wanted to get a show on TV that would talk about topics no one else would talk about. He wanted to get an interracial cast and show a black communication officer, a woman, and show an Asian at the helm and a Russian and a Vulcan, all getting along, all working together. Roddenberry was populating his cast with different nationalities, to show that we could all work together and that we could survive.

If you ever hung with him when he was drinking, which was every night, he would start telling you how he really felt about things. But in the morning, he would get back to the typewriter and write positive stuff.

**BRANNON BRAGA (co-creator, *Star Trek: Enterprise*):** Roddenberry's vision of the future — I may be projecting some of this, I don't know — but I think it's powerful. It's a mythology we can get behind. [Where humanity is on] a path where we fixed stuff and we figured it out and we overcame our amygdala issues and leaned into the frontal lobe. We became a thriving species that wasn't choking each other to death. The acquisition of wealth being the main thing was gone.

Gene envisioned a secular society, where the negative impact of thinking we are separate from nature and created special, as a separate entity from the natural world, is gone. Now you can call it anti-religion, but I like to think of it as more anti-superstition. People see reality more clearly. We are a part of nature and know our place in the

universe. And we have some humility and respect for other species, other humans, and the natural world.

**JOHN BILLINGSLEY:** As soon as you begin to think man is perfectible, you are led into thinking you have the right to tell somebody else what to do, which is antithetical to what the Prime Directive is supposed to be about. It's because we believe that we have achieved perfection and they have not that we can go in and tell them they fucked up their world. I recognize that there is this incredible contradiction between the desire to help and the trap of imposing. I would just say that it is possible to evolve morally as an individual, but no human being is perfectible by definition because you're simply not going to live long enough. So man is not perfectible. I'm not tearing down the ethos of *Star Trek* or suggesting that there is anything wrong with aspirational fiction or aspirational drama. We're drawn to it for a reason, because we need positive messaging. We need to believe that there is something bigger than we are, and that we can be bigger than we are now. I'm just saying that I think that it is possible to throw the baby out with the bathwater and fail to reckon with the obverse of that. The biggest challenge for any great work of art is to try and hold two opposite ideas in your head at the same time in balance.

**MARC CUSHMAN:** Gene didn't have a racist bone in his body. And he didn't have a sexist bone in his body either. He loved sex, he loved women, but he would not hesitate to hire a woman to run his show. He hired Dorothy Fontana to be his story editor on *Star Trek*, and his associate producer on *Star Trek: The Animated Series*, long before anybody else was doing this. He was very open-minded, but he knew the terrible things that people could do.

*Of the key players who were hired early on in the production of* Star Trek, *possibly none are more important to the history of the franchise than D.C. Fontana.*

*Dorothy Catherine Fontana was born in Sussex, New Jersey, on March 25, 1939. A prolific writer of science fiction and westerns, Dorothy Fontana rose through the ranks from secretary to Gene Roddenberry to being the modern*

*equivalent of showrunner for* Star Trek: The Animated Series. *In addition, she was an early supporter of the* Star Trek *fanzines, a major factor in galvanizing the* Trek *fans in the call for the show's return. In her later years, Dorothy taught screenwriting at numerous colleges, lastly at the American Film Institute, where she taught the History of Television to the writer of this book. She passed away on December 2, 2019, at the age of 80.*

**DAVID GERROLD:** My best friend in the field would be Dorothy Fontana. We would go out to Jerry's Deli for lunch. And she sat in on a lot of my writing classes, and I sat in on a lot of hers. I don't know what I'm going to do without her.

**DOROTHY FONTANA:** I've been writing stories since I was 11 years old. Even then I was writing short stories, thinking I would probably be a novelist. But then, when I graduated college with an executive secretarial degree, I saw an ad in the New York papers. I'm from New Jersey. It was for the junior secretary to the president of Screen Gems, which is of course the television arm of Columbia Pictures. I applied and I kept bugging them and they finally hired me. They said they hired me because I was the only one who kept coming back and saying, "so can I have the job?" Ralph Cohn was the president then of Screen Gems. Unfortunately, I took the job in June and he died in the middle of July with a heart attack. So I went back to New Jersey, but in the time that I had been in that New York office, I had read a number of television scripts and saying the fatal thing – "I can do that."

I decided that I would save up my money, I would come out to California and see if I couldn't get a job. I'd take a two-week vacation and see if I could get a job, which I did at Revue, which was then a major, major television corporation. They had just taken over the Universal lot. I went into the typing pool and I saw a job on the board saying, "executive secretary, production secretary for a television series." And I got the job with Samuel A. Peeples, who was the creator and executive producer of *Overland Trail*. That started a whole lot, because Sam Peeples was a huge science fiction person. He had written any number of westerns and he did three series in a row with that. I was on *Overland Trail, The Tall Man,* and *Frontier Circus.* He had told me, because

he knew how much I wanted to write, "You tell me a good story and I will buy it." And I told him a good story on *The Tall Man*. He bought it. That was my first sale. I was 21 years old and it was 1960. I've been writing ever since.

*Dorothy Fontana would go on to write four episodes of* The Tall Man *(1960-1962), one* Frontier Circus *(1961-1962), and one* Shotgun Slade *(1959-1961), (all while still officially being a production secretary) before meeting the man who would change her life forever.*

**DOROTHY FONTANA:** I met Gene Roddenberry in 1963 on *The Lieutenant* at MGM. I was on the series as the secretary to the associate producer, Del Reisman. And that was where I met Gene Roddenberry. He created *The Lieutenant*. He was a big man. Enthusiastic. He really loved producing a show – which he had never done before. He had worked on many, many westerns, but this was his first creation that had sold. Unfortunately, it was a one-year series.

He knew that I had sold some things, and that I wanted to be a writer, a full-time writer. He called me into his office and said, "What do you think of this?" He showed me about a 10-, 12-page piece that was called *Star Trek*. I went home, I read it, and I came back the next day and said, "Who plays Mr. Spock?" I mean, it was good, but it was very basic. It was about the U.S.S. Yorktown, and Captain Robert April, but there was Mr. Spock, at that point he was a Martian first officer. He shoved a picture of Leonard Nimoy across the desk at me. Leonard had done a guest star role on *The Lieutenant*, but he had also been the guest star in the very first story I ever sold to television on *The Tall Man*. It was wonderful.

**JOHN TENUTO:** D.C. Fontana certainly was the heart of Spock and the heart of *Star Trek*. She brought a different sensibility, a different perspective, a different kind of talent. An ability to write "people" stories. She was instrumental not only for the original *Star Trek*, but she ran *The Animated Series,* and also helped shepherd the very early days of *The Next Generation*. She was Gene Roddenberry's secretary, but she had a dream of being a writer.

**49**

**RALPH SENENSKY (director, Star Trek, "This Side of Paradise"):** Dorothy Fontana, who worked under the name D.C. Fontana to camouflage the fact that she was a woman, was on the staff of *Star Trek* when the script came in for [what would one day become] "This Side of Paradise." When Dorothy read it, she went to Gene Roddenberry and said, "This is not a Sulu script." The script was written with Sulu, George Takei, as the lead. Dorothy said, "This is not a Sulu script, this is a Spock script." And she outlined how she thought the script should go, and Gene said, "Okay, go write it. And if it comes out okay, you'll be our story editor." So she did.

During that time, she bumped into Leonard Nimoy, Spock, and she told him, "Leonard, I'm writing a love story for you." Leonard was stunned. He had appeared in both of the pilots for *Star Trek*. He had appeared in 19 or 20 episodes at that point. He had found it difficult to create the emotionless Spock, but he had worked at it and he had, step by step, really tied it down. So he knew what he was doing and was comfortable with it. And his response to her was, "Well, you can't write a love story for Spock. He's emotionless." And she said, "Wait till you read it."

**DOROTHY FONTANA:** There were problems with [This Side of Paradise] in the beginning, and that was, all the spores which were affecting people were in a cave. They were bubbling up and down and things like this, and this pool in the cave. And the answer to that is, don't go into the cave. So my idea was to make it all over the planet. You can't avoid it. You cannot get away from it. You will be affected by the spores and including our crew as they come down. The other thing was the love story. Originally it was posited as being for Mr. Sulu and Layla. I adore George Takei, but this was a story for Leonard Nimoy as Mr. Spock, because with the spores, you get a chance to see who he really is inside and the humanity of him because of his mother, who was human. We get a chance to see this character as we will never have seen him before. And that was what moved the story.

**JOHN TENUTO:** When she was working on *Star Trek*, she's actually the youngest story editor in the history of television. She's one

of the few female story editors in television when she was working on *Star Trek*. It's a few years later, she's running the animated show. It was her idea to bring on some of the best writers. She would have a long relationship working with Roddenberry's other proposed shows, even writing some novelizations for them, and she would contribute to *Star Trek* through her life. She contributes to *The Next Generation*, to the *Star Trek* video games, novels, and comic books. Her willingness to give her time and energy to try and cultivate a new generation of writers — she understood what it meant that somebody gave her a chance. She also understood that you needed to have talents and ability and hard work to make that open door be something you could walk through, but she also gave a great deal of her time teaching the next generation of writers.

**DOROTHY FONTANA:** I've always seen myself as I'm just a writer. I'm not a woman writer. I am a writer. If I write science fiction, if I write westerns, if I write solid dramas, it doesn't matter to me. I want to write good stories and good stories at that time had to do with the movement of women in our culture and elsewhere in the world. What are we doing? How are we moving forward? How are we making our mark on society? But it wasn't necessarily the drive of the show. What's the story? Who are the characters? What's the problem? Why do I care? Those are storyteller notes that you always have to keep in mind. It's how I judge films. It's how I write films, whether it was for television or novels or anything else.

At the time I came in, there were very few women writers doing action-adventure. Margaret Armen was one. Leigh Brackett in film. But there were very few actual women writers doing action-adventure. Most women at that time were either writing romances or the daytime soaps. Or they wrote comedy very often with a male partner. I, like Margaret Armen, Leigh Brackett, was writing alone. These are my stories. These are the ones I wanted to tell. The first few I wrote for *The Tall Man* and *Frontier Circus*, and I did a rewrite on *Shotgun Slade*. But those were all for people I knew. So I used Dorothy C. Fontana on those first six episodes. Then I found when I was trying [to find work] and I had an agent, they were saying, "Oh, I don't think she can write

our show." "Well, why not?" "She's a woman." "Okay, fine." So I wrote a *Ben Casey*, and put D.C. Fontana on it, figuring, "Well, they'll at least read it without knowing I'm a woman." And they liked it and they bought it, and I kept D.C. Fontana on it, figuring, "Well, that helped me get in that door." And I've used it ever since.

*Filming began on the first episode of the season, "The Corbomite Maneuver," on May 24, 1966. The series was given a tight schedule of six shooting days, in an effort to save money where they could, as Desilu was already vastly overbudget on the series.*

**LEONARD NIMOY (actor, "Spock," *Star Trek*):** The series was shot in six days. Bang, bang, bang. Very low budget. It was very undersold. *Mission Impossible*, which was sold by the same company at the same time, aired the same month of September of '66, had an eight- or nine-day shooting schedule. We were six. That's it. I'm not sure what the mechanics and mechanics were all about, I just know CBS gave Desilu more money to make *Mission Impossible* than NBC gave Desilu to make *Star Trek*.

**LARRY NEMECEK (author, *Star Trek: The Next Generation Companion*, podcast host, *The Trek Files*):** Hollywood was not set up to handle a weekly science fiction show, even when they were light on visual effects. Even when Bob Justman had the idea of having stock visual effects – the good old Enterprise flyby, the tight on the viewscreen over Sulu's shoulder – all those stock shots were done to save money. Even besides the budget, Hollywood just didn't have the infrastructure. They used every available visual effects house — four of the visual effects houses in Hollywood — to produce *Star Trek*.

**DOROTHY FONTANA:** We didn't necessarily look ahead and say, "Oh, this is a technology we should do." It was just, "Is this something we can use? Can we make it work in the realm of the show?" We did have Harvey Lynn, who was a representative of the RAND Corporation, which was a very high-tech science corporation at that time. He would advise us on the technological stuff. For instance, when Gene originally wrote the first pilot script, there were laser rifles

or laser guns in it, and Harvey said, "No, no, make it phaser. Because we have lasers, and by the time you're talking about in the future, lasers will be outdated." So we made up phasers.

*NBC chose to air the fifth episode produced, "The Man Trap," as the first episode to air. September 8, 1966, saw the premiere episode of* Star Trek *on NBC's much-coveted Thursday night lineup, against the stiff competition of* Bewitched! *and* My Three Sons. *Partly, the reason for choosing "The Man Trap" was that it included a strong sci-fi premise and startling alien scares reminiscent of the best episodes of* The Twilight Zone *and* The Outer Limits.

**SANDRA LEE GIMPEL (stunt actress, M-113 Creature, "The Man Trap"):** When I went to do "The Man Trap," first thing we did was a costume fitting. So they built the costume to fit me. Then they took a plaster cast of my head to build the mask. Then the fingers and the suckers — they were basically gloves that went up and then the costume went over it. My fingers looked really long. There was a little problem though [in filming] – I'm supposed to put my hands up to William Shatner's face and suck all the salt out – but I can't see. So I don't know where he is. I missed his face every time. Finally, I say, "Guys, we have to take the head off. I have to see where I am." So they took the whole head off and rehearsed it [many times with the head off] until I learned the moves like a dance routine. I worked at least a week or two on that show, because it took so long to get all that stuff together.

**ANDREW PROBERT (production illustrator, *Star Trek: The Motion Picture*):** When *Star Trek: The Original Series* came out, there were no science fiction shows of any quality on TV. So it was exciting to have a TV show weekly on a spaceship. Out in space all the time. It wasn't like landing on Earth – Gene never really wanted to show contemporary Earth, because it would always be out-designed by reality anyway, he wanted to keep the fantasy in space. So, I loved everything. I liked the color of the costumes – which was a big deal for the networks because they were just changing over to color from black and white. So they wanted to have a lot of color in their sets and costumes.

**MARC CUSHMAN:** "The Man Trap," the first episode aired on NBC in 1966, had a 47.5 percent audience share, which is unheard of today. If you have 11 percent, you're Number 1. But the difference is in the 1960s, there were only really three channels in a lot of markets, the big three networks. They wanted to at least get a 30 share. *Star Trek* had a 30 share in its first season.

*As the weekly series began, it became clear the first season would go on to get a full 29-episode order. In order to accommodate the episode order,* Star Trek *brought in numerous acclaimed science fiction novelists to pitch ideas for the series. Not unusual for the time to bring in freelance writers to write episodes – but to bring in principally novelists to write teleplays was an interesting choice. In the days before an episode had aired, writers would be given the show bible to look at and be asked to come up with ideas from there.*

**DOROTHY FONTANA:** The system at that time for almost every show, independent writers came in and pitched. Sometimes they'd be given a story, and other times they'd come in and pitch an idea. That's what we were doing on *Star Trek.* So we did have a lot of outside writers. The only ones on staff were myself, Gene Coon, Gene Roddenberry. Everybody else was outside. The producer, the executive producer, and the story editor. Gene Roddenberry, Gene Coon, and myself. When we had John Black as a story editor he came up with stories. When we had John Meredith Lucas as a producer, he came up with stories, etc. Steve Carabatsos was story editor before me. It was always very few. Executive producer: Gene Roddenberry; producer: Gene Coon or John Meredith Lucas; and story editor: John D.F. Black, Steve Carabatsos, then me. Really the only writers on staff – everybody else came from outside.

**LARRY NIVEN (science fiction author,** *Tales of Known Space* **series):** [I was a fan of *Star Trek.*] There was the Science Fiction Writers of America, and it was brand new. There was Roddenberry, ready to run with two scripts for pilots. He wanted to show the pilots to everyone he could that was a science fiction writer. That was Gene Roddenberry's big breakthrough: He used science fiction writers instead of scriptwriters, and taught them how to do the scripts. So he

invited a bunch of us to watch both pilots.

**MARC CUSHMAN:** Gene didn't like the carelessness of the way violence was portrayed. He had nothing against violence on television. He had been to war. He felt violence was something we need to see, but he wanted a character when he gets shot to be screaming in agony, "I'm dying, I'm bleeding. I'm hurt. This is a nightmare." He wanted to show that. And the networks wouldn't let you show that. That was the problem he had with the way violence was shown on TV in an unrealistic way to where kids would go hit each other on their heads because Marshall Dillon never gets hurt, why should I? So he was a realist.

**DOROTHY FONTANA:** In the original bible, there were a number of stories that were proposed. One of which was "Charlie X." I fell in love with "Charlie X." When Gene offered me the opportunity to do a *Star Trek* script, because I had written nine other shows at that time, I said, "I'd like to do 'Charlie'." So Gene Roddenberry gets credit for the story on that, but I did the script. I think that it was very well realized because it's about a boy who was raised by aliens and with no human contact. Now what does that do to you when you now come in contact with real human beings and you have to interact with them? Charlie didn't know he had a temper that lashed out. He didn't know how to control that because he never had to. It's kind of like abusive parents and the result in how they treat their child and how the child then acts later on as a grownup or an almost grown-up. It was a story that I felt worked really, really well. And certainly, Robert Walker Jr. was excellent. He was outstanding. It was one of the stories people remember because Charlie was naive, unschooled, and educated, and yet there were things he could do that were beyond human powers.

**JOHN TENUTO:** "Space Seed" was an idea submitted to *Star Trek* very early in *Star Trek*'s production by a writer named Carey Wilber. He submitted a very inventive premise about a prisoner ship in the future that is awakened by the crew of the Enterprise. It had a sort of Nordic leader named Ragnor Thorwald. In different versions the name changed to John Harrison, Eric Harrison, it had all these different permutations – and eventually, they would settle on Khan. It was a very

inventive premise. The broad strokes are the same, but as you drill down into the proposal, there's a lot of differences in the episode. For example, Spock has telepathic powers, like the Force. There was supposed to be a scene where Kirk is keelhauled and thrown out an airlock. [It was] just a very expansive episode that would have been too costly. But Carey Wilber was a very talented writer and was given first crack at the script — which has many of the same strokes that is the "Space Seed" we know and love. But it was really Gene Coon that really guided that episode. He wrote to Carey Wilber and saw the potential in this villain. This was great foresight, because Khan in many ways is the greatest villain faced by the original crew.

In a memo Gene Coon writes to Carey Wilber, Gene writes, "We have the potential to create a villain here that rivals Kirk. That really is Kirk's first threat." And he encourages Wilber to create a giant of a man, because originally, he was more of a gangster. It was Gene Coon's suggestion to make Khan genetically superior. Then Gene Coon takes a crack at the script. It would be Gene Roddenberry who would write the final uncredited version of "Space Seed," but that middle step of bringing it from an unworkable television script to a workable television script, and perhaps one of *Star Trek's* most important episodes, was Gene Coon.

**DOROTHY FONTANA:** Gene had absolutely no problems with doing what would be a subject that could not be touched on any other show. Let's just do it. He was very open that way as was Gene Coon as was John Meredith Lucas, our producers. The writers came in and said, "Oh God, I can write about this? How wonderful. They came up with good stories to illustrate what the problem was without saying "Vietnam War" or "racism" or "feminism," etc. We just did it.

**JOHN TENUTO:** There were lots of discussions about making sure that there was representation on *Star Trek*. If they could find an actor to fit a role, and they needed to change the ethnicity or the sex of that character to bring a great actor in no matter what his ethnic background was or racial background was or sex was — they would do that. They would bring in that person and then change the character

if needed. Khan is a great example. Khan was named Khan because Ricardo Montalban was cast.

*Gene L. Coon is often cited as the unsung hero of the original* Star Trek. *Born January 7, 1924, in Beatrice, Nebraska, he found a passion for writing early, through producing plays in his hometown. In the mid-'50s, Coon began writing teleplays for westerns and hour dramas such as* Suspicion *(1957) and Walt Disney's* Zorro *(1958) and continued in this vein until landing a brief stint showrunning the troubled first season of* The Wild, Wild West *in 1966. Because of his work on such shows as* Wagon Train *(1958-63), which involved strong moral lessons in each story, Coon was hired by Roddenberry to take over many of the showrunning duties on* Star Trek *in the middle of the first season.*

**JOHN TENUTO:** Gene Coon served in two wars. He served in World War II and he served in the Korean War. You see a lot of his ideas about war and peace in his *Star Trek* scripts. Gene Roddenberry created *Star Trek*, but so many of the details of what makes *Star Trek* great were contributed by other people.

**DOROTHY FONTANA:** Gene Coon was remarkable. He had a wonderful sense of humor. Unfortunately, he also smoked like mad every day. That's what killed him, ultimately. He had lung cancer. But a remarkable man. He had been a Marine veteran and had written novels and got into the business. I'm not exactly sure how we got him on our show, but he had been on other shows. He'd certainly written for a lot of them. And when he came in, it was transformative because he was there every day. He had this great sense of humor. He was involved in every script there was. Roddenberry would read them and make his notes, but Gene Coon was there actively talking with the writers, working with the writers, and writing his own scripts. He was a very fast writer. That man could write a script in about a day if he just sat down and started.

**MARK A. ALTMAN:** When Gene Roddenberry did 13 episodes, was completely burnt out and had to go to the hospital, they needed someone who could take the mantel, and that someone was Gene

L. Coon. Gene L. Coon was a remarkable writer. First script he did, which he wrote in a weekend, was "The Devil in the Dark." The things we know today as *Star Trek* come as much from Gene Coon as from Gene Roddenberry. This was the episode that said, "The horrible looking alien creature that's killing our people, that we must destroy, it turns out it's a mother protecting its young. So maybe we shouldn't judge on appearance?"

Gene Coon came up with the non-interference Prime Directive. Gene Coon came up with the Klingons as our antagonist in "The Errand of Mercy." Gene Coon is the one who wrote the brilliant "A Taste of Armageddon" – which is one of the best allegories for Vietnam — where people are being sent into disintegration chambers, because two civilizations would rather fight a war by computers than destroy their actual cities.

**JOHN TENUTO:** For Roddenberry, *Star Trek* was always meant to be metaphorical. It was the human family in outer space. It was always meant to be *Gulliver's Travels*, and a bit of Horatio Hornblower, in outer space. Gene Coon enjoyed bringing a bit more humor into the scripts. And you do see that in what scripts are purchased – in "Tribbles" and "A Piece of the Action" – lightening it up every once in a while. I've always thought of it as Gene Roddenberry wanted Kirk to have a twinkle in his eye and Gene Coon wanted Kirk to have a smile on his face. Roddenberry understood the necessity of humor — he recognizes that we need to ground these characters as recognizable people, even though some of them are not from our world. And that humor is a great way to do that, but I think it was a matter of degree.

*One of the many duties Gene L. Coon and Gene Roddenberry would have had, would be receiving notes from the network, NBC.*

**DOROTHY FONTANA:** We never got notes about racism or feminism or advancing those causes. We got things about language occasionally. Sexuality. Costumes. What's funny is, Bill Theiss's costumes never showed anything important or sexy. That was Bill's thing. Those costumes never came off, they never fell off, they were glued to the

actor. (laughs) Although we always got costume notes, "Don't show this, don't show that, be careful about this." But rarely did we have notes on the themes of the stories – which dealt with anti-racism, pro-feminism, and of course, the war. We were one of the few shows that actually could approach the question of the Vietnam War, because nobody else could. We could call it something else and still have it be about the war. There were several war stories that we did, strongly anti-war or comments on the Vietnam War, and nobody ever said a word to us.

*One of the show's main points of contact with NBC was with Stanley Robertson, who goes down in history as being among the first African American network executives in American television.*

**DOROTHY FONTANA:** Stanley Robertson was very good to work with. He had a good perspective on the show and often brought up philosophical kinds of questions for us. It almost never was, "Do this, don't do that." It was usually suggestions. And generally speaking, we had a good relationship with him. The one time he referred to "his" writers on the show, Gene Roddenberry got very upset, and I think called him out on it. But other than that, we had no real problems with Mr. Robertson. He was very smart. He was into the show, he got it. Therefore, we didn't have a lot of major, "You must change this" kinds of suggestions. You never did that. It was always, "You could do this or you might do that, or would you do this?" And generally speaking, we worked with him.

*Another key figure on any film/TV set is the assistant director.*

**MARY JO TENUTO:** Charlie Washburn is an inspiration and a role model. He was from Tennessee. He grew up in the segregated South, went to segregated schools and he earned a bachelor's in business administration. But his dream is to become a director. So, he applies for the Directors Guild of America's apprentice program. He is the first black person to apply and graduate. The exam to apply is a rigorous, eight-hour written exam. Then an interview with a producer, a director, and an executive, and he's accepted. He graduates at the top

of his class and gets a job. He works as an apprentice for *Star Trek: The Original Series*, and then is hired as an assistant director. He's one of three black assistant directors in all of television and one of three African Americans at Desilu. It's Charlie Washburn, Nichelle Nichols, and the food truck guy. It's just the three of them. *Star Trek* were pioneers in front of and behind the camera.

**JOHN TENUTO:** One of the people whose contributions to *Star Trek* deserves a great deal of attention is Wa Chang. He was really a child genius. He was an artist from the time he was a young boy. An artist in many different mediums — painting, sculpting — in the scientific arts in the sense that he understood technology and how to bring an artistic aesthetic to technology. Wa Chang would be contracted on an episode-to-episode basis. When they needed a prop, even a creature, he would help design and build that creature or prop. He was responsible for the look of the Tricorder and the physical production of the Tricorder, the Communicator and the physical production of the Communicator, and even the Tribbles. He doesn't get a lot of credit because he wasn't part of the regular production team, he was just brought on whenever they'd need his services. But he's definitely someone who deserves mention.

*This is not to say that the production on the first season went smoothly, nor that every episode was an instant classic.*

**MARC CUSHMAN:** "Alternative Factor" was maybe the worst episode ever made for the original *Star Trek* series. And they thought that too. In fact, Bob Justman wrote a memo saying, "I wish we could take this out and bury it," but NBC already paid for half of it and they're going to want to air it. So they pushed it to the end of the first season even though it was shot in the middle.

It was supposed to have John Drew Barrymore as the guest star. Big name. That's Drew Barrymore's dad. A couple of days before filming was supposed to begin, they hired Janet MacLachlan to play the character that Lazarus seduces. NBC, though, didn't know she was black, and they found out a day before production was supposed to start. So

Gene Coon was contacted and told, "Either replace the actress or take the love story out." Which would have included TV's first interracial kiss, which *Star Trek* later did with "Plato's Stepchildren." Gene Coon was not prejudiced, and he was not going to fire this actress. So he gutted the script, took the love story out. It was a big part of the script.

Barrymore came in, was in makeup, and was handed the revised pages. He's reading them and says, "This is not what I signed up for. This isn't as good." He got up and he walked. So they're supposed to be filming in an hour, and there goes their guest star. Roddenberry walks over to Shatner and says, "Do you know anybody?" Shatner recommends Robert Brown. He's called last minute, doesn't even know what *Star Trek* is. So it was like dominos falling. It was just a mess. The whole thing imploded on itself.

*Kirk: "So you're the terrible thing? The murdering monster? The creature?"*
*Lazarus: "Yes, Captain. Or he is. It depends on your point of view, doesn't it?"*
~ The Alternative Factor, Star Trek: The Original Series

**MARC CUSHMAN:** *Star Trek* was trying to push the limits in a lot of ways. They had a script called, "Portrait in Black and White," which they never produced. It was an episode with a story by Gene Roddenberry and a script by Barry Trivers, who had written "The Conscience of the King." In the episode, the crew beams down to an Earth-parallel planet, which is Earth circa pre-Civil War, except blacks are in control and whites are slaved and shackled. And Uhura saves the day, because everyone else is shackled. NBC wouldn't let them make it.

*A major turning point in the history of* Star Trek *came with what many people call the greatest episode of* Star Trek *ever made, "The City on the Edge of Forever." The episode was a critical hit, and a hit with fans for over 50 years — but was also the most tumultuous behind the scenes, and the most expensive episode of the series, serving as a major nail in the coffin for what was to come...*

*The episode was written by acclaimed sci-fi novelist Harlan Ellison, who at*

*the time had near Beatles-level status in sci-fi culture. Securing Harlan Ellison for an episode was important for Roddenberry, as it lent credibility to the often sneered-at sci-fi television genre from people who were only fans of the limitless possibilities afforded science fiction in the written word.*

**LEONARD NIMOY:** "City on the Edge of Forever" – wonderful episode written by Harlan Ellison. One of the best episodes we ever did. Ended tragically. Edith Keeler, played by Joan Collins, dies. Kirk has to let her die in order that history isn't disturbed. If she doesn't die, Hitler wins all the marbles. So she had to die. And Joan Collins played the role very good. Very touching, beautiful lady.

**WALTER KOENIG:** Harlan Ellison was a science fiction, or speculative fiction as he'd like to be remembered, author. In the '50s and '60s, he was like a pop star. He went to all the conventions. He was extraordinarily witty and bright. Difficult man to remain friends with. It started with the *Alfred Hitchcock Hour* – he had written an episode and I was cast as one of the lead roles opposite James Caan. Harlan and I maintained a very shaky and turbulent relationship for over 50 years.

**DAVID GERROLD:** Harlan was probably one of the greatest romantics in science fiction. To prove it, he got married five times. The last one stuck. He was married to Susan for 33 years, and that was a great relationship. They could fight with each other. Nobody else would fight with Harlan.

**WALTER KOENIG:** As far as I was concerned, "City on the Edge of Forever" was *Star Trek*'s best episode.

**MARC CUSHMAN:** "City on the Edge of Forever" had a very interesting history of development. Right from the very first treatment, it was a brilliant story. Everybody knew that. Everybody was delighted to have Harlan doing it. But they couldn't get him to keep working. At one point, Bob Justman and John D.F. Black gave him an office on the set and locked him in his office, because they needed those pages. And in response, he'd play music, Rolling Stones at full blast, and drove them all crazy. It was hard to get him to write inside the budget and

to get him to write the characters as they appear in the show. That's why everyone had to start rewriting the script, and it became less and less his script. So by the time they filmed it, Harlan didn't want his name on it. That became the first big fight between Harlan and Gene Roddenberry.

**JOHN TENUTO:** One of the most famous episodes of *Star Trek*, and usually the episode that's chosen as the fan-favorite is "The City on the Edge of Forever," which is a beautiful episode where Captain Kirk and Spock have to travel back in time to stop Dr. McCoy, who has been infected and gone insane. McCoy, having gone back in time, has irrevocably changed history. Similar to what you get in *Back to the Future II,* and *The Terminator.* What we learn is that the linchpin of history is Edith Keeler. Kirk, of course, falls in love with Edith Keeler, but he has to let history play out, which means Edith Keeler has to die. Because the episode is set primarily in the 1930s, the non-regular *Star Trek* viewer can enjoy that episode, as there's not a lot of *Star Trek* in it, and still be affected by it emotionally.

The script for "City on the Edge of Forever" was written by science fiction writer Harlan Ellison, who has written some of history's most important pieces of science fiction. Roddenberry was very wise in that he would go for advice and for scripts from award-winning science fiction writers, even if they'd never written for television before. Ellison's original script, while the broad strokes are the same, there are significant differences. It's fair to say that it was an ambitious script.

This script was rewritten. There were hard feelings about it. There were disagreements over who gets credit for what. That's a normal thing in television. But Harlan Ellison wasn't happy about being rewritten. He felt the final episode diluted some of the power of his original story. I think Roddenberry's position would be, "I need to make this viable for NBC, TV, and for the confines of what *Star Trek* is."

*Harlan Ellison first pitched the idea for "City on the Edge of Forever" to Gene Roddenberry in March of 1966 – before cameras had even rolled on the first season, and before Gene Coon came on board as showrunner. Roddenberry*

*was very excited by the prospect and commissioned the episode, but it would take Ellison 11 weeks to turn in a first draft. In the 1960s, the average time for a first draft was three weeks. The first draft was submitted June 3, 1966.*

**MARK A. ALTMAN:** Even though "City on The Edge of Forever" was commissioned early in the first season, Harlan was a notorious procrastinator. At the time he was writing "City," he would have rather been doing anything other than sitting at his typewriter pounding the keys. In a famous story, that some might suggest is apocryphal, Gene Coon locked Harlan in a room to finish his script so they'd have something to shoot at the end of the first season; Harlan proceeded to slip out a window and go down to the set, where he spent time hanging out with the cast, much to the consternation of the producers. Ultimately, Harlan wrote a brilliant piece of science fiction, but one that was hardly producible on a TV budget, nor uniquely *Star Trek*.

**DAVID GERROLD:** I've read Harlan's script. It's brilliantly written. It's brilliantly overwritten. And it's not *Star Trek*. *Star Trek* had pretty well established itself by the end of its first season, and Harlan was slow on delivering. That's not meant to be down on Harlan, he was passionate about what he'd written. And it's a brilliant script. But if you read it and you read it in the context of *Star Trek*, it doesn't work as *Star Trek*. It's overwritten and there's dialogue that is not going to play. The dialogue is passionately overwritten, and Harlan's grasps on the characters were a little off.

*Harlan Ellison's initial draft (which can be read/seen/heard in almost every medium except television thanks to Ellison's determination to get the material out there — was atypical for* Star Trek. *It involves two new characters named Beckwith and Trooper, drug use on the Enterprise, and the "city" of "The City on the Edge of Forever" being a literal city that had a reverse side to it which was in another time. Great ideas for an original sci-fi novel, but difficult to make on a TV budget.*

**DAVID GERROLD:** Harlan had written a lot of big moments that, if we were doing television today — easy to do. Because now, they'll spend four or five million on an hour of television because they

want it to look spectacular. The average *Star Trek* episode was $178,000, ($1,457,999.12 in 2021 dollars). It was a lot of money in those days. It was a very expensive show. They spent $272,000 on "City on the Edge of Forever." So Harlan's episode was the most expensive episode of *Star Trek* ever.

**LARRY NIVEN:** "City on the Edge of Forever" was an excellent time-travel story. It was excellent when Harlan wrote it, and when it appeared on the screen. They were somewhat different treatments, enough to annoy Harlan. Harlan made a career out of being annoyed. Harlan Ellison did a lot of good in his life. He did things to help younger, newer writers, including me, but also, he was hard to get along with.

**DAVID GERROLD:** Gene Roddenberry had a lot of comments on it, Gene Coon and Dorothy Fontana mostly did that rewrite. I'm not sure who did what parts, but Dorothy finally admitted to Harlan that she had done the rewrite. He wasn't mad — he couldn't be mad at her. Nobody could be mad at Dorothy.

**MARK A. ALTMAN:** Gene Coon, Roddenberry, and D.C. Fontana all spent time reworking Harlan's script turning it into one of the greatest pieces of dramatic fiction ever televised and, to date, *Star Trek*'s finest episode ever. While Harlan was peeved over being rewritten and would eventually receive a WGA award for HIS script — which he surreptitiously submitted to the Guild much to the consternation of the two Genes, which was Harlan's hope — it's a brilliant distillation of his idea with some inspired and brilliant sci-fi and time travel conceits courtesy of Harlan with some potent character drama added courtesy of Coon and Fontana, who for years was wary of confiding in Harlan that she had worked on his script, for fear of ruining their friendship. To Harlan's credit, he was magnanimous about it, at least to Dorothy. Harlan was a remarkable writer and an absolute force of nature.

**ROB KLEIN:** "City on the Edge of Forever" started filming on Friday, February 3, 1967, and it completed on Monday, February 13, 1967. Seven days of shooting. I find it fascinating that they started out

on Forty Acres [backlot at Desilu Studios in Culver City], and they are taking all the clothing off the fire escape, etc., and then the last day of shooting, they're on the Guardian of Forever sets and they're doing all the leaping through the vortex stuff. Middle was all the interior sets. It's always fascinating to me the shooting out of context. Of course, shooting on Forty Acres – I always say to everyone, when you watch that, look out for the *Andy Griffith Show* Mayberry sets and even the *Gone with the Wind* sets. It's kind of a fun crossover.

**DAVID GERROLD:** In fact, if you look closely, Floyd's barbershop from Mayberry is one of the places they walked past. It was a very expensive episode and they had to scrimp and save on a lot of other episodes to bring in "City on the Edge of Forever."

**ROB KLEIN:** Joan Collins is half the reason the episode stands out. What a beautiful actress, and she played it with such sincerity. You can believe Kirk and Edith were really a great match. It's got the best ending of any *Star Trek* ever, where Kirk has the pain of losing Edith, and he says, "Let's get the hell out of here." They beam up and the camera holds on the surface and roll credits. I'm getting goosebumps just thinking about it.

**MARC CUSHMAN:** That was the first time on NBC anyone was allowed to use the word "hell," when Kirk says, "Let's get the hell out of here." NBC wanted to take that out, and Gene Roddenberry fought for it. It's a wonderful memo from NBC, they go back and forth and Gene explains to them what Kirk has just been through, and the person from Broadcast Standards writes back to Gene and says, "Oh what the hell, keep it in."

*"The City on the Edge of Forever" premiered April 6, 1967, and earned a 28.4 percent audience share, with an estimated 11.6 million viewers for the night. As time progressed, appreciation grew, with the episode appearing on many top 10 lists for favorite* Star Trek *episodes. "The City on the Edge of Forever" also won two Hugo Awards in 1968… though under somewhat less than usual circumstances.*

**MARC CUSHMAN:** "City on the Edge of Forever" won the Hugo Award as best science fiction production of the year. And it was entered into the Writers Guild competition as best TV teleplay of the year. It lost out to Harlan's original draft, which Harlan submitted. When he won that award at the Writers Guild award ceremony, he held the script up over his head and said, "Don't let them rewrite you!" Herb Solow was sitting at a table with Lucille Ball, Gene Roddenberry, Robert Justman, and a few others from Desilu. [Solow] said, "I was looking down at my plate, my knife, my fork, and my spoon, and I was thinking, 'which of these utensils should I use when I murder Harlan? Which one will take longer and hurt the most?...'"

**DAVID GERROLD:** Gene's version won the Hugo Award, but Harlan accepted it. And actually, it wasn't Gene's version, it was Dorothy Fontana's. She didn't tell Harlan for like three decades that she had done the rewrite. She let him blame Gene. We were terrified of Harlan's anger back in the '70s. (laughs.)

**MARK A. ALTMAN:** I've had the good fortune to spend some time with him over the years and one of my favorites was as we were all heading as guests to a Star Trek convention in Madison, Wisconsin, shortly after 9/11. My writing partner, Steve Kriozere, had just been taken away to be questioned by TSA due to his vaguely Middle Eastern appearance. Harlan starts screaming at the TSA officers: "Hey, let him go, he's a Jew from Chicago." To which Steve looks back at Harlan and yells firmly and trepidatiously at him: "Harlan, please <u>don't help!</u>" Despite the fact he made a career as a professional curmudgeon, you couldn't help but love Harlan Ellison.

**DAVID GERROLD:** Harlan did not have Scotty dealing drugs, but Gene wanted to justify his side, because they had this feud about "City on the Edge of Forever." When we got to *Next Generation*, I thought, "Wouldn't it be great to get another script out of Harlan." I got him on the phone with Roddenberry, and Harlan said, "Gene, please stop telling people I had Scotty dealing drugs." Gene said, "Okay, I'll do that." And a week later Gene was in front of an audience and Harlan had Scotty dealing drugs again. I was very upset by that.

Star Trek*'s popularity grew to realms outside of the science fiction fan base, particularly with Leonard Nimoy's portrayal of Mr. Spock, for which he was nominated for an Emmy Award each year* Star Trek *was on the air. In addition, the pointy-eared, emotionally distant Vulcan soon became something of a sex symbol for the* Star Trek *fandom.*

**LEONARD NIMOY:** The list of actors or actresses who have won awards, like Emmys or Oscars, from working in a science fiction project is a very short list. Very short. It is simply not recognized by members of the Academy as levels of worth that deserve to be honored in that way. Particularly then, in those years, it was considered less than honorable. That's why actors avoided it. I found a level of comfort to it. Science fiction writers are often people with wonderful imaginations, who have ideas that cannot be expressed in other forms. They find wonderful opportunities to express themselves in science fiction.

**MARY JO TENUTO:** There were two times that Leonard Nimoy appeared as Spock in his ears outside of *Star Trek*. The first was in Medford, Oregon. He was the grand marshal for the Pear Blossom Festival Parade. After the parade, they set up a table at the bandstand for him to sign autographs. They were expecting maybe a couple of hundred people, but he was swarmed with people wanting his autograph. The bandstand started moving so much that he was afraid that there would be a stampede and people would be crushed. After that, he got on the phone with NBC and said that he would never do this again. He would never appear as Spock in public because he was genuinely afraid of people's safety.

**LARRY NIVEN:** I watched *Star Trek* when it aired in the '60s. In fact, visiting my then-girlfriend in Boston, we would gather on the proper nights to watch *Star Trek* and make comments. I vividly remember watching some Enterprise crew on a cold planet, shivering, complaining about the cold. I said, "Heat up a rock with the phasers!" And they heated up a rock with the phasers immediately.

**WALTER KOENIG:** One of the things that drove me crazy is the adulation by the public was so intense. It's understandable for Bill and

Leonard, but it was disproportionate for the rest of us. It was way out of line with what we actually contributed. That made me uncomfortable. I felt, "I'm getting all this acclaim and love and enthusiasm, and I'm doing nothing. I'm up here doing nothing to speak of." That was uncomfortable. I went to conventions feeling that way, when everybody gave me these energetic ovations. When I came out and that was the way I was greeted, I felt, "I should be enjoying this more, but I know what I've contributed to the show, and it hasn't been very much at all."

*While the small, but devoted, group of* Star Trek *fans grew with each passing episode, it was becoming harder and harder to ignore the elephant in the room — thanks to* Star Trek *and* Mission Impossible... *Desilu was on the edge of broke.*

**MARC CUSHMAN:** Desilu did the second pilot, "Where No Man Has Gone Before," and did it for about $450,000. That's still remarkably expensive — they had all the sets and it still cost that much. So, NBC came forward and said, "Okay, we'll take 16 episodes. The first half of the first season of hour-long episodes. And we're going to pay you a hundred thousand dollars each." It's going to cost us $185,000 if we bring it in on budget. So Desilu's going into the hole 85 grand with every episode they're making. And look at "The City on the Edge of Forever." It costs $250,000. They're going deeper and deeper into the hole. So the old guard told Lucy, "Don't do it." She had an order for 16 episodes and they said, "Don't do it. You'll put the studio out of business." And they were right. Halfway in the second season, they ran out of money, and Lucille Ball had to sell the studio. But she was also right. She had said, "Bring me a show that can rerun as long as *I Love Lucy*." And as of today, the two most rerun shows in history are *I Love Lucy* and *Star Trek*.

*Possibly the first thing that marked doom and gloom on the horizon for* Star Trek, *was the departure of Gene L. Coon from his producing duties in the middle of the second season.*

**MARK A. ALTMAN:** What happened with Gene Coon is the

same thing that happened with Roddenberry. He was working a punishing schedule, drinking and drugs, and there comes a point where if you don't get a break, you just can't do it. You can only run a marathon for so long. And Gene Coon was running a marathon since he put pen to paper on "Devil in the Dark." By the time you have a very short hiatus between Seasons 1 and 2, he's still rewriting all these scripts, he's writing a bunch of scripts on his own. He just couldn't do it anymore. Paramount's buying Desilu, they're cutting the budget, Gene Roddenberry's back — and he has his opinions. The cast has become more and more of a pain in the ass, and [Gene Coon had] had it.

**LARRY NEMECEK:** It's a little murky about why Gene Coon left. For one thing, the pace was exhausting and Gene Coon was starting to suffer some health effects. The show was wearing everybody out. It was exhausting to do. They were putting in so much time. We love it now, but they put so much time, care, attention, everybody, all the departments, they were working overtime and fighting budgets and fighting the bureaucracy and fighting censors and fighting NBC. Gene Coon was still a writing machine. Thanks, speed. That's one of the ways Gene was able to crank out a script. His assistant, Ande Richardson, who is still with us, leveled with me once and said, "Yeah, it was speed." He had the creative, but also… There was a point where Gene Roddenberry had been on vacation and didn't like the tone that some of the episodes were falling into. Didn't like the [comedy] of "A Piece of the Action."

**MARK A. ALTMAN:** That's not true. Gene Roddenberry loved the fact that Gene Coon was introducing all the comedy. He loved Gene Coon and tried to keep him. He didn't want Gene Coon to leave. He ended up writing *Questor Tapes* with Gene too. Tried to hire him in the future.

*Gene L. Coon died of cancer in 1973 at the age of 49.*

**TOM GILBERT (author, *Desilu: The Story of Lucille Ball and Desi Arnaz*):** Desilu got to the point where it had *Star Trek* and *Mission Impossible*. It was a boon and a bane because you have these two shows

sold to the network, major buzz, but they were hugely expensive to produce. Ed Holly, who was the finance VP at Desilu, told me that when he saw the figures, when they got closer to production, of how much it was going to cost to do both shows, *Star Trek* was enormous. Because each week was a different set, you had futuristic stuff, all kinds of special effects. So Ed Holly knew they needed to sell the company.

**JOHN TENUTO:** At a meeting after the first season of *Star Trek*, not only did NBC consider canceling *Star Trek*, but the executives at Desilu wanted it gone. The executives at Desilu met with Lucy and said, "We should get rid of the show. It's too expensive, it's not doing what we want it to do." And Lucille Ball said, "No. I like Gene Roddenberry, I like that show, it stays." That's according to Lucy Arnaz. So she believed in *Star Trek* when no other studio did.

**TOM GILBERT:** Lucy was told the shows were too expensive. The finance people were getting nervous about it, but she wanted to go ahead. Luckily her instincts were right, because she was able to sell the studio because it had these two shows. Unbeknownst to the buyer, the shows were crippling the studio because they were so expensive to produce. But luckily the buyer had the resources to keep them going. And it wasn't like *Star Trek* was a huge success, as expensive as it was. It was floundering in the ratings the first season.

**ROB KLEIN:** To understand why Paramount – Gulf & Western — wanted Desilu is because all the major motion picture studios, Warner Brothers, MGM, Paramount, previously thought television was just a fad. After the years went by and television started to become this phenomenon, the studios decided, "Okay, we got to get into the television game." Instead of starting from scratch, they thought, "Well, let's just keep throwing money at the mom-and-pop production companies like [Desilu. Then] we'll just acquire those kinds of people." And that's exactly what they did. They ended up acquiring Desilu because they wanted the content that they were producing at the time — *Star Trek* and *Mission Impossible*.

**JOHN TENUTO:** *Star Trek* was NBC's only prestige show. It got

lots of press, it was on the cover of lots of magazines, lot of TV Guides. The character of Spock was very popular, and Leonard Nimoy was nominated every year for an Emmy. [NBC] didn't have anything like that. Also, *Star Trek* was getting incredible fan mail. Only *The Monkees* show got more fan mail than *Star Trek*. They were averaging 6,000 letters a week to *Star Trek*. Although the number one person to get letters was not Leonard Nimoy or William Shatner, but the Enterprise.

**MARC CUSHMAN:** Gulf & Western bought Paramount one year earlier. Paramount was big in making movies. They only had a couple of TV shows on. Desilu had a lot of TV shows on. So Gulf & Western wanted to take over the studio and merge the two. Also, the two studios, Paramount and Desilu, were right next to each other, with just a brick wall separating them. So Lucy had no choice, she had to sell. They were going broke because of *Star Trek* and because of *Mission Impossible*. The day she was supposed to sign the contract, she ran away. They found her in Miami Beach – she went out there to do a guest spot on a Jackie Gleeson show, and get away from all the lawyers. So the head of Gulf & Western flew out there, and said, "I'm going to take care of your studio." That's how torn she was, because this was a studio that she and her husband had built. This was all she had left of her marriage. She thought she was letting people down by selling to a corporation. So he says, "I'm going to take care of your people. I'll do the right thing." So with tears in her eyes, she signs the contracts. Then the first thing Paramount did was cut the budgets on all her shows. They slashed everything across the board after they made that promise. Well, don't trust corporations. And Lucy knew that, but she didn't have a choice.

**TOM GILBERT:** When Lucy bought out Desi and Desilu, the company was valued at $6 million. When Lucy sold the studio, five years later, it was valued at $17 million. And she sold it to Gulf & Western for that. Out of which, she realized $11 million as the major stockholder. The difference had to be *Star Trek* and *Mission Impossible* because that was really the big draw — there's nothing else going on there besides Lucy.

**MARC CUSHMAN:** A lot of people wanted to take credit for *Star Trek* and they didn't feel they could share the credit with Lucille Ball. She was the one who put her studio on the line for *Star Trek*. She was the one who felt this could rerun as long as *I Love Lucy* and she deserves to be acknowledged.

*With the Desilu sale complete, and the wall separating Desilu Studios and Paramount demolished, Lucille Ball's involvement with* Star Trek *came to an end. Paramount initially chose to cancel* Star Trek, *only bringing it back for a third season when a massive letter-writing campaign convinced the studio that there may be life in the stars. However, the budget for the third season was severely slashed.*

**TOM GILBERT:** After Lucy sold Desilu to Gulf & Western, Charlie Bluhdorn, who was the head of Gulf & Western, called Ed Holly, who was in charge of finance for Desilu and said, "What have you sold me? I'm going bankrupt." Because *Star Trek* and *Mission Impossible* were so costly to produce that they couldn't make up the money that it was costing to produce them. The network licensing fee they were getting was not enough to cover the cost of doing the show.

**DAVID GERROLD:** We were planning a third season of *Star Trek*. NBC had promised Gene the 8 pm on Monday time slot but ended up giving it to *Laugh-In*, because *Laugh-In* had gotten such strong ratings over the summer. They never understood *Star Trek*, so they gave *Star Trek* the 10 pm on Friday night slot. So Gene quit the show, and [the studio] brought in Fred Freiberger.

**JOHN TENUTO:** When *Star Trek* reaches its third season, the network decides that it's going to move it to a time slot that Roddenberry isn't happy with. He didn't want to see the show go to a time period where it would not succeed or that it would lose its audience. So he threatened the network saying, "If you put it at this timeslot, I'm going to step back. I won't be involved as much." But they still did it.

**DAVID GERROLD:** Gene and I had previously talked of doing a sequel to the "Tribbles" episode. And this time the Tribbles were

going to grow real big. I had begun working on an outline, when Fred Freiberger came in. I swear to god, his first words to me were, "I screened "Tribbles" this morning. I did not like it. *Star Trek* is not a comedy." Fred Freiberger was not known for his social skills. He had developed a reputation around Hollywood as "the show killer." He pissed off Dorothy Fontana, he pissed of Walter Koenig. He wasn't a bad man, he just wasn't the man to steer *Star Trek*.

**MARK A. ALTMAN:** Season 3 of *Star Trek* is largely considered the worst of the *TOS* seasons and understandably so. There are a number of reasons for this. First, the departure of Gene Coon towards the end of the second season, the heart and soul of *Star Trek* who imbued it with its humanity and heart. (Coon was contractually obligated to deliver a few additional scripts, which he wrote under the pseudonym Lee Cronin and would be rewritten and most aren't particularly memorable.) Fortunately, Gene Roddenberry was planning on coming back to the show in a hands-on capacity, but when he made an ultimatum to NBC about demanding a better time slot, they instead programmed the show to Friday nights in a death slot for any show that was watched by younger viewers. Given little choice, Gene stepped away from the day-to-day running of the show, although he would still be peripherally involved in reviewing scripts, giving notes and hired Fred Freiberger as the showrunner. Freiberger had been successful in launching *The Wild Wild West* among other series. Fred didn't like comedy and seemingly didn't even really like *Star Trek* all that much. He did like Shatner though, and considered the show at its best when it was Kirk-centric. (Who could blame him? Shatner was genius, but Spock was an equally important ingredient in the soup.) Along with his story editor, Arthur Singer, Fred produced a season that seemed to miss the point of everything *Star Trek* was about and aspired to be. Through it all, there were some notable episodes like "The Enterprise Incident," "The Empath" and "Spectre of the Gun," but largely it was silly, underpopulated and disappointing. Ultimately, after his tenure on the second season of *Space: 1999,* which was canceled shortly thereafter, Freiberger became known by fans as "the show killer." It was a reputation Freiberger, who had much success in his career otherwise, despised. He famously told Ed Gross that he spent several years in a

German POW camp after being shot down during World War II, and it was a better experience than *Star Trek* for him.

**WALTER KOENIG:** Didn't like him. Fred Freiberger was kind of surly. He was known as the producer who came in and killed shows. I'm sure it had nothing to do with him, but that's just the way it worked out. But he was surly.

**DOROTHY FONTANA:** I only worked with Fred Freiberger on one script, which was "The Enterprise Incident." And I knew we were in trouble. I was in trouble when I proposed the Joanna's story [McCoy's daughter]. And he said, "Oh no, no, no. DeForest Kelley is a Bill Shatner contemporary." No, they're 10 years apart, and we always played it that way. DeForest Kelley was 10 years older than Bill Shatner and Leonard Nimoy. And we always played it that way. So that there was an age gap, where there was some experience that Dr. McCoy could bring to our Captain Kirk. It was a companionship. And for Fred Freiberger to say, "Oh no, he's Kirk's contemporary. Therefore, he cannot have a 22-year-old daughter." My reaction to my agent was, "Get me out of this because they don't understand the show." And I have to say that honestly. I got out, I ditched the two other stories I could have done scripts for and said, "Just give them to them, just pay me for those two stories. And I'm out of here." And that's what happened. I was gone. I went off to *Big Valley* and did that and *Bonanza* and other stuff.

**MARC CUSHMAN:** The third season gets dismissed a lot. It's not up to the standard in the first two seasons, but the budget had been cut. Drastically. The scenes were longer. Instead of a three-minute briefing room scene, we'd have a six-minute briefing room scene. Every time you move to another room, you got to light it, you got to do everything, that takes time. They didn't have the time to do it anymore. So there was less movement in the series. The scripts were just as good in their first and second drafts, but by the time they got before the camera, a lot of good stuff had been taken out because they just couldn't afford to shoot everything that was in there.

*Ratings for the third season of* Star Trek *slipped dramatically from the*

*previous year, but it wasn't helped by the fact that the whole system of "ratings" was fairly new.*

**MARC CUSHMAN:** The performance that *Star Trek* had in the ratings was respectable for its time. It gets confusing, because when you look at old ratings reports, you'd see *Star Trek* down around number 45, 47, out of 90. So that doesn't look so good. It's not terrible, it's in the middle, but it doesn't look so good. But when you look at the actual ratings reports for the specific nights that *Star Trek* is airing, and what its competition is doing, you see that *Star Trek* has a 29 percent audience share, *Gomer Pyle* has a 35 percent over on ABC, *Hondo* has a 21 percent. Not so bad. It's right in the middle of its time slot on Friday night, and doing better than any other NBC show at that night. So the whole folklore about *Star Trek* underperforming on NBC isn't true.

*The third season would be the last for* Star Trek, *with NBC pulling the plug on the Starship Enterprise with the final episode, "Turnabout Intruder," on June 3, 1969. Most would have thought that would spell the end for* Star Trek *– William Shatner went to live in a camper, Leonard Nimoy took on some stage work, Gene Roddenberry started to develop new shows – little did they know the journey was just beginning.*

**MARC CUSHMAN:** The full third season got us the rerun package. So you can look at those episodes as not very good, but they did what they had to for the bigger picture. To win the war.

# SATURDAY MORNING BLUES
Conventions, Animation, and *Phase II*

*"Barely an instant in eternity, Jim." ~Dr. McCoy*

*Despite* Star Trek *having been decommissioned following its third season in 1969, the fandom was not ready to end their mission.*

**ANDRE BORMANIS (screenwriter, *Star Trek: Enterprise*):** A show like *Star Trek* has a devoted following and a lot of really intelligent, smart people. It makes people want to think of ideas, to come up with stories. The whole phenomenon of "fan fiction" really started with *Star Trek*. People started publishing their own fan fiction and fan magazines. I don't think anyone did that for *Perry Mason* or *Adam-12*.

*The first* Star Trek *fanzine, Spockanalia, was published in September 7, 1967. Edited by Devra Langsam and Sherna Comerford, Spockanalia would garner official recognition from the cast and crew of* Star Trek, *often featuring articles/fiction from the crew, or in-character correspondence written by the actors. Other fanzines followed through the '70s and '80s (the full list too long to count) such as Vulcanalia, Triskelion, and Subspace Chatter. These fanzines would feature fan fiction, poetry, and nonfiction articles centered on the show they loved. "Slash" fiction was also incredibly popular – fan fiction which showed Kirk and Spock in more… erotic situations than fans were used to seeing in the show.*

**LARRY NEMECEK (author, *Star Trek: The Next Generation Companion*, podcast host, *The Trek Files*):** Here is fandom organizing itself. People writing fan fiction into fanzine stories. That's an organizing engine. Here's fan clubs happening and springing up. The first conventions. But people are wanting all that kind of information. The first entity to emerge from that is an organization called the Star Trek Welcommittee, which I call basically the internet on stamps and paper. It did everything the internet does now before the internet existed, because nothing like *Star Trek* had ever had a passionate demand from people who expected this stuff.

**JOHN TENUTO (*Star Trek* historian, startreknews.net):** D.C. Fontana understood the importance of *Star Trek* fans. She would contribute to fanzines. And one of the fanzines even lists Spock's full name, which she types out, and it's exceptionally long, unpronounceable. She's doing it, of course, tongue in cheek. She would even encourage the actors to be involved. So there are fanzines where Leonard Nimoy, as Spock, would write letters and DeForest Kelley, as McCoy, is answering back to him. D.C. Fontana understood the power and passion of fans. She was one of the guests at the very first *Star Trek* conventions.

**RONALD D. MOORE (executive producer, *Star Trek: Deep Space Nine*):** Probably one of the most influential books in my life was *The Making of Star Trek* by Stephen Whitfield, which I found at a school book fair in the sixth grade. I read that thing cover to cover, over and over again, because that really was about the making of a television series, about selling a pilot, show bibles, production questions, and issues/fighting with networks. I was completely enthralled with it and it imprinted itself on me in a profound way. I didn't really think about becoming a television writer at that age and wouldn't for many, many years, but reading that book gave me a hunger to do it. I wanted on some basic level to do that — to do those things like Gene had done.

**LARRY NEMECEK:** Science fiction was this tiny island inhabited by nerds who weren't even out of the closet to be hooted at. No one even knew science fiction existed, unless you went down to watch the bug-eyed monster movie. Occasionally, you had *Forbidden Planet*, and *The Day the Earth Stood Still*, but... *Star Trek* grabbed onto that audience, but the audience that really found *Star Trek* was in syndication.

**LUCIE SALHANY (president, Paramount Domestic Television 1985–1991):** I was a television station executive [during the time of the original *Star Trek* syndication era]. NBC had canceled it; the show was in syndication on all our stations. We stripped it, which meant we ran it Monday through Friday, and sometimes Saturday. We didn't have a lot of programming. There are only 79 episodes, so we kept running it and rerunning it. This was in the late '60s, early '70s. We would take the show and we would run it in order, and would

promote it that way. Then we would get a hold of one of the stars and have them do promos and interviews, and edit the show so we would insert their interviews. Then we'd have personal appearances and everybody came in and did a lot of work to promote the show. It's very important.

[It was unusual for the cast of a canceled TV show to do promotional appearances,] absolutely. Casts did that in syndication, depending on your deals, because a lot of them get paid residuals and things like that, but that was really unusual. That cast… DeForest Kelley would come to town, Leonard Nimoy would come to town, they would call and ask "What do you need?" They were extremely cooperative. They weren't forced to do it, that was their choice. If they had been forced to, they would have cooperated, but they went above and beyond.

**RONALD D. MOORE:** The first time I encountered *Star Trek* was probably around the third grade. So, 1973 or so. I was a kid that saw the original moon landings. That got me interested in space when I was young. I came to science fiction and *Star Trek* through the space program. I watched all the Apollo missions, then I'd come home after school in first and second grade and discovered *Lost in Space* and that was my show. Then somehow I started seeing *Star Trek*, which was also syndicated five days a week in Chowchilla, where I grew up, and I started watching that. I left *Lost in Space* far behind and *Star Trek* became my show.

**MANNY COTO (executive producer, *Star Trek: Enterprise*):** *Star Trek* was what made me go into this business. I was one of the generation that found *Star Trek* in the reruns. I was that group that discovered it and went fanatical over it. All my friends in high school just went crazy watching. They would run it in Orlando on Channel 35, every night at 7, over and over and over again every night. So it never stopped. We would record the sound on a tape recorder, take the tape recorder to school just to listen to it, listen to Kirk. We would run the shows in our head. That's how crazy we were. Then there was the first *Star Trek* convention in Orlando, that was a huge deal. I think it was '79. The guest of honor was Walter Koenig — Chekov. I still have

the photos. I thrust my face in there with Koenig sitting at the table signing off. It was crazy. He was the first *Star Trek* celebrity that I ever got a photo with.

**LARRY NEMECEK:** I was a syndication baby. There was no internet, you'd get an occasional blip on a periodical or something. There was no 24/7 anything, you were looking for scraps of information. There had never been anything with the demand of *Star Trek*. The hunger for information *Star Trek* created was a completely new paradigm.

**RONALD D. MOORE:** What appealed to me the most at that age about *Star Trek* was that it seemed to believe that it was all real. *Lost in Space* seemed like, even at that age, they weren't taking it seriously. It was kind of silly and it was fun on that basic level, but it didn't seem like they were really in space and really going to all these places. I think because I loved the space program, *Star Trek* to me at that point felt real. It felt like they all took it seriously. I do remember when I was a kid, I thought there was a real.

There was a sense of truth and authenticity to it that appealed to me even as a kid. And there were great stories and action-adventure. Then over the years, in fifth grade or so, I started getting into the morals of the story, I remember "The Devil in the Dark" episode with the Horta, that really left a big impression on me as a kid. Kirk didn't kill the monster — the monster was a mother and had all these eggs. I remember that being a very profound moment for a kid my age.

**LUCIE SALHANY:** [The popularity grew during reruns.] Stations promoted it and promoted it to a new audience. One could watch it every day. And that 18-to-34 audience was who we were going for. They just ate it up. Then we promoted it with all these stories and personalities and personality profiles and interviews. That's when the ratings really started growing.

I'm a Trekkie. I love the show. I thought it was phenomenal. From then on, we all wanted to bring *Star Trek* back. Mel Harris, Rich Frank, and a group of people at Paramount would get together and talk to us

all the time about, "Would we be interested if they brought it back?" And then it would die. Nobody would talk about it anymore. We at the station level kept pushing it because we were hungry for product. This had a perfect audience makeup. It was a show that appealed to 18-to-49 with a little lean toward 18-to-34, and it was split between men and women. It was a perfect sales demographic. That's where NBC missed out. In 1985, I went to Paramount. We had tried to relaunch it in '81, '82, '83. Barry Diller, who ran Paramount, was interested, but it never really happened. So when I went off into Paramount in 1985 and took over Domestic Television, our group pushed. We made an offer to the company that our division would take *Star Trek* out in syndication, go station by station, and relaunch it.

**MARK A. ALTMAN (creator, *Pandora*; author, *The Fifty-Year Mission*):** What is truly hard to appreciate for a younger audience where every successful show has hundreds of licensees and merchandising ranging from action figures to cookie cutters to condoms, is that *Star Trek* was initially homegrown. It was the fans who were creating fanzines and homemade Tribbles and stitching together costumes. It was the ground zero for what we consider fandom today.

As a kid watching repeats of *Star Trek* on WPIX Channel 11 in New York every night at 6 pm, there was an insatiable hunger to learn more about my favorite show. When Starlog debuted in 1976, it filled a huge hole in covering *Star Trek*. Although there had been magazines like the Official *Star Trek* Poster Book and About *Star Trek* Fan Clubs that appeared sporadically before that and the opening of the Federation Trading Post in midtown Manhattan was every *Star Trek* fan's Mecca. But I think what really got us excited as fans at the time were not only the novelizations by James Blish and particularly the adaptations of the animated show by Alan Dean Foster, but the brilliant *Star Trek* Blueprints and Technical Manual by Franz Joseph, which put you in the actual world of *Star Trek* and helped contribute to the idea that this was a real thing. It was at the heart of the DNA of canon being a real, living and breathing thing. It fleshed out aspects of the Universe the show had only hinted at and that fired all our imaginations at just the right time in our lives. Then you read something like Gene Roddenberry

and Stephen Whitfield's *The Making of Star Trek* and David Gerrold's book *The Trouble With Tribbles* and you realize that this is something that one could actually do for a living someday. Many of us like David Goodman, Ronald D. Moore and myself actually did.

**JOHN TENUTO:** The very first *Star Trek* convention was held in March of 1969. It's actually held in the Newark Public Library. It was organized by two fans named Sherna Comerford and Devra Langsam [co-editors of Spockanalia, a fanzine.] There were no "guests" there, but it was a gathering of several hundred fans to talk specifically about *Star Trek*. The first *Star Trek* convention that has guests at it, who worked on *Star Trek*, was held at the Statler Hilton hotel in New York on January 23, 1972. Gene Roddenberry's there, Majel Roddenberry is there, D.C. Fontana, Isaac Asimov, and they're expecting a few hundred people. They get thousands. So much so that the fire marshal has to let groups of people in as they let groups of people out.

**LARRY NEMECEK:** You have to look at these things in context. When Gene was doing his college tours, he went from just being a producer on a show, to being a "philosopher-king." Growing the fan-base – he was a guy trying to pay his mortgage. It went from *Star Trek* being the thing you hated to refer to, because in Hollywood you had to look to your future successes and not look back, because at the time who cared, [to being something he only wanted to talk about]. Here's Gene struggling to pay his bills, but there's no new work coming in.

**JOHN TENUTO:** You also have *Star Trek* entering the mainstream in terms of toys. The Mego toys in the mid-'70s become one of the bestselling toy lines. They sell $12 million worth of toys the first year — a toy line based on a franchise that had been off the air for nearly half a decade. So *Star Trek* becomes this sort of cultural phenomenon and Paramount is still receiving letters. At this time Paramount is the owner of *Star Trek*, and they're still receiving 500 letters a week from fans asking for *Star Trek*'s return in some way.

**MARC CUSHMAN (author, *These Are the Voyages*):** Paramount believes *Star Trek* was only going to do well for a couple of years in

syndication because there were just 79 episodes. They were shocked, as was Gene Roddenberry, as was William Shatner, Leonard Nimoy, when each year starting in late '69 and then into 1970, '71, '72, and forward, the ratings are actually better. People are watching the show now for the third, fourth, fifth, sixth, seventh time, to the point where they have the dialogue memorized. It really made the entertainment industry rethink the potential of reruns: If somebody loves a show, they're going to keep watching this thing. They want new episodes, but they'll keep watching the old ones. But Paramount was worried that if we make new ones, the reruns won't be as attractive. We may lose a lot of that money and that's free money to them. The product had already been paid for now. It's just sending it out to 180 stations across America, more stations than any single network had at that time are carrying *Star Trek* reruns by the middle of the 1970s. And it continued to grow up to 200 stations by the time *The Motion Picture* came out in 1979. That's the power that *Star Trek* had in reruns during the 1970s. Paramount was making a fortune from *Star Trek* out of production.

**AARON HARVEY (author, *Star Trek: The Official Guide to The Animated Series*):** *Star Trek* was growing in popularity in syndication. People who hadn't seen it originally got a chance to see it on a daily basis after school or after work. NBC wanted to capitalize on that. At one point they tried to get the actual show back, but by then the sets have all been taken apart and people had moved on. I think Gene was in that "I've done *Star Trek* and now moving on to do something else," mindset, because he was working on *The Questor Tapes*, and was going to be doing *Genesis II*.

*The pseudo-revival that Paramount/NBC was able to agree on was a Saturday morning animated series produced by Filmation (thus, Paramount/ NBC didn't need to spend any money on it). This series would feature many of the original actors and screenwriters, in an attempt to make it as much like the live-action* Star Trek *as possible. However, in the years following* The Animated Series, *and as* Star Trek *returned to the big screens and live-action television with* The Motion Picture *and* Star Trek: The Next Generation, *Roddenberry in particular attempted to distance the franchise proper from* The Animated Series. *Coupled with its lack of availability both in syndication*

*and later on home video, as well as for years being excluded from the official
Trek chronology on startrek.com, many fans never even knew the series existed
until recent years, when it became more widely available on home video and
streaming.*

**AARON HARVEY:** There was a *Star Trek* animated series. It was
not a fever dream. There was an animated *Brady Bunch*. There was an
animated *I Dream of Jeannie*. Anything that was live-action in the early
to mid-seventies suddenly became a cartoon, and much like *The Star
Wars Holiday Special*, some people just didn't believe that this thing
existed.

**FRED BRONSON (publicist, *Star Trek: The Animated Series*):** I
think one of the reasons *Star Trek: The Animated Series* was so great, and
won an Emmy, is it appealed to adults as well as children. It's on Sat-
urday morning, and there are definitely rules about what you can and
cannot do on Saturday mornings. But they addressed topics like suicide,
the whole concept of Satan, issues about women. *Star Trek* spoke to all
levels.

**RONALD D. MOORE:** I watched *The Animated Series* religious-
ly when it came on. I was very excited and was just happy to see *Star
Trek*. I remember being frustrated by the very limited animation of the
series. The characters basically stopped and then their mouths would
move. And then the repetition of a lot of shots over and over again got
frustrating. But I was very used to that as when someone watched a lot
of Saturday morning television, I could just tell this was done on the
cheap. They didn't have money to do good animation.

**FRED BRONSON:** Filmation was an independent animation
studio over in Reseda. They had their own building, close to Ventura
Boulevard. They were like Hanna-Barbera, an independent animation
company. They weren't as big as Hanna-Barbera, but they had a lot of
success prior to *Star Trek* with *The Archie Show*. That was their biggest
show before *Star Trek*. They were not owned by a big studio, so they
got to have the final say in what they were doing. Lou Scheimer and
Norm Prescott made the decisions and ran the company. It was a

well-oiled machine.

**MARC CUSHMAN:** Filmation was one of the top animation houses in television back in the 1970s. They had about a dozen different shows being done at that time. They did all the animation locally in America. *Star Trek: The Animated Series* was made in America, which is rare these days. Gene had offers from a couple of different animation houses and Paramount chose Filmation to do the animated show. It may look archaic today, but that's the way animation looked back then.

**BOB KLINE (art designer, *Star Trek: The Animated Series*):** Filmation was a really thriving outfit in those days, doing Saturday morning television shows, many of which were based on movies and television that had already been successful. Anything from Fox's *Journey to the Center of the Earth, The Brady Bunch, Gilligan's Island*. The year we did *Star Trek* at Filmation, we did five other shows at the same time. So it was a bustling outfit. Especially since everything was done there. Part of the reason for the limited animation aspect of those shows was they only had so many people who could put them together. It was a fascinating time.

**RICH SCHEPIS (author, *Star Trek: The Official Guide to The Animated Series*):** Filmation was an animation company that did Saturday morning cartoons. When I was interviewing David Gerrold, he [told of] sitting in Lou Scheimer's office one day and Lou was just popping off different ideas for different series. They were just like a factory warehouse. It was Lou, Norm Prescott [as founding partners]. Irv Kaplan was one of the other people that founded Filmation, but Irv didn't want to be a partner. So Irv ended up just working on the shows as a colorist.

**DAVID GERROLD (screenwriter, *Star Trek: The Animated Series*):** Lou Scheimer over at Filmation wanted to do *Star Trek* Academy with young Kirk, young Spock, etc. But Gene said, "No, we're going to do real *Star Trek*." Originally, Gene was very resistant to *Star Trek* being an animated show. Especially the Starfleet Academy version. He didn't want *Star Trek* to become a kids show. The only thing that convinced

him was that they would do "real" *Star Trek* as an animated show. There was a lot of resistance. The audience was very unhappy. People wanted live-action *Star Trek*. They didn't want animation. They watched the animated cartoon, but they wanted the real *Star Trek*.

**AARON HARVEY:** *Star Trek: The Animated Series* came out in 1973. It was pitched earlier that year. But a lot of people don't know that it was originally pitched in 1969. It was going to be a Starfleet Academy show that was going to feature each of the characters of the Enterprise, where they have a cadet in training with them. Spock was going to have a Vulcan named Steve. I'm fairly convinced that had to be a placeholder name. But Gene really was not interested in doing that. He didn't want to do a kiddie version of *Star Trek*. They got as far as concept art and they broke down some stories. Interestingly enough, Chekov was also eliminated from this version as well, because he was considered not old enough to have a cadet under his wing.

**DOROTHY FONTANA (story editor/associate producer, *Star Trek: The Animated Series*):** In 1973, Roddenberry called me up and said, "Filmation is thinking of doing this animated series of *Star Trek*." I said, "Oh, that's cool." He said, "I want you to be on it." We did it, NBC bought it, and we did 22 episodes in a year and a half, basically. I was only on the first 16 episodes as story editor and associate producer, and I worked closely with the writers. The glory of the animated show is we could do anything, on any planet. Any kind of creature, any situation that you could dream of – that could be drawn – was there on the film. It was all done in Tarzana, California, by people working for Filmation. It was all hand-done. Artists sitting there painting in the cels. The one technological advancement that we had was that you could Xerox the black and white cels that were standard cels for backgrounds or facial expressions, things like that. But they still had to be painted in by hand. What that allowed us to do was tell stories we could not tell well on *The Original Series* because of crazy creatures or great planet-scapes that we just couldn't afford to do. But we could do on animation.

**DAVID GERROLD:** Dorothy came on as the producer. Gene got

the credit, but Dorothy did the work. Dorothy's instructions to all of us were, "We're doing real *Star Trek*." We could do things we couldn't show in live-action. We were writing 45-page scripts for the animated show, because it was a much faster pace.

**MARK A. ALTMAN:** On *The Animated Series*, Gene wanted the money but not the work. To his credit, he was smart enough to hire D.C. Fontana to basically be the showrunner. You have to remember, on the first season, she oversaw all the scripts and the rewrites and who they hired. She wasn't involved with the second season, which was just leftover scripts from the first season.

**AARON HARVEY:** Talking to Dorothy Fontana about *The Animated Series*, she considered *The Animated Series* the fourth season of *The Original Series*. Even people who didn't believe it was canon kind of did see it as this successor to *The Original Series*. It's probably the closest thing you can get to *The Original Series* because it was done so shortly afterwards with a lot of the people who were originally involved.

**FRED BRONSON:** Dorothy was the showrunner, and she was fiercely protective of *Star Trek* – as she should be. The worst thing that could have happened would be if NBC had put on a silly Saturday morning cartoon, and it was jokey and didn't match what *Star Trek* was. So Dorothy made sure it was *Star Trek*. Gene was not the showrunner, but he did read all the scripts. Anything I asked him to do to publicize it, he did. I never got the impression that Gene looked down on it.

**MARC CUSHMAN:** The approach that Gene Roddenberry and D.C. Fontana had in giving out the script assignments was to continue on the five-year mission. They had already done three years, so this was the fourth year. The only different thing, besides compressing a sixty-minute episode into a thirty, was Gene would encourage them to paint bigger vistas. "We can do things in this show we couldn't do in the original. You can have giants, cyclops, you can have all of it."

**DAVID GERROLD:** You could write a cat-shaped alien, or a

complex alien, and have them on the bridge as regular characters. You couldn't do that makeup week after week on a live-action show, but for an animated show, it didn't matter. So we could write things that would be very difficult to shoot live-action. In one shot, I have Kirk and Spock being dropped into a lake. [On the original] we'd have had to go out on location that would have been a half-day or a day's worth of shooting. That would have been an extra $10,000. You can't do that. So we had a lot of interesting aliens in the animated show.

**AARON HARVEY:** Originally, they did talk to everybody [about reprising their roles for *The Animated Series*], but then they realized they couldn't afford it. It had a budget of $75,000 per episode – but the majority of that budget goes to the voice actors. The writers got about 13 to 15 hundred dollars, and then you had the cost of putting the show together. But the majority of the budget went to the actors. Originally, they were going to have Majel Roddenberry and James Doohan play Uhura and Sulu. Leonard Nimoy then said, "I'm not going to do it unless Nichelle Nichols and George Takei are brought back." So shortly after, they were brought back.

**FRED BRONSON:** I took one of our NBC photographers over to Filmation on the first day recording session with William Shatner, Leonard Nimoy, DeForest Kelley, James Doohan – but no Nichelle Nichols and no George Takei. Leonard was understandably very upset that their voices were going to be done by other people. So he made it known to Filmation, if Nichelle and George were not going to be a part of this, neither was he. Obviously, they did not want to lose Leonard Nimoy, so Nichelle and George were quickly hired to do their own voices. I believe that Leonard was mainly concerned about the solidarity of the cast and keeping the original cast together. It is true that they were two people of color who were not being included; whether he made that a point then or not, I don't know.

**MARC CUSHMAN:** Chekov was supposed to be a part of *The Animated Series* – they even drew the character – but they couldn't afford to bring everybody back. So they were only going to bring back James Doohan, Majel Barrett, Shatner, Nimoy, and Kelley. Originally,

Doohan and Majel were going to do the voices for Sulu and Uhura. And it was Leonard Nimoy, when he found that out, said, "I will not do this show unless you bring back the original cast." That's when they decided to bring back Nichelle Nichols and George Takei. They didn't bring back Walter though, again because of budget problems. But they said, "Well, look, he wasn't on the show when it first aired."

**BOB KLINE:** Walter Koenig wrote one of the scripts for *The Animated Series*, and I was excited to see that, because he was not on the bridge. You did not see Chekov on the show. In fact, I was the one who was responsible for creating his replacement, Lieutenant Arex. The three arms, three legs alien. That was lots of fun, but I was also like, "Wait a minute?..."

**WALTER KOENIG (screenwriter, *Star Trek: The Animated Series*):** Filmation was the company, and they were very cheap. I don't know if you know this, they didn't want to hire George and Nichelle either. They were going to have Majel Barrett do all of the female voices and Jimmy Doohan was going to do all the male voices, including me. [Later, when I wrote an episode for the series,] I said, "Well, can I read for the villain in the piece?" [Dr. Keniclius, in Walter Koenig's episode.] They said, "Okay," but they'd have to pay me for just one episode. I read, and I read well, and they didn't cast me. They went with Jimmy or whoever. They were pacifying me by letting me read for the part, knowing they would never actually cast me.

**BILL REED (director, *Star Trek: The Animated Series*, season 2):** It was a very low-budget show. I don't know why. The network was not sure – it wasn't really a kids program. Its designs were leaning towards adults. And then you look at the stories, *Star Trek: The Animated Series* was really aimed towards adults. So I think they gave this a low budget, not really thinking it would be popular. Filmation was low-budget for sure, if you look at their shows. The thing that saved Filmation was their stock program that Hal Sutherland pretty much invented. Their stock program each had their close-ups that could be used many, many times, a medium shot, a walk, and a run. Those were used over and over again. There was a down shot of the bridge, Spock

looking into his viewer – you can spot a stock scene because you see the same setup over and over again. It saved them a lot of money. A walk cycle alone would take a week for an animator and assistant animator to animate.

**BOB KLINE:** I came on in March of '73. They had already sold the show, they were already writing scripts. Dorothy Fontana was hard at work making sure the show was as much like *Star Trek* as it could be. My first job in layout was to create a derelict alien ship that was in the first episode of *The Animated Series*. It took me a hundred drawings to get something that Gene Roddenberry okayed. I never met with him, I was given directions, and I tried this and tried that. None of those drawings went to waste though – they all ended up in a much later episode in a graveyard of derelict scripts.

Mostly I was tasked with creating layouts, so I wouldn't get a script, I would get a storyboard. Hal Sutherland and a couple of other fellows did the storyboards. There were very little drawings, and we had to turn them into animatable elements. We'd get a section of the film, and we'd do that. There was a lot of back and forth between different artists on the show, so there'd be consistency with the show. They overlapped. The only way to get it done in time was to have everything overlap. So all the stuff was going on at the same time. As soon as the script was ready, it was going to storyboard. As soon as the storyboard was ready, it was going to layout and so on through all the various stages.

**RICH SCHEPIS:** Colorblindness on *The Animated Series* is one of those fun urban legends, and there were actually two production team members that were colorblind. Hal Sutherland, who was the director, and Don Christensen, who was the art director. Irv Kaplan was actually the one that did all the colors though. And he liked purples and greens and pinks. Bob Kline, who was one of the artists on the show, remembers that Irv wanted to color sometimes. Bob would ask, "What color should this be?" And then Irv would say, "Just make it pink." You saw the pinkish uniforms, that purple-pink Klingon uniforms. But the people who were colorblind did not make the choices. And remember, Irv was a founding member of Filmation. He was probably going to

do whatever he wanted to do anyway. So he liked that color scheme, and that's what he used. (shrugs) Irv was not colorblind. The one who chose those colors that everybody blamed colorblindness on was not colorblind.

**BOB KLINE**: Herb Hazelton was real important to the show, as he designed all of the prime characters – Kirk, Spock, and so forth. He was the most talented artist in the whole design department. He was a fine artist, drew people better than anyone. It was one of the reasons that people were constantly having to trace the models, because of the subtlety of the design. You rarely saw someone try to draw one of those characters without directly involving themselves with one of Herb's original models for those characters.

**BILL REED:** After the first season was over, Filmation got a lot of other work to do, and Lou Scheimer asked me to take over the second season. Everything was already set – the stock scenes were set, the stock backgrounds. Everybody knew what to do, according to what had been done in the first season, so it was pretty much doing storyboards and new animation. A lot of the animation had already been done – the walks, the runs, the close-ups of Kirk and Spock as they deliver their dialogue. It was fairly easy for me to just jump in on that.

**BOB KLINE:** The stock system was a cornerstone of all the Filmation products. All the shows, if you were doing storyboards or even layouts, you were given a ring binder which had little reproductions of the stock scenes you could use for the show you were either storyboarding or laying out. There were folders of those stock scenes down near the camera, and it was possible for the cameraman to use these stock scenes with stock backgrounds. *Star Trek* had a lot of scenes set on the ship, so there were a lot of ship interiors that were stock backgrounds. So for every show, they did the same thing where they had multiple copies of scenes and multiple copies of backgrounds that they could use and just expose them differently depending on what the director had written on the exposure sheet.

**AARON HARVEY:** Traditionally in the 1970s, you would order

a children's program for two seasons. One would be 22, 23 episodes, and the other one would be half that or less. The thought was that in the next season, we can just sprinkle in previous episodes because kids don't know the difference between a rerun and an original showing. This is hilarious to me because as a child, you would be very disappointed and you're like, "Oh, I've already seen this." It's a really interesting division between children's programming then and now. They treat children much more adult and savvier than they did back then.

**FRED BRONSON:** The episode with the devil caused a huge protest. The episode called "The Magicks of Megas-Tu" had them going to a plane of existence where there was perhaps a devil-like creature. Not "the" devil. But a lot of people, particularly in religious areas and the Bible Belt, took offense to it and complained to NBC.

**JOHN TENUTO:** The contributions that D.C. Fontana made to *The Animated Series* were both as the story editor and showrunner, but also as a scriptwriter. She writes easily one of the best episodes of *The Animated Series* and arguably one of the best episodes of *Star Trek*. It's called "Yesteryear." It's a sequel to "The City on the Edge of Forever," which gives you a peek into the character of Spock and what his home life was like as a boy. It's really one of the sweetest *Star Trek* stories. [D.C. Fontana] was the person who was able to bring a type of heart to *Star Trek*. The story really is about a father and a son not understanding each other, a mother and wife understanding both of them, but trying to navigate both of them. Also, something that little kids deal with quite a bit, which is the loss of a pet. And at what point do you start separating from your parents? These were really heady issues for a Saturday morning cartoon show. In many ways we have to remember, the most adult animated program you had at that time was probably *The Flintstones*. But the idea that somehow animation could deal with heavy social issues is also something that *Star Trek* breaks ground on and a good deal of that credit goes to D.C. Fontana.

**BOB KLINE:** I love "Yesteryear" because it is pure Dorothy Fontana, and really represents things that Dorothy wanted to add to the whole *Star Trek* mythos.

**RICH SCHEPIS:** "Yesteryear" represented everything that Gene and Dorothy wanted to do with *The Animated Series*. They wanted to be able to tell stories that they were not able to do in the live-action original series because of budget constraints. Dorothy was very excited because there was a wide-open canvas, you could go back in time, and tell the story about Spock's childhood. It's a powerful story. It's quintessential *Star Trek* for me, because when *Star Trek* is great it's when it tells moral stories, where it has to go back in time to fix something, or they have to make a sacrifice. The interesting thing at the end of the episode was Spock notes that nothing else had changed except one thing, the death of a pet. And Kirk says, "A pet? Well, that wouldn't mean much in the course of time." And Spock says, "It might, to some."

**MARC CUSHMAN:** Spock's parents were introduced in "Journey to Babel," the second season episode from *Star Trek: The Original Series*. And it was planned they were going to come back. There was a third season script that was being floated around that didn't get shot. As a matter of fact, Dorothy Fontana included them in a third season episode that she wrote called "The Enterprise Incident," but because of budget problems, they had to start taking things out. And that was one of the first things to come out. So when she did "Yesteryear" for *The Animated Series*, she brought Spock's parents back for that. But not just as parents, we get to meet his childhood pet, which has fangs. And it is actually bigger than he is. They talked about that in "Journey to Babel" but we didn't see it until "Yesteryear." So there were a lot of things that came out of *The Animated Series* that became part of the *Star Trek* universe from that point forward.

**AARON HARVEY:** To bolster the idea that this is the fourth season of *The Original Series*, you have a lot of returning characters. You have Sarek and Amanda, you have Harry Mudd, you have Cyrano Jones, Kor the Klingon. You even have fictional characters like Alice in Wonderland from the Shore Leave planet. There are so many returning bits and pieces. Today we might call that fan service. But this at that time was really the only way to experience that unless you caught a rerun of *The Original Series*. So it was sort of like visiting an old friend.

**RICH SCHEPIS:** Mark Lenard was one of only three guest actors to reprise his role from *The Original Series*. Mark Lenard came back to play Sarek, Roger Carmel came back to play Mudd, and Stanley Adams came back to play Sirena Jones. They did have other recurring characters —Kor, Amanda, Spock's mom — but they were voiced by different actors. They were voiced by either Jimmy Doohan or Majel Barrett. Mark Lenard comes back and that lends a gravitas to the episode as well, especially from a viewer standpoint. I think it would have been a different episode if Jimmy Doohan was doing a voice for that.

**FRED BRONSON:** One strange thing that happened with *The Animated Series* was the first episode couldn't be aired. The first episode was "Beyond the Farthest Star." It couldn't air in Los Angeles because George Takei was running for political office. There were rules in 1973/74 that said if you were running for political office, you had to have equal air time with your opponent. So they decided not to show it in L.A. So the first episode that we saw in Los Angeles was "Yesteryear," which was episode number two. "Yesteryear" is not only the finest animated episode; it would be in the top five episodes of all time of any series.

**RICH SCHEPIS:** "Yesteryear" was one of three episodes that the original cast members returned for and recorded together. Shatner, Nimoy, Kelley, Nichols, Doohan, Takei, and Barrett. They only recorded three episodes all together, and they recorded them in one day — "Yesteryear," "Beyond the Farthest Star," "More Tribbles, More Troubles." They were the first episodes recorded and first episodes produced. After that, Leonard Nimoy and William Shatner, especially, they were busy, they were traveling, they were filming other roles, they were performing in plays and things like that. So they didn't really have an opportunity to bring them back to join the full cast all the time. Most of the time they probably recorded their lines in a studio, [near wherever they happened to be]. There's actually one episode where Shatner recorded his captain's log on a tape recorder.

**AARON HARVEY:** Interestingly, *Star Trek: The Animated Series* wouldn't have turned out the way that it did if there wasn't a writers

strike. At the time, the way the guild rules were written, you could not write live-action television if there was a strike, but you could do one animated episode. Dorothy Fontana approached people who wrote on the original *Star Trek* and said, "Hey, you can't write anything right now, but you can do this animated show. And it's now open! You can create anything you want. Create ships and aliens and locations without any sort of budgetary constraints." So it was enticing to people like David Gerrold, who was able to do his Bem character, which was cost-prohibitive in *The Original Series*.

**DAVID GERROLD:** There was another episode that also I had wanted to do [in the fourth season of *The Original Series* prior to cancellation] called "Bem," which they bought the script [for *The Animated Series*] and then it got shelved because they bought extra scripts. But they had the script and ended up doing it for the sixth episode, second season. But the "Bem" episode, Gene had decided he needed to be hands-on. And so he said to me, "Let them meet God." This was Gene's story. Whenever the story gets bogged down or he didn't know what to do, he said, "Let's let them meet God." So the whole God character in *BEM* is specifically written for Nichelle Nichols, that it should be her voice playing God, that God is this very gentle, warm woman.

**MARC CUSHMAN:** *The Animated Series* certainly shouldn't be dismissed. It was a big stepping stone to getting *Star Trek* back. It's a very good quality for a Saturday morning show from that time period. And it also established a lot of things that carried on in the *Star Trek* canon later and would show up in the movies or some of the other TV shows. Prior to *The Animated Series*, we knew that Kirk's name was James T. Kirk, but the middle name Tiberius didn't come up until *The Animated Series*. That was David Gerrold, who came up with that for a second-season episode he wrote called "Bem." Also, it was in a second-season episode that we first heard of the holodeck and actually saw it work. That was in an episode called "The Practical Joker." When they developed *Phase II* in '77, the holodeck was going to be part of that series.

**RICH SCHEPIS:** Larry Niven, acclaimed fiction writer who

created his own Known Space universe was approached by Dorothy Fontana to write for *The Animated Series*. He loved the opportunity and adapted one of his short stories, *The Soft Weapon*, which became "The Slaver Weapon." Slaver Weapons rule. Interesting episode. First of all, it's really the only time any characters die on *The Animated Series*. But the other interesting thing about "The Slaver Weapon," it's the only episode in *The Original Series*, *The Animated Series*, and the films with the original cast that James Kirk doesn't appear. There is no Kirk, there's no Enterprise in "The Slaver Weapon." Larry's story only needed three crew members. Spock was a natural choice. They needed a female, so that was Uhura. And then he chose Sulu at random thinking he can be missed on the bridge and could pilot the shuttle. That's the only reason Sulu was on the mission.

**LARRY NIVEN:** I didn't need Kirk for this story. I had to ask permission and they gave it. If there was a fight, I didn't see it. [Spock and Uhura are in it.] I wanted a woman because she could play the Kzinti against their failings. I started with three people in *The Soft Weapon*. Maybe I didn't need Sulu, but the script would have been a little poorer without him.

*As was customary for the time, there was no "writers' room" for* Star Trek: The Animated Series. *Rather, script proposals would be written, and if bought, scripted by freelance writers, with the "story editor" (our modern equivalent is a showrunner) wrangling, reviewing, and revising these scripts to make sure they are in line with the series.*

**LARRY NIVEN:** Dorothy Fontana invited me to write a *Star Trek* cartoon, and that sounded like fun. I was testing the limits, I suppose. That was silly. I did not know Dorothy very well. I knew her well enough to trust her because of her involvement with other writers. She brought me to Gene Roddenberry's house at one point and we talked and then one of them suggested I use *The Slaver Weapon* as a script. My impression is this is a guy totally confident at what he's doing. I wrote a couple of *Star Trek* scripts, which were rejected for good reason. One of them I've got Kirk and Kzin killing each other over and over again in virtual reality inside Spock's mind. That isn't for the kiddies. I wrote

a script using a quantum black hole, and that isn't for anyone who isn't a trained scientist. Either Dorothy or Gene Roddenberry suggested I used [my short story] "The Soft Weapon" as the basis for a script, and that is how that came about.

I did several versions [of the script], which took a few days, with around three passes. I don't remember how long it took to generate the episode, but not long enough to annoy me. I was used to things taking a while because I write books. I liked it very much. D.C. Fontana apologized to me for so much pink and purple in the city background. I thought that was just fine. That's the way their planet is as described in numerous works I've written. I didn't get really creative with the Slavers compared to Pierson Puppeteers or the Kzinti.

**BOB KLINE:** The process in "The Slaver Weapon" for designing the Kzinti was, someone had handed me a fan drawing of the Kzinti that I wasn't thrilled with – so I went on to design my own idea for what they should look like. Every aspect of them, their suits, their saucer-like ships, everything. That was one of the famous situations where Irv Kaplan decided they needed pink outfits for them. Astonishing to me that that was his solution. Anyway. The design was based on what was in the script, not in the books, since I hadn't read any of them.

**LARRY NIVEN:** I've known that some people want to involve the Kzinti in *Star Trek*, but just as a general thing. Jimmy Diggs has been eager to get the Kzinti into the *Star Trek* universe for years. I suspect by now he's given up. [I would have been amenable.] Sure. Why not? I allowed the Kzinti into the *Star Trek* universe with that cartoon to see what they would do with them. Essentially, they did nothing.

**MANNY COTO:** We had chatted briefly about incorporating the Kzinti mythos into *Trek*, but decided not to, ultimately. But it was really nothing more than just a musing in the writers' room about the possibility of it. In the end, it felt like going outside the *Star Trek* world for no reason. We can create our own, we have plenty of species that are fascinating to deal with. I don't remember a lot of serious discussions. The Reeves-Stevens may have discussed it more. What we did take a

lot from *The Animated Series* was the visit to Vulcan. "Yesteryear." That one was inspirational in "The Forge" for season four [of *Star Trek: Enterprise*], because we were like, "What do we want to see at Vulcan? We want to see elements of Vulcan that we have not seen before. I want to see a Selot." *The Animated Series* was inspirational in that way, because it was able to go to see things that the regular series was not able to do because of budget.

**FRED BRONSON:** Where I got the idea from my animated episode, I will tell no lie. My favorite science fiction author was Philip K. Dick. And this is way before anybody really knew who he was. He had a novel called *Counter-Clock World*, where time ran backward. That was my inspiration. I'd like to say it was an homage to Philip K. Dick. I took counter clock from his title and worked it into my title, which I actually liked that title a lot.

When I wrote "The Counter-Clock Incident," I came up with the idea of there being a predecessor to Captain Pike, that there was an original first captain of the Enterprise. Just to make sure, I went back and watched "The Menagerie" to see if they ever say Captain Pike was the first captain. They never said that. So I felt safe in making this up. Now I needed a name. There was a book, *The Making of Star Trek*, and in that book, there's the list of names that Gene put together to pick the name for the captain. Of course, Christopher Pike is on that list, which he used. And then when he needed another name for the recasting of the role, he went back to that list and James Kirk was on the list. So he picked James Kirk. Well, that left seven names that I could choose from, and I just liked the name Robert April. But it was one of Gene's names.

I submitted my script directly to Lou Scheimer. I had a working relationship with him for two years at this point, and he knew me pretty well, so he was willing to read it. Fortunately for me, he liked it well enough. Then it went to NBC to the programming executive and he had to say yes. And it went into production. Was it a thrill? I would say to that point in my life, it was the biggest thrill of my life, because I had wanted to write for *Star Trek* ever since September 8, 1966, and now it

was actually happening.

**WALTER KOENIG**: I had asked [Susan Sackett, Gene's executive secretary] to type up a script or a book I was writing. She was impressed and showed it to Gene, who asked me if I'd like to write one of the episodes of the animated *Star Trek*. I found out a little bit later that part of his motivation may have been, and this is to his credit, that I wasn't going to be in *The Animated Series*. I didn't know that yet, I found that out by a fan at a convention in L.A. that I was not going to be. So that might be part of the reason why they offered me the animated show. Except that when I got done with the animated show, they offered me a second one to write. I turned that down. I found that Gene is the master rewriter. He rewrites everybody's script. You would never find the original work on the screen. He asked me to rewrite "The Infinite Vulcan" at least seven or eight times, little things here, little things there. I got crazy with it. So when I handed it in, I said to myself, "That's it." Then they called me and said, "Would you like to write another one?" I said, "Nope." The changes he wanted seemed so insignificant and unimportant and didn't punch up the story or move the story faster. It was just another little thing. And I guess that was kind of a trademark of Gene's that he had to rewrite everybody's work.

When I did hear comments about the episode, the complaint was a 50-foot Spock. It just didn't feel right to those people from whom I heard. I said, "Well, I guess it was a pretty lousy episode," and I just left it at that. I didn't have my heart and soul in it. I thought it was okay. It was about cloning, and that was very current at the time. I read about it in the papers and extrapolated that idea for my story. Then I read this book, this very handsome book about the animated *Star Trek*, and Dorothy Fontana, who was the associate producer of the show and was involved in my getting the part, said it was the show she liked best. Can you imagine that? I'd been going along all these years, thinking that it was really a bad show, and she said she really liked it. So there you are.

Star Trek, *or as it would later be known as,* Star Trek: The Animated Series, *premiered on September 8, 1973, with its last episode airing on*

*October 12 of the following year. Despite the show being a success in the ratings, the viewers tended to be of an older demographic than the Saturday morning advertisers were trying to sell to. This, coupled with the high cost of the voice cast, ensured that the series would only last two seasons. Though it should be noted, the majority of animated TV series at the time, from* Scooby-Doo, *to* Johnny Quest, *had short episode orders. If shown to be popular, Filmation or Hanna-Barbera would commission a new show, under a different title, so the old could be rerun at a different time as often as they wished.*

**AARON HARVEY:** There wasn't a lot of marketing material with *Star Trek: The Animated Series.* They did have a few things like a View-master reel, where they had Filmation redraw and simplify the work for the Viewmaster format. They adapted "Yesteryear" and changed it to "Mr. Spock's Time Trek." I'm not exactly sure why they changed the name, but...

**MARC CUSHMAN:** *The Animated Series* was a great gift to us *Star Trek* fans in the 1970s, because we wanted more. We had seen the 79 episodes from *The Original Series* over and over. And so when that came on, [it was a great gift]. You had Gene Roddenberry and D.C. Fontana producing it. You had the original cast doing the voices, and you had all the original writers, a lot of the original writers, doing the scripts and it was way above anything on Saturday mornings. It was frustrating because we wanted to see live-action *Star Trek,* but in lieu of that, not being able to get that, I watched it. I was about 15, 16, and I would stay at home Saturday morning and watch that thing instead of being out, hang with the friends.

**LARRY NEMECEK:** There were fans who, we found the flyer, there was a movement called, "STAB." *Star Trek* Animation Boycott. And here's Gene and Dorothy going, "NOOooo!!" It's the idiocy of people who don't get how media works. If you don't watch this, you don't get another.

**MARC CUSHMAN:** What's important about *The Animated Series* is that it was a big and very important stepping stone to getting *Star Trek* back. NBC wanted *Star Trek* back a year after they canceled it and

Paramount wouldn't give it to them because they had destroyed the sets and had given away the Enterprise to the Smithsonian Institute. The expense was just too high, as well as getting the cast back together. So they kept coming back every year saying, "Can we have *Star Trek* back?" And Paramount kept saying no. Then finally they said, "We'll give it to you in a different format, a half-hour animated series for prime time or Saturday mornings, whichever you want." NBC chose to put it on Saturday mornings and won an Emmy as best children's show. There was nothing children about it.

*The stepping stone to bringing* Star Trek *back was not originally meant to lead to* The Motion Picture, *nor a new season of* The Original Series, *nor even a new season of The Animated Series. Beginning in the mid-1970s, Paramount instigated development on multiple* Star Trek *revivals that never saw the light of a projector bulb — the one which made it the farthest to production was the infamous* Star Trek: Phase II, *a sequel/reboot of sorts that would have seen members of the original cast blended with new cast in a second five-year mission on the U.S.S. Enterprise.*

*Prior to* Phase II, *however, a number of feature film projects were proposed. The first instance of a formal* Star Trek *feature film pitch came from Gene Roddenberry in 1973, when he pitched a concept that had briefly been developed for* The Original Series, A Question of Cannibalism *(thankfully retitled for the pitch* The Cattlemen*) as a motion picture. While Paramount was interested, Roddenberry demanded a script fee Paramount was unwilling to pay, and the project stalled. As conventions, merchandising, and syndications continued to bring in revenue, Paramount instigated talks of a revival on their own.*

**MARC CUSHMAN:** In 1975, Paramount finally got wise and said, "We have to make a *Star Trek* motion picture." The reruns are making gangbusters. Comics, books, merchandising — the conventions are getting bigger and bigger. So they finally said, "Okay, let's do a *Star Trek* movie." They couldn't find a script they liked. They rejected Roddenberry's first script, *The God Thing*, because Barry Diller, who was running Paramount at the time, was Catholic, and didn't like how the script dealt with religion. Roddenberry turned in a second treatment, and they responded with a form rejection letter. This is going to Gene

Roddenberry.

**JOHN TENUTO:** The very first mention of *Star Trek* coming back in a live-action format occurs around August 1972 at about the time they announced the animated show. There are discussions that Roddenberry is having with Paramount about bringing *Star Trek* back, either as a motion picture or a television movie of the week, or maybe even a second television show. Those plans will be put on hold a little bit until after the animated show completes its run. But by 1975, Paramount has greenlit a brand-new *Star Trek* movie that was to be called *Star Trek: Planet of the Titans*, which if that name sounds familiar, it's no coincidence that it sounds awfully familiar to *Planet of the Apes*, which had been a highly successful not only film franchise, but when it premiered on television, it became a television ratings blockbuster. And so, a $5 million budget was allocated [to the *Star Trek* film.] At that time a significant amount for a science fiction film.

Roddenberry was on board as producer, and the director was going to be Philip Kaufman. He tried his hand at one version, and there was also a version written by two authors, Chris Bryant and Alan Scott. Several versions of the script were written, there were even some conversations with cast options. Ralph McQuarrie was brought in, who is a very famous illustrator now for his work on *Star Wars* and is responsible for the look of *Star Wars*, and he designs a new Enterprise.

**MARK A. ALTMAN:** Philip Kaufman's *Planet of the Titans* was going to be a feature film in the mid-seventies. We find out in the denouement that the Enterprise crew are the Titans of myth who bequeathed ancient man fire. Phil Kaufman had this very high affluent, pretentious approach to *Star Trek*, where he was thinking this could be the first R-rated *Star Trek* movie. We're going to deal with a therapist who is dealing with Spock during Pon Farr, and it was going to be sexy and cool. He really loved Leonard Nimoy and he didn't really care so much about the Kirk character. Ultimately, he ends up hiring Leonard to do the *Invasion of the Body Snatchers* (1978). *Planet of the Titans* is just this crazy concept, written by Chris Bryant and Alan Scott. The '70s *Star Trek* movies that never happened were all very bizarre. From

Gene's *The God Thing* where Kirk fights Jesus on the bridge of the Enterprise, to the *Planet of the Titans*, where the crew of the Enterprise bequeaths ancient man with fire, to ultimately Gene's aborted version of *Star Trek II* where Captain Kirk meets Kennedy when they go back in time and the Klingons are working with the Russians and the Enterprise is mistaken for a UFO and Kirk has to convince Kennedy to help them. It's crazy. All these paths never taken.

*Perhaps the most intriguing "road not taken" for* Star Trek, *was an offer Paramount made to the young director of the then recent indie hit* Assault on Precinct 13 (1975), *John Carpenter, to direct the* Star Trek *motion picture. While Carpenter turned down the offer almost immediately, it is fun to contemplate what the future director of* Halloween (1978), The Thing (1982) *and* Escape from New York (1981) *would have brought to the world of* Star Trek.

**MARC CUSHMAN:** The entire cast was supposed to return for *Planet of the Titans* that was being written in '75 and '76, and Phil Kaufman was signed to direct. But the studio had problems with it. And if you read the script, you'll know why. Roddenberry wasn't allowed to rewrite it, but he gave notes and he tried to help them along. So Phil Kaufman wanted to do a draft and he wrote almost an entirely different script based on the general idea of *Planet of the Titans*. And that was immediately rejected. So Paramount decided, "Okay, we've spent two years trying to make a movie and we're not getting anything done. Let's do what we know how to do. Let Gene make another TV series on *Star Trek*."

**JOHN TENUTO:** By the time you get to April 1977 – a month before *Star Wars* became the phenomenon that it became – all these movie projects are shelved. The reason is that Paramount decides they want to try their hand at a fourth television network. At the time, the only networks that existed in the United States were CBS, NBC, and ABC. Paramount wanted to try a new network and thought *Star Trek* could be an anchor show, that could drive revenue, drive advertisers, and help sell this concept of a fourth network. The idea of that new show was called *Star Trek: Phase II*.

**ANDREW PROBERT (production illustrator, *Star Trek: The Motion Picture*):** Back in the '70s, Paramount and Gene wanted to put out a show called *Phase II*, which was supposed to be the next logical step after *The Original Series* and Captain Kirk. They already had the design for the Enterprise and Dry Dock already built. Then *Star Wars* came along, and scrapped *Phase II*, and made *Star Trek: The Motion Picture*.

**JOHN TENUTO:** The idea behind *Star Trek: Phase II* was that the crew was on another five-year mission, but there are some significant differences. The Enterprise is more advanced, and the crew is more varied. Spock was not going to be in *Phase II* and he was going to be replaced by a new, younger Vulcan named Xon. The pilot episode for *Phase II* was called "In Thy Image," written by Harold Livingston, based on a story treatment idea by science fiction author Alan Dean Foster. It is very similar to what became *Star Trek: The Motion Picture* with differences to make it cinematic.

**HAROLD LIVINGSTON (story editor, *Star Trek: Phase II*):** I was on the Paramount lot working as a story editor for an Ernie Borgnine series called *Future Cop*. They didn't renew it. The head of Paramount Television, Arthur Fellows, mentioned to Gene Roddenberry that we had similar wartime backgrounds. All I know is Roddenberry called me in one day – I'd never seen a *Star Trek* in my life – and they offered me this job to produce a new series. So why not?

**JOHN TENUTO:** All the preparation for the show is occurring between April 1977 and November 1977. The reason that the plug is pulled on *Star Trek: Phase II* is because by November '77, it becomes clear to Paramount that there just is not enough interest in a fourth network. By this time, *Star Wars* is almost the highest-grossing film of all time in American history. It'll take a few more weeks for it to get there, but it's well on its way. A lot of time and energy has been invested in trying to bring *Star Trek* back in one way or another. But now that the fourth network idea is dead in the water, there isn't going to be a *Star Trek: Phase II*.

**HAROLD LIVINGSTON:** My responsibilities were to develop 13 hour-long episodes of *Star Trek: Phase II*. I had never seen a *Star Trek* episode in my life, so Jon Povill, who was Roddenberry's "assistant" — actually his gopher — took me into a projection room and I watched 79 episodes. I didn't pay any attention to them really. Povill was such a nice young man, he showed me some scripts – but I had some ideas of my own. There I am, hiring writers, listening to story pitches. We hired some very prestigious writers, if I remember.

**MARC CUSHMAN:** *Phase II* got along a lot further than most people realize. There was a two-hour pilot written, which was turned into *Star Trek: The Motion Picture*. Alan Dean Foster wrote the treatment, and then Harold Livingston and Gene Roddenberry wrote the script. There were 16 scripts written to follow that. Written by a lot of original *Star Trek* writers. They were about two weeks away from filming when Paramount decided to take the script for the two-hour pilot and turn it into a movie.

They'd already built the sets. Other than Engineering, which they'd enlarged to be two stories, all the sets looked pretty close to the way they had in *The Original Series*. It wasn't a whole new Enterprise. The uniforms were the same — slight variations, but not many. Everybody was signed except Leonard Nimoy, who they were talking to about maybe appearing in a couple of episodes. So they introduced a new Vulcan, a younger Vulcan, Xon. And it works very well in the scripts. He gets into a lot of trouble.

**JOHN TENUTO:** One of the characters that was going to be new in *Phase II* was Xon. Xon was going to be Spock's replacement character. They wanted a Vulcan on the show, but they wanted a character who'd be different than Spock. Xon was a young Starfleet officer, a full Vulcan, but wanted to be on a mostly human ship because he wanted to learn about the human element more. He wanted to learn about emotion. So, in many ways he's the inverse of Spock. Spock was trying to control his human emotions, Xon is trying to explore what it means to be human, even though he doesn't have a human side.

**DAVID GAUTREAUX (actor, "Xon," *Star Trek: Phase II*):** I'm David Gautreaux, and sometime in the fall of 1977, I was cast as an interesting character named Lieutenant Xon. A full Vulcan, top of his class, the Vulcan Academy. He was to be commissioned, his first commission as a young lieutenant, was to take over a vacancy on the Enterprise.

**MARC CUSHMAN:** Some of the scripts are very good. Robert Bloch did an amazing script for them involving time travel. Nothing like The City on the Edge of Forever. A couple of them were made later for *Star Trek: The Next Generation*.

**DAVID GAUTREAUX:** They were building the sets for what was to be the Enterprise. We knew, as the actors, that there was a start date. Like if this screen test was on or about October 17, I believe that there was an actual start date of November 1, to start shooting *Star Trek: Phase II*. That's pretty much a hurry-up for them. So my memory of the atmosphere is, there are sets being built and we're going to utilize one of their built sets [for the screen test].

During the screen test, my hair was quite long. and they said, "don't cut it." Now, I'm thinking, "This isn't going to look like your usual Vulcans." As we learn later in the pilot script, upon graduating from the Vulcan science academy, Xon went off into the desert for a period of fasting and meditation. Therefore, when he was to be beamed aboard – he was described as "Jesus-like." Meditation robes, sandals, hair covering his ears. Stinking to high-heaven.

*While the scripts were written, the sets were built, the cast secured, David Gautreaux and Persis Khambatta were hired as newcomers to the crew, Xon and Ilia, the project had a major change-up just prior to shooting.*

**DAVID GAUTREAUX:** I get the call from Gene Roddenberry's office. "David, we have a lot to celebrate and we want you here for it. Can you come right down to the studio? This is a magic moment for all of us and yes, you got the role." Oh my God. I'm really, really excited. I fly down the flight of stairs, jump into this '64 Ford Falcon

Futura where the cab roof never closed, drive onto Sunset. The lot at Paramount, the gates fly open, I'm brought right up to Gene Rodden-berry's office. I'm in a big room. And there's Gene and he's got a drink in his hand and he's offering me, "What would you like, David?" And I go, "Well, I happen to like bourbon." "Pour David a bourbon." So, Gene is really the master of ceremonies for this.

There's a lot of men in this room and they're all wearing suits and I'm not wearing a suit because I would not look good wearing a suit at this point in my life. I learned later it was not only Gene Roddenber-ry doing all the talking, but there was Jeffrey Katzenberg and Michael Eisner and a whole bunch of men. There was Bob Goodwin and Bob Collins, and I see these other gentlemen that don't look native to the show business. I learned later on that they were some JPL people. So "David, congratulations. You are our new science officer. Hurray for David Gautreaux, Lieutenant Xon." Everybody drinks, a sip bourbon, all that stuff, but, and here's Gene Roddenberry going, "But here's another one, we're going to be a major motion picture!"

Everyone's very excited about this, but I'm sort of like, "???" So I go to Bob Goodwin later and say, "Bob, this is all fascinating, but what's going on here?" He says, "Well David, because *Star Wars* did so well for Fox, Paramount realizes that *Star Trek* is their most important product, so we're going to make a movie. Then after the movie, go directly into the series." I go, "Wow!" He goes, "You're contractually good, you're Xon, you'll be in *The Motion Picture*."

*He wasn't.*
*But that's a story for the next chapter.*

# I WAS AT THE MOVIES

Star Trek: The Motion Picture, Star Trek II: The Wrath of Khan

*"Is this all that I am?... Is there nothing more?..." ~Spock,* Star Trek: The Motion Picture

**HAROLD LIVINGSTON (screenwriter, *Star Trek: The Motion Picture*):** Do you know how old I am, for Christ's sake?! At my age, most people are dead! I don't remember.

*The decision to turn* Star Trek *into a major motion picture has an evolution of attributed causes. Some cite the release of* Star Wars *in May of 1977, which went on to gross $307,263,857 domestically in its initial theater run alone ($1.06851006 billion in 2021 dollars.)*

**MARC CUSHMAN (author, *These Are the Voyages*):** Misinformation. The popular belief is that *Star Trek: The Motion Picture* got made because of *Star Wars*. It's true that *Star Wars* came out in the summer of '77 when *Phase II* was in development and they were planning on filming *Phase II*. Paramount always wanted to make a *Star Trek* movie because the people running Paramount were with the motion picture division, and they looked down on TV. They were only going to do TV if they could launch their own network and there'd be enough revenue to make that worthwhile. They didn't want to do *Star Trek* as a TV series again — which is why they kept turning NBC down — unless they could do it on their own network. They looked down on *Star Trek* because even though it made the studio so much money and even saved the studio, it was television.

*Regardless of the cause, science fiction was entering popular culture in a new way with hit motion pictures like* Jaws (1975), Star Wars (1977), *and* Close Encounters of the Third Kind (1978), *each breaking records at the box office, shocking studios and creatives alike.*

*On October 21, 1977, Paramount makes the decision internally to turn the two-hour pilot for* Star Trek: Phase II *into a full-blown motion picture. The decision came on the same day that Harold Livingston turned in the draft for the*

*Phase II pilot. At this stage,* The Motion Picture *was meant to be produced for a relatively small budget, and lead directly into the* Phase II *television series, utilizing the same sets and cast/crew. Unfortunately, this effort to streamline the production of the first motion picture would meet even more difficulties than the previous efforts.*

**MARK A. ALTMAN (creator, *Pandora*; author, *The Fifty-Year Mission*):** The roots of *The Motion Picture*'s troubled production can be traced all the way back to *The Cattleman*, which was Gene Roddenberry's low-budget take on a *Star Trek* feature, which would have been about an alien species of sentient cows being hunted by ranchers. It's a noble idea — and a vegan's dream movie — but it would have been awful and it led to a litany of underbaked, ham-fisted, derivative attempts at a *Trek* movie like *The God Thing*, which culminates with Kirk fighting Jesus on the bridge of the Enterprise. Ultimately, the studio decides to greenlight a new TV series, *Phase II*, for a new ad hoc Paramount network which was basically what they would do in first-run syndication a decade later. But anyone who's read the scripts for that aborted show realizes it would have been a disaster, not to mention the little test footage that exists is pretty threadbare. Ultimately, when that show is mercifully abandoned, the studio waters the seeds of "In Thy Image," the pilot for the show written by the delightful curmudgeon Harold Livingston and turns it into what became *The Motion Picture*.

**MARC CUSHMAN:** It's a real a shame that *Phase II* never got up and running. Even when they made *Star Trek: The Motion Picture,* they were planning on still doing the series. They said, "Let's just get a movie out there. And that'll recoup the cost of building all the sets and everything. And then we can just start pumping out the episodes." They were still writing episodes for *Phase II* in January and February of 1978.

**PRESTON NEAL JONES (author, *Return to Tomorrow — The Filming of Star Trek: The Motion Picture*):** The first draft script for what would become *Star Trek: The Motion Picture* was submitted in October 1977 by screenwriter Harold Livingston. The credit on the title page read, "Screenplay by Harold Livingston, Story by Gene Roddenberry and Alan Dean Foster." The screenplay for the longest time

has been thought of as a collaboration between Harold Livingston and Gene Roddenberry.

Alan Dean Foster is a science fiction writer in his own right. He's been published in science fiction magazines and has written science fiction books. He also had a connection to *Star Trek* for having written the novelization books based on the episodes of the animated *Star Trek* series. But he had never met Roddenberry himself. He'd had no direct contact with the people who had made *The Original Series*, until such time as a *Phase II* would eventually lead to *Star Trek: The Motion Picture*. Paramount talked to many writers to develop the idea for *Star Trek* – either as a movie or as a series - and Alan Dean Foster was one of the writers who was brought in.

**HAROLD LIVINGSTON:** The movie is an expanded version of the TV pilot.

**WALTER KOENIG (actor, "Chekov,"** *Star Trek: The Motion Picture*): There was a perspective in Hollywood that if you're a television performer, you're not a movie performer. Movie performers are either better or have more fans, but you don't make that transition. There was a time when it was considered very bold for an actor to go from being an actor on a television series to being a star in a motion picture. That changed in the last 50 years, but that was the attitude at the time.

The Motion Picture *star, Persis Khambatta was hired in late October for both a motion picture appearance and to be a regular on* Phase II, *as the alien, Ilia.*

**PRESTON NEAL JONES:** Persis Khambatta felt that when she got the role as Ilia for *Star Trek: The Motion Picture*, that it had been her destiny. Growing up as a child in India, she had fallen in love with the *Star Trek* series, and she wanted to be on it, and was disappointed to learn the series was long gone. But when she became actress, she wanted to be part of *Star Trek*. She did something very smart for her audition – most actresses auditioned like they would for any other,

dressed and made up in their finest – she bought a bald cap and wore it to her audition. So they could get an idea of what she'd look like bald.

*During the month of October, before a viable script or even the cast was secured, Robert Abel & Associates won the bid to produce the visual effects for the picture. Robert Abel had produced a number of visually revolutionary television commercials, and would go on to pioneer the field of computer graphics in the 1980s, but this would be the team's first major motion picture.*

**ANDREW PROBERT (production illustrator, *Star Trek: The Motion Picture*):** Robert Abel & Associates was a company that was doing a lot of commercials and they were adding a lot of special effects to these commercials. They were winning awards for these commercials. So I was on a great team to begin with.

*While early on, certain design elements were expected to transfer over from* Phase II, *it quickly became clear that many elements would have to start from scratch.*

**ANDREW PROBERT:** When Gene Roddenberry announced he was going to "do it again," and make a new *Star Trek*, my ears perked right up. I was going to Art Center, the college of design in Pasadena, California, and was recommended to work on *Star Trek: The Motion Picture*. So I went to Robert Abel and applied for the job under the art director, Richard Taylor. Richard wanted me right from the get-go to design all the humanoid spacecraft in the movie, because he thought that would create a certain sense of continuity. And that was like, "give me a break." From a *Star Trek* fan, watching and loving the show, to working on the movie and creating the new look for the franchise.

The first time I met Gene it was like anybody meeting any hero. I'd followed *The Original Series* from day one, so to meet the man who actually created that was a big thrill for me. But working with him was great because he wasn't one of these flighty people that didn't know what they wanted. Gene had very specific ideas about how his universe should operate. And I liked that. It gave me some rules to design to. He and I got along very well.

*As design and special-effects work began, work on the script trudged along
on a slower pace. Continued creative differences between Harold Livingston and
Gene Roddenberry caused Harold Livingston to quit the production in De-
cember of 1977. Paramount was committed to the project by now, however, and
attention shifted to finding a director. In March of 1978, Robert Wise was hired
to be the director of* Star Trek: The Motion Picture.

**PRESTON NEAL JONES:** Robert Wise was the first and only
name on the list considered for making *Star Trek* into a movie – once
it was going to be a major motion picture. He was one of the major
directors of the golden and silver age of Hollywood history. He came
up the ranks as an editor for RKO – where one of his projects was
*Citizen Kane* (1941). His first chance to direct came from Val Lewton,
the famous producer of horror movies, very sophisticated cinematic
presentations. He went on to do film noirs and virtually every kind
of movie, from musicals to westerns. His biggest commercial successes
were *West Side Story* (1961) and *The Sound of Music* (1965). He was the
first one they asked [to direct *Star Trek: The Motion Picture*], and he said
yes, so they didn't bother looking any further. Nor did they want to.
One of the things that intrigued him was his previous science fiction
films had been Earth-bound in their settings. Here was a chance to
really get out into outer space.

**ANDREW PROBERT:** Sometimes in production meetings,
there'd be Gene Roddenberry and Robert Wise, and… give me a
break! I mean, Robert Wise from *The Sound of Music* and *The Day the
Earth Stood Still* is doing *Star Trek*? I can't believe it. Really nice fellow.
He had some great ideas and was very concerned about quality and
very concerned about keeping *Star Trek* on track, and not wandering
off into some other direction that the fans wouldn't recognize.

**PRESTON NEAL JONES:** As soon as Robert Wise came in,
he was not happy to learn that Paramount's plan was to start right in
shooting the movie on the sets that had been built for *Phase II*. He
would have none of it. For a major motion picture, he felt these sets
would be totally inadequate. So he hired art director Harold Mi-
chaelson, and he in turn hired Leon Harris, and they went to work

designing motion picture sets for the films.

*By this point, Paramount had pre-sold the motion picture to theater chains and to the ABC television network as a way of recouping the cost of production early.*

**PRESTON NEAL JONES:** Nothing can be understood about the tremendous human effort that became necessary to get *Star Trek: The Motion Picture* made without the knowledge of Paramount's fateful decision to cut a deal with the motion picture distributors. The distributors were promised that there would be a *Star Trek* movie that they could show in their theaters on December 7, 1979. The distributors gave a lot of money to Paramount to help them get started — seed money, if you will. If that deadline was not to be met, Paramount would have to give back to the theater owners, zillions of millions that they had gotten from them and zillions more on top of that. That informed everything for better or worse, and often for worse, from that day forward, once that decision had been made.

*Now locked in to making the movie, a question that kept appearing in everyone's mind — "Where's Mr. Spock?"*

**PRESTON NEAL JONES:** *The Motion Picture* would not have happened if not for Robert Wise. He was not a Trekker himself, but his wife and her son were. When he agreed to do the film, Mr. Nimoy was still not involved with the project. They had another Vulcan character [Xon], and Mr. Wise's family told him, "It's crazy to do it without Spock! It's like doing it without Kirk!" So Wise went to Paramount, and said, "There's got to be a way we can get him."

**MARK A. ALTMAN:** They had a very difficult time getting Leonard Nimoy to come back for *Star Trek I*. There was a lot of antipathy between the studio and him. He felt like he wasn't being paid for all the merchandising, all the money they had made off his likeness. The straw that broke the camel's back was this famous beer ad with a Vulcan with pointy ears that start to droop when he's not drinking the right beer, and they drink the right beer and suddenly his pointed ears are

up again vertically. So for a long time, Leonard's not going to do *Phase II*. He's not going to do the movie. It's really only on *Star Trek: The Motion Picture* where Robert Wise, his daughter says "You can't do a *Star Trek* movie without Spock!" And Robert Wise goes to Jeffrey Katzenberg and says, "We have to get Leonard." Jeffrey Katzenberg flies to New York where Leonard's doing *Equus* at the time on Broadway, and says to him, "Look, we need you to do *Star Trek*. We're going to settle this lawsuit. We're going to win to make it work." And sure enough, he gets it done, gets it settled.

**PRESTON NEAL JONES:** Days before the press conference that was to announce there would be a *Star Trek* motion picture, and that almost all the Enterprise crew was to be reunited, except Leonard Nimoy – Leonard Nimoy came on board. For the longest time, the one holdout was Leonard Nimoy. There are actually two perspectives on the whys of that. Leonard Nimoy, when he came on board, said he wasn't a holdout at all. It had a lot to do with scheduling. Originally, he was signed up to be on the motion picture directed by Philip Kaufman, but then when it looked like *Star Trek* would be a series, Nimoy didn't want to be a part-time Spock. Because he didn't want to do the series again, and when they offered him the pilot and guest on a few, he said he didn't want to do that, because he didn't want to be a part-time Spock. At the same time, there had been disputes with both Mr. Nimoy and Mr. Shatner, legal issues and financial, involving royalties from the series, involving merchandising, and many other things. Suddenly, when they were about to make a major motion picture, and they needed to have Mr. Nimoy on board, all of those issues were quickly resolved.

*On March 28, 1978, at the largest press conference since the one for* The Ten Commandments *in 1923, it was announced that there would be a* Star Trek *motion picture, with original cast members William Shatner, Leonard Nimoy, DeForest Kelley, Nichelle Nichols, James Doohan, George Takei, and Walter Koenig returning. Near the same time, Robert Abel asked for an increase in their special effects budget by $750,000. One key problem remained – they still didn't have a viable script.*

**PRESTON NEAL JONES:** Harold Livingston had been involved with *Phase II*, and when Paramount was not having success getting a good usable script [for *The Motion Picture*], there was a deadline looming, they had to start shooting, Roddenberry invited Harold Livingston back and said, "You know this material better than the people we've been bringing in from the outside, so let's get to work." Livingston would write a section and hand it to Roddenberry, Roddenberry would rewrite the section and hand it back to Livingston, Livingston would rewrite the rewrite – then the rewrite of the rewrite would get rewritten. That was the process. Ultimately, the screenplay process led to pages that Paramount felt could go ahead and be put on screen, even though it did not have a complete last act.

**HAROLD LIVINGSTON:** When I got through with *Fantasy Island*, I got a telephone call – this was after they had announced that *Star Trek: The Motion Picture* would be a big picture with Bob Wise to direct – I found out that my name was not on the script. So I raised hell about that. Then they assured me they'd put my name on the credits.

I agreed to meet with Roddenberry and Bob Wise. This I'll never forget. Bob Wise is an idol. We're sitting down, and Bob Wise said to me, "What did you think of the script?" I said, "What I think, Mr. Wise, is you should take cyanide." That brought a big laugh. We talked for a while, and they asked me if I'd rewrite it. I said, "I'll rewrite it, as long as it's contractually agreed Gene Roddenberry doesn't put pen to paper." The next day, I'm in Paramount, and I signed the contract. They gave me a lot of money.

Anyway, I'm now rewriting this script under Bob Wise's direction. I write a first draft, which Eisner wants to see. He and Katzenberg are in Paris. I write the first draft, Bob approves it, and I give it to Gene's secretary to send to Eisner in Paris. About three days later, my phone rings. It's Eisner, calling from Paris. "What kind of shit did you send me?!" I said, "What are you talking about?! It was a good script. Bob liked it." He said, "Nobody could like this crap!" We find out what happened was I gave the script to Gene's secretary, Susan Sackett, and

she sent Gene's, unbeknownst to anybody, rewrite of that script to Eisner in Paris. We finally straightened that one out when Eisner came back from Paris.

*During the spring and summer of 1978, work on the script continued as pre-production and special effects continued. More money is allocated to Robert Abel – bringing the special effects budget up to five million dollars. Stephen Collins was cast as the last new addition in the role of Captain Decker – Kirk's younger replacement. Principal photography began on August 7, 1978, with a scene on the bridge of the retrofitted Enterprise. The new set designs by Harold Michelson were meant to expand the scope of the Enterprise from* The Original Series. *Similar marching orders were given to the team designing the new miniature of the Enterprise.*

**ANDREW PROBERT:** Who wouldn't want to redesign the Enterprise? The thing is, for *Phase II* an Enterprise had already been built, but it was too small. It was like, I don't know, six feet long-ish. Richard Taylor thought that if we're going to put this on the big screen, the miniature needs to be as big. So they decided on maybe a 10-foot model. 10 feet-ish. Then a lot of detailing in addition to that. Robert Wise wanted people to believe these ships were actually as big as they were supposed to be. In subsequent films, it seems like the majesty that Mr. Wise put into his ships – through the special effects teams that actually did them – got left behind.

*A similar redesign of* The Original Series *was in effect for the costumes.*

**ROB KLEIN (pop culture historian/archivist):** It was Isaac Asimov who said, "No, no, no… people who work in space would only wear pastel colors." So you can blame him for not having the classic red, gold, and blue colors.

**PRESTON NEAL JONES:** Oddly enough for a major motion picture, because of the nature of the storyline, *Star Trek: The Motion Picture* was shot, not completely, but in many ways in sequence, which is very rarely the case. But you had very few sets and most of them were on the Enterprise, so they had that luxury. The first day on that set was

a very emotional reunion day for the members of the cast, all except Leonard Nimoy, who wasn't in that scene and hadn't arrived yet. People were hugging each other and shedding tears. Robert Wise said, "Is this the legendary crew of the Enterprise I've always heard about? You sentimental softies!"

**WALTER KOENIG:** One story. It was very early in the shoot. I went up to Mr. Wise and said, "Mr. Wise are we going to come back and do a closeup of Chekov?" He said, "Please, don't talk about those actor things to me." It destroyed me. He was absolutely right. I was thinking of me, me, me. I'd been fighting for a part on *Star Trek* where I had something to do, and I had gotten into that reflex condition where I was trying to protect the character. This was a place where Chekov could have a minute, but it was wrong. An actor should do what an actor is paid to do and what the director tells him. The leads in the movie have that available to them, but not for me. I'm thinking, "God, he knew Orson Welles and he knew this person and he directed that person, and here is this bit player asking for a closeup." I don't know if it was three days later, or 10 days later, or the last day of the shooting, but Mr. Wise was talking about the setup and he said, "Oh, and we've got to come in on a closeup for Mr. Chekov." Bless his heart.

**HAROLD LIVINGSTON:** Shatner was a very nice guy. I liked Shatner. The man who was very helpful to me was Leonard Nimoy. He would come to my house every night for many a month in a row, after dinner, and we'd go over the next day's pages. He was immensely helpful in leading me into these *Star Trek* characters and who they were, without Roddenberry's crazy shit.

*Despite the fact that filming on* Star Trek: The Motion Picture *had begun, the script was still undergoing massive rewrites.*

**HAROLD LIVINGSTON:** We had no third act. I'm surprised we had a second act — that's a miracle too.

*The problem lay with constant rewrites demanded by all parties involved, creating a vortex of rewrites constantly happening on and off the set — with input*

*from nearly everyone imaginable on what should and shouldn't be in the film.*

**HAROLD LIVINGSTON:** I walked out twice. They were paying me a lot of money, but I just quit.

**JOHN TENUTO (*Star Trek* historian, startreknews.net):** One problem was that the script was not in the shape that they had hoped it would be. It had been rushed. Rushed when it was made as *In Thy Image*, and it had been rushed to convert *In Thy Image* into *Star Trek: The Motion Picture*. There were also problems with the script in terms of character. Some of the actors were concerned as to how the characters were acting. The actors really spent a lot of time, especially Leonard Nimoy, William Shatner, and DeForest Kelley, trying to find ways to bring some of that twinkle in the character that was in the original show. That meant constant story meetings. And any story meetings you have cause problems. [Any changes] cost money, cost time. Another problem was how to end the movie.

**HAROLD LIVINGSTON:** I would write a page or two, and they'd go to Gene. Gene would rewrite my pages, and put his initials and the time of day — GR 4:15. Then I'd rewrite him. HL 5:00. You wonder why this picture cost so much money! So finally – he wouldn't stop rewriting. He was just maniacal about it. So I quit. I get a call from Katzenberg one day. They sent a car for me to go to his office at 7 pm. I walk into his office, his secretary locks the door. She says, "He'll be in in a minute." Half an hour later, Katzenberg comes in and says, "All right, you're going to come back to work." I said, "No I'm not." He said, "What do you want?" I said, "I want ten thousand dollars a week, and I want a script commitment." "You got it." That's what I had to do. That's the way that picture was made.

**PRESTON NEAL JONES:** Associate producer Jon Povill told me, "Different people were doing different revisions. There would be GR pages, HL pages, GR/HL pages, JP pages, JP/HL pages. There were no RW pages. Bob did not involve himself in the writing except in an advisory capacity.

**MARC CUSHMAN:** The big problem is they didn't have an act three. They didn't know how it was going to end; that didn't come up until almost the very end of the filming. They were rewriting that script as they were filming it because it was a TV script being written for the big screen. Now, as it was being filmed by Robert Wise. So it was being reinvented, rewritten, made bigger. And they never had an ending that everybody loved until they were almost ready to film the ending. And then Jon Povill, who was an associate producer and smoking pot, came up with the ending, that these two characters were going to merge. Decker was supposed to live because he was needed to do the TV show. All the scripts had been written for Ilia and Decker and Kirk and everybody else. And they already had these scripts.

**WALTER KOENIG:** It was a huge deal. We were so long getting around to shooting this, when we finally started shooting and the special effects weren't working, there came a day when we all came in and they said, "Don't get into your costumes, we're going to do some rewrites."

They gave us a two-act script in a three-act movie. We did not have an ending to the story. They prepared a room, including Al Livingston, Gene Roddenberry, Bob Wise, and a couple of other associate producers. After a few weeks, Bill and Leonard join the party. There were so many voices and so much self-interest that it interfered with them finding the end of the story. Somebody who was in the room recently told me that Bill Shatner said "Let's have Chekov do this" on a couple of occasions, that would have substantially boosted my part. They didn't go for it. They had painted themselves into a corner. A lot of it had to do with the special effects that the company had let us down. My sense was stories should move in a way that when it reaches the ending, it has dovetailed to that ending. You have a dramatic, satisfying, intense story that you feel you have experienced in all its stages. We did not have a third act. The whole thing just didn't have the dynamics or drama that was required.

**PRESTON NEAL JONES:** All during the early phase of production, Livingston and Roddenberry were sweating bullets trying to devise an ending that would work. Ideas were considered, they were

thrown out, other ideas were considered. Ultimately, it was Jon Povill who added the last little piece of the puzzle when he suggested what he called, "the mind meld," when the Decker character fuses and becomes one with V'ger.

*The final(ish) script for* Star Trek: The Motion Picture *tells the story of desk-bound Admiral James T. Kirk, who coerces his way back into command of the Enterprise when a probe of unspeakable destructive power is detected on a collision course with Earth. The crew of the Enterprise had dissolved years before, from some incident we know not of, and a tension permeates the air. Spock, who has spent years trying to purge the final parts of his psyche of emotion, rejoins the crew once he received a telepathic communication from the probe. As the Enterprise approaches the probe, the probe attacks the Enterprise, and takes on the form of the Enterprise helmsman, Ilia, to communicate with the crew. Spock meanwhile, travels into the probe and mind melds with it — learning to his shock that the probe, V'ger, is a machine devoid of emotion, just as he wishes to be, and is asking if there is nothing to life. Kirk, Spock, and Captain Decker discover the probe is really an old NASA probe, Voyager 7, which had been upgraded by a race of sentient machines, and had returned to Earth looking for purpose from its creator. It is determined the solution to V'ger's plight is that it must "join with the creator," and thus Decker sacrifices himself to be with V'ger and what remains of Ilia, the woman he loved.*

**DAVID GERROLD (screenwriter, *Star Trek*):** Gene only has one story, "We meet god, and beat the crap out of him."

**HAROLD LIVINGSTON:** Gene claimed screenplay credit. So I said, "Gene you didn't write this." "Yes I did." "You didn't write a goddamn word of it!!!" He said, "I wrote it!" I said, "Take your name off the credits." He wouldn't do that, so I said, "Let it go to arbitration." So he said, "Okay, let it go to arbitration." Before it went to arbitration, he withdrew. "You want the credit, I never interfere with a writer who wants credit." (laughs) He got his revenge on me. Unbeknownst to me, stupid me, he had made a deal with Simon & Schuster to novelize the screenplay for a cool $400,000 [nearly $1.5 million in 2021 dollars]. And that novel exists today, based upon my screenplay, novel by Gene Roddenberry.

**JOHN TENUTO:** There was an episode of the original *Star Trek* called The Changeling, written by John Meredith Lucas. That episode involved the Enterprise coming across a very sophisticated robot named NOMAD. NOMAD is roaming the universe trying to purify any imperfection that it comes across. It turns out that NOMAD is actually the result of an Earth space probe that was created by a man named Jackson Roy Kirk. NOMAD is confused and believes that James T. Kirk is Jackson Roy Kirk. On a meta-scope, that is similar to what we see in the pilot for *Star Trek: Phase II*, and eventually in *Star Trek: The Motion Picture*.

**MARK A. ALTMAN:** *Star Trek: The Motion Picture* ends up being a soft remake of *The Changeling*. I love *Star Trek: The Motion Picture*. I think it's visually the most interesting *Star Trek* movie, it does so much right – but I understand the people that don't like it. It's the last film that's really influenced by *2001*, because you start to find that the *Star Trek* films later on are influenced by *Star Wars* more than anything else. That's a whole paradigm shift in terms of popular culture in general.

**MARC CUSHMAN:** I asked Gene Roddenberry about *Star Trek: The Motion Picture* feeling a little bit like *The Changeling*. Gene felt they were two different stories. Yes, it was a space probe, but from a machine world, a world populated by machines, a world that just deals with logic and nothing but logic, but has evolved to the point to where they're now asking themselves, "Is this all I am?" Machines wanting to achieve consciousness that was completely different than *The Changeling*. That's what he saw as the story. Because he was looking at that bigger picture, he was missing the smaller part that all of us picked up on. He wanted to show Kirk and Spock going through a midlife crisis, because he was going through a midlife crisis.

*Principal photography on* Star Trek: The Motion Picture *wrapped on January 26, 1979, with the scene of the V'ger and Decker fusion. The six-month shoot was three months overdue, and resulted in more hikes to the budget.*

*February 20, 1979, a day people behind the scenes were dreading, came. Tensions with Robert Abel & Associates and the production crew had reached a*

**121**

*boiling point. Paramount executives and Robert Wise descended on the studio to see what work they had done for the film.*

**PRESTON NEAL JONES:** From the people I've spoken to from the effects – people who were building models from the beginning for Robert Abel & Associates, and who stayed on to do models and special effects photography for Doug Trumbull and John Dykstra – Robert Abel & Associates were very creative and had wonderful artists who were very good at creating very vivid sketches and conceptual drawings. At the same time, they went down a lot of blind alleys. They wanted to go beyond the state-of-the-art and create a new standard. As one example, they wanted to have the Klingon ships at the beginning not explode, but implode. That was their high concept for that. At the same time, they were bringing in more equipment, they were asking for more equipment. They claimed they were shooting, but they were playing their cards very close to their chest. They weren't letting any-body see what they were doing.

**ANDREW PROBERT:** Robert Abel and his team were creating visual effects that had never been seen before. Never been seen before. There was a lot of research and development going into these scenes. Like when the V'ger probe comes aboard the Enterprise, they had this rig designed to where the central core would turn and sparkle, and then they had these light rays shooting in and out of it. It looked amazing. But they hadn't actually produced any final footage of the film, and the film was under a time deadline. Because Paramount had promised the movie would be in theaters next year, and they had a hard release date. Which backed everybody against the wall. So since Richard and Robert Abel were focused on making these effects unlike anything we've seen, Paramount started looking at them like "They're not producing anything we can use." Well, true, not yet. So they turned to someone they knew, Doug Trumbull.

So I'm working away in the studio, and I look up, and here comes Douglas Trumbull from *2001* and *Silent Running* and all these great movies – I couldn't believe it. And I'm like, "What's going on?" Well, later I find out that he promised them the ability to complete these

effects on time. So Robert was out and Doug was in.

**MARC CUSHMAN:** I talked to a lot of people who worked on the production, and they all said the same thing – that Robert Wise had the patience of a saint. You never saw him lose his temper. Even when everything was going wrong. But… that one time, when Robert Abel came forward after a year, and five million dollars, to screen what they had, and the screen lasted maybe a minute. There wasn't anything quality enough to use, and they were opening the movie in nine months. Robert Wise stormed out and said, "I never want to see that man again!" So they brought on Doug Trumbull, who had worked on *Close Encounters*. So he came on and started working from scratch. They had nine months. They were working around the clock, three teams.

**PRESTON NEAL JONES:** There was no question it was a trial for Robert Wise. He certainly never had to start a picture that didn't have a finished script before. He was a very careful craftsman and thorough planner. This was not his way of making a Robert Wise film. Bear in mind too, the films he'd made in recent years were Robert Wise Productions, here he was a gun for hire, just directing the picture. He made the best of a bad situation, and managed to get the ship into port by December 7.

*While projects like* Star Wars, Close Encounters *and* Alien *had ushered in a new era for visual effects, the number of visual effects houses in Hollywood was still relatively small. As such, this crisis became very much an "all hands on deck" scenario.*

**JOHN DYKSTRA (special photographic effects supervisor, *Star Trek: The Motion Picture*):** I came on at the end of the project, when the majority of the live-action material had been shot. I came on as an adjunct to Doug Trumbull, who was doing the show. Jeff Katzenberg was a baby executive at the time, and he was given this movie. But he was put in the position of having to make sure that they had a film that they could release in theaters, because there was a rumor of a class-action lawsuit against the studio if they didn't deliver on the date that the exhibitors had signed up for. Robert Abel had bitten off

a huge chunk. He had proposed and pursued doing the effects for the movie in a digital environment, meaning the way movies are made now at when *Star Trek* was being made, he proposed that it be made the way films are made currently with computers that were about as powerful as your cell phone. Incredibly ambitious. Doug Trumbull became involved, and they asked him to do the effects in a conventional fashion.

**PRESTON NEAL JONES:** I asked Robert Wise early in '79, where it looked like they were going to have to do two years' worth of special effects work in one year's time, because Paramount was absolutely deadlocked into the December 7, 1979, release date. I asked him, "Are you going to make it?" And he said, "Just… by the skin of our teeth…"

**JOHN DYKSTRA:** We immediately knew we were in a nightmare. In a couple of months we were working three, eight-hour shifts. We had stages that were constructed, so that one individual was being built at one end of the stage while it was being photographed at the other end of the stage. Everybody's hair was on fire.

Doug Trumbull wanted to do the Enterprise, because he was excited about that. It was sectioned and resectioned over time, as we completed some sections and as the script changed, new things would become needed and we'd figure out who was best suited to do it. He was working in 65 millimeter, which was great for all of the hero shots, tight shots of the miniatures. And we were working in Vistavision, which is a smaller format, quality, not quite so good, but was great for a lot of the motion stuff. That was the kind of thing that our systems were uniquely suited to.

The V'ger model was sixty feet long. There were times when we were photographing one end of the V'ger model, with the smoke, with curtains and plastic draped all around, and the other end of the model would be sticking out into the other end of the stage where the modelmakers would actually be constructing it or changing its configuration.

Jeff Katzenberg was the boss. People came and went, Bob Wise was involved sometimes, and then sometimes not, and Gene Roddenberry was involved sometimes and sometimes not. I think it was a project that was in the mode of the actor who asks for his motivation and the director says, "I'll tell you when you get here." It was that kind of a situation.

**MARC CUSHMAN:** They finished the last of the special effects about a week before the movie was about to open. They still had to make a few hundred prints. So they had half of the print houses in town making prints to deliver it to all these different theaters.

**MARK A. ALTMAN:** You cannot understate the importance of *The Motion Picture* in the resurrection of *Star Trek*. It's not only one of the first times a canceled TV series becomes a major motion picture long before IP fever gripped Hollywood, but it's an event picture presaging everything from *Mission Impossible* to *Charlie's Angels* to *The X-Files*. Unfortunately, the studio is locked into a release date of December 7, 1979, a day that will live in infamy. Unable to push the release and with delays in shooting compounded by the visual effects company they hired being in over their heads, they're forced to bring in the two giants of the special effects world, *Star Wars'* John Dykstra, and *2001*'s Douglas Trumbull. It's like the Genesis Effect. What Abel couldn't do in years, they did in eight months… amazing. It's some of the most stunning and impressive visual effects ever produced for motion pictures. Unfortunately, there's just too much of it. And that's because there was no time to fine-cut the film. They barely got it out on time. Bob Wise's son was literally splicing together a wet print on the way to the premiere which was hand-carried on the plane to Washington D.C. When the movie unspooled that Friday, entire sound-stages at Paramount were taken over with thousands of cans of film reels — some were being trucked to Westwood even as the beginning of the film was playing and they were waiting for the rest of the film to arrive before they ran out of film. It's an incredible story.

**PRESTON NEAL JONES:** At the end of the premiere at NASA, Robert Wise came up to Harold Livingston and said, "We were

fucking lucky. We were **fucking lucky**."

**JOHN TENUTO:** When *Star Trek: The Motion Picture* is released December 7, 1979. It actually is well received by many fans and also by critics. Some reviews that called it slow. Some reviews that questioned why the characters needed to spend so long looking at the special effects. Some reviews that called into question the missing humanity of the characters. But a lot of the reviews were focused on what a towering achievement *Star Trek: The Motion Picture* was. That it was able to take a 1960s television show produced out of 1960s budget with 1960s special effects technology and transform it into something realistic and believable, and in a quite imaginative way.

Star Trek: The Motion Picture *opened on December 7, 1979, and would go on to earn over $139 million worldwide. By comparison,* Alien, *which came out six months before, earned $109 million. It was a smash hit for a show that had been canceled for low ratings merely ten years before. However, as studio heads and critics were quick to point out, the budget was an exorbitant $45 million — meaning the returns from* The Motion Picture *were not as good as hoped.*

**PRESTON NEAL JONES:** A lot of the critics who didn't like *The Motion Picture* didn't like it because they were expecting *Star Wars*. Which *Star Trek* never has been and never will be. Some of them said, "There should have been a big battle! There wasn't enough action."

**LEONARD NIMOY (actor, "Spock," *Star Trek: The Motion Picture*):** Listen, Robert Wise was a very good filmmaker. He was hired because he had done a classic science fiction movie called *The Day the Earth Stood Still*. He also had done *Sound of Music*. It was a multiple Academy Award-winning director, but he did not know *Star Trek*. And he was at the mercy of people who said, "This is the way that this should be done." So, "Oh, okay. I'll do that." And he did what he was asked to do. And he did it very professionally. The movie is slick and very well-made. He ran into some problems, not of his making, because the special effects people were not producing what he needed. And suddenly there was a crash rush at the end to get a whole bunch

of special effects people to do bits and pieces all around Los Angeles to try to get the movie done in time. So he had those problems, not of his making. But I just never felt that the movie worked as a *Star Trek* movie.

**RONALD D. MOORE (screenwriter, *Star Trek: Generations*):** When I saw *The Motion Picture*, I absolutely loved it. It was such a golden moment, because I had come to my *Star Trek* fandom in the '70s. The show had been off the air for a long time, and *Star Trek* fandom at that point felt like we were holding up a lost cause. "Paramount is never going to listen! They're never going to give us another show or movie." I was never even aware there was talk of a *Phase II* movie. That was way off in the distance. So from my perspective, it was a, "Oh my god, they're finally all back together." And that long tour Kirk takes of the Enterprise in dry dock − I watched every second of it. I was enthralled.

**MARK A. ALTMAN:** For a while, the future of *Star Trek* was in doubt. There was a movie and it was canceled, a new TV series and it was canceled, and then a movie again. It seemed like we were waiting decades when in fact less time went by between the end of *The Original Series* and the first movie than between the premiere of *Next Generation* and today. Way more. So when *Star Trek* debuted on December 7 it was a huge milestone in the life of any *Trek* fan.

I was in middle school and had made a plan with a few of my friends to descend on the Loew's Georgetowne Theater in Brooklyn, New York, to see the film immediately after school. Unfortunately, despite the fact it was rated G, due to some recent unruly theatergoers, they wouldn't let kids it without an adult guardian. This sent me into a spiral of anxiety and depression. The thought of not seeing *The Motion Picture* on opening day was inconceivable. And it was then I realized my mother would be at the bank nearby depositing her paycheck and I raced to the Brooklyn Savings Bank, where I found my mom in line and promptly tugged on her arm and demanded she take us to see *Star Trek*. To her everlasting credit, she did and the rest is history. And I was fortunate enough to immortalize this testament to my mom in my first

feature film, *Free Enterprise*, in which Marilyn Kentz of *The Mommies* played my mother and I presented a thinly veiled version of what had actually happened, including an appearance by William Shatner as an apparition who counsels a young me. Art imitating life imitating art imitating life, I guess. All I can say is standing on set chronicling this moment in celluloid was surreal, to say the least.

**WALTER KOENIG:** I just think that was very slow moving. We did not have a riveting conflict going on. There were little squabbles between Kirk and the new captain. It didn't seem very important. It certainly didn't have the electricity and the emotional power that one would anticipate on the re-introduction of *Star Trek*, particularly in the form of a motion picture. It was flat. I knew this was not going to be a success. I knew halfway through the movie, how conscious I was of how slow it was, how it wasn't going anywhere. If I'm conscious of that during the filming, during the screening, then my sense is that it's not going to improve.

I don't think it was a good film, but the papers were brutal. In the Washington papers the next day they were brutal. They just said we were these old guys who should have stuck to television, they don't belong on the big screen. It was just awful. The only thing was, I evidently was so anonymous in the picture that when their reviews started naming the actors who were out of their league by being in this picture, they ignored my existence entirely. I wasn't one of the people that they thought was too old because I wasn't there.

**ROBERT SALLIN (producer, *Star Trek II: The Wrath of Khan*):** I thought *Star Trek: The Motion Picture* was unengaging. It was uninvolving and a little boring, to be honest with you. To my mind there was an overemphasis on sci-fi and too little emphasis on the human condition. Having been a professional actor when I was young and a director of radio when I was younger, as well as doing a lot of things at UCLA, I have a tendency to focus on the emotional content. To me, that's where the story is, not ships colliding in space or monsters consuming each other. It has to be about something that touches people, and that film simply did not touch me. The fans supported it, and thank goodness they did, because otherwise there wouldn't even have been a second

one. But I would not have become involved in that picture if I had been offered this script, whatever condition it was at the time.

**LEONARD NIMOY:** It had very little to do with *Star Trek*. It had the spaceship, the Enterprise, it had the crew, but the story had very little to do with anything *Star Trek*-y. The characters were not in shape, playing off of each other and with each other the way we did best. It was about some other people, other things that we were kind of along for the ride, trying to figure out how to deal with this and not really being good at it. It was cold. It was distant. It was kind of in the mold of *2001*. The feelings seem to be, we can't do television now we're making a very important, big motion picture here.

**DAVID GERROLD:** *The Motion Picture* had some great moments, but it suffered from slow pacing. It was turgid. They had scored the picture, so the effects went on too long because they had already scored the picture. You had Roddenberry rewriting pages after scenes had been shot. Robert Wise was not happy. There were so many delays and Roddenberry was at fault there because he was no longer as sharp as he was when he was working on *The Lieutenant* and *The Original Series*. He had been heavily into substance abuse and I'm pretty sure that his lawyer, Leonard Maizlish, was the connection delivering this crap to him.

**JOHN TENUTO:** It's a bit unfair to tack on the $45 million budget onto that film, because the film had a long gestation period, lots of starts and stops – all that was built into that budget. So the budget of all the aborted films and *Phase II* are wrapped into the budget of *Star Trek: The Motion Picture*. The film is actually more profitable than people think. Once adjusted for inflation, *Star Trek: The Motion Picture* is the most successful *Star Trek* film until *Star Trek* '09.

**MARC CUSHMAN:** *Star Trek: The Motion Picture* was extremely successful. It was number one at the box office for three months, the second most successful movie of 1980, only behind *Kramer vs. Kramer*. And if you add the box office from the first three weeks of its release in '79, it made more than *Kramer vs. Kramer*. It made a ton of money. *Star*

*Trek: The Motion Picture* was such a big hit, *Phase II* went away for that reason. They wanted to make more movies.

**LARRY NEMECEK (author, *Star Trek: The Next Generation Companion*, podcast host, *The Trek Files*):** I will always defend it. I will always say, "Gang, you cannot look at *The Motion Picture* as just a movie. It was also a sociological pop culture landmark. Nothing like that had ever been done before. Actors coming back, little-known TV actors coming back. There were politics aplenty involved in its making. If you want to critique it as a piece of cinema, fine, go ahead. That's what it is. But please know the context. This movie was truly historic."

**MARK A. ALTMAN:** Ultimately, whatever failings *The Motion Picture* has, it does so much more right. It has an epic scope and a visual poetry that none of the subsequent films had. You certainly can't argue that *The Wrath of Khan* is the most entertaining of the *Trek* films, but *The Motion Picture* captures a sense of wonder and an ennui amongst the characters (Kirk pining away for his true love, the Enterprise; Spock grappling with the emotions bubbling underneath the surface) that makes it the most thoughtful and in ways compelling of any *Star Trek* before or since. Like the first *Trek* pilot, which was lambasted by the network as being "too cerebral," you could argue that was the case with *The Motion Picture,* and so you get the action-packed space battles and revenge drama of the *Where No Man Has Gone Before*-like second re-pilot for the movie series, *Wrath of Khan.* This isn't to say it's not great, it is, but it's safer and certainly more of a throwback to the TV series than an attempt to go big or go home like the awe-inspiring *Motion Picture* with its sense of wonder and galactic scope.

**HAROLD LIVINGSTON:** I always liked the picture. I know a lot of people didn't. I don't know what they wanted, because I was never a *Star Trek* fan in the first place!

**WALTER KOENIG:** I bet Jon Povill $50 we'd never do another *Star Trek* movie. To my everlasting shame, I haven't seen him since. If I ever do, I owe him $50.

Star Trek: The Motion Picture *was seen as a pseudo-success by*

*Paramount. It made money, but it cost a lot of money. It got made, but the production was a hassle, and Paramount was not keen to work with Roddenberry again. Nevertheless, talks started on a proposed* Star Trek II *in 1980.*

**MARC CUSHMAN:** When *The Motion Picture* got mixed reviews and the budget was so high, Paramount used that as an excuse to take *Star Trek* away from Gene. He was the guy that kept creating problems for them, with the stories and things of that nature. So finally, they had a reason to take *Star Trek* away and gave him a new contract that said that he would be a very well-paid script consultant, creative consultant on the *Star Trek* movies. And they handed off *Star Trek* to Harve Bennett to produce.

**NICHOLAS MEYER (director/uncredited screenwriter, *Star Trek II: The Wrath of Khan*):** Memory is fallible. People would say to me, "Did you have much interaction with Gene Roddenberry during *The Wrath of Khan*?" And I would say, "No, I don't think so. I met him, but he was not involved with the production." Then later, when I went back to the University of Iowa, which is the repository of my papers, they showed me a lengthy correspondence, not entirely pleasant, between Roddenberry and myself. Memoranda written back and forth about how he didn't like the screenplay.

**ROBERT SALLIN:** Gene Roddenberry's position on *Star Trek II* was that of consultant. He did not have any responsibility for the production or for shaping the material. He acted as a consultant, and as the thing went on, various drafts came in, and people came on board, Gene would send us memos. They were by and large disregarded. We were under no obligation to listen to Gene, but he was certainly free to voice his thoughts to us, which he did. Gene was out of sync with what we were trying to do. He had his deal with Paramount, and I'm sure he was rewarded handsomely.

**JOHN TENUTO:** Paramount wants to go in a different direction [with *Star Trek II*]. The original thought is that perhaps they want to do *Star Trek II*, as a movie of the week. If you're thinking of TV-movie, or a TV science fiction at that time, really the two kings were Glen Larson

**131**

and Harve Bennett. Harve Bennett had produced the *Six Million Dollar Man*. Incredibly popular. He knew how to do a television show, he knew how to do a science fiction show, and he knew how to do a show on budget.

Harve Bennett is called into a meeting with Charlie Bluhdorn, Michael Eisner, and Barry Diller, who were the heads of Paramount at the time. They asked him for his honest opinion on *Star Trek: The Motion Picture*, and he said, "Well… boring." And they said, "Okay, can you make us a *Star Trek* movie for less than $45 million?" And he said, "Where I come from, I can make you several motion pictures for that amount." So he was given the responsibility of creating the sequel to *Star Trek: The Motion Picture*. The only rule he had to follow was it could not be a sequel to *Star Trek: The Motion Picture*. Which is ironic.

So he decides, if he can't do a sequel to a movie, he'll do a sequel to an episode. And he screens all 79 episodes, and the episode "Space Seed" sets itself up perfectly for a sequel when you have a Spock wondering what would happen a hundred years from now, what would be the result. This is around December 1980 when the decision is made.

*The original "Space Seed," which aired February 16, 1967, centered on the Enterprise encountering a group of genetically engineered super-humans, entombed in cryo-sleep from the Earth's 1990s. Their leader, Khan Noonien Singh (Ricardo Montalban), attempts to take the Enterprise, but Kirk overpowers him. Rather than punish Khan, however, Kirk leaves Khan and his group on an uninhabited planet, with Spock lamenting at the end, "It would be interesting, Captain, to return to that world in a hundred years and to learn what crop has sprung from the seed you planted today."*

**ROBERT SALLIN:** It was very early on when I came on board. Harve was tasked with working on the story and my job was to do everything else. That's the way it ended up. I was line producing, but it went beyond. To be candid, anybody who undertook *Star Trek* at that point in time had better be a director as well. We had no director, we barely had the beginnings of a script, and there were a lot of aspects I could sense that came to be reality. You've gotta know more than just

production.

Harve didn't tell me anything. He just said, "We're going to make this picture. It's going to be done under the eyes of the television division, as opposed to the feature division, because of the outrageous overruns of the first film." The intention, by moving it to the television division, is to produce another film for theatrical release, but with the constraints and discipline of people who worked in television. That's why Harve tapped me, because I worked in commercials; the constraints on budget in commercials make you a very disciplined filmmaker.

**MARK A. ALTMAN:** After *Star Trek: The Motion Picture,* which was a big expensive film that recouped its massive budget, the studio was wary of taking another chance on *Trek.* They felt they had dodged a bullet with its success despite its runaway budget. Despite Gene Roddenberry's attempts to entice them with his own script, the infamous Kirk meets JFK to stop the Klingons from destroying the future, the studio hired a trusted TV showrunner, Harve Bennett, to take over the *Trek* franchise. Wary of another runaway production, they produced the film under the aegis of the TV division and kept the production on a tight leash. Bennett, a TV vet, hired as his line producer Bob Sallin, a veteran of TV commercials. Together, they produced the most beloved *Trek* film of all, which paved the way for everything that was to come.

**JOHN TENUTO:** It was definitely considered a movie of the week. We have the memos where they talk about the shift. "What if we don't make this as a movie of the week? What if this isn't a movie that week? What if we make it a movie? How much does everyone's salary go up? How much does the set design cost us?" Initially, [the budget was] only $8 million. And then as they're seeing it come together and realizing it's looking pretty special, it's bumped up to $11 million. But still, that *Wrath of Khan* budget is nothing. *Empire Strikes Back*, produced several years before, had a budget of $30 million — three times the budget of *Wrath of Khan.*

**ROBERT SALLIN:** Harve, having come from a lifetime in television production, knew a lot of writers. They started to come in, we

started having these meetings, and the story started to evolve. I wasn't comfortable because, once again, where's the humanity in all this? We were getting these creatures that spouted fire and electricity from their fingertips. I was very concerned, and I've voiced my concerns privately to Harve. I had a sense that he was trying to find his way too, because he wasn't any more a *Star Trek* fan than I was. Harve screened all the previous episodes and it was in doing so that he came up with the idea of bringing Khan back into the picture. It was a great creative call. But as the story would develop, and writer after writer, nothing seemed to work. The clock was ticking, we're getting a lot of pressure, and we didn't have anything. The old studio time constraint was there. They preset the date for release without asking us if we could make the picture within that time frame.

*Prior to all this, the first screenwriter to take a stab at* Star Trek II *would be* Star Trek *creator Gene Roddenberry himself. His treatment for* Star Trek II *was a virtual greatest hits of* Trek *lore, with the Guardians of Forever, time travel, the Klingons aiding Russians in the 1960s, and Kirk needing to convince JFK that he must die so the future can be secured.*

*Roddenberry out and Harve Bennett in, Harve Bennett himself works up a one-page treatment for* Star Trek: War of the Generations, *which featured a rebellious Federation planet, Kirk's son leading the charge, and the reveal that the real puppet master was Kirk's old enemy Khan Noonien Singh. Kirk and his son must team up to defeat Khan. Even at this early stage, the themes of aging and the sins of the past are present — though so, too, are many other elements that would never see the light of a projector bulb.*

*Next, Harve Bennett hired screenwriter Jack B. Sowards (The Streets of San Francisco, Bonanza) to develop the treatment into a full script. While Bennett's original treatment had no mention of Spock, it was Sowards who brought the character in.*

**MARK A. ALTMAN:** They're not sure they're going to get Leonard Nimoy for *Star Trek II*. The way that Harve Bennett cagily engineers Leonard participating is, "We'll give you the death of a lifetime." And what actor is going to say no to a great death scene?

**LEONARD NIMOY:** When I was first approached to do *Star Trek II*, Harve Bennett, producer, in my home on a social evening, we were friends, we were planning to do this. I'd agreed to do this. Now they were doing the script. He said to me, "How'd you like to have a great death scene?" Interesting. I really believed this was going to be the final *Star Trek* movie. I thought they wanted to get one last squeeze out of this thing after the last one. [*The Motion Picture*] made money, but it didn't quite work as a *Star Trek* film. So I thought, "Well, if *Star Trek* is coming to an end, maybe Spock should die saving the ship and the crew, and go out in a blaze of glory?" So I said, "Let's look into that. Let's explore that."

*Spock's death in* Star Trek II *was leaked to the fanbase early by none other than Gene Roddenberry, hoping to validate his displeasure in the film's direction by garnering fan support.*

**ROBERT SALLIN:** When they came up with the idea of the Kobayashi Maru exercise, I think it was Nick's idea to have Spock "die" early in the picture, so that the audience who had been anticipating the worst would say, "Oh, that's all they meant by it. They're not really going to kill him."

*With the rest of the cast expected to return, Robert Sallin started to negotiate new contracts.*

**ROBERT SALLIN:** All of the talent negotiations had to start from scratch. There were no preexisting deals, no multiple picture deals. We had to approach each of the players, and that was an interesting experience. My recollection is that Bill wanted to do it, but was dubious because of his experience on the first film, as were all the other guys and Nichelle. Those negotiations had to be dealt with carefully. That leads me to Leonard, who had no interest in doing this again. As he told me, "Bob, I really don't want to put on the ears again." He was tired of it. I really did understand. Leonard was a good actor, and like so many creative people, he wanted to do something else. So we had to go back and convince him. The thing that did it was Sam Peeples and Harve coming up with the concept to kill Spock off. "Come back for this

one more time and you're free." I thought that was brilliant. I thought, "Boy, that's a gutsy one to do in face of what the fans are going to think." I was aware of the energy and the fandom, but it's a great story. Let's go for it.

As you're well aware, the brouhaha that ensued was monumental. I'm just trying to produce my first motion picture, and I get death threats. Once we decided this is what we were going to do, we decided to put a lid on this. Based on my Air Force experience, we got to treat this with top security. So I told my assistant Deborah, "Let's code these scripts." Each script was numbered and had a different element in it, so that if anybody referenced that script or something in it, we could then trace it based on what the number was. A lot of good it did us. Based on what I was told, it was Gene who leaked it. He was upset about not being included. He didn't like the direction we were going in at multiple levels. This wasn't his kind of film. So the word got out and the next thing I know, on my home telephone answering machine, I got a message that says, "You kill Spock, and we'll kill you." This is really silly, but I served in the Marine Corps and the Air Force, I've never had my life in danger, but producing a *Star Trek* picture and my life is being threatened. I had a wife and two little kids, I had to get enhanced security around my home. Fortunately, nothing came of it.

**WALTER KOENIG:** I got the first draft of the script before it was released to anybody else. Spock dies in the second act? You gotta be kidding me. You can't kill off one of the icons of *Star Trek* in the second act, it's gotta be the climax. So I called up Harve Bennett, who didn't know me, and said "Mr. Bennett. I want to talk to you." "I don't talk to actors." "I'm not calling you about being an actor in your film. I'm calling you about an egregious structural mistake that has been made and it has to be rectified. You can't kill Spock in the second act. You must've been told this already." He said, "No," which I find almost as improbable as science fiction itself. He took it to heart and rewrote it, and then called me and asked me to do a Trekkie run on the script to see what other inconsistencies there might be with what we did in the series. I found little things; they took those out and changed them, and the script was terrific.

*Despite having secured Leonard Nimoy for the role of Spock early in 1981, and pre-production going forward, the script was not in the best of shape. Samuel A. Peeples (yes, the same Samuel A. Peeples who had written* Where No Man Has Gone Before *fifteen years before) was brought in to write a new script, using some of the same themes, but with a new set of villains often referred to unofficially as "The Wonder Twins."*

**MARK A. ALTMAN:** People don't realize how close *Star Trek II* came to not happening. Harve Bennett had been brought in to develop it. He had developed a couple of scripts. One of them, Khan had superpowers and had telepathic powers and could create illusions. There was another one where Khan was gone and there were these two twin aliens that Sam Peeples had written. If you go through the history of *Star Trek II* drafts, they were all awful.

*In September of 1981, work began on the film's special effects — even though neither director nor finalized script had been secured. Nevertheless, preliminary effects shots could be completed, and models / design work could commence. Thankfully, between 1978 and 1981, the special effects landscape of Hollywood had changed. The filmmaking paradigm where George Lucas could not find a visual effects house for* Star Wars *in the mid-seventies, had now become saturated with science fiction films and action films. Harve Bennett and Robert Sallin now had options. Rather than taking a gamble with a company that had never worked on a motion picture before, the decision was made to go with a visual effects company that could be relied upon to turn in material on time.*

*By 1981, Paramount had formed a healthy relationship with Industrial Light & Magic — the George Lucas-formed company that helmed the special effects of the* Star Wars *trilogy, as well as* Raiders of the Lost Ark *(1981), and* Dragonslayer *(1981). Due to Doug Trumbull's commitments to direct his own feature film,* Brainstorm *(1983), Robert Sallin instead hired ILM to produce the special effects. Work began in earnest, with the June 1982 release date looming.*

**KEN RALSTON (special visual effects supervisor, *Star Trek II: The Wrath of Khan*):** *Khan* was done with a smaller budget than a lot of films. Especially since things were starting to ramp up in the

sci-fi world with what George Lucas had caused throughout the world. But that also is a great challenge and it's a great discipline to work within the budget you're given. The budget on *Khan* was not as big as the budget on *Empire* or something like that.

*As the film was a sequel, many of the models and visuals were able to be reused from* The Motion Picture, *helping to keep the film's budget down. A similar tactic was done on the production design – with a subtle redress of* The Motion Picture*'s bridge set used not only for the bridge for the Enterprise, but also Khan's absconded vessel, the Reliant, and the bridge for the simulator on the Kobayashi Maru scene.*

**KEN RALSTON:** My first thought about *Khan* was definitely, "I hope it is not as dull as the first movie." And the good news was as soon as we started talking to Nick Meyer, Harve Bennett and everyone, and then Bob Sallin, who was on the show, they definitely wanted to capture the TV show and not the feature film that had come out prior to that. And I was all for that. It's like, "Great. We can get kind of down and dirty with it and get more energy into some of the sequences and have some fun with it."

**JOHN TENUTO:** One of the big differences between *Star Wars* and *Star Trek* is in the way ships move. And the way we, as an audience, get to enjoy these incredibly imaginative designs. That's because *Star Trek* is meant to be a riff on the military trappings of the U.S. Navy. You have captains, first officers, sickbays – these are all U.S. military terms. So ships needed to move like a ship would move on the ocean. They would not be doing barrel rolls, spinning, transverse physics because of its size and purpose.

**KEN RALSTON:** When I first got on *Khan*, the first thing to decide was — because Jim Veilleux was also on the movie — can we comfortably split this up so we don't kill each other? So there's little or no overlap on what each of us is doing, except for the continuity of the look of the movie. And that seemed to work out well with that film. I got all the action stuff, the crazy stuff with the Reliant attacking the Enterprise or the Nebula. Jim got more of the establishing shots.

We had the Enterprise [from the last movie] coming in from Doug Trumbull. Which was a gorgeous model – the exterior was so subtle with beautiful little iridescent squares and things to give the impression of detailed panels and items like that. But he shot it in a technique which I'll call front and back light. It wasn't blue screen. And it gave him an opportunity to light it in a way where it really showed off all that stuff. One of the decisions I had to make, which was not easy because I'm a huge miniature guy. I love modelmakers. The ship came up, we're shooting it with blue screen. We got to move through this stuff. When you turn a blue screen on behind the Enterprise, that model disappeared because the surface was so shiny. So I had to spray it down with matte spray. Sorry. It was painful actually to have to do that, but we couldn't get through it any other way.

*One of the most iconic space battles in* Star Trek *history comes from the battle between the Enterprise and the Reliant in a visually striking nebula. The nebula was such a success, the same shots of the nebula were repurposed in subsequent* Star Trek *television series – most notably in* The Next Generation *as the Enterprise-D hid from the Borg in "The Best of Both Worlds."*

**KEN RALSTON:** The cloud tank is basically a large square metal container with glass panels on each side and on the bottom; it's open at the top. And it's filled with water. Warm water up to about three-quarters of the way up or wherever you wanted it, then insanely you would lay a piece of plastic on it, very gently. Then you would gently pour in cold water and you would create an inversion layer. You would slip the plastic out. Oh my God. The reason you have an inversion layer in the cloud tank is in some shots when you put the material for the cloud in there, which was a mixture of latex and like an opaque, white paint, it takes these forms and shapes it moves around, but when it hits it flattens out and it starts to give almost a look of thunderheads or clouds that are spreading on. And there's a nice, fake sense of a scale to it when you do that.

*ILM's work was not just for the fun space battles. There was a lot of… waxing away too.*

**KEN RALSTON:** I sculpted a giant ear for a shot of the eel [going into Chekov's brain]. The second sized eel, first we had the little one. Then there was one about four inches long. And then I did the bigger one, which I shot in our sandy sort of Khan tank, but that was all back at ILM. [A thing that made ILM different] — if you could do different jobs, you could do it. And I found that so great creatively where I'm doing the nebula, I'm designing the ship shots, I'm shooting the ship, I'm lighting the ship, and then I can go sculpt the stupid ear, hoping it'll work. Then cast it, and foam, painted up, put the fake hair on this thing. Of course, I had a lot of help, but still, I was still in there doing a lot of it. And that was a great way to work. It was really exciting.

*While the special effects weren't meant to reinvent the wheel, as was hoped with* The Motion Picture, *many remember the Enterprise/Reliant nebula fight, and the other effects shots in the movie, better than those of any other* Star Trek *film.*

**KEN RALSTON:** Harve Bennett and I did work a fair amount together. Harve was a busy guy and he really did have his hands in all the pieces of that project. He was very much involved with the visual effects. But he was a great guy, I really liked him a lot. Same with Bob Sallin. What I loved about them and Nick Meyer the most was something you don't get on a movie, especially for my first supervising gig: As crazy as it sounds, I was left alone to do my job. There wasn't a lot of micromanaging involved, if any. It made it a very creative and fun experience.

*While special effects work continued, and a release date was set, an elephant still loomed in the room, ready to squash the project where it sat. There was no script, there was no director. Still unsatisfied with the previously submitted drafts, and the clock ticking on the shoot date, Bennett and producer Robert Sallin took the most important meeting for the film, and possibly for* Star Trek *history.*

**MARK A. ALTMAN:** It was Karen Moore who was an executive at Paramount who suggested, "Hey, my friend Nick Meyer is looking for a job." And they figure, "Okay, smart, doesn't know much about *Star Trek*, loves Sherlock Holmes, might be a good fit." They bring in Nick

Meyer, and Nick says, "Send me all the scripts." Harve says, "No…
they're all terrible…" What Harve doesn't tell him is that Paramount
is about to pull the plug on *Star Trek II* if they can't come up with a
shootable script. There's a ticking clock, Nick doesn't realize there's a
ticking clock.

**ROBERT SALLIN:** One of the many tasks that I had was to find
a director. There was a director strike looming, so I decided to attack it
at two levels: maybe there won't be a strike, so I'll still look at Directors
Guild members as candidates, but also I would look at some directors
from overseas. I was very keen on European directors, particularly the
British. I made up a list of 30 or 40 people who could shoot under
the constraints of what I anticipated was going to be a low budget.
The way I intended to shoot this was like a number of commercials all
strung together. I wanted the same financial discipline to be exercised.
What I found out was a lot of people didn't want to do *Star Trek*, a
sequel, or sci-fi. And some directors just weren't available. I couldn't
believe that in this town, I couldn't find somebody that would fit all
the parameters that I had set.

Here's a story. At the Directors Guild screening, I had just seen *Char-
iots of Fire* and Hugh Hudson, who directed that film. I thought the
film was an absolutely stunning piece of storytelling, so I told some of
the senior executives at Paramount that I was thinking of approaching
Hugh Hudson. And they said, "Who's he?" So we had a screening in
the Paramount screening room. We ran *Chariots of Fire*, the lights come
up, and all the heads swiveled as one to me and gave me the look, "Are
you out of your mind? What are you thinking of?" I thought, "Have
I lost my touch? Do I not know what I'm doing?" I said, "The guy is
great." They just went out shaking their heads. They did not like the
film, and did not see him as a viable candidate.

So at that point, Karen Moore, who was a creative executive at
Paramount and who was friendly with my assistant Deborah, told
her about Nick Meyer, and Deborah came to me. I hadn't thought of
him to be honest, because he had done one feature, but he had done
the book *Seven Per-Cent Solution*, which I thought was wonderful,

very imaginative, and very creative. But that was it. He didn't have the experience of doing weekly television, which was what I kind of was looking for, because the multiple setups, pages per day, and so on. But a creative guy and interesting. I called him, we chatted, and I sent the script over that we had at that time. He had even greater reservations than I did. But we talked, I said, "Look, it's a space opera," and he got that right away. So we had a meeting with Harve, and when we finished that meeting, Harve turned to me and said, "I don't know. He's going to be trouble." I said, "I don't know what you're talking about. I don't care. He's smart. He's talented. He gets it. And we don't have anybody else. Let's get him." So we signed him, and that's how we got Nick. It was his uncredited complete page one rewrite that saved this film. If he hadn't done that, the film would have been a disaster. It would have been a failure, probably worse than the first one.

**NICHOLAS MEYER:** I'm in Hollywood trying to make it in the movie business, and a friend of mine, who is an executive at Paramount, brought me in to meet Harve Bennett. They showed me *Star Trek: The Motion Picture*, and Harve explained that he was in charge of making the next *Star Trek* movie. Second one. And I liked Harve quite a lot. I watched the movie and I still wasn't getting it, but it did occur to me that *Star Trek* reminded me of something that I really did like, which was a series of novels that I'd read when I was about 13 years old, about someone called Captain Horatio Hornblower. He was a captain in the Royal Navy during the Napoleonic Wars. And I thought, "Gosh, this *Star Trek* thing is sort of like Hornblower in outer space." Which could be cool.

**MARK A. ALTMAN:** You talk about the man that saved the franchise – if there's one man who saved the franchise, it really was Nick Meyer. Because *Star Trek II* was this close to getting canned. And the studio probably would have never gone back.

**NICHOLAS MEYER:** How people create is really quite bizarre. Harve Bennett said, "Would you like to direct this movie? Draft five of the script is coming in." I said, "Great. Send it to me." And then looking up and it's weeks later and I say, "What happened to it?" And

he said, "I don't like it. I'm not sending it." And I said, "Well, what about draft four?" And he goes, "No, no, no, you don't understand. There are just five distinct attempts to get a second *Star Trek* movie." And I said, "Well, send them all." So I read them. And then I say to him and Robert Sallin, his producing partner, "I have an idea." I had a legal pad and I said, "Why don't we make a list? Just the three of us right now, all the things we like in these five scripts could be a major plot, could be a subplot, could be a sequence, could be a scene, could be a character, could be a line of dialogue. I don't care. And then I'll write a screenplay. I will try to cobble this together and make a new movie that incorporates as much of this as possible." I'm shortening this story because I actually like you. They say, "Well, the problem is that if we don't have a draft of a script in 12 days, ILM say they cannot deliver the special effects shots in time for the June opening." At which point I go, "What June opening?" Cause I only directed one movie and they said, "Oh yeah, we booked the thing into 600 theaters or something." And I go, "You booked it into the theaters, then there's no movie?!" He goes, "Yeah, well, that's how it works."

By this point, I was really jazzed to do a space opera. I go, "Okay, I can do it in twelve days, but we have to start now." And they don't look happy, and they say, "We couldn't even make your deal in twelve days." And that's when I made my mistake, and said, "Forget about the deal, forget about the credit – if we don't do this right now, there's isn't going to be any movie."

In trying to tell you about the twelve days – I don't remember the twelve damn days. I was in a trance. Whether I was taking dictation from God, whether I was inspired, that's for other people to debate or argue about. I was very busy, and my back hurt. Maybe I was think-ing about Oedipus and the glasses when Kirk puts them on. I don't know. I do know that as I worked, certain themes began to jump out at me. It was like fiddling with a Rubik's cube, putting together these different things, taking the simulator sequence, which was from some script three. And it was on page 50 and moving into the beginning and sticking Spock in it. And all those things that you're frantically moving around. But along the way, certain themes are jumping out at you. And

you start to realize, I'm writing a movie about friendship, old age, and death, and you start leaning into those themes. This is a cast that is getting older, so rather than pretending that they're not, go ahead and face it head-on and give them glasses.

**ROBERT SALLIN:** My general feeling is that we had concerns about getting him money to do the rewrite, because it wasn't in the budget, and that our concern was that they're going to drag their feet on this upstairs in the administration building. I said "I don't know if I can get you a deal for writing." Nick's attitude was "That's okay." I was really dumbstruck, because he said "I'll do it, and I won't take credit." Later he told me his agent told him he was crazy. He was the one that asked for all the previous drafts of the script, and in 12 days he delivered what was ultimately the final shooting script. It was terrific. I'll give Nick all the credit in that regard, that his rewrite made the picture possible.

**NICHOLAS MEYER:** I knew William Shatner socially, from before I had ever had anything to do with *Star Trek*. So we had a glancing acquaintance. My meeting with him was a traumatic meeting because I was up at ILM discussing drawings and effect shots and whatever, and I got a call from Harve Bennett. He said, "We have a problem." I said, "What's the problem?" He said, "Bill Shatner hates the script." "What's the hate? Everybody likes this script. Everybody says they liked this script." He said, "Well, we'll have a meeting and we'll see what happens." And I think again, only my second movie, "Oh, that's it, we're done, we're toast."

So the following, whatever it is when I'm back in Los Angeles, Shatner comes into Harve Bennett's office and says, "This is a disaster." All I remember about the meeting is that I had to keep getting up and going to pee because I didn't know where to put either my embarrassment or my rage or whatever. Finally, Shatner leaves, and I'm sitting there totally finished. Harve, who's done *The Mod Squad* and *Six Million Dollar Man* — he'd been around, which I had not — figured out that Shatner basically always wanted to be the first one through the door. He wanted to be the leading man. So I was learning how to write for

a star. Once Harve explained the problem, I went home and fixed it in eight hours.

Bill was understandably protective over the character he helped create, Captain Kirk. He was very willing to investigate the whole dilemma of a man growing older. Of a man sitting behind a desk when he wanted to be flying. "I'm pining for youth that I feel is rightfully mine." And this is one of Bill's best performances ever. What he said, "I don't mind playing older, I'd just prefer if you don't specify what his age is."

**LEONARD NIMOY:** One of the most refreshing moments in my career, in an office with Nick Meyer and Harve Bennett. I was in Israel working on a project for Harve Bennett – a movie called *The Woman Called Golda*, which I acted in — when I got the script for *Star Trek II*. I didn't like it. I thought it was troubled. I was coming back to the United States for about an eight- or nine-day break from Israel, and Harve Bennett asked me to come to his office, where I met Nicholas Meyer for the first time. Nicholas said, "I understand you have problems with the script." And I said, "I do. Here's what I think," A, B, C and D. He said, "I agree with you." "Really?" He said, "I'm going to work on it. When are you leaving to go back to Israel? I'll have the script for you to read on the plane." Working in television, you never hear that. I'll never forget that. I got the script, and the whole thing started to sing.

**NICHOLAS MEYER:** What was true of Leonard and what was true of the rest of the cast was their extraordinary generosity. These were people who were used to working with a different director every week, all the time they were doing the shows. And the fact that I was a *Star Trek* newbie was not, per se, something that troubled them. They were welcoming.

The issues that I had with Leonard, was not apparent when we met. They were apparent when he saw the set for his stateroom. He wasn't happy and thought things about it were cheesy. And he was right. When we did *Star Trek VI*, I made sure his stateroom aboard the

**145**

Enterprise was not cheesy. He was a thorough professional. With a great eye for and attention to detail. I never had to tell Leonard very much. He loved the way I wrote [Spock's dialogue.] He was over the moon about that.

*Principal photography began in earnest on November 9, 1981, for a scheduled twelve-week shoot. The first scene to be shot took place in Khan's makeshift encampment on Ceti Alpha V between Chekov, Captain Terrell, and a lengthy monologue by Khan (Ricardo Montalban). Montalban, a veteran actor with a credits list longer than most people's in Hollywood, had, by the time of 1981, become recognizable worldwide for his role as the suave, gentile resort owner, Mr. Roarke, in the lighthearted drama* Fantasy Island *(1977–1984). A far cry away from the menacing demeanor needed for Khan.*

**NICHOLAS MEYER:** I once asked Montalban why he did *Fantasy Island*. And he said, "My kid needed dental work."

**KEN RALSTON:** I think the first scene I was involved with was the introduction of Khan, Ricardo Montalban — who was, by the way, such a great guy. What a gentleman. I went down and the first thing that happened was, as they were getting ready to begin rehearsal, this radio-controlled little tractor came in, and there was an inflatable character and somebody stuck the face of Hervé Villechaize [costar with Montalban on *Fantasy Island*] on it. And it came rolling into the set and Montalban started cracking up and it was hilarious. It was a nice way to bring him into the show.

**MARY JO TENUTO (***Star Trek*** historian, startreknews.net):** Both Nicholas Meyer and Robert Fletcher were instrumental in getting Ricardo Montalban to return to the role of Khan. It had been fifteen years since Ricardo Montalban had played Khan in "Space Seed," and he was apprehensive about stepping back into the role and finding Khan's voice. But Montalban really credits Robert Fletcher's costume with helping him find that voice.

**ROBERT SALLIN:** I have to be honest with you regarding Ricardo Montalban: the fact that he had been so successful in *Fantasy*

*Island* and other things really was not a consideration. All I thought about was here's an established character, rich in dimension, and we could certainly use something rich in dimension because the script does not have it where we are today. I was a great fan of Ricardo. I had seen him in the early days, back when he was a major star, and just thought that he was a wonderful guy. I don't recall us ever considering anybody else but Ricardo for that role. We were so enamored of the idea that we just said, "We're going for it, and whatever it takes to get him, that's what we're going to do." He wanted to do it, that was the kicker. It couldn't have been better.

**NICHOLAS MEYER:** We were doing the Cargo Bay sequence where we're introduced to Khan, and I think there was like six pages of more or less a monologue as to why he was enraged with Kirk for having abandoned him. Montalban, who had the longest resume of anyone we were working with, and who was by any measure a truly great actor, certainly the best of this group of people, he came on in full outfit – and yes that's his real chest – and I had this idea, based on the fact that I came out of a theater background: Wouldn't there be a way for him to do the whole thing in one go? So he could build up his steam, and etc., I think there were 23 marks he needed to hit. And as I say, we had met, we had lunch, I had given him a copy of *Moby Dick*, but because of his TV show schedule, there was no rehearsal time. He was letter perfect. He had memorized everything. I gave him these 23 marks to hit, he hit every one of them. But he screamed the whole thing at the top of his lungs. I really didn't know what to do, he had all these credits, I was sort of awed by him. This was the second movie I'd ever directed. Is he going to yell at me? And I said, "Let's go into your trailer and have a little conversation as they're lighting things up." He was very courteous. We're sitting there in his Winnebago or whatever, and I say, "You know, Laurence Olivier once said, 'An actor should never show the audience his top. Because once you show them your top, they know you have no place else to go.' And besides, the thing about a crazy person is, a crazy person never really has to raise their voice. They're just terrifying all by themselves. You'll never know when they'll go berserk." And he leans back and goes, "Ohhh, you're going to direct me. That's good. I need direction. I don't know what I'm doing

up there."

*Beginning with the first scene, so began one of the great unsolved mysteries of Star Trek lore — the mystery of Khan's baby. The rumors swirled as magazine articles referenced Nicholas Meyer directing a scene with "Khan's baby," while early concept art also referenced children. When the movie arrived in theaters — no kids were present. Daydreaming Trek fans may presume the children of Khan reference an abandoned sub-plot — perhaps Khan was using the Genesis weapon as a way of resurrecting his lost love? The children to be a vessel for that nefarious scheme. Unfortunately, the answer to this riddle held no grand reveal.*

**MARY JO TENUTO:** We first see a picture of Nicholas Meyer with a little baby crawling on the transporter in Starblazer magazine in 1982, in an article entitled *The Man Who Saved Star Trek*. Nicholas Meyer and the baby, and the caption reads "Nicholas Meyer directs Khan's baby son." There's nothing in the article about a baby. This was a mystery that we wanted to solve. So we went straight to the source. We went to Nicholas Meyer's papers, which are at the University of Iowa, and found a number of interesting things. There is a call sheet calling for two children, so they needed two babies to work with and a social worker.

In one draft of the script, you have Chekov and Captain Terrell when they beamed down to the planets, they're exploring in a cargo container and we see a baby's playpen. Then he'll see a baby's face and hear a baby's gurgle is startled by that. Now that part was filmed. Then we would not see the baby again in the film until the end, when Khan is ready to detonate the Genesis device. The Genesis device would be in the transporter room and the baby would be attracted to the lights on the Genesis device. The baby was supposed to crawl over to the device. Khan would detonate it, blowing up the baby and the ship. The idea here was, first of all, having the baby would show that Khan's people were thriving, that they were able to live on the harsh conditions of the planet, and they were able to procreate — so the baby represented the future of Khan's people.

There were two problems with the scene. The first one was that

they were not able to get any usable footage of that baby because the baby was too scared to get very close. There are images that we found of Craig Denault trying to get the baby acclimated, bringing the baby close to the device and then trying to leave the baby there to step away. The baby starts crying. Then they also thought, the real problem here is this is too dark for *Star Trek*. To have a baby in essence blow up along with Khan and the ship, is too dark for *Star Trek*.

**NICHOLAS MEYER:** There were two scenes involving the baby, as I recall. One was when Chekov and Terrell were looking around this abandoned cargo bay and they hear a baby. And the other, which we probably shot the same day, was the baby and the Genesis device. Once we decided that the babies in the empty cargo bay didn't work, there was no point putting it next to the Genesis device, because the baby would have come out of nowhere. No setup. That's my recollection.

*Accommodating Ricardo Montalban's* Fantasy Island *filming schedule was as such, that he never crossed paths with either William Shatner or Leonard Nimoy – a fact that may surprise the casual filmgoer, the hero and villain never meet face to face in the film.*

**LEONARD NIMOY:** Montalban was a charismatic actor. Great presence on screen. Strength, power, sexuality emanated from him. Powerful to watch. I never met the man. Never met him. Never shook his hand. He was working on days when I was not there, and vice versa. Never met. But he really gave a wonderful performance. Magical, imaginative, creative performance as Khan in *Star Trek II*. He looked great. And that was his chest that people thought had been built up with makeup. That was him. He was great.

**JOHN TENUTO:** There are a few things you don't realize until you see it several times. You never realized that Kirk and Khan are never in the same room together. They are only on the view screen together, which is amazing considering the relationship the two have, and the fact that they weren't necessarily always acting opposite to each other. Although originally in the script, there was a one-on-one fight with Kirk and Khan, using regular swords in the Genesis cave. But

that was decided it was a little too… a low-end version of a lightsaber battle, and it was decided that would be forgotten. Also, that Khan was defeating Kirk too many times, but letting him go.

You may not realize when you watch the film the first time is that almost 65 percent of the film is the same exact set. It's the Enterprise. [Both the Reliant and the Enterprise are the same set.] But through Gayne Rescher's cinematography, through lighting, through clever set tricks, by changing the color of the upholstery [it looks different].

*In addition to Ricardo Montalban as Khan, newcomers to the series, Kirstie Alley and Merritt Butrick joined the cast as Lt. Saavik and Kirk's son, David.*

**NICHOLAS MEYER:** [Kirstie Alley] was just off the boat from Wichita, Kansas, as I recall. And she had these very light-colored eyes, which reminded me of Meg Foster's at the time. From the time she was a little girl, she was fixated on Spock. Saavik doesn't have any humor at all. It's not a Vulcan trait. Kirstie has a lot of humor. I think it took somebody with a lot of humor to put over that particular brand of humorlessness.

*A major change was instigated by Meyer in the redesign of the costumes, which would stay a fixture for the remaining Kirk/Spock era films, and a marker of the Enterprise-A through Enterprise-C time period of Federation history.*

**MARY JO TENUTO:** Nicholas Meyer felt that the costumes and *Star Trek: The Motion Picture* were visually uninteresting. So he asked Robert Fletcher, who does the costumes for *Star Trek I, II, III,* and *IV* to give him two things. The first request is that he wants the uniforms to look nautical. His second, he wants Robert Fletcher to draw inspiration from the film *Prisoner of Zenda.* Robert Fletcher, who is a three-time Tony nominee, gives them those two things. When you look at the *Prisoner of Zenda,* the prisoner Zenda has the high collars, the ribs collars, the wide flaps, the open flaps, and the open flap on the chest. Nicholas Meyer liked that because it frames the face and it gives a color contrast.

**NICHOLAS MEYER:** I may have talked in general terms about Horatio Hornblower, and the notion, from my standpoint – and I came to this as a complete outsider to *Star Trek* – of ships, of submarines, and destroyers, and that I wanted this to be nautical. One of Roddenberry's rules or observations is that Starfleet was not a military organization – that it sort of resembled the Coast Guard. Which is a sort of military organization. And I thought, "Who are we kidding here?" And so I went all out to make them Navy.

*With the first week of filming complete, producer Robert Sallin began to worry the film may be destined to repeat the mistakes of* The Motion Picture.

**ROBERT SALLIN:** I made one of my fatal errors on the picture – and I've apologized to Nick for it too. Mind you, it's my first film, and I come from the highly disciplined world of commercials. I know how to shoot, I know how to shoot on time, everything, because I've done it. We started production, and at the end of the first three days, Nick was a week behind. And I panicked. Pure and simple. I didn't know where this would go – would this extend logarithmically, beyond the moon? I didn't know what to do. I called Harve, Harve was in London, and he said, "Do whatever you think." Well, that's helpful… I didn't know what to do. Nick's attitude was always to keep me at a distance. So I went to management, and I said here's what's going on. "I don't want to be the director, but as a director, I think this could be a big problem. We should replace him." Michael Eisner said, "No. We're not going to do that." I said, "Why?" He said, "Because then nobody would want to work at Paramount."

**NICHOLAS MEYER:** I wasn't aware of it until the movie was over, when my production manager, Austin Jewell, came to me and said, "This man is not your friend." Referring to Robert Sallin. "He tried to get you fired the first week of filming." I hadn't known anything about it. They showed footage to [Michael] Eisner, whose comment was, "I only wish *Grease* looked this good." That's how my job got saved.

*While the filming progressed well and even on schedule, Spock's death scene loomed in the final days of shooting. On top of this, the cast and crew were starting to get the feeling they had something more on their hands with* Star Trek II *than just a final money grab for a failing franchise. The film that had originally been relegated to the Paramount television division was now potentially going to be a smash hit.*

**LEONARD NIMOY:** During the making of the movie, I thought, "This movie is going to work." I liked Nick Meyer's script. I could see the work being done was *Star Trek.* We were doing *Star Trek.* And I began to be concerned that maybe I was making a mistake. And on the day we went to shoot Spock's death scene, where McCoy's unconscious, Scotty's unconscious, and Spock's about to go into the chamber and die saving the ship, Harve came to me on the set. I was really tense, because I thought I'd made a mistake. Harve came to me and said, "What can you give us that might be a thread for the future for Spock in *Star Trek?*" It took a moment, and I said, "I can do a mind-meld on DeForest Kelley, who's lying there unconscious, and say something like, 'Remember.'" And he said, "Let's do that." But even watching that movie at screenings, I was always very touched by what happened in that sequence. I thought it was a beautifully written death scene. And it really worked in the film. I have people still today who write me in and say, "every time I still see that picture for the fifth, 10th time, I still cry."

**ROBERT SALLIN:** We didn't know we were going to bring him back. We were doing it strictly from a story and an audience perspective. Did it hurt the story? No. I don't think it hurt the story one bit. It didn't detract in any way from the death, which was everything that we had hoped for. Bill and Leonard really just nailed that. There was sobbing on the set.

**NICHOLAS MEYER:** By the time it came to film Spock's death, first of all, I think Leonard was having jittery feelings about (A) "Do I really want to end this all." And (B) If this really is it, he was feeling really jittery and testy and nervous about it. Now, Leonard Nimoy said in one of his memoirs, that I came to the set on the day of filming that

scene dressed as Sherlock Holmes, and that infuriated him. I've never dressed as Sherlock Holmes in my life. Remember, memory comes into play here. So what could he be remembering? I said earlier in this exhaustive interview that I am an opera fan. And when we were shooting *Star Trek II*, the New York City Opera, as it then existed, would come out here every year for three weeks. I would go every night. We shot *Star Trek II* on soundstages, so you could expect to be done by a certain time, and make it to the opera. And you can see the photograph of me sitting on a crane, looking like an old-time movie director, cause I'm wearing a suit. That's what he sort of misremembered. Anyway, he was sort of jittery and, and testy, because of what we were shooting that day.

I didn't really understand the significance to so many people of what was going on while we were shooting this until I turn around and see my cinematographer is crying. The prop guy is crying. And I'm just making a movie. Because I didn't come from all that.

**ROBERT SALLIN:** Once we knew that the Spock was going to go, we had planned this very elaborate funeral scene, with the whole crew standing around, Bill Shatner saying his eulogy, and so on. Harve said, "What do you think if we had Scotty play the bagpipes and play Amazing Grace?" I thought that was a terrific idea. You know how moving that piece of music is, it's a very touching thing, and I thought that it would just enrich that moment like nothing else. I said, "That's a brilliant idea. Let's do it." So we shot it. Now I'm in Kansas City for one of the very first test screenings. I'm sitting in the audience, and Spock dies. The sobbing in the theater, and the handkerchiefs, there was just so much sadness and emotions. It was just overwhelmed. Then Scotty started playing the bagpipes, and the audience laughed. I was stunned, all the color drained out of my face. I said, "I don't get it. I don't understand what happened here." Not only did it happen at the first screening, but it happened at the second screening. I said, "I don't care. It's too great. I don't understand it, but that's staying in."

*Principal photography concluded on what was then titled,* The Undiscovered Country, *and would subsequently be retitled* The Vengeance of Khan

*on January 29, 1982.*

**NICHOLAS MEYER:** Michael Eisner, who was running production at the time, and Jeffrey Katzenberg, saw a rough cut of the movie, and they loved the movie. And they had a couple of notes.

*One such note was to include a scene that would set up a potential sequel. Despite protests by Meyer, a shot of Spock's sarcophagus on the Genesis planet lying open and empty was shot.*

**NICHOLAS MEYER:** To the degree that I have any gift at all. It's a gift for telling stories. That is it. I did not think about franchise. I did not think about sequels. I did not think about anything except the one movie that I was tasked with bringing into being. I just devoted all my energy to making the best movie, the best story. The movie was being finished and people were seeing it or seeing rough cuts of bins — and then I start hearing about, "Oh, maybe there's more." I think Leonard was wondering whether he should have died. Because originally I think that the condition he stipulated for doing the movie was that he'd be given a great death scene. And then when he saw the death scene and the rest of it… "Hang on, not so fast."

*The post-production on the film required a fast turnaround, as the film was scheduled to be released on June 4, 1982.*

**NICHOLAS MEYER:** We didn't have anything like the amount of money that Jerry Goldsmith gets to write a score, so Jerry Goldsmith was out. So we just started listening to music. Back then there were these things called cassettes and composers would send in samples. They all sounded genetically similar – music sounded the same. But James Horner had sent in a tape, and I really liked it. I met him and I liked him. Thought I could communicate with him. Which is tricky because usually when directors and composers are talking, it's a different language.

*The film's title, which had gone through many changes over the whirlwind production, was finally settled on,* The Wrath of Khan, *in April of 1982, at*

*the request of none other than George Lucas.*

**ROBERT SALLIN:** The two things I recall the most where Nick and I disagreed on was the title. Nick wanted to call it *The Undiscovered Country*, which he ultimately got to use in a subsequent film, but I didn't like it. It was an intellectual concept, and I wanted something that had a little more stuff. We had always wanted to call it *Star Trek: The Revenge of Khan*. That got pushed aside because George Lucas called and said, "I'd rather you didn't use the word revenge. I'm planning to use it in the title of one of my films." We went "Sure, George, whatever you say." So that's how *Wrath* came about. But the more significant aspect of the script where we had disagreement was the ending. Nick was adamant that he did not want to have any ending scenes where we go to the Genesis planet and show the sarcophagus of Spock. Harve and I felt very strongly that we needed to plant in the audiences' minds the maybe idea, that just maybe idea. We also did that within the script. During the death scene in the engine room, he puts his hand up and says to Bones "Remember me." These were just little things, but Nick was really against it, but I was absolutely insistent that we do it. I designed that last sequence, storyboarded it, and I directed it with ILM up in Golden Gate Park.

Star Trek: The Wrath of Khan *premiered on June 4, 1982, to largely positive reviews from both critics and audiences alike. Janet Maslin of the New York Times proclaimed, "Now this is more like it: after the colossal, big-budget bore that was* Star Trek: The Motion Picture, *here comes a sequel that's worth its salt. The second* Star Trek *movie is swift, droll and adventurous, not to mention appealingly gadget-happy. It's everything the first one should have been and wasn't."*

**MARK A. ALTMAN:** If *The Motion Picture* stood in the shadow of *2001*, Khan was clearly the first of the *Star Trek* pictures to feel the influence of *Star Wars* and delighted fans and audiences alike in the summer of 1982, one of the greatest years for genre fans ever, with the release of *Poltergeist* (also on June 4), *Conan the Barbarian, The Thing, E.T., Blade Runner, Tron, Dark Crystal, Cat People,* and so much more. Without the success of *Star Trek II*, which ushered in a new era of *Star*

*Trek*, there would be no *Next Generation*, no *Deep Space Nine* and possibly not even a CBS/Paramount streaming service. Forty years later it continues to cast a large shadow over everything *Star Trek,* with studio executives still asking would-be *Trek* filmmakers, "Who's our Khan in this?"

**NICHOLAS MEYER:** The reason why my *Star Trek* may be so violent compared to others is that I haven't seen the others, but I have seen and love the plays of Shakespeare. And the plays of Shakespeare are exceedingly violent.

**ROBERT SALLIN:** I think *Star Trek II* is the best of the series. I'm prejudiced, but if you ask the fans, if you query some of the audiences and the reviews, I think most folks agree. I had not worked on *Star Trek* previously. As a matter of fact, I wasn't even a Trekkie, I thought it was interesting, I thought it was unusual and I thought, "Gee, that's something quite special. I wonder if it will succeed?" But I wasn't really involved in it.

**WALTER KOENIG:** [*The Wrath of Khan*] was one of my favorite episodes. When I read it, I knew we had a winner because we had an antagonist who, for all his strength and ability, was human. He was a human being, he wasn't a machine. He wasn't some vegetable grown to enormous size, or some alien. He was a human being with human feelings. He was very angry because he had lost his wife, the woman he loved. He had lost her inadvertently, but because of the Federation, because we had banned him and his family to an uninhabitable planet. You could identify, if not with the intensity, with the feeling of loss and how the Federation was responsible. Now that's the kind of antagonist you want to play against. What we had was the immovable object and the unstoppable force. That's pure conflict. You may know that Kirk's going to win because of the series and it's a movie, but you know you're in for a ride, and it ain't going to be easy. In the back of your head, there's always the possibility that you can lose the hero, because you have such an enormously powerful antagonist. I read that and I knew this was a story that was going to evolve and keep the audience totally on the edge of their seats and that it had a relatively good part

for me.

**RONALD D. MOORE:** *Wrath of Kahn* is a classic. It works on every level. It just does. It's pop entertainment, it's a fan's dream, it's funny, the visual effects are state of the art and really hold up even to this day. The character stuff is so good. Acknowledging that they're older, Kirk getting that pair of glasses, the death of Spock, the friendship with McCoy, McCoy challenging him on what he's done – you don't want to say it's perfect, but it's the perfect *Star Trek* film.

It's the one that's referenced over and over again. In some ways, in a bad way. Because I could easily make the argument that what *Wrath of Kahn* did, was it permanently sent every subsequent *Star Trek* film down the same path. They all then, with the exception of *IV*, went, "We need a villain like Khan." I can't tell you how many times I heard that. "We need a Khan. Who's the Khan in this movie." It all became about emulating that story.

**MARK A. ALTMAN:** Would we be talking about *Star Trek II* all these years later if Gene Roddenberry's *Star Trek II* had been made? I don't think so. So you have to give Harve Bennett credit and Nick Meyer and Bob Sallin credit – for reading the room. *Star Trek* really changes gears with them. To a lot of people, *Star Trek II* is *Star Trek*. I'm not one of them – I love *Star Trek II*, but I do feel it's a little too militaristic, and too much about space battles. *Star Trek II*, for better or for worse, really changes the direction of the franchise. Up until then, *Star Trek* was really influenced by *2001*, headier and more cerebral. *Star Trek II* is in the shadow of *Star Wars*. Much more about space battles, action, and having a black-hat villain.

*The film would go on to earn $95,800,000 off of an estimated $12 million budget. While not as much of a success as* The Motion Picture *in box office, the film's low budget meant it earned nearly eight times its budget, compared to the 2.5 of its predecessor.*

*Because of* The Wrath of Khan's *success both critically and commercially,* Star Trek *went from being a franchise on its last legs to a franchise with a new*

157

*lease on life. Paramount quickly announced the production of* Star Trek III: The Search for Spock, *with a release date of merely two years after* The Wrath of Khan.

**NICHOLAS MEYER:** When we did *Star Trek II*, up until the very final parts of *Star Trek II*, it was a standalone film. And then when they thought, "Oh, maybe he doesn't die. Maybe we need the shot on the coffin or…" Then it became a yes [to *Star Trek III*.] They asked me if I wanted to direct it. And I said, "What's it going to be about?" "Well, he comes back to life." I go, "Resurrection… I don't think I know how to do that." So I didn't do it. But then after they resurrected him, it was about getting home [with *Star Trek IV*.] And I wasn't a part of the original writing. I had nothing to do with *IV* until I got an emergency call from Dawn Steele, who was my friend [and] was running the studio at the time, along with Ned Tanen saying "Help, help." So I came and… that was another real rush job.

**MARC CUSHMAN:** The movie was such a big hit, they came to Nimoy and said, "What would it take to get you to do another?" And he said, "let me direct it." "You got it." And that became *Star Trek III: The Search for Spock.*

**LEONARD NIMOY:** I decided to make the move [towards directing.] When we made *Star Trek II*, Nicholas Meyer, very talented guy, I started thinking, "I could do what he does. Why shouldn't I do this?" So when they called me, after *Star Trek II*, and asked me to come to a meeting, I had a conversation with my agent about it, and said, "Obviously they want me to act again in *Star Trek III*, and this is a chance to broaden my career. So I should take it now. If I don't, I'll never get the chance again."

When I went in for the meeting, they said, "We'd like to know if you'd like to be involved in *Star Trek III*." I said, "Yes, and I'd like to direct it." To my surprise, they didn't throw me out of the office. At that moment, it seemed easy. They said, "Oh, we've thought about that too. Interesting idea. Let us think about that." About a week later they said, "We'd like you to come and have a meeting with Michael Eisner,"

who was running the studio. I went for a meeting with him. He was brilliant about it. "Wow. Great. Leonard Nimoy directs *The Search for Spock*! Great. Wow. The promotion people, they'll love it. That's a great story." But this is too easy.

Several days went by and we didn't hear anything. My agent called to try and make the deal – they didn't return his calls. So I called Michael Eisner. I get him on the phone, and said, "Michael, my agent can't get in touch with your business affairs people. We have to get started." He said, "I can't have you direct this movie." I said, "Why, Michael?" He said, "You hate *Star Trek*. You insisted on the Spock character being killed in *Star Trek II* – you had it in your contract that Spock had to die. I can't have you direct a *Star Trek* movie." I said, "Michael this is really crazy. None of that is true. I don't hate *Star Trek*. I did not insist on the Spock character dying. It was not in my contract. The contract is in a file in the building you're in! Somebody is giving you bad information – take a look at it and see if you can find anything like that in the contract. It's not there. It's not true."

He said, "Come in tomorrow morning." So I went in the next morning, and I put it to him very simply. I said, "Michael, you have two problems: you want me to play Spock in *Star Trek III*, and you need a director. I solve both of your problems with one stroke." And that's the way it went. He said, "Okay, let's make a deal." And we went to work.

*With Leonard Nimoy directing* Star Trek III, *Harve Bennett returning to produce, the* Trek *franchise entered into a "repertory theater" mode of film-making, with the same cast and crew utilized over numerous films in order to efficiently and cheaply produce features. Leonard Nimoy directed* Star Trek III *and* IV, *William Shatner directed* V, *Nicholas Meyer co-wrote* IV *and wrote/ directed* VI, *and Harve Bennett was the producer in charge for* Trek II-V. *All the while, the main cast from the* Star Trek *television series returned for the new voyages of the Enterprise.*

**MARK A. ALTMAN:** *Trek II* is produced under the aegis of the TV division, at a considerably reduced budget from the first film.

Although the seams in *Khan* show, Meyer's sure-handed drama over-shadows any of the potential flaws. Inspired by *Moby Dick* and *Horatio Hornblower*, he crafts the seminal *Star Trek* film, which set the template for everything to follow. With *Star Trek III*, Bennett, now writing and producing, spends two hours spinning his wheels to bring back Spock and Nimoy slides effortlessly into the director's chair. The whole affair feels like an okay episode of *The Original Series* — but great cinema, it's not. But with *Star Trek IV*, the studio finally hands the series back over to the film division, and as Leonard Nimoy would often say, "The training wheels were off." With Ralph Winter producing with Bennett, the film is a sure-handed, humorous winner with a social conscience. Save the whales! There's no villain in *Trek IV* other than humanity itself. It's an inspired concept in the tradition of the classic series' lighter episodes like "Tribbles" and "A Piece of the Action," and well-executed by Nimoy, who went on to direct the equally successful *Three Men and a Baby* for Disney. *The Final Frontier*, the fifth *Trek* movie, helmed by William Shatner, is more divisive, largely due to its incompetent visual effects by Bran Ferren, who was in way over his head. Unfortunately, arguments over money on *The Voyage Home* with ILM led Winter to make the ill-fated decision to change horses and, in retrospect, it was a costly mistake, almost tanking the franchise despite the many things Shatner does right with the characters. Despite Bennett and Winter's lobbying the studio to do a prequel film, *The Academy Years*, a risk-averse studio turned to Nimoy and Nick Meyer once again for the farewell tour, *The Undiscovered Country*. Steeped in heavy-handed real-world politics and some sure-handed action sequences, the film also suffers from its truncated budget. But Takei finally gets his promotion so everyone is happy and there's a nifty denouement with Kirk & Company to the rescue one last time.

Star Trek IV: The Voyage Home *would prove to be the most financially successful of the original Star Trek films, with a box office total of $133 million, against an estimated budget of $21 million.* Trek *movies continued throughout the '80s and into the early '90s. But with the release of* Star Trek III *in 1984, amounting to $87 million, Paramount began to set its eyes on expanding the* Star Trek *franchise back to its television roots. A new cast, a new era, and bringing* Star Trek *to a new generation…*

# QUEUE FOR Q
*Star Trek: The Next Generation* Seasons 1-2

"Let's see what's out there…" ~Captain Jean Luc Picard

*While* Phase II *was canceled in favor of a film series, that didn't stop the people at Paramount counting the lucrative income the studio was still pulling in from syndication of the original* Star Trek *TV series. Even though the show had been off the air since 1969, just 79 episodes, the show was still making money. Paramount wanted a new* Star Trek *TV series. But how to do it?*

**MARK A. ALTMAN (creator, *Pandora*; author, *The Fifty-Year Mission*):** The evolution of *Star Trek: The Next Generation* is really fascinating. You have the fact that Gene Roddenberry had no interest in trying to do another *Star Trek* series; you have, Greg Strangis (*War of the Worlds* [1988–89]), who the studio brought in, and he developed a take on *Star Trek* which at the time was "The Next Adventure." This would have been about cadets on a Vulcan starship, and there would have been a Vulcan captain and a Klingon officer. He sort of describes it as Jihad in space. When Gene finds out that the studio is moving forward without him, "Oh, my ex-girlfriend is dating someone else now?! I want my girlfriend back!!!" So he basically says to the studio, "Well, you can't catch lightning in a bottle again, nobody can, except me!" The studio agrees – which may have been their plan all along. They were very afraid of what the fans would think if Gene went out there and started saying, "They're doing *Star Trek* without me, it's not *Star Trek*! It's going to be a disaster." This was already happening. The actors were already dismissing the new show, "It's not *Star Trek* without Kirk, Spock, and McCoy."

**LARRY NEMECEK (author, *Star Trek: The Next Generation Companion*, podcast host, *The Trek Files*):** Greg Strangis had a *Next Generation* ready to go, but Gene didn't want to be a hands-off producer. It's a 6–8-page document, and was all about a Klingon/Federation war that had happened beyond Kirk/Spock's time. There had been a ten-year war, it had finally ended in a fragile peace, and one of the aspects of it was there would be a Klingon/Federation observer on the

crew for every respective ship. The pilot begins a few years into that, and there's an incident that happens where the instinct might be to blame each other, but smarter heads realize someone else was behind it. So the larger mission was to save the peace from this third party. You have a starship with a Klingon officer aboard, and there were these enemies trying to get along. The broad strokes were there, but it was definitely written at a time before much of *Trek* mythology was written.

*It's important to clear one thing up at the top – go to Hollywood, throw a rock, and odds are you'll hit someone with a pitch for "the greatest science fiction show of all time." The key thing that stops these "geniuses" from getting their product on the air is – who's going to pay for it? Money runs Hollywood. It's the reason Star Trek was canceled, it's the reason Trek wasn't brought back, and it'd be the reason now, in 1986/7, that it would be. The studio thinks they can make money. The way they would make that money, however, would decide Star Trek's future for nearly twenty years. Given the mountains of dollars Paramount was still bringing in by selling the original Star Trek to syndication, the decision was made to use that same infrastructure to sell a new show.*

**LUCIE SALHANY (President, Paramount Domestic Television 1985-1991):** [Before *TNG*, syndicated shows were mostly viewed as lower budget.] They were mainly talk shows, but low-budget shows. Not a question. Our division cleaned up. We went in, cleaned up, we made the money. Then we started creating our own shows with *Entertainment Tonight*. It was extremely profitable, but it was a magazine show. So syndication was mainly talk shows and magazine shows and a few very low-budget scripted shows, but we made a lot of money. We reinvented the wheel, really created the wheel. I don't think there were any scripted hours on the air at the time. But we had that, and tying it to a series the way we did was totally new. We all just believed it would work, we had no doubts. We were scared because it was so costly, and I'm sure the executives at Gulf & Western and Paramount were a little nervous about it. We didn't have any doubts. You could talk to anyone in our division, and we believed in *Star Trek*. We believed it was the time, we believed that space was going to be an important part of what people were thinking and talking about. And we believed in Gene Roddenberry, and ultimately the team that was put together to

produce the show. But we did not have any question that *Star Trek* as an entity would work.

*As technology evolves, and time drags on — it may be worth taking a moment to explain to the younger reader just "what" syndication is. Before the era of streaming services, on-demand videos, and the internet — there were "three big networks" in the country: ABC, CBS, and NBC. These would be sent over the airwaves, a la wi-fi in your own home (not quite, hopefully the analogy works). The channels would be picked up by antennas or satellites and distributed by cables to local homes. These would be funded by ad revenue. (Public access and PBS were also there, and funded by government grants, donations and occasional advertising.) Independent stations were also in existence, and would carry "second-run syndication" of shows and movies. In other words, they rarely produced their own content, but leased programming to air from the studios. PBS would occasionally fund their own big-budget programs, but mostly did educational programs like* Sesame Street, *or rerun international programs like* The Forsyte Saga — *which led to the anthology program,* Masterpiece Theater. *But in terms of new, top-tier television comedy/drama — ABC, NBC, and CBS were the place to go.*

Star Trek, *as mentioned in a previous chapter, had aired on NBC in its initial inception, licensed for $100,000 per episode, with Desilu going into the hole $85,000 per episode.* Star Trek *in syndication, was making Paramount a mountain and a half in dollars, because they sold* The Original Series *directly to independent stations across the county for second-run syndication — 200 or so at its peak.*

*The revolutionary idea Paramount had was to utilize these same 200+ independent stations and sell the new* Star Trek *show directly to them in "first-run" syndication. The station could air it whenever it wished, and however often it wished — which is why* The Next Generation *was so quick to become a fixture in reruns. (KPTV Channel 12, for the writer of this book.)*

**LUCIE SALHANY:** *Star Trek* was heating up. We were talking about it, others were talking about it. At Paramount Domestic Television, the division I ran, which produced first-round programming like *Entertainment Tonight, Maury Povich, Arsenio Hall*, we wanted

to ultimately launch a fourth network. There was ABC, NBC, and CBS, and we wanted to be the foundation for the fourth network. We couldn't, because no one wanted to really commit the dollars for a fourth network, so we went to Paramount and said, "let us syndicate," which means selling a show station by station — knocking on the door to all the television stations, doing the research, convincing them to run the show, and selling it to them. Ultimately, we made a presentation to Paramount and like everybody else, we had to go to our bosses, and everybody wanted it. They were producing the movies. So they said, "Why should we do a TV show? Why should we let it go into syndication? We should take it to a network." Fox network had started [by then], and they wanted it. We went to Paramount, and these two guys named Greg Meidel and Steve Goldman put together an incredible sales pitch. They said, "We will go to television stations and we will sell the original 79 episodes, and we will sell them the new *Star Trek*." So we'll have this foundation of money from the original 79, and we'll have the advertising revenue from the new *Star Trek*'s. We held back advertising. We gave it to the stations, held back advertising, and that's how we pay for the show. We would guarantee a year, which is 26 episodes of *The Next Generation*. So with that in hand, Paramount said to the other competitors, "What will you offer?", and the competitors wouldn't. NBC offered a pilot. Fox said they would give us an episode order of eight. Somebody else said, "Well, you know, we'll see."

We [on the other hand] pushed and pushed, and we got it. We had talked to Gene, so we started meeting on the show. He was on board, but Gene wanted to be on a network. Everyone did, because that's prestigious. Syndication – here are these television stations around the country that would run it at different times, and it had to run twice, so you could run it early and another time. And we would cue the audience, so if it got a three rating and a one rating, it was a four rating. It got everybody more advertising dollars because you sold a higher rating. It's all pretty confusing, but that's the way. As part of this, I have to give the stations who took it credit, because it was something so new for them. So costly and so intricate in the deal. We met with Gene, and he was okay once he found out we guaranteed 26 episodes and we would promote it. Pressure was unbelievable.

We went into a room to meet with Gene one of the early times, and we didn't have a name for it. We were pitching our heart out about why we want to do it. We said to him "Gene, what you don't understand is there's an entire generation that hasn't watched *Star Trek*. They don't know about *Star Trek* because the originals are skewing older. They're appealing to an older audience who remembered it back from when it was on NBC stations. So you're talking about a brand-new audience." We kept talking about this next generation. We all looked at each other and I don't even know how it came up, but that's how we named the show. It was *Star Trek*, colon, *The Next Generation*. It was unbelievable, I get chills every time I think about it.

**MARK A. ALTMAN:** When Gene comes back, he's 20 years older, and the job hasn't gotten any easier. There are a lot more decisions to be made. There are a lot more challenges. There's a lot bigger budget, and there's a lot more riding on it than there was on the original. The original would have died quietly if it hadn't worked, this was not going to die quietly. And it potentially would kill the goose that laid the golden eggs because *Star Trek* was a franchise. It was making a lot of people a lot of money.

**LUCIE SALHANY:** Paramount didn't want to lose money on it because it was very expensive to produce. So we had to come up with a plan that guaranteed Paramount cash money for a contract. We gave the stations the new show, but we took half of their advertising time within that 60 minutes. That was the proposal. Imagine yourself as a station owner, we said, "We're going to bring back *Star Trek*, it's going to be phenomenal. We are going to produce it for the same amount of money they produce shows on the network, so it's going to be network quality. You don't have any first-run, never-before-seen, network-quality programs on your station. In return for that, we will sell you the 79 episodes of the original *Star Trek*, so you can run them; we're not going to charge you a lot, but we think that's a good promotion vehicle for the new show. The new show will carry 14 minutes of advertising time. We will give you seven minutes and we will keep seven minutes, which we will sell." That is by the way, the network model: ABC, NBC, CBS kept the stations' advertising time in the

show, and gave the stations a little time to sell. That's how they make their money. So we kept seven minutes, the stations got seven minutes, and it made sense because those seven minutes would be three to four times more valuable than any programming they would run in that time period. It was a gamble that stations took, but they believed in Paramount and believed that we would deliver a first-rate show. They believed in Gene Roddenberry, who was a genius. The show cleared in 90 percent of the country, 90 percent of the stations said yes. Most of those stations were independent stations, they had no network. When the show started really working, affiliate stations wanted *Star Trek*, and they wanted to cover network programming, which didn't happen a lot. We're just talking about domestic. Canada and worldwide, it was sold differently.

**DAVID GERROLD (program consultant, *Star Trek: The Next Generation*):** It was a breakthrough. The idea that *Star Trek* would go directly to syndication was a breakthrough idea. The studio knew that if we could sell something like 200 markets, the show would break even and anything above that would be profit. By the time we were moving into our final offices, the studio had already sold over a hundred markets, so it was well on its way to hitting its target.

**LARRY NEMECEK:** Sci-fi sequel, syndicated. A lot of people thought that was a recipe for going nowhere. It's why even on the business side of things, *Next Generation* was this amazing paradigm shift. What eventually happened for *Next Generation* in stripping daily reruns after school, just like its older brother had done, but also for *Voyager, DS9,* and even *Enterprise,* was that the success that *Star Trek: The Next Generation* wrought was its own worst enemy because then you had *Hercules* and *Xena* and *Babylon 5*, and you had this boom. The sci-fi boom in the '70s, we'll do it on TV in the '90s.

*Getting Gene Roddenberry on board was no easy feat, for the creator of* Star Trek *was still bitter over the franchise being taken away from him following* Star Trek: The Motion Picture. *In addition, Roddenberry felt there was money owed from the lucrative syndication deals of* The Original Series. *Roddenberry's lawyer, Leonard Maizlish, had a solution.*

**MARC CUSHMAN (author, *These Are the Voyages*):** Gene Roddenberry had not gotten a dime of his 20 percent ownership of *Star Trek*. A lot of people think he had 25 percent, but he had given 5 percent to William Shatner [instead of a pay raise during *The Original Series*], but neither had gotten any money. Leonard Maizlish came to Roddenberry and said, "Paramount wants to do a new series. I think you should do it so you can keep them from destroying *Star Trek*, and we're going to figure out a way to get you your money. So here's what Leonard Maizlish did, he wrote a contract that said Roddenberry would get a percentage of the ownership, like he had with the original show, but that he would get paid by certain specific dates, against the royalties – and that he would get to inspect the books. He had never been able to inspect the books on *The Original Series*. Paramount was still telling him in 1986 that *Star Trek* was still in the red – and it's airing in 60 countries and 250 TV stations. Leonard writes the contract, and they have a big party for the press at Paramount, and contracts were signed. Gene Roddenberry goes over to the Paramount guy and said, "By the way, I'm going to have my accountant come over next week to inspect the books." And the Paramount guy laughs, and says, "But Gene, there aren't any books. We haven't started doing the show yet." Gene says, "Look at my contract." Leonard Maizlish didn't put *Star Trek: The Next Generation*, he put *Star Trek:* The Series. So Gene now had the right to inspect the books from the original *Star Trek*. A week later, a Rolls Royce was delivered to his office at Paramount. That's what Leonard Maizlish was able to do for Roddenberry – and in return, Roddenberry gave him a lot of power, which others resented.

*As development began in earnest for the titled* Star Trek: The Next Generation, *Roddenberry's initial plan was to bring back the original behind-the-scenes team he'd worked with successfully on* The Original Series. *Bob Justman as the producer, original writers Dorothy Fontana and David Gerrold, as well as others. It had, after all, only been 17 years since the cancellation of* The Original Series. *However, the intervening years had changed much for the people who worked behind the scenes in* Star Trek.

**ANDREW PROBERT (consulting senior illustrator,** *Star Trek: The Next Generation*): When *The Next Generation* was

announced, I was called into Gene's office. He reviewed my work and got to know me a bit better. He remembered me from *The Motion Picture*. I ended up being the fifth person hired on that show. The reason that they wanted a designer so early was to give me plenty of lead time to create what they needed to design. The first focus was the bridge, because that's where they knew that they were going to spend most of their time. They wanted something that everybody agreed on, something that worked cinematically, and something that they were very comfortable with.

**DAVID GERROLD:** I get a call from Gene Roddenberry, "Come on down and have lunch." Here's me, Bob Justman, Eddie Milkis, Susan Sackett, and Gene, and we talk about the show. I'm feeling like I'm getting acknowledged and respected for everything I've learned. Later on, Gene says, "I want you to write the show bible." We'd talk about the captain, we'd talk about Number One, we'd talk about how we needed a Spock character. Gene said, "We can't have a Vulcan, let's have an android who wants to learn how to be human." I said, "We could have a Klingon on the bridge." Gene said no. Dorothy came along later and said, "Let's have a Klingon on the bridge," Gene said no. Everybody who came in to pitch said, "Let's have a Klingon crewmember," Gene said no. We get to *Encounter at Farpoint*, and Dorothy writes it to where Tasha Yar is in command of one of the sections of the Enterprise – and Gene rewrites it and introduces the character of Worf so he won't have to have a woman in the command chair. Dorothy never forgave him for that.

*One of the most important additions for the new series came with the hiring of Rick Berman as supervising producer, to handle the day-to-day operations.*

**DAVID LIVINGSTON (line producer, *Star Trek: The Next Generation*):** Without Rick Berman, *Star Trek* would not have been what it was. He does not get the credit that he deserves. He gave me countless opportunities, kept pushing me, and I am forever grateful. Rick ran the show as he thought it should be run. Rick said, "I work from my gut, I only do what I think is best for the show. If that rubs certain people the wrong way, so be it." But he was consistent in his

vision and how he approached the work. The one irony to that is on his desk he had a bust of Gene Roddenberry, with a bandana around his eyes.

**MARK A. ALTMAN:** In the wake of *Star Trek III*, Paramount realizes – "The cast is getting older, how many more of these can we really make?" They decide a TV series could be so much more lucrative. "But how can we do that? We can't hire Kirk, Spock, and McCoy. We went down that road in the '70s, so what are we going to do?" So they decide they're going to develop this new *Star Trek* series. Who are they going to go to? They realize they have a legitimacy problem because Gene Roddenberry has already told them no. So they go to Leonard Nimoy. Leonard Nimoy turns them down – and the reason he does that is, you have to remember, at the time of *Star Trek IV*, he does *Three Men and a Baby* for Disney. Which was a huge success, one of the top movies of the year – so now Leonard is considered an A-list director. He thinks, "This is my chance to escape from *Star Trek*. Why would I want to develop this TV show, when I'm being courted by every studio in town?" Then they go to Ralph Winter – who had produced a bunch of the *Star Trek* movies. Ralph Winter also feels, "I don't want to do *Star Trek* for the rest of my life," so he also passes. Paramount has a dilemma, "Who are we going to bring in to produce *Star Trek*?" That's when they realize the person is under their own roof – which is Rick Berman, who is running the Mini-Series and Special Projects department, which is going away. They think if they have a studio suit in there, it'll be easier to deal with Gene, who they have already had problems with.

**DAVID LIVINGSTON:** Rick would always reiterate that he wanted to protect Gene's vision, but he wanted to recognize that he had to go with what he felt in order to react to that vision and not to assume what Gene would want. Rick's guiding vision was always, "What would Gene want in these circumstances?"

**MARK A. ALTMAN:** We talk about Gene Roddenberry because he created it, but the second most important person behind the scenes is probably Rick Berman. His DNA is in four of the shows – that's huge. He had a strong concept for what *Star Trek* was and what *Star*

*Trek* wasn't, and you see that through all the shows.

**LOLITA FATJO (pre-production associate, *Star Trek: The Next Generation*):** Rick Berman is a very complicated man. He was very talented at getting the shows done, very talented at working with the suits at Paramount or UPN, but he's also a very, very intense, and sometimes scary human being. On any given day, you might get one side of Rick or the other side of Rick. The truth of the matter is he got the job done for a very, very long time. So much credit has to go to him.

**RICK BERMAN (executive producer, *Star Trek: The Next Generation*):** My name is Rick Berman, and I was the executive producer of four *Star Trek* series and the producer of four *Star Trek* movies. The way I managed to pull off all the work – especially for the period where we were doing two television series at the same time – all had to do with having a remarkable team working with me. We were like family. For the nineteen years I was involved with making *Star Trek*, a huge portion of the people I worked with remained for the full nineteen years. That's unheard of, even on a show that runs for four years.

**BRENT SPINER (actor, "Data," *Star Trek: The Next Generation*):** Certainly, Rick exercised a great deal of control over the show; he was the showrunner, that's what they do. Somebody has to, and he had to do it very well. There were times where he had so many balls in the air. Most of the time he had two shows running at the same time. Trying to crank out 26 episodes a season of one show, much less two, and they were always ready on time and delivered. There's a lot to be said for that. We were shooting seven, eight-day episodes. We were working anywhere from 12 to 16 hours a day, 10 months out of the year, and Rick was there working all the time, getting the job done.

**RICK BERMAN:** I was in a meeting as vice president of current programing for Paramount television. In the meeting, there was a discussion as to whether *Encounter at Farpoint* was going to be one hour or two hours. The studio wanted it to be two, Gene wanted it to be one. Gene was a very stubborn man. He was furious and he did not want to

do two hours. I was one of eight studio executives in the room. Somebody said something, one of the studio executives, and I rolled my eyes, because I thought it was ridiculous. Gene saw me roll my eyes, as did his lawyer. And they thought, "Wow, maybe this guy is okay." That led to lunch with the lawyer, and lunch with Gene. Because of my work with documentaries, I had been all over the world, and so had Gene. One of the questions he asked me was, "You've been all over West Africa? What's the capital of Upper Volta?" I said, "It's not called Upper Volta anymore, it's called Burkina Faso, and the capital is Ouagadougou. And he fell in love with me at that moment. But most important was that I knew very little about *Star Trek*. He was surrounded in the very beginning by people who had worked with him 17 years earlier on *The Original Series*, and he liked the fact that I was younger, considerably younger. Although I owe a tremendous amount to Bob Justman, who worked on *The Original Series* and who sort of became my mentor as a fellow producer in the first beginning of the first season.

**DAVID GERROLD:** Rick Berman was the studio's man. The studio was very concerned about letting Gene run a show because they had had a very bad experience with him all the way back to *Phase II* in '77 and the even worse experience with *Star Trek: The Motion Picture*, which went so far over budget. I thought Rick was going to be an asset, helping to keep the show functioning. But as it became clear Gene was not capable, Rick took over more and more control of the show, to the point where Gene was "promoted" to producer emeritus, and Rick stepped into the vacuum. A lot of people have said a lot of negative things about Rick. He and I always got along well, but after Gene started saying all the negative things about me, Rick took his side.

**RICK BERMAN:** I've been accused by a number of people as a "suit," meaning a studio executive. The irony of that is when I came to California, I spent 20 years in New York as a filmmaker – as a cameraman, assistant cameraman, editor, director. I produced seven years of a show called, *Big Blue Marble*, which won all kinds of awards for PBS. I produced a number of PBS specials. I had been a filmmaker and I came to L.A. and I got a job as a studio executive that lasted a year and

a half, and then I went back into producing. Right before I went back into producing, I had been in charge of current programming at Paramount. I didn't have a whole lot of fun as a studio executive.

**WENDY NEUSS (post-production supervisor, *Star Trek: The Next Generation*):** Jim Wilmington, who created so many of the great sound effects, was there for the first season. He said it was so fraught with tension in the beginning. You had Bob Justman and Rick Berman, and they were on opposite sides. Bob Justman loved everything that was reminiscent of the original *Star Trek*, so every sound that sounded like that, he loved. Rick was trying to do new things. So there was almost nothing that they agreed on. Jim was worried that he was going to get fired because, after a couple of days, they had gotten nowhere. Then Gene came in, and he was just lovely and easygoing. He would say, "I like that. I think that's going to work." Then everyone else would say, "Yeah, that's good. That's great." He resolved some of those more contentious things, but from what I hear the whole season was a bit fraught. Things were political, and it wasn't until the second season when Rick was a little more in charge that things started to settle down.

**MARK A. ALTMAN:** One of the reasons Gene liked Rick so much is at the time Rick wasn't a writer. So he didn't feel threatened. He didn't feel that Rick was a threat to him. Rick was a producer, and his jobs were to make sure the show came in on budget. As a result, Gene felt he could trust him. As Leonard Maizlish did.

**MARC CUSHMAN:** Gene's health was very bad those few years he was with *Star Trek: The Next Generation*. I would see him once every six months or so, and it was always such a shock, because it was such a profound difference. In how he looked, in how he was getting around. How he was walking. The sharping of his mind. It was all deteriorating.

**MARK A. ALTMAN:** Gene is finally making real money after all these years. Because you got to remember, even on the movies, [after] *Star Trek: The Motion Picture*, he was an executive consultant. He was basically paid off to go away and not make noise. So on *Next*

*Generation*, he's finally making, what they call in the industry, "F-you money." He's happy about that. He wants this thing to go for years and years and years, because that money is going to keep on coming in and he doesn't want anything to upset the apple cart. He's older and it's a tougher time. I think he realizes whether he likes it or not, he's going to have to turn the show over to the next generation. And the heir apparent is Rick Berman.

**DAVID LIVINGSTON:** Leonard Maizlish was Gene's consigliere. He was looking after Gene's interests from a legal standpoint and was his protector. Gene's an artist, he wasn't necessarily in the business part.

*As work progressed towards the season premiere of* The Next Generation, *casting on the new show began. Wanting to distance itself from* The Original Series *in hopes of securing a new audience, it was decided early that there would be no direct line to the original cast.*

*As the new captain of the Enterprise, Jean Luc Picard, Patrick Stewart was cast. Born in Yorkshire, England, on July 13, 1940, Stewart had made a successful career in the theatre as a member of the Royal Shakespeare Company, and had occasional film roles in such classics as John Boorman's* Excalibur *(1981) and somewhat less classic but still beloved (by me anyway),* Lifeforce *(1985). Jonathan Frakes, cast as William Riker, had mostly been known for supporting roles in the miniseries* North and South *(1985) and* Falcon's Crest *(1985). Brent Spiner, cast as the android Data, had worked as a character actor in Hollywood for a number of years, most notably in a recurring guest spot on the comedy series* Night Court *(1984-1992). Michael Dorn, cast as Worf, had been a regular on* CHIPs *(1977-1982), but finding work after proved difficult, and he thus took the smaller role in TNG, not knowing it would go on to be a defining role of his career. Gates McFadden would be Doctor Beverley Crusher; her major claim to fame before* Star Trek *was as a choreographer for the 1986 film* Labyrinth. *Denise Crosby, security chief Tasha Yar, had previously starred in the* Terminator/Robocop/Star Wars *on a budget sci-fi movie,* Eliminators *(1986). (Don't ask.) Marina Sirtis, cast as Deanna Troi, had worked regularly in the U.K., but would have been unrecognizable to most American audiences in the era where foreign films/TV were not as available as they are today. The most recognizable faces to American audiences would come from two*

*supporting roles, Wil Wheaton as Wesley Crusher, and LeVar Burton as Geordi LaForge.*

**MARK A. ALTMAN:** You have to remember at the time, Wil Wheaton was the biggest star on that show, besides LeVar Burton. He had come off *Stand By Me* (1986), people knew who he was, that was a big get for *Star Trek*. Then you had LeVar Burton from *Roots* (1977). Other than that – Patrick Stewart had done theater and been in bad movies like *Lifeforce*, but people didn't know who he was. Jonathan Frakes had been in a bunch of miniseries like *North and South*. Brent Spiner had done theater. But they were nobodies to the viewing audience at home. So it was really Wil Wheaton and LeVar Burton who anybody ever knew. I remember when they first announced the cast, I was like, "Who are these people?"

**RICK BERMAN:** *The Next Generation* was a little bit risky. It was a sequel, and sequels had never really worked on television. It was in syndication – syndicated shows were not a big deal. And it was science fiction, and there was very, very little science fiction on television.

**DENISE CROSBY (actress, "Tasha Yar," *Star Trek: The Next Generation*):** I had been working on an independent film called *Miracle Mile* when I got the audition for *The Next Generation*. It was presented to me as a first-run syndicated remake of *Star Trek*. I had seen and loved the original, so at first, I was somewhat skeptical. I was thinking, "Why are they going to touch this? And first-run syndication?" It had all the hallmarks of being a cheesy rehash of something. This was 1986, and television didn't have the cache it has now, with all the great writing and cable shows – everything hadn't changed yet.

I was concerned from day one that this would turn out to be a disaster. It just had this vibe of — we were the bastard stepchild of the lot. I used to go to the set of *Cheers* and take food. We had a craft service table with basically tomato slices. The cereal boxes were locked in a cupboard, so I had to find a guy to open the cupboard. Our trailers were a box that they must've pulled out of storage and they hadn't seen the light of day since 1962.

**MERRI D. HOWARD (first assistant director, *Star Trek: The Next Generation*):** All the *Next Generation* folks, I'm still friends with them today. When I think about that cast, they're still the best of friends. They still get together and interact. As a cast and a community, they're there for each other all the time. It's pretty remarkable, because you don't see that all that often. You're working with these people day in and day out, for 12, 14 or 16 hours a day, they're like your family. You probably see them more than the people you see at home.

We laughed a lot. When we were on the bridge, it was like child's play. You literally had to focus these guys, "Okay, enough laughing. Enough good times. Stop being in the playground, we have to get to work." But at the same time, I loved that, because everybody had fun together. There were moments of tenseness, but at the end of the day, how great it was that you could come and just laugh.

**DAVID LIVINGSTON:** I was all by myself in the trailer and this was very early on in pre-production and I got a call from the gate saying that there's an actor here who is looking for the hair department. I said okay. He says he's with *Star Trek*. I said, okay, send them back to the trailer. He shows up, and it's this bald guy, and he has this box in his hand. He says with his very proper English accent, "Hi, I'm Patrick Stewart, and I need to go see the hair department." I said, okay. I took them over to the hair department and I subsequently found out, because I wasn't a part of the meeting, in the box were wigs that Patrick was told to bring from England and take over to the hair department for a hair test, because Gene Roddenberry was not about to have — and Patrick had already been hired — he was not about to have a bald captain. His imagery was William Shatner. William Shatner was not bald. Needless to say, Gene was overruled. I mean, I'm sure Gene realized the mistake, but that was my first meeting with Patrick Stewart of holding this little box of fur balls.

*(In truth, William Shatner has worn a hairpiece going back to* The Original Series *in the '60s, much to the existential dismay of the person writing this book.)*

**MARC CUSHMAN:** Gene originally didn't want Patrick Stewart. What they ended up doing was taking Gene to see Patrick in a play, and he was so impressed by his acting range and his dynamic, that Gene said okay. I think Gene originally thought, "We could put a hairpiece on him. We did it with Shatner." Shatner wasn't bald, but it was a little spotty up there. Bob Justman is saying, "Why not just let him be what he is? It won't be compared to the original *Star Trek*." Gene gave in on that point.

**LUCIE SALHANY:** Patrick Stewart was an interesting choice to take William Shatner's place. The thought process was everybody who bought the show, and those of us who sold the show mentally thought, "Well, it would probably be somebody that's a younger-looking Shatner, and be like him." I wasn't privy to the conversations with Gene, but I can tell you that it would have been a mistake. Had the production arm of Paramount put in somebody who was more like Shatner... they needed somebody to be different. That's where the brilliance came in. So if it had been at a traditional network, ABC, NBC, CBS, they would have thought the way we did: somebody more traditional. I believe that if it had gone to Fox, they may have gone along with it, or they may have wanted somebody 18 years old. They may have wanted some kid.

**RONALD D. MOORE (screenwriter, *Star Trek: The Next Generation*):** It took a while to bring Riker into focus. I know that Michael [Piller] in particular had a great affinity for the character. Michael felt that he was Riker. When he wrote *Best of Both Worlds*, Michael explicitly said, "This is me because I'm facing this challenge." Michael felt he was the number two guy on the show, and he had offers to go run shows and be the number one guy. And did Michael want to leave *Star Trek* and go run a show on his own? Or did he want to stay as number two? That was his expression of his own experience. And as we went forward, Michael always singled out moments with Riker that were meaningful to him. So the character became an expression of Michael's, not subconscious, but Michael's own character. At least as he perceived it. That helped the rest of us kind of figure out what to do with them as well.

It's a difficult role to be the second in command in that series, if you're not the Vulcan science officer. Because the Vulcan science officer has a whole rich cultural thing as a character that you can get into, that's providing a yin and a yang to McCoy and a confidant and friend to Kirk. So that functions differently. Now it's a human person, who's supposedly just as ambitious, just as capable and a dynamic hero in his own. Right. Okay. Why is he staying to be number two? It's a tricky role to pull off, but Jonathan pulls it off because Jonathan is so innately charming and fun, and you really, really liked him. You like Riker and you're intrigued by this backstory with Troi, and again, the force of the actor brings the character home.

**WENDY NEUSS:** *Next Generation* was an amazing group of people, and the cast became really close quite early on. Because I was doing the looping on this big, dark stage of modern sound, it became a bit of a confessional, a bit of a psychiatrist's office. People would come in and they would feel at home. We made them feel at home. Bill Wistrom was the head sound editor, and he was just a fantastic, wonderful guy. I think they felt really at home and comfortable. We had a great time. We always laughed a lot. We made it an atmosphere where they felt welcomed. We had so many stories. We had so many times where we just all laughed our heads off.

*As the cast was in place and cameras were preparing to roll, turmoil behind the scenes grew.*

**DAVID GERROLD:** I was in there functioning as a story editor/ producer. The studio was pleased with my work, and they'd tell Gene how much they liked me. Gene's lawyer panicked, thinking the studio was going to fire Gene and hire David Gerrold. So what happened was, Gene would end up bawling me out. The studio praised me in the morning, and in the afternoon, Gene would bawl me out. This was weird, because I was doing all the heavy work. I wrote the production bible, I was bringing in writers to pitch stories, I hired them. I was functioning as a producer, but was only titled as a consultant. It ended up being a whole Guild thing.

**DOROTHY FONTANA (associate producer, *Star Trek: The Next Generation*):** Gene Roddenberry called me and said, "Let's go to dinner." He and Majel and I. He was talking about a new version of *Star Trek*. And I said, "Well, that's interesting, Gene. What do you have in mind?" He came up with the basics of the older captain, the characters that we see in *Next Gen*. I was okay with that. He asked me if I would write the pilot script, "Encounter at Farpoint." I said, "Okay. Fine with that." But I was constantly bounced back and forth between – is it an hour, is it 90 minutes, is it a two-hour? I finally wrote a 90-minute script. The question had been, would Gene do a retrospective back to *The Original Series* to lead into this? Or would he add to my pilot script? And he ended up adding to my pilot script. He added all the stuff that had to do with Q. Which I didn't particularly care for, but that's not my choice. That was the first thing that was a little disappointing. I had to share that script credit with him. Of course, he wrote the material, that's okay. Then after that, as a story editor, I was not terribly well treated. Things went over my head on things I could have had input with, and so forth. I stayed for the first 13 episodes and then I left. It was not a terribly happy experience. Although working with those actors was very good because they're all solid, good actors who knew their jobs and delivered.

**MARK A. ALTMAN:** The problem unfortunately is, there's a wildcard in there, and that was Gene Roddenberry. Gene, throughout the '70s, struggled with money. After the cancellation of *Star Trek*, he sold a couple of shows that didn't go, he had a lot of alimony payments to make after he married Majel, to his ex-wife. As a result, he had an enforcer/attorney named Leonard Maizlish. Leonard and him were really tight. Leonard was always looking out for him – sometimes to Gene's detriment, because he antagonized and upset a lot of longtime relationships.

So, when David Gerrold and D.C. Fontana are invited to *Star Trek: The Next Generation*, they're very excited. David Gerrold in particular gets to suggest all these ideas that have percolated over the last decade. David is just knocking off all these ideas. Bob Justman is saying, "Hey, we should have a Klingon on the bridge," and Gene is very persistent

in saying, "I don't want anything to do with the original show." Then you have D.C. Fontana who's also coming up with ideas, she co-writes the pilot with Gene. Now, she writes all the *Farpoint* storyline, which originally just going to be an hour script, but the studio is pushing for it to be a two-hour pilot. Gene is fighting it at first, but then realizes if his name is on the pilot, he gets paid for every subsequent episode. So he writes the "frame" of Q. Sort of a thinly veiled version of Trelane from *The Original Series*, which D.C. calls him out on.

The problem you have at this time is you have a lot of people who love *Star Trek*, and everyone thinks they know *Star Trek*. So you have a room of very strong personalities – you have David, you have Gene, you have D.C., obviously Rick and the Paramount executives. Also, Gene is reaching out to a ton of people he worked with on *The Animated Series*, on the failed pilots, on *The Original Series*. It becomes a problem – because Leonard Maizlish wants to keep this pot of money for Gene – so David finds he's not being offered what he's worth and not getting credit he was originally offered. All this unprecedented stuff. At the center of this tornado is Leonard Maizlish, who is "protecting" Gene, but is going above and beyond. Maizlish was blaming the studio — you'd call the studio and the studio would say, "No, this was Gene's decision." It was a mess. Unfortunately, it was very acrimonious between Gene and David. David ended up leaving the show. There was a lawsuit because he wrote the show bible and makes the case that a lot of stuff that found its way into the show and he should get a co-created by credit, which he didn't get, but there was a financial settlement involved. D.C. was also unhappy and they part ways.

**DAVID GERROLD:** [Leonard Maizlish] was, to put it politely, one of the most despicable, detestable, excuses for a human being – an absolute waste of DNA. I couldn't say enough evil things about him. When he came down with a brain tumor, I wanted to send a get-well card to the tumor. There was absolutely nothing worthwhile to say about Leonard Maizlish. One of the most vile human beings I've ever had to deal with.

**MARK A. ALTMAN:** Gene talked out both sides of his mouth.

He espoused all this aspirational philosophy. As Dorothy Fontana says, he walked the walk in the '60s, he believed in equality and diversity and women's rights – you saw it in the way the show was cast. By the time you get to *The Next Generation* – whether it was partially from the drink or health issues – it's a different Gene Roddenberry. Also, there's a sense of, "I have been so insulted and marginalized and beat up over this past decade," he was a very bitter guy. So for all of his wonderful traits, which there are many, there were also some negativity, cynicism, and darkness there.

**DAVID GERROLD:** First of all, Gene had lied to [Dorothy]. And secondly, he now was getting half the credit and half the money, half the residuals on this script. And she felt that the addition of Q weakened the story. They had a lot of fun with Q throughout the series and, and John de Lancie is a marvelous actor. But Gene shoehorned Q into that script. Dorothy never forgave Gene for that. It was a betrayal. It was a betrayal of their friendship, it was a betrayal of ethics, because you don't jump other people's credits.

What they did give Dorothy Fontana is they said, "You can do the novelization of *Encounter at Farpoint*." There was a lot of money in the novelization, because Pocketbook was going to give $30,000 for the novelization. And she had done it. She had written the novelization, and was about to turn it in. Then at the last minute, Leonard Maizlish said, "We're going to take the novelization away from you." Leonard Maizlish then comes to me, and offers me the book! I'm like, "Well, geez. If I don't say yes, they're going to give it to somebody else." So I said, "Yeah, I can do that." The deadline's in two weeks. So I go to Dorothy, very quietly, very privately, and say, "I know you finished the book and I know what Leonard has done. Give me your book, I'll turn it in and give you the money." Leonard Maizlish never found out about it. It's her book, but it's my name on it.

**FRED BRONSON (screenwriter, *Star Trek: The Next Generation*):** Everything you've heard about Leonard Maizlish is true, I'm sure.

**DAVID GERROLD:** Leonard Maizlish had complete control over Gene. He was the puppet master pulling the strings. We all knew it by then. We knew he was rewriting scripts for Gene. We had the evidence. We turned it in to the Guild. Here was the evidence that Leonard was doing producer-level work on the show when he wasn't qualified, and this was a violation of Writers Guild rules. Leonard Maizlish was later thrown off the lot.

**MARK A. ALTMAN:** While Maizlish is looking out for Rodden-berry's interests, that's not necessarily analogous to the show's interests. He's antagonized the studio, he's antagonized executives. Roddenberry was always a handful to begin with, and basically the studio says "We've had enough. We do not want to hear or see from Leonard Maizlish again." And they're the ones paying the bills and Maizlish is gone. He's no longer, and things start to run a lot better. That's during season two.

*The finalized script for "Encounter at Farpoint" told of the first adventure for the crew of the Enterprise-D, under the command of Captain Jean Luc Picard. As the crew is on their way to Farpoint to gather their remaining crewmembers, Picard and the Enterprise are stopped by the omnipotent being, Q, who orders them back to human space and accuses them of being a savage race. Picard contests, claiming human history shows they have evolved beyond their blunders of history. Q is bemused and agrees to put humanity on trial. Q agrees to observe the Farpoint mission as a test of humanity's valor. Meanwhile, on Farpoint, Commander Riker and Doctor Crusher observe several mysterious scenarios in this city. All is not what it seems. The Enterprise arrives, and an investigation into the odd goings-on at Farpoint commences. Picard, Riker, and the crew discover Farpoint sits atop a sentient lifeform that is being held prisoner and must provide for all the city's wants. The Enterprise frees the creature. Back with the trial, Q agrees that humanity deserves a reprieve, for now, and allows them to go on their journey. Setting off on a new adventure, Picard eagerly says, "Let's see what's out there," as the Enterprise speeds to warp.*

*Filming on the pilot for* Star Trek: The Next Generation *began on May 29, 1987. In addition to screenwriter Dorothy Fontana co-writing the script with Gene Roddenberry, original series costume designer Bill Theiss, returned. Two titans of the* Trek *world also started their long careers with the franchise*

*on the first episode, production designer Herman Zimmerman, and makeup su-
pervisor Michael Westmore. David Livingston joined for the pilot as production
manager, and later made the transition to line producer, and ultimately, director
– directing the largest number of episodes of the* Star Trek *franchise to date: 68.
Michael and Denise Okuda were hired onto the art department, and would
go on to be legends in the* Trek *lexicon in their own right, being the first to
envision the concept of the touchscreen.*

**DAVID LIVINGSTON:** I was not a *Star Trek* fan when I was
in high school. I watched *The Man from U.N.C.L.E.*, so it was a new
world to me. It was a job. I was the first one in the trailer as production
manager for the pilot of *The Next Generation*. My job was to do the
budget, hire the crew, create the production schedule. It's called below
the line, it's a non-creative function. I started in '87 on the pilot, and I
left as a supervising producer on the first year of *Voyager*, but I contin-
ued to direct episodes through *Enterprise,* 1987–2005.

**ANDREW PROBERT:** Herman Zimmerman. I love that guy.
He's the most generous person in his position. The thing is, I think the
last thing he designed [prior to *The Next Generation*] was the *Cheers*
bar. So he was not in on science fiction. I was already in place when
he came in – and I'd designed the bridge and the ship and various
other things. He came in and I said, "Okay, here you go." He said, "No,
you've already got this thing going, let's talk about this." So I was really
bringing him up to speed on what I'd established. He took it from
there and just upgraded what I did. He plussed it.

**HERMAN ZIMMERMAN (production designer, *Star Trek:
The Next Generation*):** Rick Berman is probably the best producer
I've worked with. He's a very loyal man to the people that do good
work for him. He'll always hire you the second time. The third time,
fourth time.

**MICHAEL OKUDA (scenic art supervisor, *Star Trek: The
Next Generation*):** My direct boss was Herman Zimmerman, and I also
worked with the art director, Sandy Veneziano. Both of these people
had an enormous nuts-and-bolts understanding of the way production

works. It's not just "What do you want to do?" It's, "Oh can you get as much possible on-screen with the time, resources, and budget?"

Herman's vision was to define the ship. Production designer is not merely as an artist, but a production designer has to figure out how to get from what you want, to how do we do it on stage, given the amount of stage space and amount of budget. He spent an enormous amount of energy just figuring out how to best utilize the stage space to get, get the greatest number of interesting sets and how to do it in a sequence of construction that worked with the production schedule. If you don't do those things right, it doesn't matter how brilliant your set design is. We had some amazing designers, like Andy Probert, but Herman Zimmerman had to translate that into something that was buildable on time and on budget. And that's no small task.

**DENISE OKUDA (scenic artist, *Star Trek: The Next Generation*):** You have to remember that each department has a different responsibility. And we were fortunate enough to work in the art department and our leader, our fearless leader, was Herman Zimmerman, whom Michael has said is the best boss we've ever had, which is true. He was brilliant. He was generous. He treated us like family. He respected our work. He wanted our opinion. That's so rare out in the world. We worked in the graphics department and we were all fans. We were all *Star Trek* fans and certainly science fiction fans. Even when it got really difficult and they got really difficult, we bolstered each other up and that created a lifelong relationship. There were about five of us that worked on two series and did a feature every other year – I don't know how we did it. Where did we get the energy? We just kept going, and going, and going...

**MICHAEL OKUDA:** When we started doing *Next Generation*, Gene Roddenberry wanted specifically to avoid a lot of the science fiction tropes that had worked so well on *The Original Series*. That was Gene having the guts to say, "We're going to do different things, and not rely on the stuff that had been done before."

**DENISE CROSBY:** Gene Roddenberry brought Bill Theiss,

his costume designer on *The Original Series*. There were often times where I felt Bill was still doing the '60s. These costumes hadn't really evolved. If you look at the first season, some of the away missions we did – there's one where everybody is in hot pants and they like to run everywhere – bare-chested and pink sashes everywhere.

*As* Star Trek: The Original Series *is seen as pioneering things like cell phones and the internet,* The Next Generation *would very tangibly be responsible for something wholly unheard of at the time, but we now use every day — touchscreens.*

**MICHAEL OKUDA:** When we started *Star Trek: The Next Generation,* no one really had a strong opinion on how the control panels should look. I had thought about it a fair amount, because I had worked on *Star Trek IV*, and also just as a science fiction fan – I loved control panels. Yet, I was very much aware that time, schedule, and budget are going to be major determinants. Even if you have a lot of time, several weeks to do something, once you get into production, I guarantee you the director is going to say, "Can we have a control panel there?" If you have an expensive control panel style, you're out of luck. So, how do you make control panels? What is the least expensive decision every step of the way? I ended up with a solution of a plexiglass surface, which has a photographic transparency. So the cost per square foot was quite low. Behind that were inexpensive lighting gels – which were certainly cheaper than drilling holes, putting toggle switches in, and blinking lights.

**MICHAEL WESTMORE (makeup supervisor, *Star Trek: The Next Generation*):** I'm from a long line of makeup artists. My grandfather created the first makeup department in 1917. He had six sons and a daughter, and they all went into the business. My grandfather trained them to do mainly hair in the beginning, and then makeup was brought into it. Each one of my uncles and my dad spun off into one of the major studios. My dad became Rudolph Valentino's makeup artist and went to work for David O. Selznick.

When I got the call to interview for *Star Trek*, I really jumped on it,

because I had heard they were interviewing makeup artists for a while. Then I got a call from Paramount studios that asked me if I would like to come in for an interview. I went over on a Thursday and met Gene Roddenberry and everybody else in the offices. We talked for a bit. And then when I got home, there was a message on the machine saying, "If you want the job, it's yours."

**RICK BERMAN:** Michael Westmore was a member of probably the most renowned makeup family in the history of motion pictures. You could watch movies from the '30s and '40s and there's a Westmore in there. Michael was brilliant. He had a team with him, most of whom stayed with him through the entire 19 years. Michael would do sketches and drawings and bring them to me. After a while, it was almost unnecessary. He knew what I liked. I knew what he liked. He knew what I didn't like. I also was aware of what he was capable of doing within the budgetary limitations that we had. Whether it was a single unique prosthetic or makeup, or whether it was a makeup that was going to be for 80 extras, he always managed to pull it off. I don't think there was a harsh word spoken or a budgetary item brought up in the 19 years that I worked with Michael. A man that I have an incredible amount of respect for.

**MICHAEL WESTMORE:** I would have to turn out aliens in days, not weeks, days sometimes, because schedules would change. Once we settled on what I wanted to do, it meant sculpting and molding and taking face casts, pouring the rubber, and having it ready. Many times, we didn't have the latex ready to glue on the face until the morning the actor was actually sitting in the chair. Which means we have to pour and make that rubber overnight and let it bake overnight, and pray it would turn out.

To create the characters, they have to be sculpted out of clay with regular sculpting tools, and turned into plaster molds. Opened, the clay is cleared out of them so it's just a hollow shell inside. Foam latex that has been beaten up like whipped cream is injected into these molds, and then the molds are put into an oven that's 200 degrees. It's the same process as making a tire. They are heated at 200 degrees for

anywhere for anywhere from one hour to three hours to five hours, depending on how big it is. In that heating process, it vulcanized as the rubber and literally turns it into a sponge. And that is what comes out of the mold. I take the mold out of the hot oven and open it up and peel out this rubber, and it's the shape that you sculpted. If you've actually sculpted it on the actor's face who's going to wear it, it will fit like a glove right on over the face.

Every time I had a new Vulcan or Klingon or something, the molds were saved in a big loft room I had, so when they came back to shoot, we're going from two Klingons to six, I had things to pull from. I had Vulcan ears of every size you could imagine – from little tiny ones to… The gentlemen who played Spock's father, Mark Lenard — he had the biggest ears in the world. He had ears that were so large, they didn't fit anyone else.

**LUCIE SALHANY**: I'm going to say [the budget for the show] was $1.7 million per episode on average. The pilot was much more. It was network pricing. $2 million. We spent as much on that as a network show. With the smaller stations, they didn't pay us. We gave it to them, and we kept half the advertising time. If they had a program on Saturday or Sunday night at seven, if they had 14 advertising minutes, if they were only doing a two rating, then that was it. They sold it and then they got whatever they got. But with *Star Trek*, they saw the potential of getting much higher ratings, and we told them they could get seven or eight rating points. So they said, "Okay, we will try it." They believed in us, we had a great track record, and we sold them on it. [An average hour of television on a network show at that time was generating $800,000 in advertising. *Star Trek* was averaging a million.] It was profitable for us, but don't forget, we also sold the original 79 along with that.

**MICHAEL WESTMORE**: *Star Trek* started slow. Basically nothing in "Encounter at Farpoint." And then after that, we shot a show where the alien's name was the Traveler. And again, that's only one face. It took a while and built and built and built to where, by the time we hit into *Deep Space* and *Voyager*, it was multitudes of things that we were

doing.

DeForest Kelley was the first appliance we ever used, and that was in "Encounter at Farpoint." But they came in and wanted to do that so fast, we didn't have time to do a cast of his face and sculpt it new. There were some pieces that were available, and we grabbed those up. So it wasn't a new creation for us, it was off the rack.

**BRENT SPINER**: I think there was a pantheon in regards to the success of the show, and it started undoubtedly with Gene Roddenberry, then Rick, then, of course, our writing staff, which was incredible. I'll mention Michael Piller, Jeri Taylor, Ron Moore, Brannon Braga, and so many of the wonderful young writers we had at the time who are now showrunners and major forces in the industry. But in that pantheon, without a doubt, is Michael Westmore. Every week he had to come up with something, some alien race that nobody had ever seen before, and create magic. And that's what he did. He's a genius, he really is. The Westmores have always been the geniuses of makeup in Hollywood, and at that particular point in time, Michael was the reigning genius. We all knew he was the master. I was lucky enough to have [Michael Westmore] making me up every day, and I was honored to have him make me up. Not just that, he was a really pleasant source of comfort. He was the first person I saw in the morning. I'd come into Michael's trailer and I always enjoyed it. I was enjoying spending time with him because he's such a lovely guy too. He never panicked. He was very calm, and in so many cases, he really was responsible for performance.

When I played Dr. Soong the first time, which was like a hundred something years old, the way that that came about was Rick wrote the episode "Brothers," and he wrote the father and the two sons. Obviously, I was going to play the two sons, and I thought, "Well, shouldn't I play the father? Wouldn't that have more depth? I would not just be the father, I'd be the creator. It makes sense that they looked like me, that he made them in his image." They had already hired an actor, Keye Luke, a fantastic actor, when I came up with this brilliant idea that I should play the part. I talked Rick into it, so they paid Keye Luke, and

Rick said, "Okay, you can play the part." I started to panic and thought, "How am I going to do this? How do I play this old man?" I had never played an old man before. I was trying voices and things; I didn't know what I was going to do. The day before we shot, Michael had designed the makeup for Dr. Soong. He said, "I want to try it out today before we shoot tomorrow and make sure everything works." So he put me in the full makeup, I looked at myself in the mirror, and I knew exactly how to do it. It was like, "Okay, thank you. You've done the job for me. You've told me how to play Dr. Soong." The makeup was so brilliant.

**MICHAEL WESTMORE:** Gene Roddenberry originally wanted Data to be either bubble gum pink or battleship gray. And I said, "I'd like to save gray for the villains, and bubblegum pink is going to make him look like some sort of a doll." I said, "Let me find something and we'll test it." We did something like 21 different color tests. The one I really loved was the soft gold look. Of all the characters, Brent's make-up never changed from the first day we did the test. It was his face and the gold color forever.

*The routine that Michael Westmore fell into for over 18 years, four television series, and four motion pictures, was a grueling yet rewarding experience.*

**MICHAEL WESTMORE:** On *Star Trek*, if they needed at seven o'clock on Monday morning, and this was like Thursday, might even have to work over the weekend to do it. There wasn't going in saying, "Sorry, I can't have it ready on time." The production meetings were held literally only a couple of days beforehand. There was a constant stress. If I had been a person who couldn't handle stress, I couldn't do the job. In my mind, I would think, "Okay, how am I going to do it? What am I going to do?" It wasn't something I could put off. I'd go back right away and put the wheels in motion, get a sculptor going. We had a thing called the Westmore Alien - the Westmore Alien was boxes of noses and heads and ears from previous aliens that we could pull out. It was like a Mr. Potato Head. Let's take a nose from this box, a forehead from this one, and put it all together and we'll paint him red with stripes.

To be able to create a new character for the show, there's not a lot of time to do that. So what I would do is I would take a cast of the actor's face, and in the lab, we'd sculpt my idea on there. I had the greatest job in the world. I could come up with an idea, create it, and then I'd take the clay sculpture up to the producer. In the beginning, Gene was involved, but he wasn't there very long. The producers would look at it, and go, "Okay." Because it's like, "What could you really say? We don't have any time. This has to be ready in two days." So, I would say, 99 percent of everything I ever did was accepted.

In all the aliens you saw, there was inspirations from Earth in them. I didn't try to do fantasy or science fiction or strange things that you might see in some of the other sci-fi shows. I always had something in Earth that the people could associate with, but they didn't know. The Jem'Hadar was a little bit of dinosaur and rhinoceros.

*As filming continued on the pilot, the regular crew met the villain who would become a touchstone for* Star Trek *in the years to come – John de Lancie as the god-like being, "Q".*

**JOHN DE LANCIE (actor, "Q,"** *Star Trek: The Next Generation***):** I got a call from my agent saying, "You have an audition for *Star Trek*. It must be a typo, it's just the letter Q. They want to see you tomorrow at four o'clock." I said, "I'm in production, I'm in a play. I'm rehearsing, I've got a big part." I didn't go, I couldn't get out. A week later I got a call saying, "They're willing to see you. Whenever your lunch hour is, you can shoot up to Paramount, do your audition, and go back." I did. A tall guy walks out, he puts his hand on my shoulder, and says, "You make my words sound better than they are." I said, "You must be the writer." He said, "I'm Gene Roddenberry." I had no idea who that was. He said, "We're going to be seeing more of you." I said, "Okay, thanks." I'm rushing to the door, and at the door there's another guy who had also been in the room. He said, "This is a payback." I go, "What?" He says "I'm one of the producers." (He actually wasn't, he was Gene's lawyer.) "About four or five years ago, I was flat on my back with a quadruple bypass operation, and you made me laugh when I thought I was going to die. Every day I would watch you." I

knew where he was going at that point. I had been on a soap opera. That's how I got it. This guy, Leonard Maizlish, brought me in and said, "There's somebody you've got to see." From what I understand from Rick Berman, I'm the only one who auditioned for the role. Leonard Maizlish said "They're going to hire you." Well, now I am interested for the first time.

**RONALD D. MOORE:** A tremendous amount [of Q's popularity and success] is due simply to John's portrayal of Q. A lot of the charm and wit and intelligence and joy of the character is rooted in his performance of it. Because the character on the page is just not as entertaining. You give it to John de Lancie and it becomes this other thing. Everyone enjoyed writing for him. People would just write scene after scene after scene for Q at any of those shows. Many of them were too silly or too over the top, but you just really enjoyed it. You really couldn't wait to dig into a Q episode. Internally, what we said all the time was Q is in love with Picard. That was the fundamental of the relationship. He's in love with him. He just is. He loves Picard. It's a particular relationship with this one human in this omnipotent being that's bizarre, but that's really what's at the heart of it. Which is why, in my opinion, when they tried to translate him to *Deep Space Nine* and have a relationship with Sisko, it didn't work because it didn't, absent that element. Then Q just became a weird prankster that showed up arbitrarily, just kind of screw with people. But with Picard, that was something personal. He had a personal relationship with this man, testing him, challenging him, protecting him. It was like a whole different kind of thing. And it just didn't work with anybody else.

**JOHN DE LANCIE:** Do you know Plato's story of the cave? And the humans who are chained and can only see the shadows that come through the light? They think that the shadow is reality. I always sort of thought that the Q were those people, and that we are processing all of this to send it out to the universe. So no one sees the essence, everyone only sees the shadow. And this Q broke his chains, and is now traveling the universe, wanting to have a real experience, not a shadow experience. He lives in this superficial, shadow world, and he's going out to actually have a real experience. From an acting point of view, I don't

have to have it airtight. It gives me a place I came from and a place that I'm moving back to, and that this event takes place in the middle. It's all part of a continuum.

*Q's appearances on the show were also noted for their abrupt and spontaneous wardrobe changes – a job initially done by Bill Theiss.*

**JOHN DE LANCIE:** The costume was fabulous. I looked like Robespierre, like Cardinal Richelieu. It was great. Bill Theiss brought it in, it must have weighed 30 pounds or so, and they sat it on me. "Oh my God, this is fantastic." They put me on the crane. I have to say, when I saw that wobbly crane shot when the show was aired, I went, "Oh dear, this show isn't going to go anywhere. Oh my God, it's horrible." I'm an omnipotent being, it should be smoothed out.

*While today, acting in a* Star Trek *show would be the highlight of one's acting career, in 1987, the opinions of the actors towards this new* Trek *were… less than optimistic of its chances.*

**MARK A. ALTMAN:** Patrick Stewart talks about how he never unpacked his suitcase. He thought this would be 13 episodes and after one season the show would end, he'd be going back to England and that'd be it. You talk to Rick Berman, he talks about what a huge risk it was to leave Paramount as an executive to go oversee this show because it was a syndicated sci-fi show. For all intents and purposes, the whole television series was an entirely new cast. The chance of this show actually working were…. There was no sense that the show could work. At the time, there was so much antagonism against the fact – you have to remember, people loved the original *Star Trek*. They loved Kirk, Spock, and McCoy. So they were really unwilling to embrace a *Star Trek* with an entirely new cast. It had a lot of things stacked against it.

It's a testament to Rick Berman, who doesn't get enough credit, that he was able to nurture this beast for 19 years, and keep the franchise relevant and successful, and make something that was of great value to the studio. It could have easily gone the other way.

**BRENT SPINER:** I'm not sure I was aware of [the show being on first-run syndication], I probably wasn't at all. I didn't care, because I needed a job. I was an actor for hire and I was happy to have a job. Really my point of view at that time was, as I recall we had a year guaranteed, and I was thinking, "This is *Star Trek*. It's not going to last more than a year. You can't recreate *Star Trek*. I'll do a season, I'll pay off all my bills and debts, and then I'll go onto the next thing." Then, you know what happened.

**JOHN DE LANCIE:** Brent very nicely made the comment to the effect of, "We were all struggling, and you came in fully baked. You knew where you were going to go and what you were going to do." I think a lot of it is because I had just walked off the stage with a character that was not very different. One of the things in which I wanted to bring to this character was a little bit of a naughty wink. As far as I'm concerned, the villain is another hero. There are actually two heroes, and I'm one of them. What I wanted to bring was that wink and a nod. I never thought I would have a second chance at it, even though Gene told me while we're shooting, "I'm going to have you come back five or six times a year." He came to me a month or so later, once they had hired me again, and said, "Actually, I can't do that." That made sense to me as well. I had done *Romeo and Juliet* twice, playing Romeo. I know exactly how it feels when Mercutio gets killed and the audience goes, "Oh gosh, the funny guy is gone." The guy who had all the energy and is really fun is gone. Now it's on Romeo. The way in which Q was written had that kind of Mercutio quality about him. I'm not surprised that they just went "Once a season will be more than enough."

**BRENT SPINER:** At the time, Leonard Nimoy said that it was very unlikely that it was going to have the same impact as the original *Star Trek*. He said, "We created lightning in a bottle. How many times could you create lightning in a bottle twice?" I think he was right; it was unlikely that we were going to be a success. Looking back, it's kind of amazing.

**JOHN DE LANCIE:** I have seen little snippets here and there, and I agree it's very slow. I remember being told by Michael Piller that if

they had not had a guarantee of two seasons, this show would not have gotten past the first season. I never really watched it that closely. Hundreds, if not thousands, of people in the 30 years since have told me, "We would get together and we would watch this multi-generationally, and then use the subject of that *Star Trek* teleplay that Friday night and talk about it." That was unheard of to me. There's something about this show which has created relationships, which have allowed people who are on two sides of an issue to be able to actually talk about the issue. There's something, and if people could put it into a bottle, they would, but they can't. All they can do is keep on creating *Star Trek*-like stories. You can tell when it's not a *Star Trek* story. They're not about endless action. There's some sort of a philosophical weight to the best of the *Star Trek* stories.

*The first episode of* Star Trek: The Next Generation, *"Encounter at Farpoint," aired on September 28, 1987. The ratings for the first episode were a huge success, with the 98 independent stations and 118 local affiliates reporting massive numbers, beating out all the major network competition. Whether this would prove the show had the ability to last multiple years, or just one episode, was still a concern for Paramount executives. In addition, turmoil behind the scenes was increasing, and Gene Roddenberry's health was deteriorating, as the show moved through its first, and ultimately second season.*

**MANNY COTO (executive producer, *Star Trek: Enterprise*):** I really hated *The Next Generation*. People forget that when *TNG* was announced, there was a bunch of fans who were like "*Trek* is Kirk, Spock, and McCoy. Who are these people?" Nobody wanted to like the show. And when "Encounter at Farpoint" premiered and was as bad as it was... it was a hard watch.

I just thought it was flat, dull, predictable, pedantic, and not engaging. Then the episodes that followed it were pretty bad themselves. I had completely switched off. I was done with that until my little brother called me around season three and said, "You got to start watching this again. This show is great." Then I started watching and sure enough, it was.

193

**BRENT SPINER:** [Gene] wasn't really well as we got into the show, but in the first couple of years he was dominant. I had lunch with him, he would invite us to his parties, and he would be on the set from time to time. Particularly when Majel worked, he was always there. I like Gene, he was always really nice to me. I don't know what other people have said, but like any genius, he's a complicated individual. But as far as my relationship to him, he was almost grandfatherly in a way. He was kind and supportive, I always enjoyed being around him. As I say, we're all complicated. I think just a handful of people actually create something that lasts 55 years, you know? You have to look at everything about him. He was a really interesting guy.

**DAVID LIVINGSTON:** We were certainly spending a lot of money and certainly an unprecedented amount of money spending on a syndicated show because I don't think anybody really knew what the return was going to be from syndication. Because with syndication, you have to go out and sell the program. You don't have a network that's giving you a license fee. Paramount is assuming the production costs and hoping to recoup them by syndicating the show and having stations around the nation, around the world, pay for the privilege to be able to broadcast that show.

In syndication, you make your money by selling the show directly to stations who then pay you a license fee. That model is more direct and you can end up making more money that way, because you can show the program more often at a lower cost than you could as a network show in a network show, the residuals that you have to pay the creative people, the directors, the actors, and the writers are much greater than it is syndication. So on a network show, you might show it once or maybe twice, but probably never a third time, because you'd never recoup your money. In syndication, you can play it 12 times and you're going to keep making money each time because of the way that the economics are structured around how you get your money back.

**LUCIE SALHANY:** *Next Generation* absolutely was profitable from the start, but don't forget that we had sold the original '79, which was highly profitable because we weren't paying huge residuals or any

heavy costs on that show. For Paramount, we made our money, but it was money in the bank. Then when *Next Generation* went on, it was extremely profitable, and got more profitable after years went on. So together they were highly profitable for Paramount. It went on the air, and the early returns were phenomenal. They were far beyond what anybody thought they would be. We knew we had a major hit on our hands, and it just got better. As it happens, advertisers who didn't really advertise on these stations because of the quality of their programs bought more and more advertising. They not only bought for *Next Generation*, but they looked at the shows around it and said, "You're promoting in it, your ratings are up, we'll give you even more money."

**DAVID GERROLD:** I give Rick Berman credit for one thing: He wrote a memo, a three-page memo of issues that the new *Star Trek* could address. I read this memo and said, "Yeah, these are the stories that *Star Trek* should be doing. *Star Trek* is not just this sci-fi adventure thingy. It is commentary on the world we live in. It's commentary on us. What is our place in the universe? Who are we? What does it mean to be a human being? *Star Trek* is supposed to ask these questions. And the best episodes of *Star Trek* would address this aspect or that aspect. The third one on the list was "We should do a story about AIDS." I wanted to do that one, because AIDS was becoming a major epidemic, I wanted to do an episode to inspire people to help in the real world. To donate blood.

A few weeks later we're in a meeting, and Gene mentioned that at some point we'll probably have to have a gay crewmember. Bob Justman — I love him dearly but this was a mistake on his part — said, "What, are we going to have a Lieutenant Tutti-Frutti?" Gene bawled him out. Said, "No, no. We have to have all human experience." So when I wrote "Blood and Fire," there's a scene where Riker turns to Freeman and says, "How long have you and Hodel been together?" "Since the Academy." That was the only reference that they were lovers.

I go off on a *Star Trek* cruise. Gene sends me a telegram, "Everybody loves your script, have a great cruise." Okay. I come home, Sunday night there's a message from Dorothy Fontana, "Don't do anything

until I talk to you." Because 'all hell had broken loose over the weekend with Rick Berman writing a memo saying, "We can't shoot this script, we can't have gay characters on *Star Trek* because mommies will write letters." And there's a whole bunch of people taking sides about the issue of having gay characters on the ship. I wrote a memo, which says, "Gene promised there'd be gay characters on the Enterprise. If not now, when?" Herb Wright, who was one of the producers, popped his head into my office: "Great memo. We still have to take the characters out." So I turned one of the characters into Tasha Yar, and had to re-write the script. Eventually, the whole script got shelved, and that's why I quit. Because this is hypocrisy. Here's this memo saying we should do these stories, here's an episode doing the things we have promised our-selves we'd do for months, real *Star Trek*. I was getting chronic fatigue syndrome. I was emotionally beaten down.

A few weeks later, Maurice Hurley was telling people I had been fired. My agent tells me, "I can't get you work anywhere because *Star Trek* is bad-mouthing you. What did you do over there? They said you didn't do anything useful." I brought in all my memos, all my script drafts, and everything. We take this stack over to the Writers Guild and we file a grievance with the studio against *Star Trek*. Dorothy Fon-tana had also left by then and she was part of that. Gene was furious and was telling all kinds of crap about me, and his lawyer was telling people I was mentally ill. Well, by then the Guild had brought in Marty Singer — he's a great lawyer — Marty calls up Leonard Maizlish and says, "If you ever repeat that to anyone else, I will have your car, I will have your house…" Maizlish was a bully, but that also means he was a coward.

**MARK A. ALTMAN:** There was no respect for the Writers Guild [that first season]. They were paying people below scale, at one point, to save money on the budget, Maizlish went to all the writers and said, "Well, we're paying you network rates for scripts, we want to change that to syndicated rates," which were cheaper. Everybody said, "NO!" This stuff was happening all the time. It's amazing *Star Trek* survived.

**DAVID LIVINGSTON:** Initially Gene had total control, but

by Christmas of the first season, Gene realized that the day-to-day running of the show from a creative standpoint needed to be turned to the next generation. And that was Rick Berman. Gene recognized that, and Gene actually made a statement at the Christmas party, at the hiatus, for the first season of *the Next Generation*, that Rick would be assuming the mantle.

*While big changes were happening behind the scenes, an equal number of changes were happening in front of the screen. Allegations, whether direct or indirect, were being made of sexism, discrimination, and racism, which made for a less than pleasant working environment.*

**DENISE CROSBY:** Part of my reason for leaving the show was that it was getting very frustrating about the writing. It was very hard to keep good writers, and find writers that were capable of writing this kind of stuff. Science fiction and weekly, it was just chewing them up and spitting them out.

**GATES MCFADDEN:** "Code of Honor" was the most egregiously racist script you could imagine. I found it appalling. I wasn't someone who knew all about *Star Trek*, but I felt this was wild we were going to go back and do things that were like from the '50s. They were offensive. I remember being in my trailer talking with Bob Justman with tears in my eyes, and the response was, "You're so beautiful when you cry." Which was not really what I was going for. I was trying to get him to explain why these scripts were getting done – because they really were retro in the worst possible way. I learned then that I had no real power.

**DENISE CROSBY:** I finally spoke to Gene Roddenberry, and he was the one who said to me, "Look, I'm not going to lie to you. The stories are going to focus on the Captain, the First Officer, and Data. It's that Kirk, Spock, Bones, kind of thing. You'll once in a while get a storyline or something, but it's a formula I know, it's a formula I know that works, and I'm going to stick with that. I don't want you to go, but I understand your frustration." Only by him saying that was I able to leave – because I had a contract. But he had total control over the

show, and he allowed me to leave. He said, "I want this character to be killed. I've never done it, but the only problem is, you won't be able to come back." Which of course, turns out to be wrong.

**RICK BERMAN:** When Denise Crosby decided to leave the show, we got a call from Whoopi Goldberg saying that she wanted to be considered to take Denise's role of head of security. But Whoopi wasn't really the head of security type for us. Gene and I sat down and discussed it. "What a great idea to have a bartender?" To build a bar where people could socialize, and who better than Whoopi to play a bartender, who had some kind of strange, never quite explained, past relationship with Picard. The reason that Whoopi, who was a pretty big movie star at that point, wanted to do this was that as a kid, she'd watched the original show, she'd seen Uhura, a black woman in a position of responsibility and power. It meant a great deal to her and she wanted to give back.

**DAVID GERROLD:** I consider Gene Roddenberry a blind man carrying a lantern for the rest of us because he created *Star Trek*. He gave us *Star Trek*. Whatever anger I might have about some of the things he did or didn't do, I still admire the fact that somehow, he managed to bring all these pieces together and create this iconic thing. That for me defines the best part of the 20th century, a vision of hope, a vision of what could be a way to ask questions about who we are and what we're up to in the world. He deserves every bit of credit for that.

**DENISE CROSBY:** Patrick loosened up as time went on, but that first season he was very serious about it all. Whereas we were not. Actually, Patrick chewed me out one day when – there was a director who went to the producers and said, "This cast is out of control. I can't get them to focus." Which is untrue, when they said "action," we were right there. But between takes, Frakes and Spiner are very funny. The director felt like we were out of control. The producers came and talked to us, and I said, "Look, we're here all day long, five days a week, we're just goofing off to breathe some life into this thing and have some fun." And Patrick turned to me and said, "This is not fun! I didn't sign up for fun! This is acting! We're making a show!"

**MERRI D. HOWARD:** I think Jonathan probably rode him the hardest. Marina too. Especially with Patrick being British, Marina was like, "Get over yourself." They just made fun of him. [laughs] I think they wore him down. But in a good way. In a really good way.

**MARK A. ALTMAN:** One of the guys who joins *Star Trek* at that pivotal first season is a guy named Maurice Hurley. Maurice Hurley – old school New Yorker, he's gone from show to show, he's worked on *The Equalizer*, kind of the old school cigar-chomping TV writer. Not a man who was generally beloved, but he knew how to suck up to the boss. So Gene loved him. At the time, the show was such a mess in terms of production and scripts not getting written, the fact that he could make the trains run on time was enough for everyone to get excited for Maurice Hurley. Not a sci-fi fan. Not somebody who loved the genre. He got along great with Rick, he got along great with Gene, and he started to turn the corner. He was writing scripts, stuff like "Heart of Glory," which was one of the early Klingon episodes – where you start to see glimmers of a pulse in *Next Generation*. "Oh, this show that we want to love so badly, but is so not very good, starts to show glimmers of life." He knew how to play the game. He was a political animal. Maurice ends up taking over the show, he runs it the end of first season, he runs it second season.

**LOLITA FATJO:** [It was] the beginning of season two, and they needed someone to type scripts, because they were still writing scripts by hand and sending them to the script department in the studio. They were just learning how to use computers, and they wanted the writers to start using them, so they needed a Microsoft Word expert. Which I was not, but I said I was, and it was the best acting job I've ever done. I walked in that day in the Hart Building, where Gene Roddenberry was for years with his writing staff. I opened the door, there's four offices on each side of this long hall, and there's a man standing outside each one of those doors. There were no women around. One of them said, "Oh, thank God. You must be the Microsoft Word expert." I said, "Yes, I am." And that was it, I just faked my way through it.

**MARK A. ALTMAN:** Sadly, one of the victims of the Hurley era

is Gates McFadden. Gates, who played Doctor Crusher. Look, there's various different perspectives on this — but the bottom line is, [Hurley] was very sexist, and he was hitting on her and when she didn't reciprocate, he was not happy with her. Sadly, that led to him pushing a way to reenergize the show was for them to have a new doctor. To replace Gates. And that's exactly what happened.

**GATES MCFADDEN:** I remember very clearly after the wrap party at season one, I felt very good because my agent had told me how popular my character was. I remember walking into the room, and it really was astonishing — Maurice Hurley gave me this look of, "you just wait…" There was something just chilling. Then it was a week later that my agent told me I'd been fired. Or "not signed." Whatever term they used.

**MARK A. ALTMAN:** So it was Gene's idea to bring in Diana Muldaur. Diana Muldaur had guest starred in "Return to Tomorrow," which was an episode of the original *Star Trek*, and had also been in "Is There in Truth No Beauty?" Gene always loved her performance, she was a friend of the show, but unfortunately, it was like oil and water. Not a good mix. She was getting paid more than the rest of the cast because she had better credits. She came in with this attitude — I wouldn't say a chip on her shoulder, but a belief that she had been brought in to save the show. So the rest of the cast really didn't like that kind of attitude. There was just not a lot of love there. Certainly, on the part of the fans, there was a feeling that the beloved character — because Gates had really had a great following among fans and was the mother of Wesley Crusher — they were upset about it. Plus, it didn't help that this was a character, in the case of Diana Muldaur's character of Doctor Pulaski, who is mean to Data. It was one thing when McCoy was mean to Spock, because he could take it, but you now have Pulaski basically tormenting a child, because he kind of had the emotional IQ of a child. He was naive. So when she starts to harass and say all these terrible things to Data, who was by now a beloved member of the family, the fans were like, "Who the hell is this woman who is saying all these terrible things about Data?!" It wasn't cute like it was with McCoy and Spock. As a result, it really antagonized the fan base.

Maurice Hurley left basically at the end of the second season – he was done, he was ready to go back and do cop shows. He ended up running *Kung Fu: The Legend Continues*. But he was out of there, and one of the first things that happened at the beginning of the third season was, "Let's bring Gates back." That was something that was important to Patrick, important to the cast, and it was clear to the producers as well that fans wanted to see Gates back. And Diana was never spoken of again. That's why, other than maybe some fan fiction, you never hear Pulaski brought up in the series. No mentions of her. It's sort of the lost year of *Star Trek* as a result of that.

**GATES MCFADDEN**: Gene and I once had lunch when I came back in the third season. And I knew it was going to be a little awkward. He cleared the air, but it was hard to get him engaged. There was a gulf between that kind of executive and someone who was a feminist. Gene was always really nice to me. I would have loved to know Gene when he was younger, because he clearly had some extraordinary ideas.

**LOLITA FATJO:**  Gene Roddenberry was there for sure. Maurice Hurley, Burt Armus. There were a lot of people that started then to come on that staff. It was pretty bare-bones when I first got there, because it had just come back after the strike. [For the first two seasons there was a lot of turnover.] You can say it was a big revolving door. There was another guy named Michael Wagner that came in for a while as a showrunner. Once Michael Piller got there, things really started to settle down, and he started to build that staff. When he brought in Jeri Taylor, that made it even more so of a solid staff with a woman, thank god. You're always going to have turnaround in a writing department, but in those later years, it was pretty stable.

**MARK A. ALTMAN:** Maurice Hurley left the show of his own volition. He wasn't fired. He'd been doing the show for two years. You have to remember that second year, was done in the shadow of the writers strike, so for many months the show was shut down due to the Writers Guild strike, so when the show got back up, they had a really punishing schedule. This was a show, they were still producing 26 episodes a season. It's not like now where you do ten, eight, some shows

do six a season. It was a punishing schedule and none more than that second season where the Writers Guild strike basically forced them into production and to generate scripts on an insanely quick basis, and then to deal with the production problems. So Maurice was done. Now, that said, there were people on staff, like Melinda Snodgrass, who liked Maurice. Who feel he was a mentor to them. So I don't want to just dismiss him. He is responsible for some great episodes – let's face it, Maurice Hurley is the one who created the Borg with "Q Who." It was his concept. Cyberpunk was a huge thing in the '80s, and he was smart enough to say, "We need a new villain." The Klingons were now uncomfortable allies, the Romulans they really hadn't done that much with. They had reintroduced them at the end of the first season, and in fact, that was meant to lead the way into the Borg, but because of the writers strike, plans to introduce more serialized elements were jettisoned. So you have Maurice Hurley write what is arguably the best episode of the first two seasons, "Q Who," which introduced the Borg. [The Borg] would become a huge part of the *Trek* mythology, through *Next Generation* into *Voyager* and beyond.

**LOLITA FATJO:** We used to jokingly say that *Star Trek* killed more trees in the Los Angeles area than anybody. We put up revisions after revisions. It all stemmed from Gene Roddenberry on the first series. Anything that needed to be changed, even if it was saying "yes" instead of "yeah," had to be approved through the powers that be, and a script page had to go out. For all the shows I worked on, that was what we had to do. It had to be on paper.

**MARK A. ALTMAN:** *Star Trek* in that era of the late '80s and early '90s, was a boys club. No question about it. The argument a lot of the writers and a lot of the writers who didn't last long on that show would say was, "It was whoever could become drinking buddies with Gene, would have his ear." It was almost like the Roman Colosseum – you could be a favorite of the emperor one day, and the next week you're out of favor and you're gone. That's why *Star Trek* had an infamous revolving-door policy, because writers would come in and then be gone. They went through more writers in a season than any show I've ever heard of. It's pretty remarkable.

But one thing Maurice had an unerring capacity for was getting the ear of Gene Roddenberry. Gene was so grateful to have somebody who could generate scripts on a regular basis that were producible, and would manage things on set, and would also respect Gene or at least feel Gene's input would be heard. Because a lot of people fought Gene – they thought they were better than Gene. Maurice Hurley didn't have a horse in the race. He was like, "Whatever Gene wants, I'm going to do." So he knew how to pacify Gene. As a result, Gene gave him a lot of power, and a lot of control, and he was the one who was able to convince Gene that Gates should go. A lot of people felt this was the result of an unsuccessful attempt to seduce her, but he would argue that he just didn't think the character worked for the show and needed to be replaced. We weren't there, we don't know the truth, but that's the story. Either way it's really sad, because the mother/son dynamic that had been set up in the pilot, was never really explored in interesting ways. I think a lot of that has to do with that Crusher's gone in the second season, and then a couple of seasons later you have Wesley leaving the show, and you never have an interesting exploration of that dynamic of a mother/son.

Other writers come in, and it becomes a revolving door. Writers were there for a couple of weeks, and then they were gone. Some of the more successful writers early on were people like Tracy Tormé, who wrote a wonderful film noir homage in *The Big Goodbye*. He had a really tight relationship with Gene, and looked like the heir apparent for a while, but then you had Maurice Hurley enter the picture, and he just knew how to play Gene. By the end of the first season, Maurice Hurley becomes what we now know to be a showrunner, but what at the time was called head writer.

**LOLITA FATJO:** I think that having a strict policy on revisions was a smart thing. You have seven actors on a set. If you just had people doing Shakespeare in different accents, it wouldn't work. *Star Trek* has its own way of speaking. So if you have people just off the cuff changing things, the shows would not have been what they were. I think there was a real reason for that control. I know a lot of actors were frustrated with it. They would vent about it all the time, but now they

look back at it and they say, "You know what? It was the right thing to do." The shows came out, they were great. The captains of course had a little more say, but that's a different story. I think it all took them a while to get that say. It was earned. Absolutely.

*By the end of the second season, almost none of the behind-the-scenes team Roddenberry had brought to the new series from the original remained.*

**MARK A. ALTMAN:** A lot of the people from the original *Star Trek* are gone. D.C. Fontana, David Gerrold are gone early first season. Bob Justman makes it to the end of the first season, and then he leaves because of health concerns. It was a brutal year. Also, Eddie Milkis, who was a producer on the original *Star Trek*, he's gone after fighting with Roddenberry very early on in production of the first season as well. So you see a lot of the old guard going by the wayside and there's a lot of new people entering the picture. Now the question for Gene was who do you trust? Because a lot of these old people that he'd worked with and he knew are no longer on the show, and one of the things Gene really resented was people who thought they knew better than him. Because at the end of the day, Gene created the show, and if you couldn't acknowledge that and couldn't show Gene the proper deference, chances are you wouldn't last very long. Particularly that first season, Gene was very involved, but as his health starts to decline, and they're finding it tougher and tougher to get scripts to the station on time, he really opens up the opportunity for Maurice Hurley to become indispensable. What he could do is — he could finish scripts, he could write very quickly, he could get them to the stage on time, he could get them into prep so the key members of production could start building and start making costumes. One of the most expensive problems you have on TV is, if writers don't get their scripts in on time, everything becomes more expensive. Because people can't build the sets yet, the costume designers can't design, you can't cast, everything becomes more expensive. One of the most valuable things in television, less than even being a great writer, is being able to deliver on time. As a result, Maurice Hurley makes himself indispensable.

By second season, [Maurice Hurley is] pretty much running things

and Gene is becoming less and less involved. Again, he's having health problems, he's in his late 60s, and he can't run the show the way he ran the original show. It's interesting because even if you look at *The Original Series*, Gene was kind of gone from the day-to-day capacity after the first 13 episodes. Because that's how brutal *Star Trek* is, because *Star Trek* is not just about casting – it's about what costumes look like in the future, what sets look like, what makeup looks like. There's so many more decisions you have to make on a sci-fi show, and particularly on the original *Star Trek*, because we've never seen anything like it before. He was inventing the wheel.

**WENDY NEUSS:** What it felt like to me was Rick was imposing order. I think the beginning of season two was shaky because there had been the writers strike, and it was a shorter season. I was so busy just figuring out what my job was. I came in, nobody had left anything for me. No documents, no instructions, nothing. So I just dove in headfirst. Second unit had been pretty casual the first season, and now production was getting more complicated, there was more of a need for it, so I made that sort of my niche. Second unit could be anything from a closeup, a hand double for Data or a lock-off for an Okudagram, or one of Dick Brownfield's famous explosions, which sometimes were successful and sometimes almost blew up the stage. I would get notes from the editor saying we need this shot, that shot, and then I would send out memos to practically everybody, we'd have a meeting, and we would do a second unit. So that was fun.

*Gene Roddenberry had left the day-to-day operations of the show during season one, with his final writing credit going to the twelfth episode of the first season, "Datalore." While he maintained a certain level of involvement in the years to come, the health of the* Star Trek *creator deteriorated considerably. Gene Roddenberry died on October 24, 1991, at the age of 70.*

**MARC CUSHMAN:** Gene suffered several mini-strokes, and may have suffered more and they didn't know. He had a drinking problem. He had a drug problem. Paramount drove him to drink, drove him to do some other things. He came from the cocktail generation; his father was an alcoholic, so he was prone to, in his dark moments, to drink and

to smoke. Heavy smoker.

**MARK A. ALTMAN:** Gene Roddenberry was a genius who came up with an amazing idea for *Star Trek*. And the fact that we're still talking about it 55 years later is a testament to the genius of this man. Now did Gene Roddenberry have demons? Of course, he did. He drank too much. He was a sexist and you could argue he was a misogynist, but at the same time, those qualities in his personal life can't take away from the fact that on-screen, he postulated a world in which we would be better than we are now, in which everyone is equal, in which science is important, and no matter what planet you're from, we don't discriminate, and that we will have evolved as a species, and the future will be better than it is now.

**LOLITA FATJO:** Gene was a great guy. I'm sure you hear different things about him all the time, but my dealings with Gene Roddenberry were nothing but pleasant. He always came in every morning and would say hello to everybody, especially on the first floor where he was. He never forgot a birthday. He'd always have a little party for people in his office. He was just a really nice man. I'm sure a very complicated man. I didn't know him on any deep level, but I have nothing bad to say about him. He's a genius. You and I wouldn't be sitting here having this conversation if it weren't for Gene Roddenberry. I feel like I owe him everything because walking into the Hart building that very first day changed my life for the best. I give full credit to Gene for creating this wonderful, crazy world of *Star Trek*.

**MARC CUSHMAN:** I felt Gene Roddenberry was a tragic figure in some ways, but I feel most writers are. Myself included. Because writers are very sensitive people and we empathize with other people. You have to be to write characters that the audience can empathize with. You have to feel and feel deeply and you have to reflect deeply. And so writers, we all have to deal with our personal demons. Gene Roddenberry would escape and go down to San Diego. He had a house down there on the water and he'd go down there after his battles with Paramount. He was just not answering the phone for a week, disappear for a week, do a lot of drinking. I think Gene Roddenberry

was his own worst enemy.

**LOLITA FATJO:** The day Gene passed away, that was a somber day, but his memorial service was amazing. It was a perfect send-off to him. We were all there, hundreds and hundreds of people. They had the Blue Angels fly over at the end. It was a real tribute. Nichelle Nichols sang a song that she had written for him. It was all it should have been as a tribute to somebody like Gene. The last year or so of Gene's life, he was definitely not around like he used to. He would come in once in a while, but I think just because his family wanted him to feel like he was getting out of the house. It was very rare that he came, and he definitely wasn't involved in the writing. I don't remember if filming shut down after his death. I know that the writing department didn't stop. We all said a toast to Gene and went on.

**DENISE OKUDA:** It was [a shock] even though he had been ill for quite some time and really didn't come around that much. It's always a shock when it happens and you're never ready. Production shut down. We all kind of gathered together, those of us who loved Gene and knew Gene. He was such a big part of our lives and, of course, responsible for our jobs too. It was very difficult. I especially remember being outside and watching the sun go down and thinking, this is the last day that Gene Roddenberry was on this planet.

**MICHAEL OKUDA:** Gene knew he was at the end of his career, and possibly his life. He had brought in Rick Berman, Michael Piller, and Maurice Hurley to shoulder the writing responsibilities. Yet, he was very much a father figure, especially to those of us who grew up loving *Star Trek*. He was the guy who made it happen.

**DENISE OKUDA:** Gene Roddenberry was always very generous and kind to both Michael and I. So that, coupled with the fact that we'd admired his work from childhood through adulthood – it was a bitter loss. Even though we knew he was in ill health, it's always a shock.

**JERI TAYLOR (screenwriter/executive producer, *Star Trek:***

*The Next Generation*): Rick, Michael, and I were in Rick's office, as we often were, going over a script. Rick got a phone call, took it and didn't say much. He came back over and said Gene had died. My reaction was the realization that one of the most significant men in television was gone. He fit a niche that was uniquely his own. There have certainly been people who have created many successful series, and written many memorable episodes, but what Gene did, I can't think of anyone else who has done anything quite like it. He got one series on the air for three years only, and that spawned everything else.

**RICK BERMAN:** Gene's optimistic attitude for the future, I always felt deep in my heart was somewhat unrealistic. But it was his attitude, and it was what *Star Trek* was all about. When he got sick and passed away, I felt it was my responsibility to keep Gene's optimism alive. I think I managed to do that all the way till the end.

**LUCIE SALHANY:** Shows always get better. After a while the cast starts melding together, the storylines are easier, they find what the audience wants and they gear it toward them. We did a lot of research, but for us and for those television stations, it was a hit from day one. It was the patriarch of all the television shows. Had Domestic Television Paramount not been given approval and continued fighting for that show, I guarantee no one would have launched it. No one. It would have been sold to a network, may have been made for a couple of years or whatever, and then, gone.

*Star Trek* was a wholesome program. Advertisers liked being in it. When Gene had created the first show, it was about mankind in the future and how it was going to continue and how good people were. It was often good and benevolent, and so advertisers liked that environment.

**MICHAEL OKUDA:** I'm in the camp of – I'm very proud and fond of the show – I don't think the first or second seasons are particularly strong. We worked very, very hard on that show. First season was a killer. I think we're very lucky that because of the structure of the deal, we stayed on the air.

*Thankfully, the show did stay on the air, and the third season saw a major revamp and reappraisal for the* Star Trek *series – one which would ensure the show would be remembered for… generations.*

# (WE NEEDED IT) YESTERDAY'S ENTERPRISE
### Yesterday's Enterprise, TNG Seasons 3-7, and beyond

*"Let's make sure history never forgets the name... Enterprise." ~Captain Jean Luc Picard*

*The beginning of the third season of* Star Trek: The Next Generation *saw a number of changes both in front of and behind the scenes. Gene Roddenberry and the majority of the writers he had hired were gone, and a new group of writers were brought in. Michael Piller, Ronald D. Moore, Ira Steven Behr, and others would go on to define the writing and style of* Star Trek *for a generation. Viewers for the new season would also note even a difference to the visual aesthetic of the series – due in part to the hiring of new cinematographer Marvin Rush, whose preference for bright, natural color schemes strongly contrasts the colder, metallic appearance of the first two seasons. Robert Blackman was also brought on as the new costume designer – who brought a more naturalistic approach to the costumes.*

**MARC CUSHMAN (author, *These Are the Voyages*):** *Next Generation* took about three years to find itself. Especially the first season is weak.

**DAVID LIVINGSTON (supervising producer, *Star Trek: The Next Generation*):** The first couple of years on *Star Trek: The Next Generation* were difficult. The writers were trying to find their voice. When they did, it was a phenomenal change. The ratings reflected it. The Emmy nomination for best show on its seventh season proved that out. But the first three and the first year particularly was quite trying.

**LOLITA FATJO (pre-production associate, *Star Trek: The Next Generation*):** The first two years that I worked on *The Next Generation*, there was definitely a lot of conflict amongst the producers, the writers, the "suits" at Paramount. It took a good while for that to all get sorted out. When Michael Piller came on board and started working directly with Rick Berman, things really took a turn and seemed to start going in the right direction. That's my feeling. Then

with bringing Jeri Taylor in and eventually Ira Behr coming in to run *Deep Space Nine*, it just really worked. I give Michael Piller much of the credit for turning that writing department around.

**WENDY NEUSS (co-producer, *Star Trek: The Next Generation*):** I think that by season three *Star Trek* was really hitting its stride. Michael Piller coming on made a big difference. Rick was more in charge. Ron Moore came on that season and the scripts started getting a lot better. Gates McFadden came back, that was a whole interesting thing. When I started on season two, Diana Muldaur was the doctor. She was a lovely person but that was not a happy experience for her. I felt for her, I really did, that was a tough time for her. Then season three, Gates McFadden came back [as Doctor Crusher]. She was lovely and we became very good friends, but that was a whole strange thing. I think that she settled in and I think that was probably a better relationship. She fit maybe more because she'd been there.

**MARK A. ALTMAN (creator, *Pandora*; author, *The Fifty-Year Mission*):** The decision to bring Gates McFadden back was a combination of Michael Wagner, who was the producer before Michael Piller stepped in, and Gene and Rick. Rick had always been a supporter of Gates. I think he did not have the power the first two seasons that he would have later on. He wasn't involved in that decision to fire Gates, and I do think he was a factor in bringing her back. The fans also felt that way, it was an easy fix. Ultimately, Gates was a really interesting character, but they never knew how to write for her. She was never a character that got a lot of love.

**RICK BERMAN (executive producer, *Star Trek: The Next Generation*):** We originally had Bill Theiss doing the costumes – he passed away. Then Bob Blackman came on. He had a huge job – dealing with the wardrobe and costumes of so many people, and trying to keep things fresh and different, but also similar to the *Trek* we've seen before. He managed to do it all, and do it all aesthetically with perfection. It became funny – Bob would always be waiting for me in the parking lot [in the morning] and would have three or four pages of drawings, and he would know pretty much exactly which one I would

like. By the time we walked to my office, we had made decisions that would go through the show.

**ROBERT BLACKMAN (costume designer, *Star Trek: The Next Generation*):** I had come from theater where I'd done nothing [science fiction]. I had spent a good portion of my design time at that period in the 19th century. I had gotten a gig through a friend for a sitcom - the only reason I took it was it had 12 four-year-olds in it and that interested me [as a designer]. The guy that ran the wardrobe department at Paramount said to me, "I need a big favor from you. They're losing their second designer for *Star Trek*, and they are having trouble having people come in. Would you do this for me?" And I said, "I'm not a futurist. I think the spoon's going to be around forever, as is the button. I don't think I'm right for this. I've never done anything like it." Which was a little bit of a lie because I had actually done a Schwarzenegger picture called *The Running Man* (1987), but that was only five minutes in the future. That's what it looks like. Anyway, I said, "No, I'm going to pass." I saw him the next couple of days, we were wrapping and he said, "You got to do this for me." So I said, "I'll do it. I'll do it." Good pal and all. So I went in, I was interviewing with David Livingston. I brought in my theater portfolio, which had an amazing amount of peculiar things. One of them was a production of the Scottish play or Macbeth done kind of Japanese modern. At that point, late '60s, early '70s, it was all that pattern, shoulder, weird cross-over racing stuff. I showed it to David and he was intrigued.

I was replacing Durinda Wood. Bill Theiss did the first season, Durinda did the second season, and then I came in for the third one. She had never done television and she was not… I mean, she's a marvelous designer, but it's a rigorous, rigorous, rigorous thing, particularly when you're doing something as inventive as *Star Trek*.

At times there were conflicts [during the era when *Next Generation* and *Deep Space Nine* were filmed] in the same week, big episodes. Then when we went to *Voyager*, the same thing happened. I think it happened two or three times on that one. But we just manned up more. We just got more people. It was a little tough for me. I had to do a lot

in a short amount of time and have to really have my wits about me, but I seem to have been able to do it. And I'm proud of that, as far as – I love the design work on all of that, don't get me wrong. That's why I stayed for 16 years, was that Rick provided me with a laboratory to experiment in.

The pressure coming into this was great for me. I knew I could handle it, but I didn't really know the degree of detail that was going to be looked at in dailies. I would have to go up to dailies on a weekly basis, at least for every episode, if not more, to look at different things that Rick had found or took issue with and wanted it corrected. Some of them were minutiae to me that were people not in the background, not in the first row, but in the second row and "Look at the wrinkles on that thing, look at the..." I was not underwater, but I was treading really hard to just keep up with the principals.

When I came in, the men particularly had objections to the spandex uniforms and that had to be dealt with. I think that's one of the reasons I was brought in. I had enough information and tailoring and so on and so forth, and I could do that. It was a long process. Then if you look at the first two or three episodes of the third season, you'll see that there is an actual migration from trying to do a wool, two-piece outfit that looked like the one-piece spandex, which didn't really work. So at some point in frustration, I just said, "Well, let's go back." I might've looked at the second World War and saw Dwight Eisenhower and his little jacket that was fashioned just for him. I said, "Let's me take that silhouette of that." That's how we came up with the two-piecer, was just simply trying to figure out how to make the things more comfortable and breathable for the guys. And it's clearly easier to use.

**JOHN TENUTO** (*Star Trek* **historian, startreknews.net**): If there is a Mount Rushmore of *Star Trek*, Michael Piller definitely deserves to be on it. He's responsible for bringing in some of the most prolific *Star Trek* writers. He co-creates *Deep Space Nine* and *Voyager*, he writes *Star Trek: Insurrection*. He takes the Borg, which had been introduced in a second season *Next Generation* episode called "Q Who" and elevates them to legends in terms of his work in "The Best of Both

Worlds." He was an incredibly gifted, imaginative writer who brought a humanity to *The Next Generation*.

**RONALD D. MOORE (screenwriter/producer, *Star Trek: The Next Generation*):** Michael Piller writes an episode, and then Rick Berman and Gene ask him to come on and be the head writer. When Michael took over the writing staff, it was a very demoralized staff. There was a lot of animosity and acrimony left over from the second season and Michael was trying to learn what the *Star Trek* universe was about. Michael's edict was, "We're going to tell stories about the Enterprise characters." Every show had to have an idea of whose episode it was. This week is a Worf episode, this week is a Troi episode. That focus to the show hadn't really happened before. There had been various stories they told about the different characters, but it didn't really come from this sort of character-centric point of view that Michael brought to the table. That philosophy guided the rest of the run.

**LOLITA FATJO:** Michael Piller was a great guy, a good friend of mine. I still really miss him a lot. We both had a passionate love of baseball. Michael of course had season tickets for the L.A. Dodgers, and we all went to the games with him a lot. He also was a wine connoisseur. Who doesn't love a wine connoisseur? But Michael was also a very complicated guy. Very, very shy, but just so full of talent. His whole thing was he wanted to pay back. Somewhere along the way, somebody gave him a break that got him his first writing assignment; his whole philosophy was that is what he wanted to do on *Star Trek*. He was able to start that open script submission policy that we had for years. No one in Hollywood was doing that, and over the years we received 30,000 scripts and discovered some very talented writers who have gone on to do amazing things. Ron Moore, René Echevarria, Brannon Braga, the list goes on and on. If it weren't for Michael, some of those people may never have gotten their break.

**MARK A. ALTMAN:** The show really finds itself in the third season, when Michael Piller comes in. He replaces Michael Wagner who basically couldn't take it. There were so many cooks in the kitchen, and Michael Wagner basically had a nervous breakdown and left the show.

But before he did, he recommended this young writer he'd worked with on *The Probe*, who was Michael Piller. Piller had started his career as a journalist and in Broadcast Standards, which was a censor for CBS. He'd worked on *Simon & Simon* and shows like that. Michael Piller, not a huge *Star Trek* fan, but instantly got *Star Trek*. The funny thing about Michael is – he was not a fan of the original *Star Trek*, but he was a fan of *The Next Generation*. So when he comes on, he knew instinctively what this show needed to be, which was a character show, and to do deeper dives into character and use that as a way to explore. It wasn't about the anomaly of the week, and it wasn't about all these tech-no-mysteries. First, it was about using the *Star Trek* universe to explore the characters in a deeper way. When Michael Piller realizes that, that's when the show starts to work.

**JERI TAYLOR (screenwriter/executive producer, *Star Trek: The Next Generation*):** Michael Piller was a very interesting man, and an excellent writer, and above all else, an excellent teacher of writers. He handled the staff firmly, but imparted so much wisdom about the process of writing. Especially the young people were fortunate to have him as a mentor. Michael could be very difficult. Especially towards the young men in the room. It was a delicate balance to handle them. They were talented, they were intelligent, they thought well of themselves, and Michael needed to keep a lid on some of that or else it would've blown up. So he could be very difficult. Firm is the nice way of saying that. I know it was frustrating in many instances. I was kind of the Earth-mother of the group, so I would pat their backs and soothe them and say, "Now, now, it's going to be all right." In retrospect, I think they all realized how valuable he was to them. But at the time there were many, many rough patches.

**JOHN TENUTO:** One of the most important things Michael Piller did was, he opened up the *Star Trek* writers' room, so that anyone could submit a script to *Star Trek*. You had to sign a release, just in case your script happened to be similar to something they were working on already. And through that process, they found some of TV's best writers, including Ronald D. Moore. That was something that existed in the original *Star Trek* too, but it wasn't as formal a policy. But it was

215

something Michael Piller thought was a great idea.

**LOLITA FATJO:** No other show in Hollywood was doing that script submission policy. It was insane, and that part of that job fell on my department as a script coordinator. My office was just piled with scripts everywhere. We had outside writers come in and cover them, and the staff would try to read, but after a while it just got to be too much. After about six years we pulled the plug on it, but it did work for quite a while.

**MARC CUSHMAN:** I came in [to pitch an episode for the show], and there were three guys on the couch. I'm pitching to Michael Piller, and he was like, "That's intriguing." Then he looks over at these three guys, and one says, "No conflict." The other says, "No conflict." Next one says, "Comic book 132." So one of these guys had watched every episode of every *Star Trek*. The other guy had read every paperback book. And the other guy had read every comic book. They were like little computers with all this data. And I was like, "Oh. I've never read comic book 132. Here's another idea." "(Cough.) Paperback 74." Everything's been done. You're pitching against a universe that's gotten so dense, everything's been done. Which is why they'd invite us in, because they needed springboards. Because they had wracked their brains.

**RICK BERMAN:** When Michael Piller joined us in seasons three, Michael created a much more standard television writing process. He had a writers' room, he had story breaks, he had writers from both outside and within do episodes and do rewrites. That was not the case in the first year with Roddenberry, or the second year with Maurice Hurley – that was more hodgepodge, "Okay, here's a story, we'll give it to so-and-so to write it." Once Michael came aboard, it became much more of a structured process.

In the first season, Gene ran the show in a very hodgepodge kind of way. People would bring him stories, he would give it to a writer, give it to others to get notes – it was very odd. Second season, Maurice Hurley, pretty similar. It was not a classic television writing staff. When Michael came in, who had experience in the classic television writing

staff, it became structured. Story meetings, breaking stories, and having the production side and the writing side collaborating every day. It was Michael's appearance in season three that got everything much closer to the way television series are run today.

*Among the many finds of Michael Piller's open script submission policy, were future titans of television and film, including Ronald D. Moore, Jane Espenson, Bryan Fuller, René Echevarria, Robert Hewitt Wolfe, and others.*

**RONALD D. MOORE:** I had gone to college to be a lawyer and discovered I didn't want to be a lawyer. Flunked out of college in my senior year, and suddenly had to start my life over again. I moved to Los Angeles with a friend of mine who was trying to make it as a writer in Hollywood. He knew that I liked to write as well, but had never really seriously considered making it a career. I lived in L.A. for about three years and I took a variety of jobs like messenger and animal hospital receptionist. One day I started dating this girl who had a connection to *Star Trek: The Next Generation*, she had helped work on the pilot and she still knew people over there. She saw that I was a *Star Trek* fan cause I had Captain Kirk posters in my apartment and she said, "You know, I know people over there, and they have a regular set tour that I could probably get you on." And I was like, "Oh my God, I get to tour the sets?! That'd be unbelievable!" So she made a call and she got me on the set tour. She said, "I've set it up. It'll be in about six weeks." And I, for whatever reason, cause I really wasn't the guy that was always a go-getter, I decided to write a spec script. So I wrote a script called *The Bonding*.

It took a couple of weeks [to write it.] I started from the premise of, they had set up the idea that the Enterprise-D had all these families on board, but they had done very little with them. I thought that was a weird concept, that there were all these families and kids, but I thought it was also interesting. Well, tell me a story about some of those people. So I thought, "What happens when a little boy has his parents die on an away team mission? What happens to that kid?" It all started from there. Then I gravitated towards, "Well, maybe - Worf was the security guy at that point - so if Worf is in charge, maybe Worf feels responsible

for this kid and it becomes like a Worf/kid's story?"

[The script complete], I tucked it under my arm and brought it with me when I went to take the tour of the *Trek* sets. Richard Arnold always gave the tour of the sets and he kind of liked me and I kind of worked him a little bit until he finally agreed he'd read it. And he liked it. I didn't know at the time, but he was one of Gene Roddenberry's assistants. Then Richard took the script, gave it to the woman who became my first agent. Agent submitted it to the show and it sat in the slush pile for seven months. This was basically second season *Next Generation*. End of seven months, Michael Piller came aboard to be the new head writer. Michael started going through the slush pile and he found my script. I get this call one day that he wants to buy it and produce it, which literally changed my life in that moment. Then Michael asked me to come in and pitch some ideas for another one. I met with the whole writing staff at that time. I pitched, one of the pitches, was a show that became "The Defector."

So I wrote "The Defector." After that, Michael called me up again out of the blue and just said, "I just fired one of the writers. Can you show up tomorrow as a staff writer?" And I said, "Oh my god!" I literally came to his office the next day, and I was there for 10 years. It was an amazing thing. I was very lucky. I had the right script at the right time. It was an unbelievable break. But I knew the show. I knew the show really well. I knew the original show backward and forwards. I watched *Next Gen* and recorded it on VHS every week. Ask your parents what that is. So I knew the mythology. I understood how the show was made. I knew the rhythms of the show and the voices of the characters. So when I got my break, I was really prepared to take advantage of it.

**LOLITA FATJO:** I love Ron, he's still a dear friend. We were all so close in those days. We were all young and fun and traveling the world together because of the conventions. But Ron always had something special. It was obvious, but he probably told you when he first came to the show with the script called "The Bonding," Michael Piller bought it and said, "Ron, go away and write another one." He was on

a week-to-week contract, so every Friday at five o'clock, he'd be a nervous wreck, wondering if this was going to be the day they'd let him go. Obviously, that never happened until he chose to leave many years later. He's had a phenomenal career. Unbelievable.

**JERI TAYLOR:** Getting a script for *Star Trek* developed was a tedious and time-consuming process. We had an open submission policy for scripts, that no show does. We invited absolute unknowns and newcomers to come in and pitch story ideas. We would do anything we could to urge people to come and give us their ideas. If we liked it, we'd pay them for the story. Then it would go on to the writing process, which is more complicated. The staff and I would sit in my office and work out the story, and whoever was assigned to write the story would go off and write the story, which would be anywhere from seven to twenty pages. Not hugely long, but enough to flesh out the story. After that came the fascinating process called Breaking the Story. An intern would stand at a whiteboard, and we'd start with the teaser and we'd all decide what happens in the teaser. Once we're all happy with that, we'd go onto Act One. Scene, characters, action. We'd very specifically layout each one. It could take days to do this. It's a very exhausting process, but a very important and necessary one. At the end of this process, there's a teaser and five acts on the board. The intern types that out and gives it to whomever has been assigned to write that script. Then it becomes solitary. Then the one writer goes off and does his or her thing and turns in a draft. Then you give notes on the draft and there's a second draft. Then it goes to the studio and the studio gives notes, and when there was a network, it would then go to the network and the network gives notes. So it's a very drawn-out process to get things from the idea to the shootable script.

*The open-submission policy also led to one of the greatest episodes of* Star Trek *history – "Yesterday's Enterprise."*

**MANNY COTO (executive producer, *Star Trek: Enterprise*):** "Yesterday's Enterprise" is the classic *TNG*. My favorite *TNG* was "Yesterday's Enterprise." It was a fascinating concept, a great idea. The idea of making Whoopi Goldberg the one who can sense that

219

all of this is wrong. I love alternate futures and alternate realities. So it immediately fascinated me in the idea that this was an alternate future dependent on – it really was their Edith Keeler, except it was a starship, and EVERYONE had to die in order for time to be restored.

**RONALD D. MOORE:** I really loved "Yesterday's Enterprise." I helped crack it. It was a spec script that had gone through a couple of drafts already, then I took a pass at it, reconceiving the story. Making it a much darker universe on the other side, and emphasizing the war aspect and the tragedy of it. But then the entire staff wrote it. We all took different acts. So it was a quilt of all of our ideas and all of our work put together. At the time, we thought it was a disaster. It was way over budget, way behind schedule, we were churning out pages almost hours before it would shoot. You just had this sense internally that this is just going to be a fiasco. So it was a pleasant, pleasant surprise when it became something of a classic.

**LOLITA FATJO:** I think that the show took a real turn there. That was a great episode. I think there's more writing credits on that episode than any other *Star Trek* episode ever. It was a real collaboration of people, and it was a fun episode that brought back a beloved character. I think it was a changing time for *Next Gen*. I didn't work on the pilot ["Farpoint"], but I remember watching it years later, and it looks so stilted and so old. "Yesterday's Enterprise" was a huge hit and a big change for *Next Generation*.

*The road to getting "Yesterday's Enterprise" on the air was far from a smooth one. The shake-ups to the writing staff in early season three, combined with new crew and the general pressure of producing 26 episodes of television a year, led to the feeling the production was always two steps behind. The infrastructure for* Star Trek *was largely starting over.*

*David Carson, who would go on to direct "Yesterday's Enterprise" as well as the first* Next Generation *feature film,* Star Trek: Generations, *originally came from a successful career as a television director in the U.K., and found the U.S. model of television production… interesting.*

**DAVID CARSON (director, *Star Trek: Yesterday's Enterprise*):**
There was a great culture shock coming here, because things are done
in a completely different way. Just to give you an example of how epi-
sodes are made — at that time, you had seven days to shoot them, seven
days to prep it, and four days to edit. In England, to do a one-hour
episode, you'd have probably six weeks to prep it, three or four weeks
to shoot it, and then four or five weeks to edit it.

I'm very concerned about performance, and work to help actors
to achieve that performance. Sometimes challenging them. As much
as one knows about directing and the challenges of production — it's
nothing without the performance. The performance is one of the
greatest things that you, as a director, can help the actor realize. I was
taught that by working in England. Because in England with our the-
ater background, performance is incredibly important.

I had done "The Enemy" [*TNG* S3E06], and they were very
pleased. The thing I had not realized about *Star Trek* when I was in
England, nose in the air, going "*Star Trek*? What's that?" I hadn't realized
what a wonderful, wonderful place *Star Trek* is to be a storyteller. You
cannot just do sci-fi; you can also relate it to our modern lives. You can
do stories about race, rich and poor, whatever. You can do that stuff
through the lens of the 24th century, which gives you the ability to pit a
Klingon versus a Romulan, and let one die because they won't take the
blood of the other, which would have given them life. Which was the
theme of "The Enemy." Very exciting for me because that was a real
human situation.

*The finished episode of "Yesterday's Enterprise" begins with the Enter-*
*prise-D encountering a spatial anomaly, out of which comes the Enterprise-C*
*— torn out of their timeline 22 years before, during a heated battle with the*
*Romulans over a Klingon outpost, and teleported to the present. As the*
*Enterprise-C enters, our heroes change — a new timeline is created where the*
*Federation has spent decades at war with the Klingons, and is on the brink of*
*destruction. Lieutenant Worf is gone and replaced by Tasha Yar, who fans know*
*too well died a horrible death 18 months before. The uniforms have changed, the*
*atmosphere has changed — the crew which supports exploration and discovery*

are now ones of war and destruction. Guinan is the only one to vaguely be aware of the change and pleads with Picard to ask the Enterprise-C to return to their previous timeline. As the wounded crew from the battle-worn ship are tended to, Tasha Yar and Lieutenant Castillo from the Enterprise-C grow closer. Tasha begins to suspect she may be a byproduct of the timeline change and confronts Guinan on the issue. Guinan is still foggy on the situation, but can say Tasha died a meaningless death in the other timeline. Picard convinces the Enterprise-C to return to their own timeline, that a Federation ship protecting a Klingon colony against suicidal odds may avert decades of war. The ship returns, but with Tasha Yar amongst the group, just as Klingon birds of prey destroy the Enterprise-D and all aboard. The timeline reverts to normal, and our crew goes about its journey.

The script for "Yesterday's Enterprise" has possibly the most complex history of any Star Trek script to date. The earliest origin comes from separate script submissions by Eric Stillwell and Trent Christopher Ganino — one which involved a change to the timeline, and one which involved the moral question of sending someone back in time to face certain death that they were meant to have. Eric Stillwell was a production assistant on the show at the time, but his script was still among the stiff competition of the thousands of other submissions at the time. Michael Piller suggested that Stillwell and Ganino combine their ideas and submit again. While the script would be bought, and Stillwell and Ganino's work completed — the scriptwriting process was only just beginning.

**MICHAEL OKUDA (scenic art supervisor, *Star Trek: The Next Generation*):** Eric Stillwell started out as a production assistant, which is the entry-level job where you work very, very hard. Eric worked his way up to become an assistant to the writing staff — he was always a big *Star Trek* fan — and when Michael Piller had his very unusual policy of open submissions, Eric tried, was very persistent, and ultimately made the sale.

**RONALD D. MOORE:** I had the advantage of not knowing what I know now. Michael Piller gave me the spec script for "Yesterday's Enterprise," and the two scripts for what would become "Sins of the Father" on the same day. It was my first week on my first show. I didn't know any better, I just thought, "Oh, this is what I'm supposed

to do." So I took "Yesterday's Enterprise" and I read it. I liked the core concept, but a lot of it didn't work. I said, "Okay, I'll just write a version of what I think works with this." So I stripped out things like the probe and Data, and all that, because I didn't think they were working – but I liked the idea of the alternate timeline. There was a mention in the script that they had been at war with the Klingons for quite a while, but it wasn't front and center of the story. I thought that was the coolest part. That would make it a darker universe. So as I wrote the story outline of what I thought this show would be, those were the primary things, keep the alternate timeline, make it darker, make it more militaristic, and strip out everything else. And I just gave it to Michael – I didn't know what kind of deep trouble we were in.

**WENDY NEUSS (co-producer, *Star Trek: The Next Generation*):** I remember it being a rush to put it together. It was based on two different scripts that were submitted, one by Eric Stillwell, who was on our staff, and one by Trent Ganino. Ira Steven Behr and Ron Moore wrote it, then Michael Piller came in and cleaned it up. They were all working very quickly to put it together. They merged the two ideas together, it took different incarnations, and it came out pretty well. When a really different, exciting script came in, you could just feel it. When the production meetings happened, everybody would be there. Somebody from every department would be there, and it really brought everybody up to their A-game. Everybody there was a talented professional, everybody wanted to do their best work, and "Yesterday's Enterprise" was that kind of script. You could hear the excitement. It was an interesting show to work on because they were creating two different time periods. That's always interesting when you have, can go back and forth, both in sound mixing and set design. I rewatched it recently, and I remember thinking how good the acting was too, with Patrick being more of a wartime captain in the past scenes. It wasn't just a good episode and it did bring everybody up to their A-game.

**RONALD D. MOORE:** Guinan was a strange, mysterious character that none of us really understood what the hell she was. In the second season there had been a scene when she and Q kind of made finger puppets at each other and you sort of went, "Okay, so Q's

worried about her? So she's like a super-being of some kind of way or something?" But that never really got explained. She can see things and sense things at the convenience of the story. When we started really getting into *Next Gen* in the later years, what we said was it's really about her relationship with Picard. Yes, she's the bartender. Yes, she listens to all their problems and gives insight to people for various issues, but she has some backstory with Picard and it's a personal relationship with him that drives that character forward. It's the only reason she's on the ship. It's the only reason that she really matters in the show. Then you would just find moments here and there, where maybe she could help us with the plot. Like in "Yesterday's Enterprise," she was key.

**BRENT SPINER (actor, "Data," *Star Trek: The Next Generation*:** It may be just my opinion, but I think we became legit when Whoopi came on the show. Whoopi was a major movie star, and she came on in the second season. That was a big deal. Whoopi Goldberg is going to be on your show, and not just doing a guest spot, she's going to be a semi-regular on the show. I think everybody had to say, "Wait, what? Let me watch this now." A major movie star decided, at the peak of her acting career, to do this show. I remember Rick called me in the hiatus and said, "Hey, I've got big news. We've got a new cast member." And I said, "Really? Who is it?" He said, "You've got to guess." I asked for a clue, and he went, "Jewish." I thought it's got to be Judd Hirsch, right? But it turned out to be Whoopi. I think it made an enormous difference to us being taken seriously.

*The rewrites on the script were handled by not one, not two, but every member of the writing staff for the episode. This was due in large part to a last-minute shuffling of the production schedule.*

**DAVID CARSON:** I wasn't sent a script; I was told to turn up at a big conference room meeting that Rick had called. We were all sitting there, and Rick announced that because Whoopi was free, we were canceling the one that I had to prep, and we were doing one called "Yesterday's Enterprise." This was seven days before we shot. There was no script. Just an outline of what the thing was. It wasn't just a rewrite, this was an entire new build of the Enterprise bridge, and dealing with

a whole new set of problems. The actors, how would they look after spending 20 years at war? How would they behave differently? What would they do? Picard became this snappy, irate commander, that we haven't seen before on *The Next Generation*.

The writers went with just an outline and started writing, and we started plotting how we were going to shoot it. We all got together with Herman Zimmerman and talked about how to make it different, but still similar to how we do it ordinarily. Putting in stairs and giving Picard a command chair — which changed the entire atmosphere. When you look at that bridge, you knew something was wrong. So it was incredibly exciting, and nerve-racking, to do that. Seven days we started shooting. Which was extraordinary.

**RONALD D. MOORE:** It was hard to get a complete script. We had carved up the show into pieces. I took the spec script and wrote a story outline from that. Then we as a writing staff sat down and formally broke the show, but we were running out of time. The clock was ticking, the show was going to prep. There was no time for any one of us to actually sit down and write a full draft. So Michael carved up the show and handed out the acts to everyone. I got teaser and one. I don't remember who got which, but somebody got the second act and the third and the fourth, and then I volunteered to do the fifth because I just really liked it, liked the episode.

*One of the highlights from the episode comes from a scene between Captain Picard and the Captain of the Enterprise-C, Rachel Garret, where Picard confesses the true state of the galaxy, and the ramifications if the Enterprise-C does not return to its timeline.*

**RONALD D. MOORE:** That scene was conceived when I was working on the story outline. That was the core of the whole concept — it's not just that they're at war, it's that they're losing the war. That's the dark thing. I think the original spec had them at war with the Klingons, but it was mostly off-camera. I thought, the riskier move would be to say, "It's not just that they're at war, but the Federation is actually losing. The good guys are losing." And that gave the episode

stakes and a bit of a tragedy. There was a doomed sense to the world that we were in. So that scene with Picard and Garrett was in the back of my head.

**DAVID CARSON:** I was very keen to see how you could take a person after 20 years, who turns out to be completely different from the one you've been seeing in a parallel universe. What happens to you after 20 years of war? The way you speak, the way you hold yourself, the way you feel about life. That was a really fascinating subject as an overall thing to do in *The Next Generation*.

We discussed it at every level. I remember a lot of discussion went into Patrick's hair, for example, and what color it would be and whether it would be more grizzled and whether it would be darker and whether the makeup would be angrier and how people would hold themselves. Jonathan's beard was completely different. So every department had this idea to make it look like they've been at war for 20 years.

**RONALD D. MOORE:** I still don't like the opening scene with Guinan and Worf. I had written a different scene that Rick Berman killed, where Worf and Guinan are sitting there in Ten Forward looking out at the stars, and Guinan says to them, "You know Worf, everyone comes in here and looks out at the stars, and you don't. Why is that?" Worf takes a beat and says something like, "To look at the stars is to ask questions. To the Klingons, we don't ask questions of the stars, the stars ask questions of us." And I loved that line! It was one of my favorite things, and Rick killed it because he said it was too poetic. Broke my heart.

*The biggest surprise to longtime fans was the return of the deceased Tasha Yar. For in a galaxy of war and not exploration, the Enterprise would never have gone to Zed Lapis sector so Tasha Yar could have been killed by that weird oil... thing.*

*It may be hard for some fans to remember, given the startling difference in almost every aspect of the show between seasons one and three, but Tasha's return*

*came only 18 months after she departed.*

**RONALD D. MOORE:** We weren't sure Denise would do it, but we were really attracted to the idea, because she had only left fairly recently in the history of the show. There was still a hole there. There was a sense of, "What a great character, the audience loved her and was sad to see her go." And there was a sense that the character of Tasha didn't really go out with the episode she deserved. So when we were talking about bringing her back, everybody was excited about the idea, but we didn't know if Denise Crosby would be willing to do it. But then she was. We knew that our fans would get a kick out of it, and definitely show that we were in an alternative timeline. It wasn't just their uniforms and the lighting scheme – something fundamental had changed aboard the Enterprise.

**DENISE CROSBY (actress, "Tasha Yar," *Star Trek: The Next Generation*):** Never in my wildest dreams did I think that that was possible. I died. We know that. One day I'm home and Rick Berman calls me up and says, "We have a script. It is so good, and it involves Tasha. We want you to come back and play her. Would you just read it?" I said, "Of course, but what do you mean? This wasn't just a dream in the shower or something." [Referring to the show *Dallas*, where they brought a character back from the dead by merely saying the season he was gone was a dream – and the reveal came from him stepping out of the shower as if nothing had happened.] He said, "No, no, no. It's a time warp space thing, and just read it." So he sent me the script and I read it and went, "Wow. This is fabulous. I'm on board." It was so fun to go back and gauge where everyone was at on this show.

**DAVID CARSON:** A theme which I've done a couple of times on *Star Trek* is, "How can you tell if your life has been worthwhile? And if you don't know, how can you change it if given the opportunity?" That's at the heart of "Yesterday's Enterprise." That's Tasha's choice. Does she know she's going to have a pointless death? Did she know that? No, she didn't. But she discovered an emotional feeling, and decided she'd rather go out and die doing something that is going to be heroic and is going to change the galaxy. She had to grapple with that,

and we had to grapple with that and how you express that.

*"Yesterday's Enterprise" was truly the crucible of fire for the new production crew of* The Next Generation. *Through its success, they proved they could do anything – and would set the gold standard for the next 15 years of* Star Trek *production.*

**DAVID CARSON:** I think one of the most thrilling things about "Yesterday's Enterprise" — and I think it was probably true for the whole crew — is the fact that we were given an outline to start with. We had no script. We didn't know where it was, where it started, where it finished, and we didn't actually have a list of sets. We didn't have anything at all, but you had everybody. You had a brilliant team of writers, great set builders, wonderful designer, brilliant people who were working on this project, "Yesterday's Enterprise." They had none of the usual things that you have when you go in to start an episode with seven days to prep it — you've [ordinarily] got a script, which you don't deviate from; you build and you create within the parameters of that script or that play. But here we were, and we had no parameters. We just had a story.

So suddenly you've got all departments talking to each other about, "Do we really want to have a bridge that's that high? What is going to happen to the death of the captain of the Enterprise-C? Who is going to play this role?" And everybody's having a part in it. So that you got a whole lot of very, very brilliant people who will all do their jobs incredibly well, suddenly unleashed, if you like. Like a lot of grounds there suddenly for free to create what they want to create in their own area and bring it to the executive producers, the writers, the director, and all of us collaborate to make what turned out to be a wonderful show.

**RONALD D. MOORE:** I wanted to kill everyone on the bridge. Like everyone was going to die. I had written a very bloody beat by beat. Every single character had their own particular way of dying on the starship bridge. And that got cut back for production reasons and money and we couldn't kill everything. I was really quite gleeful of the

idea that I was going to kill every single one of them, one by one.

**MICHAEL OKUDA:** "Yesterday's Enterprise" is a case of — when I read the script, I didn't particularly like it. I thought it was overly broad and the time-travel stuff didn't particularly work for me. It was an enormous amount of work. We had to readdress the sets and we had to come up with different ways of doing things. I mean, it was fun, but it was just so much to be done. The Enterprise-C bridge, just redressing the Enterprise-D bridge, was a big job. Richard James, our production designer on that episode, he had his hands full.

The visual effects advisor, Ron Moore, came up to the art department and he said, "We need some graphics for post-production." So I said sure. I always asked them, "Give me a rough cut of the episode because I need to understand the context." So he popped the cassette in and we watched the episode and I went, "Oh my God, I had no idea how good this was."

*"Yesterday's Enterprise" was the 15$^{th}$ episode of* Star Trek: The Next Generation's *third season, and aired on February 15, 1990, to a ratings success of 13.1 million viewers — the third highest of the series as a whole. The episode would go on to be number one on many fans' top ten lists, as well as one of the favorites for the people behind the scenes. "Yesterday's Enterprise," along with other season three episodes like "Who Watches the Watchers?" and the legendary "Best of Both Worlds," marked a turning point in the show, both for public perception of the series, and for the working conditions behind the scenes. By the fourth season, the production of* Star Trek *became a much more well-oiled machine, and would largely continue as such for the next 15 years straight.*

**WENDY NEUSS:** I think "Best of Both Worlds" was the defining moment for *Star Trek* for me because the Borg were terrific villains. They were scary, they were different, they had a huge ship. I remember the excitement around that really kicked everything up in a bigger way.

**MARK A. ALTMAN:** "Best of Both Worlds" is the show that changed the perception of *Star Trek: The Next Generation*. It got everyone talking all summer. All summer everyone was talking about *Star*

*Trek,* and people were saying, "Oh, I stopped watching that months ago." [And the response was], "Oh no, you need to watch it." People started watching repeats over the summer, and were hooked.

*Two major hires to the writers' room came with season four that would help define* Star Trek *for years to come, Jeri Taylor and Brannon Braga.*

**JERI TAYLOR:** I came to work on *Star Trek: The Next Generation* by something of a fluke. I was not a sci-fi writer; I was what I would call a "*Star Trek* virgin." I had never seen any episode, any movie, anything. So I came as a complete neophyte. Someone I had worked with on another series was on staff there, and he called me and asked if I'd be interested in doing a rewrite. They had a script that needed a rewrite. I was unemployed at the time, so I was desperately glad to get this phone call. I said, "What is the show?" He said, "*Star Trek.*" And my heart sank. Knowing nothing, I had identified it as a silly children's show that had no interest for me. But I was unemployed, so I said, "Okay, I'd be happy to do that." In preparation for the rewrite, the producers sent over a number of scripts and tapes of episodes, and I watched them and thought, "This is wonderful!" On the basis of that rewrite, I was asked to join the staff.

**BRANNON BRAGA (screenwriter/co-producer, *Star Trek: The Next Generation*):** Michael Piller hired me as an intern and introduced me to Jeri Taylor, another mentor. Michael Piller was an amazing writer. I think people correctly perceived that when Michael Piller started writing for *Next Generation,* it got better. He found ways to put the characters into believable conflict. He found ways to tell better stories. And he found really good writers. He had Jeri Taylor, who was a very seasoned writer and a great writer, but he had these kids. Ron and I were, I was 25, Ron was 26. We had no business writing for the show. And I think we did a decent job. [Michael] was always on the lookout for new writers and he brought great people together. He died very young. I wish he was still around. I would have no career if not for Michael.

**JERI TAYLOR:** I take responsibility for bringing Brannon Braga

onto the staff. He had done some writing for us, and I thought he had great value. So I concocted a way so he could be brought on staff, in a way that Paramount wouldn't really have to give us any more money to do it. And that was appealing so he was put on staff. Then he just blossomed as a writer. He was one of the most creative people I've ever known.

**LOLITA FATJO:** [Jeri Taylor] wasn't the first woman on staff, but she was the first woman to come and stay for a long time and also co-create a show. When she came on *The Next Generation* as supervising producer, she was learning as everybody does about *Star Trek* when they first come because not everybody that comes on a staff is necessarily a fan of the show or knows the history of something like *Star Trek*. So Jeri used to religiously take home every single night three VHS tapes of *The Original Series* and of the seasons she wasn't on for *Next Gen*. She just read everything, the novels and all that. She was also a very calming figure to everybody, because when you have a lot of men running around, you really need a calming woman. Besides being talented and just a wonderful human being, she was a breath of fresh air.

**JERI TAYLOR:** Very often [I was the only woman in the room.] There were times that it was difficult, but I never really felt to a deep degree any kind of resentment or any kind of negativity towards me being a woman. In television, writers are needed. And so long as I could write the show, I was valuable. I think that took precedence over sexism.

**BRANNON BRAGA:** I don't think I met Rick for the first six months that I worked on the show. He was a mysterious presence across the way in a building next door. It was like going to see the Wizard of Oz. As time went on, we became very close friends and colleagues. And when *Enterprise* happened, we wrote the pilot together and we wrote a number of episodes together. He was a lot of fun to write with, a very talented writer.

Rick oversaw everything, and was heavily involved with the editing.

He's an amazing editor. I learned a lot from him. He read and took notes on every script. Very detailed. The production at that point was largely running on its own, so Rick was mostly involved with the writing and editing.

**RONALD D. MOORE:** Rick is a complicated person, to put it lightly. Rick is a born raconteur. You sit down with Rick Berman in almost any social situation and he will start talking and he'll make you laugh. He'll tell you a tale and he'll get something out of you and he'll listen to you. He just has the gift of gab and he can entertain anybody in any situation. I've seen him do it over and over again. He can be charming. He can be funny. He can be witty. He can be your best friend. And he can be a son of a bitch. Rick can really hold the whip hand. Rick wants what Rick wants sometimes. He has an enormous capacity for work. Rick would work very long hours. Would read all the scripts. Every draft. Even when he had multiple shows going. He understood the studio system so well. He could play the political game with the suits like no one I've ever seen. Paramount left us alone. Never talked to Paramount. Only Rick.

**JERI TAYLOR:** I have nothing but good things to say about Rick Berman. I thought he was an extremely impressive person, he was bright, articulate, sensitive, compassionate. He was probably the perfect person to oversee everything. He and Michael would have great fights over scripts, because Michael had his very clear vision, and when they didn't have the same vision, things got very testy between them. But they always managed to work things out. Rick always liked my writing and was always very respectful with me. I had a wonderful working relationship with him.

*With* The Next Generation, *the creatives behind the scenes found the freedom to explore the cultures of the* Star Trek *galaxy in ways* The Original Series *had not. Episodes, books, and comic books expanded upon the lore of the Klingons, Romulans, Cardassians, even the Q, to the growing delight of fans.*

**RONALD D. MOORE:** Michael would turn to me periodically for that kind of, like, reference material. So I sat down and wrote up

a memo to Michael that outlined what I thought the Klingons were and who I thought the Romulans were. A lot of it I just pulled out of thin air to be honest. I mean, I extrapolated things I had seen them do in the movies and in *The Original Series* and sort of what had been suggested in *Next Gen* up to that point. From that I said, the Klingons were a cross between the Vikings and the Samurai. They party, they're big, they're loud, they're boisterous — and they have this very rigid internal code of honor and ethics. It was the melding of those two cliche ideas.

From that, then Michael thought, "Oh, you understand this race." He gave me a stack of scripts in my first week that they were having trouble with, and he was like, "Okay, see what you can do with these." One of them was "Yesterday's Enterprise." Then there were these other two scripts that both had Klingon elements. One had Worf's brother in it, one dealt with Worf's dead father. The idea was, "Oh, is there a way to combine these two?" And the synthesis of those two became "Sins of the Father," which took us to the Klingon homeworld and suddenly did a much deeper dive into Klingon culture and history and tradition and social mores and all that.

So in the course of writing that episode, I just started establishing a lot of things from the Klingon culture. Some of that I drew not just from my own imagination, but there was a book called, *The Final Reflection* that an author named John Ford wrote, years and years ago, that was written completely from the Klingons' point of view and encountering the Enterprise and Kirk. I loved that book as a kid. A fascinating book and it really was eye-opening in a lot of ways. When I was doing "Sins of the Father," I remember going back to things that had been established in that book about Klingon cultures and I drew elements and pieces from that to do "Sins." Once I'd done "Sins of the Father" and it ended in this open-ended way where Worf has lost his honor and someday he's going to return, well clearly, we're going to do a follow-up at some point. Then it was like, "Oh, well that was your story. Do you want to do the follow-up?" "Yeah, I'll do the next one." So then I did both "Redemptions." And then from that point, I was essentially the Margaret Mead of the Klingon Empire.

*As* The Next Generation *grew in popularity, the threat of cancellation abated, and work became more routine.*

**BRENT SPINER:** It was backbreaking, in the sense that I'd never done it before. When you're working that many hours, that many months, you get to the end and you've got two months. The first month is recovery, the second month is sort of preparing to get going again. It was seven years of it, and we did 176 episodes. It's funny because now, network episodes are still 22 episodes, but when you work on a streaming show, it's generally 10 episodes. I've been in them, and somewhere around episode three or four, the cast is going, "Oh, seven more, how are we going to do it?" I remember Patrick, first episode of the season, every season, we would get ready to finish the episode, and he went "All right, only 25 more." It was kind of backbreaking, but again, we were young and happy to have a job, so no complaints. It was daunting starting a new season and having 26 in front of you, but it was great work.

**BRANNON BRAGA:** When I started on *Next Generation*, right before season four, 26 episodes was normal. But it was crazy. We got two weeks off, and then you come back and start the next season. We had a normal-sized room too, at any given time we'd have five writers. It was a shitload of work.

**JERI TAYLOR:** It was difficult to find anyone who could write *Star Trek*. I don't know if I could give the reason why. It was a very specific kind of writing. And even people who had been quite successful writing for other shows just could not write a *Star Trek* script. So finding writers at all was difficult.

**BRANNON BRAGA:** Roddenberry's vision of the future. I may be projecting some of this, I don't know. But I think it's powerful. I think it's a mythology we can get behind. It's one without rage and one without. It's one of a path where we fixed stuff and we figured it out and we overcame our amygdala issues and leaned into the frontal lobe. We became a thriving species that wasn't choking each other to death and depriving people of things, and the acquisition of wealth being the

main thing was gone.

This is just my opinion, but I never got hung up on the "There's not enough conflict between the characters." Well then go work on another show! That's what this show is. This is a show about people who will have conflict, but when they do it will be very memorable. Michael Piller brought so much of this in, I remember an episode where Worf will not give his blood to save a Romulan's life, and Picard lays into his ass. That's conflict earned. You remember that scene. *Star Trek* is about a different kind of human beings. If you want to write about 20$^{th}$ or 21$^{st}$ century human beings – go work on a different show! I never had an issue with that. Didn't find it constraining.

Gene envisioned a secular society, where the negative impact of thinking we are separate from nature and created special as a separate entity from the natural world, is gone. Now you can call and say it is anti-religion, but I like to think of it more as anti-superstition. People see reality more clearly. We are a part of nature and know our place in the universe.

**RONALD D. MOORE:** I think if anything, I was too involved with the tech side. One of the banes of my existence was writing the technobabble on the show. There was so much time spent trying to come up with plausible scenarios scientifically to what theoretically could happen. There were just too many arguments in the writers' room, yelling about what the fucking warp drive could and could not do. So much of that took so much time of my life that I want back. And I don't think it really helped the show. There are chunks of that show where characters are talking about things that are impenetrable. And we would write them that way. There were script pages where we would literally write "tech" in the script when we didn't know what the scientific word was, and someone would help us fill it out later. You could write entire scenes that were more about rhythm and pace than about really what they were saying. Cause you were just going to fill it in with this gobbledygook. So there would be pages of dialogue where Picard would say, "Mr. LaForge, what if we tech the tech of the main deflector?" And Geordi would say, "Well, Captain, if

we tech the tech, then the tech will overload, and the tech will have a backup on deck 42." And then Data would chime in, "Captain, there is a theory that if we do tech the tech, and use Doctor Frankenburner's overdrive, then perhaps the tech won't tech anymore." "Is it possible, Mr. LaForge?" "Well, Captain, we don't have much time, but if I tech the tech right now…" It was just stuff, and we'd have pages of it. And when you watch the show, you can't follow any of it. It's impenetrable. It's nonsense.

**LOLITA FATJO:** I was talking to Brannon not too long ago, and we were saying "26 episodes a year? That is nuts." Nobody does that anymore. It's very rare. You see sometimes eight episodes, 10 episodes of most of these shows, which to me is frustrating. I like the old school, but it was exhausting. We'd be there until midnight day after day after day. About episode 15 or 16, there was a major burnout in every department. That's a lot of TV, especially if you think how many of us were working on two shows at the same time. My crossover with *TNG* and *Deep Space Nine* — that was double duty every single day. Then *DS9* and *Voyager*, and then throw the two *Next Generation* movies on top of it? That's a lot of work. More than one season overlap, especially for *TNG* and *Deep Space Nine*. The writing staff didn't really get much of a hiatus every year because it wasn't that long. You have to have something to go back to. A lot of times they were working during hiatus. Not necessarily crazy hours a day, but they were working. So it was hard, it was very stressful, but it got done. Somehow at the end of the day, it all got done. For the most part, I think most of the episodes of all those shows came out. You're always going to have some losers in the bunch, but that's okay too. It's part of TV.

**BRANNON BRAGA:** I think working in a constrained budget was a really healthy thing because it taught me how to do that. It always forced us on to tell more intimate stories and character-driven stories. I don't think a show like *Next Generation* is considered an action show. It's a drama. With more money, we would've done more action, don't get me wrong. But we had to tell these more contained character-driven stories, which is what *Star Trek*'s known for.

*While the original* Star Trek *reached its peak popularity only after its cancellation,* The Next Generation *hit peak popularity in its fourth and fifth seasons. The series which at first had been lambasted by fans for trying to replace Kirk, Spock, and McCoy (how dare they!) was now the show most identified with the term "Star Trek." Merchandising – including possibly the most varied toy line of all time – books, comics, video games, more books, more comics – the* Star Trek *fandom was no longer living in the shadows, but out in the open. Families would gather nightly to watch reruns of* The Next Generation, *educational experiences would tour the country at museums, schools found an uptick in eager students hoping to learn more of science.* Trek-Fever *had arrived for the new generation.*

*Possibly the best illustration of this new fandom comes from a story Rick Berman told in* The Fifty-Year Mission: The Next 25 Years *by Edward Gross and Mark A. Altman: "I got a phone call that Stephen Hawking was outside Stage 8 of Paramount and wanted to come in and see the* Star Trek *sets and was it okay. I immediately said it was okay and went down to the stage… We took him around, and when we got to the bridge of the Enterprise, he started punching in something that he was going to say to us… After a good 60 seconds, out of the computer came a sentence I will never forget… "Would you lift me out of my chair and put me into the captain's seat?"*

*Stephen Hawking, arguably one of the great scientific minds of the 20th century, would later appear on* The Next Generation *as himself during a poker game on the holodeck with the other great minds of history.*

*With season four turning into five and six – and popularity of the franchise only growing — discussions soon began to expand the* Star Trek *universe into further spin-offs, and even transition* The Next Generation *crew into their own feature film series.*

**RONALD D. MOORE:** I think the most fun thing I ever got from the Klingon fans was, someone sent me a hardbound edition of *Hamlet* that had been translated into Klingon. Which was astonishing. Just the idea of translating *Hamlet* into French makes my head explode. Somehow someone had taken the time and effort to translate the entire play into Klingon. It's one of my prized possessions. It's really, really

something.

**DAVID LIVINGSTON:** It became very apparent that Paramount knew that they had a cash cow in *Star Trek*. And the proof in the pudding is that they allow three other versions of that show to happen over the next 17 years. Either as a syndicated model, which was the case for *The Next Generation* and for *Deep Space Nine*, and then as a network show on two of the smaller networks for *Enterprise* and for *Voyager*. The four series that I was involved in, there was never a question of budgetary problems. The studio was always willing to underwrite all the production costs. In fact, every year in which I created a pattern budget for the different series, the budgets were increased and Paramount barely raised an eyebrow about us asking for the increases.

**BRANNON BRAGA:** Some viewers may disagree, but I was having fun. Then I remember one day in my backyard thinking about a story deep into season six — it was like walking into a brick wall. Then I went, "Oh, I'm done. I think I'm done. I think I have to move on from the show." I was getting burned out.

**JERI TAYLOR:** The writing process was handled by Michael Piller and me. Then in the last season, Michael had already moved on to *Deep Space Nine*, so I handled the writing. That's enough of a job. But I was also involved in casting, post-production, there were other roles.

**BRANNON BRAGA:** *Star Trek: The Next Generation* got taken off the air after seven seasons, which is a lot of seasons for any show, but there was some debate about whether to take it off. It was at its prime. The show was never more popular than in that final season. It got nominated for Best Dramatic Series Emmy, which was unheard of for a syndicated show. And the thinking was, "take it off in its prime and go into movies." But I think *Next Generation* could have run for a very long time. Do I think it was a bad call to take it off the air? No, no. Personally, no, because I got to work on the first two movies, and I really had a great time. And one of the movies has become a beloved *Star Trek* movie, which was *First Contact*. I'm grateful for that experience.

**BRENT SPINER:** What Ron said, about being out of gas by 17 — I think I was out of gas somewhere around four. But if you look at the show, the last ten episodes of a lot of the seasons were pretty good. So I don't know how much gas we needed.

**BRANNON BRAGA:** Season seven of *Next Generation*… I think Jeri Taylor and Michael Piller were starting to really focus on *Voyager*. Ron Moore and I were kind of let loose. There were some episodes in there where we were like, "We just need an episode." "Masks" was written by Joe Menosky. It was a script we thought was good, but turned out terrible. I think in that season we were feeling… it was hard.

**BRENT SPINER:** For me, it almost wasn't really seasons, it was a seven-year experience, and it was one long episode that lasted seven years. I don't have a photographic memory of it, as a matter of fact, I barely remember it. I remember moments of it, but I haven't seen that much of it. The experience for me is remembering doing it.

**LOLITA FATJO:** [*TNG* could have gone on for several more seasons,] but they had the bigger picture. They had the movie. That was the next step for them. I think if they didn't go into doing feature films, they probably could have run another two or three seasons. but you know, somebody's eye was on the bigger picture there.

**RONALD D. MOORE:** My perspective is not quite the same as a lot of people on that final season. I felt that we were all just exhausted and tapped out in the seventh season, to be honest. Maybe the show could have lived on for many years, but I think the writers internally, we were really tired and it felt tired in the room. We were pitching stories and struggling to come up with things. There are some good episodes in the seventh season. I'm not saying the whole season was a disaster, but, when you start doing things like, "Hey, let's bring in Worf's brother we've never heard of, and let's do Geordi's mother," you know that we're really just throwing things at the wall. So there was a sense of, "Okay, it's probably time to end the show." Even though theoretically with the ratings and the budgets the show could have lived on for

quite a while.

**BRENT SPINER:** I never really thought about leaving the show. If I thought about it and said it out loud, it was just the desire to play something else. Before *Star Trek*, I'd done a bit of work, and variety is nice, that's what you're trained to do. I remember saying it to a friend of mine, "I don't know how much longer I could do this character." He said, "Stay where you are, see it to the end, because it's cold out there." And you know, he was right. It was a dream part. I got to play so many characters on the show. Not just Lore and Dr. Soong, but there were shows that I would play three, four, five characters in. They were always throwing really interesting challenges my way, and keeping it interesting for me. We had a director somewhere around the third episode who said to me, "If this goes seven years, you're going to want to blow your brains out. How can you play this non-emotional character for seven years?" I said, "I don't know. I don't see it that way. I don't think it's that limited. I think it's an unlimited character." Fortunately, I sort of turned out to be right on that.

*The final episode of* The Next Generation, "All Good Things" … *aired on May 23, 1994. Despite the fact that one week after filming, the* TNG *cast was off filming their first motion picture,* Star Trek: Generations, *the finale for the television series felt like an end of an era. The return of the character of Q, and a well-placed temporal anomaly, sends Picard to visit three distinct timelines in his life – the first moment in "Encounter at Farpoint," the "present" of "All Good Things" …, and the distant future where Picard is elderly and suffering from a degenerative brain disorder. Unraveling the puzzle of his temporal displacement leads Picard to answer questions about his own humanity, and confront the trial Q set him on seven years before.*

**RONALD D. MOORE:** I didn't have any inkling that I was going to co-write the finale. We all internally assumed that Michael Piller was going to write the finale. He was the showrunner, the head of the writing staff, certainly. And it was his right. And we all just assumed he was going to do it. Meanwhile, Brannon and I were writing *Generations*. So we were also busy. And then suddenly Michael said no. He's devoting more of his time to *Deep Space Nine*, and he wanted Brannon

and I to write it. So we were honored and thrilled, but it was also like, "Oh my God, now we have this other two-hour we have to do."

There were a couple of things we knew going in. We had talked about bookending the series with Q. So that was kind of on the table. We knew, "All right, let's have a sense of completion to where the show began with Q." It clearly had to be a Picard story and the stakes had to be enormous. When we first started seriously talking about the finale, it wasn't until very late in the game. It was late in the season when we started actually talking about it in earnest. Then we came up with this idea of, "If we're going to revisit the events of the pilot, let's see it. Let's take Picard back to the pilot. Okay. So now we're talking about something of a time travel-esque kind of show. Maybe it's a bit of Christmas Carol, maybe it's a bit of other time periods." So we started pitching around ideas of taking Picard through different elements of his life, and it settled into past, present, and future, where we ended up. Michael really liked that idea.

Then Brannon and I went off to write it, and we probably wrote it in about a month or less. It was a big crunch because we had been working on the movie for a calendar year or more, a very long time on that movie. And we were still working on it, still struggling with it, still trying to make it happen. Then suddenly we had this other two-hour. Then there were big stretches of time where we were working on both scripts on the same day, and we would get occasionally confused. We would have moments in the room with each other where Geordi's in the engine room, yelling about some tech thing that has to happen to the warp drive. And we literally would go, "wait a minute. Are we in the wrong film? Is that the... wait a minute, what's the warp drive doing? And in the finale, is that the same?" You would get confused momentarily.

It got written in a rush. The first draft was pretty close to what we ended up doing. There were some sequences and some scenes that we cut and changed here and there, but by and large, what ended up on air was pretty close to the way we wrote it from the outset. It's really an interesting thing looking back on it because the finale turned out so

much better than the movie did. The movie we'd spent so much time and energy and effort slaving over, over, and over again. Then the finale, you just like banged out in a rush, like this thing that we weren't anticipating, "Ah, let's just write this thing," and it turned out beautifully. So it's just, it's weird how sometimes those things work.

**JERI TAYLOR:** It was a very sad time for me, and a very sad episode. Just because it was over. I had had such a wonderful experience on that show.

**BRENT SPINER:** For me, the best part of having been part of the *Star Trek* experience, are the people I've gotten to know. Particularly the actors I've gotten to know who I've worked with, our group on *Next Generation*. It was a gift to be able to be with those people, all those hours, every day. We laughed all the time. We're still really close friends, all these years later. They're family, and that was really the greatest gift of all.

*The first* Next Generation *movie,* Star Trek: Generations, *was coming just three years after the final film of the Kirk/Spock/McCoy era, and at the time, a "transition" film between the two generations was deemed necessary by the studio. While an alternate script was commissioned from the season two showrunner, Maurice Hurley, that would have featured Picard visiting a holographic version of Captain James T. Kirk to get his advice on a current galactic problem, the decision was made to go with a script by Ronald D. Moore and Brannon Braga, featuring Picard and Kirk teaming up to stop a villain who wishes to enter and stay in a spatial anomaly called the Nexus, which would allow for immortality to those inside.*

**RONALD D. MOORE:** Rick Berman called Brannon and I over to his office mysteriously one day and said, "I want to talk to the two of you." And there was no reason why. This was just a command, out of nowhere. "He wants to talk to you and Brannon tomorrow." Brannon and I speculated all night. "Well, what the hell is this? Maybe the show's getting canceled. Maybe we're all gonna be out of work?" And then Rick, being Rick, has to milk the tension and drama for all it's worth. We sit on the couch, he gets up, he walks around, he looks out

the window. He says, "I've been in negotiations with Paramount for the last several months, and they've asked me to do the next movie... And I want you to write it." We were like, "What?!" And it was a thrill. It was a huge honor. We were really shocked, really surprised, and very excited. It was our first feature film for both of us. It was a big deal. It would be a high-profile project, big part of the *Star Trek* mythos.

The conceptualization of the movie took a long time. There was like a laundry list of things to accomplish in that movie. The movie has to have all these elements in it and Guinan was one of those elements. So how do you put Guinan in it? And also in the shooting schedule, and how many days she could be in, and all that kind of nonsense, you kind of quickly go well, given the story that we're trying to tell, the Nexus felt like the most logical place to put her. Cause she's already into some kind of mysterious realm and can tell us weird things expositionally when we need her to, so let's put her there. So when Brannon and I stepped in, here's the list of things it has to be: It's going to be the first *Next Gen* movie. It can have the original cast in it. We want to transition film, but the original cast can only be in the first 10 minutes or 15 minutes of the movie tops. It has to be a Picard story. There has to be a Data humorous runner in it. We want to have a big villain sorta like Khan. We also want to have the Klingons in it, and it should probably have some time travel involved. And you're just going... Okay...

**DAVID CARSON:** Directing a TV show is very different than directing a movie. Especially if it's the same TV show that you're turning into a movie. Because really and truly, the people who created and are the executive producers of the TV show are the equivalent of the director of a movie. Because they're the ones who have the continuity, they're the ones who have the whole picture, and you go in and just do that one hour that's in front of you. In a feature film, [the whole picture] is under the purview of the director – they're the ones who sign off on the designs and the other things. So there had to be some differences in the way our relationships were run.

**RONALD D. MOORE:** It was a lot of elements that they had to all be combined into some kind of story. So from the outset, as soon

as you said, "It's going to involve both casts, the original and *Next Gen*, and in some kind of time travel kind of tale." The original thing that Brannon came up with, which in retrospect would have been the best movie, was he said the poster of this movie should be the two Enterprises firing at each other. That's the movie you want to go see. But we went away from that kind of quickly. I think Rick didn't like it. He didn't want it to be a war movie per se. And, it'd be too hard. He thought it would be too hard to try to come up with a reason why the two Enterprises would shoot at each other.

All that's perfectly valid. Some people have said it should have been "Yesterday's Enterprise," that that should have been the movie. That would have been a great idea. If we hadn't already done "Yesterday's Enterprise," that would have been a wonderful way to go. But it was what it was. So we just dug into it and tried to come up with a story that wasn't just the standard slingshot around the sun and go back in time to revisit the original cast or vice-versa to come forward to hours. So, how about a nexus to blend the two? We had talked about destroying the Enterprise and what does that mean to the show? What does that mean to the mythology? And this theme of mortality started to emerge. It's about Picard getting older. The death of members of his family, the Enterprise is going to die. Captain Kirk dies in the same. So we had this sort of overarching about heroes and heroism and dealing with sort of the end of everything.

**DAVID CARSON:** There's a story about the budget. The budget started at $25 million. That's what Mr. Jaffe told us it was going to be. We did a prior costing of it, and of course, it came out more like $49 million. They told us their "compromise" in this negotiation, would be $25 million. So we said, "Okay…" So I turned to my experienced line producer, and said, "What shall we do?" He said, "Can we cut the budget?" So we chopped the budget, and we came up with $45 or something, and we were told $25. We came down to $35, and they said, "Okay. Below that to $30. You have to cut the script." And in the script, there was a huge thing that we could cut, that would save us money, and that was the scene on the sailing boat – which is magical. So I said to them, "What if I shoot it faster? We don't shoot it in 55 days, we

shoot it in 50 days." They went, "You can't do that, can you?" I said, "Yes I can. I'm a TV guy, we're meant to be going fast." (laughs.) So we did. I cut the schedule down so we could save the sailing ship.

*The biggest risk the film took was killing off the beloved character James T. Kirk — a decision still divisive among fans even after nearly three decades.*

**RONALD D. MOORE:** That was a big thing. It was something I really wanted to do as a writer. I was attracted to writing the final chapter of that character, especially since that character was so personal to me. Kirk was my personal hero growing up, and I was going to get to write his end. That was a very attractive thing. And I was very eager to do that. But it swamped everything else in the movie and not in a good way. It became all about, "this is the movie where Kirk dies," But really it's supposed to be a Picard story and Kirk's death was supposed to help the Picard story narratively. But if you think about it now, that's really backwards. It's hard to tell the death of such a major character of Kirk and have it be supporting a tale of Picard. No one even remembers what the Picard story is in that movie. They just talk about the fact that it was Kirk's death, really. We were trying, we tried, we'd gave it our best shot. And God knows, we certainly wrote it many, many, many times, over and over again, lots and lots of rewrites, lots of different drafts over the course of over a year in development on that.

[The whole film] was just too much. In retrospect it was beyond our grasp at that point. We weren't seasoned enough writers to really tackle that. And it probably wasn't the theme to tackle in the very first *Next Generation* film and the transfer of film. So it just failed in a lot of ways. There were nice elements in it. There's some nice performances in it. The visual effects sequence of the saucer crashes was really great, especially in the pre-CGI era when this was all model-based worked, it was really a different time in terms of visual effects work. So I think that worked out really well. But yeah, it's definitely one that… it just doesn't really work on its merits.

*Despite some fans' (and creatives') low appraisal of the film, others call it their favorite* Star Trek *film.* Star Trek: Generations *premiered November 4,*

*1994, just six months after the series finale, and went on to earn $120 million worldwide. This box office total ensured that the tales of* The Next Generation *would continue for many years to come.*

**MARK A. ALTMAN:** With the farewell tour [of *The Original Series* cast in *Star Trek VI*] in the books and *Next Generation* dominating first-run syndication, the studio turns to the future crew (originally to have been called the next generation in the farewell sign-off on *Trek IV*, but Nimoy, in a fit of pique, had it changed over some perceived slight from the *TNG* gang) for the next movie. What should have been *The Avengers* of *Star Trek* movies with the *TOS* and *TNG* crews locking horns back when everyone was still alive, the studio didn't want a film that wasn't completely a *TNG* film with a dollop of *TOS*, so only Shatner is invited to the party in a major way with cameos from Koenig and Doohan, who replaced De Kelley and Nimoy, who both passed on the insultingly minuscule roles and in Nimoy's case, in directing as well. *Generations* is a bumpy beginning for the new cast on the big screen, but with [the second film] *First Contact*, *The Next Generation* finds its footing thanks in large part to the directorial aplomb of Jonathan Frakes. Unfortunately, the lessons *of First Contact* are squandered [in subsequent films] as both *Insurrection* and *Nemesis* are busts both financially and creatively.

# DANCING WITH THE SYNDICATION STATIONS IN THE PALE MOONLIGHT
## Deep Space Nine

"So… I lied. I cheated. I bribed men to cover the crimes of other men. I am an accessory to murder. But the most damning thing of all… I think I can live with it. And if I had to do it all over again, I would. Garak was right about one thing, a guilty conscience is a small price to pay for the safety of the Alpha Quadrant. So I will learn to live with it. Because I can live with it. I can live with it…" ~Captain Benjamin Sisko

*The increased popularity of* Star Trek *during the early 1990s encouraged Paramount to explore the possibility of more spin-offs for the* Star Trek *franchise. A new show, but trading off of the success of* The Next Generation *– set in the same time period of Federation history, with the possibilities of crossovers to bolster the ratings. The decision was made fairly early on to change the format compared to previous iterations. Gone is the notion of "exploring strange new worlds" on a starship, and instead, the series would be set on a space station. Swapping the allusion to* Wagon Train *for something closer to* Fort Laramie. *A Federation outpost, on the "frontier" – out of range of immediate help, in a war-torn region where the Federation was largely unwanted.*

*The story finally settled upon was of Commander Benjamin Sisko, still grieving over the death of his wife at the Battle of Wolf 359 (from the Borg invasion in "Best of Both Worlds"), who is ordered to take command of* Deep Space Nine *above the planet of Bajor. Bajor was under Cardassian occupation until recently, and the oppressors left the planet in poor shape. The Federation hopes to bring Bajor into the United Federation of Planets, and hopes the peacekeeping presence of a small Federation team will facilitate matters. Sisko and his son, Jake, arrive on the station, only to find that the spiritually minded people of Bajor see Sisko as being more than just a Federation commander – but as an Emissary to The Prophets. The Cardassians have also sought to unlock the secrets of these Prophets, so Sisko sees this mystery as a potential way to sway the Bajorans to the Federation side, allowing him to leave the station sooner with a completed mission. During the investigation, Sisko discovers the Prophets reside within a natural, yet stable, wormhole – which opens and*

*connects to the other side of the galaxy. Inside the wormhole, Sisko is haunted by visions of his dead wife – and has to relive the moment she died time and time again. On Deep Space Nine, the crew struggles with a confrontation with the Cardassians, who have returned when news of a stable wormhole reaches them. Sisko's visions lead to a catharsis, and an understanding between himself and the aliens that dwell within the wormhole – the Prophets – is formed. Sisko returns to the station, and he takes up his post to stay on Deep Space Nine.*

**LARRY NEMECEK (author, *Star Trek: The Next Generation Companion*, podcast host, *The Trek Files*):** You've got Rick Berman along with Michael Piller, who is now the number two guy in the franchise, and the go-to "writer guy." Rick is the producer-producer, and he needs Michael to be the writer-producer. They go, "What are we going to do? Are we going to do another show on a ship?" And remember, there's going to be a couple of years where *DS9* and *TNG* are going to overlap. Do you confuse the audience? Or do you set it on a space station. Out on the frontier. And set up a whole starting off conflict between two people. There's the whole thing of the Cardassians relinquishing Bajor, actually done in *TNG* as set up for *DS9*. It was an allegory for the Palestinians and the Israelis, or the Jews in Nazi Germany. The oppressed people who were fighting for liberation. And we (the Federation) are the ones looking, going "Gosh, I wish we could do something to help."

**MARK A. ALTMAN (creator, *Pandora*; author, *The Fifty-Year Mission*):** Michael Piller told this story of how, when he and Rick Berman first sat down to write the *Deep Space Nine* pilot, something just wasn't working. It was only in the wake of the L.A. riots that he figured out what it was – this is a guy who needs to rebuild his community. The riots galvanized the pilot, and they rewrote it to where *Deep Space Nine* had been gutted by the Cardassians, and the odds were stacked against them, and Sisko had something to fight for – he had to bring people together. That was at the heart of what made Sisko a great character and one of the great starship captains.

**DAVID CARSON (director, *Deep Space Nine*):** *Deep Space Nine*

was really important, not only to *Star Trek*, but also to Paramount.

**MARK A. ALTMAN:** The pilot of *Deep Space Nine* [titled "Emissary"] is fascinating because it's really risky. It's metaphysical. It's very inward-looking. The most commercial aspect of the pilot is, "Oh, we get to show people the Battle of Wolf 359, from the 'Best of Both Worlds'!" It's a great teaser. Then Patrick Stewart's in it to throw some red meat to the fans. Ultimately, it is a very cerebral and gutsy pilot, because it's about a character who doesn't want to be there, who suffered a terrible loss and basically wants out. In that sense, he's very much like Captain Pike in *The Cage*.

*In addition to influence from "The Cage," the "Emissary" script also took influence from "Encounter at Farpoint" in the way that characters would be gradually introduced over the course of the two-hour pilot. The initial hope of Michael Piller and Rick Berman was to bring a recurring character from* The Next Generation, *Ro Laren, to be a series regular on* Deep Space Nine. *Ro's Bajoran heritage and history with the Bajoran resistance had been set up in TNG since Season 5, but actress Michelle Forbes declined to participate. The role was thus redeveloped for a new Bajoran resistance fighter, Kira Nerys. The first draft for the two-hour pilot was submitted on June 12, 1992, with the hope of production to begin in August.*

*Taking advantage of the same straight-to-syndication model of the previous series, a full season commitment was given to* Deep Space Nine, *with production design and casting taking place over the summer of 1992.*

*David Carson, director of "Yesterday's Enterprise" and* Star Trek: Generations, *directed the pilot and would thus be involved with the casting of the project.*

*Unlike its predecessor,* Deep Space Nine *would feature many faces recognizable to the average American viewer — starting with the lead, of Avery Brooks as Commander Benjamin Sisko. Born October 2, 1948, in Evansville, Indiana, Brooks found early roles on the stage and Broadway before landing his first big lead role as the character of Hawk in the ABC show, Spenser for Hire, (1985-1988), and the Hawk spin-off,* A Man Called Hawk *(1989).*

*As his son, Jake Sisko, actor Cirroc Lofton was cast. A relative newcomer to acting, Lofton's previous credits included Skateboarder #2 in 1992's Beethoven. The father/son relationship between the two would go on to be a defining feature of the new series.*

**DAVID CARSON:** Well, we settled on Avery Brooks because he was the best. He was the best captain. He read the script best. He understood the script really, really well. He understood the character and he was going to bring something completely new to *Star Trek.*

**MARK A. ALTMAN:** At a time when TV was not particularly diverse, here you have this African American, single father, who was a great role model to his son, who was brought up under very difficult circumstances, and who had lost his wife. It's one of the great depictions of African American fatherhood on television. Certainly at the time, but even now. It was such an important character – because *Star Trek* had broken so many barriers – but with Sisko, you had this African American character who had agency, who was powerful, who was in command. It's really remarkable.

**CIRROC LOFTON (actor, "Jake Sisko," *Star Trek: Deep Space Nine*):** My relationship with Avery Brooks is a genuine one. It wasn't something that was predisposed, but it's something that was actually genuine and developed over the time that we worked together. He's somebody that I hold close to my heart and he's been a mentor to me from the beginning. That's why I'm so adamant about defending him and seeing the best for his legacy, and our legacy. Because I do believe that he has done an excellent job at representing black people on screen and keeping his integrity, staying true to the morality that he holds dear to himself, and laying down really excellent, quality work. 176 episodes' worth. I think he did a fantastic job.

**LARRY NEMECEK:** It seems like an eternity between 1987 and 1992. A lot changed, a lot happened, and representation matters. We think about how primitive those days must have been compared to the struggles we're still in now. Rick Berman, Michael Piller – even

as, sadly, issues of gay characters were issues they tried to dance around and handle with metaphors – coming out of the gate with *DS9*, having the lead be an African American was pioneering. The fact that he was going to be a family man, and a single [father] — it was so amazing. It still escapes documentary filmmakers – Avery Brooks and Cirroc Lofton have talked about it – when documentaries are made about black families and especially black fathers, in shows of the '90s and even '00s, trying to show positive images out there – *DS9* is never mentioned.

**RONALD D. MOORE:** I think it's certainly fair to say that Avery being the first African American captain of a *Star Trek* series, especially in that day and age, was a big deal. I think there were certainly racial overtones to some of the criticism that he took from without and from within the studio. That was uncomfortable. It wasn't overt, but I think it was there. I think everyone knew it was there. But eventually, it would all get pushed through.

**CIRROC LOFTON:** [Avery Brooks] was very professional, but also very thoughtful. We'd work late many times and that meant you would have to go way into the night, and sometimes you would require a late meal, something like pizza. So, they'll bring by pizza at midnight, one o'clock in the morning, give everybody a 15-minute break, let them just get a little snack in and replenish their energy. But I can tell you many times that Avery, during those late-night hours, would reach out to Terry Ahern, our craft service guy, and would ask him to find something good for the crew and the cast. "Let's not do pizza, let's do something else." He'd bring in hot wings, jerk chicken, this and that and all these great plates. You'd be eating some wonderful food in the middle of the night, and it was all because Avery took that initiative to say, "I want to make sure that all the guys here on the crew eat good. We've been having a long day and pizza's not going to cut it. They need something different. They need something more sustenance." So for him, to think about the crew like that and to pay for it out of his own pocket, that's the kind of person he was, looking out for you in that type of way. If he sees somebody's getting treated wrong or talked down to, he's not going to just walk past it. He's going to address it and say, "You can't talk to that person like that in front of me, it's not

going to happen. Apologize, and let's move forward." He wouldn't let injustice go. He wouldn't let somebody get mistreated. He wouldn't let somebody be abused verbally.

**DAVID CARSON:** Michael Piller set up incredible possibilities for the character of Sisko. He's working through his own emotions, all the time that he's there. Everything that happens to him is reflected in the fact that he's lost his wife and he's alone with his son, that he has to bring up. He can't just be a lonely person and captain of a ship. He's a family man at the same time, with terrible, terrible feelings of pain, and anguish, and loss. And he now has to come to terms with all that, or he has no future at all. That is the beating heart of *Deep Space Nine*.

**RONALD D. MOORE:** It took me a while to figure out Sisko and I think it took the show a little while to figure out Sisko. He was coming aboard with a very specific, complicated backstory that was different than Picard or Kirk. They were just sort of full-blown captains from Starfleet Academy and the best of the best and showed up to the flagship of the fleet. Sisko comes out of tragedy. He comes out of a tragic backstory of his wife and he's caring for his son and he's scarred by the experience of the pilot and shows up, a man with scar tissue, a wounded man, and to an assignment he doesn't want. That was a difficult fit for *Star Trek*.

**CIRROC LOFTON:** I do remember the first audition. There were a lot of kids there. You walk into a room and see 50 to 100 people. A lot of those are friends and family members, cause they're kids, but still, you walk in the room and see these 200 people. You're like, "Oh god, everybody was going out for this audition." That was the first round, but then obviously as you make it past in the rounds and you get the approval of the casting director and get callbacks, it's less and less. Finally, it was the third or fourth audition, it was down to three of us. I remember my mom was with me, the casting agent, Junie Lowry-Johnson, and Ron Surma. Avery told me later, "You were the only person that gave me a hug in the audition." I said "dad," and he gave me a hug. That was a smart move as the young Cirroc. Then the casting agent, Ron, as he was walking me out, gave me a wink, didn't

say anything just gave me that wink, "good job." As soon as I leave the audition room, my mom's like, "So what happened? Did you do good? Did you remember all the lines? Did you forget it? Did you do this? Did you do that? How many people were in there? What did they say?" I was like, "I think I did good, Momma. I think I got this job." It didn't happen right away. It was a little bit of time after, and ended up being my birthday, August 7. Around nine o'clock at night, our house phone rings, which never rang at that time. My mom picks up and she said, "There's somebody on the phone for you?" I pick it up, and it was Rick Berman congratulating me and welcoming me to the team. I had no idea how that would change my life. It was just an extra added birthday present before I go to bed.

I think I avoided the trap of being another Wesley Crusher, number one, by not knowing about Wesley Crusher. That was the first step. You can't imitate something that you have no idea of. The second part was I was instructed in the beginning to not be like Wesley Crusher. They sat down and said, "We don't want you to be like this." There was a conscious effort to not be like this character from the beginning. What I was told was that he was too much of a problem-solver/know-it-all. They wanted my character to be more human and fallible, just like a regular kid, which was really easy for me to do. That was something that they had started off in the beginning with. It was easy for me to just be a kid. They don't want a boy genius character, the guy who comes in and says, "Oh, I know what the answer is." I understand why, because you have all these adult leaders on the show who went through all this training and have all this experience. Then this guy who was 12 knows the answer. I can understand the conflict with that. But I trust that the studios know this information and that's what they related back to me. They understood that the audience wasn't really receiving the Wil Wheaton character as well as they wanted it to. So they make the necessary corrections and adjustments. You can only do what they ask you to do. If they wanted you to do something different, I'm sure Wil Wheaton has it in his repertoire to be able to switch it up and be completely fallible. It's easy for us to switch it up. But if they're asking you to do that, then he fulfilled the requirement.

*For the role of head of station security, Odo, veteran character actor and former co-star of the long-running television comedy,* Benson (1980–86), *Rene Auberjonois was cast.*

**DAVID CARSON:** Rene Auberjonois was a great piece of casting and there was no doubt in any of our minds, because during his audition, he came in and read for the role, he was as rude as he could possibly be to all of us. And that's all got into the role. He stalked into the room, shut the door firmly behind him, marched up to the table that we were all sitting behind, and started. He didn't say hello to anyone, he just read his lines, finished the audition, turned around, walked out of the room and slammed the door behind him. That was Odo!

**CIRROC LOFTON:** Rene was stoic, really seasoned, very formidable. I thought he did a fantastic job with Odo, and really almost instilled that fear as a security officer to me. How black people feel when they see the police, that's how I felt when I saw Rene, even though he's not like that in real life. It was already cemented in our relationship. Really just a joyous guy.

**NANA VISITOR (actress, "Kira Nerys,"** *Star Trek: Deep Space Nine***):** Rene was such a wonderful romantic lead – so it was such a great opportunity. And weird. I was not the typical romantic interest either – none of us were. So it was great.

*As the fierce Bajoran first officer, Nana Visitor was brought in for the role originally intended for Michelle Forbes. Visitor had appeared in a variety of roles on various TV shows and soap operas, and had most recently wrapped up a series regular role on the short-lived NBC show,* Working Girl *(1990). While the character of Kira Nerys was a late addition to the script, she quickly became a fan favorite and defining arc for the show.*

**DAVID CARSON:** When Nana Visitor did her audition for Kira, I think it was the best audition I had ever seen. The thing about casting Kira was the leading young woman's role in the next *Star Trek.* Many people vied for the role, and we auditioned for it for a long time. In their efforts to make us think they were the right fit for *Star Trek,* many

of the women came dressed in tight pants, uniform jackets, because that's what women are trapped into in *Star Trek*. But Nana was different. Nana stormed into the room and started reading. Part of the thing was she got fed up with something, got ahold of the lose chairs in the conference room, and started throwing them around. And we sat there going, "Wow. This is really a revolutionary who wants to be doing stuff." She came and did her last line, banged her hands on the tabletop and glared at us as if to say, "Okay, I got it right?" And turn them all out of the room. She was right. She got it.

**NANA VISITOR:** I knew nothing about [the role originally being meant for Michelle Forbes] when I got the sides. I read it and it said, "Major Kira," and I didn't think of Kira as being a female name. I thought it was a male role because it read that way. Especially, you have to think back 25 years [to the type of roles women were getting at the time]. I thought, "Oh, this is a mistake." And I actually called my agent and said that – and they said, "No, it's a female role." It's like, "Whaaaa?!" Because one of the recent jobs I had done was playing the mother of – I don't even think it was a pilot, it was a sizzle reel for a pilot called "Cats," where I was the mother and the cat in the show spoke. It was painful things that I was auditioning for. So this was like (deep breath). I went out and bought the boots – I had just given birth to my first child – and that was it. I wanted that role… badly.

*Armin Shimerman, known for more credits than anyone can count, was hired as the bartender/sometime criminal, Quark. Other cast members include* Hellraiser III *star, Terry Farrell as the science officer and host for an alien being that held multiple lifetimes' worth of memory, Jadzia Dax – and newcomer Alexander Siddig as the naïve, adventurous Dr. Julian Bashir. The one familiar face from the* Star Trek *universe comes from Chief Miles O'Brien, played by Colm Meaney. The once fixture of Transporter Room 3 on the Enterprise-D, going all the way back to "Encounter at Farpoint," received a transfer to head up the entire refurbishment of* Deep Space Nine.

**CIRROC LOFTON:** Armin Shimerman was just wonderful to work with. He's such a professional, he's so skilled, and he's also just genuinely a good person to talk to and vibe out with. I obviously

had crushes on both Nana Visitor and Terry Farrell, something that I constantly reminded them of while we were doing this show. But they were awesome. Now in hindsight, as I rewatched the show, I'm blown away by Nana Visitor in her performance on the show. I thought she plays a character that I don't think has been on television before her. I don't think a woman with that kind of strong will, tough but also can flip it and be sensual, playful, and sexy. She just had the full gamut of range. In hindsight, I really appreciate the work she did, but working alongside the actors was a real pleasure. We got things done. I didn't get to spend many hours with guys like Siddig. Rene and I worked together, but it was always like he was arresting me, so it was a little bit of tension. The whole cast, we had a good synergy, but nobody was as close as I was with Avery. I literally felt like he was my dad, but the whole cast was just really awesome. I love every one of them.

**NANA VISITOR:** [Working in soap operas] certainly teaches you to think on your feet. It's kind of like welding because you clock in and you clock out – the hours are like business hours. The thing is the dialogue, and you have to get good at it. You have to give up cognitively trying to hold onto the words and go, "It's in there somewhere," and you have to let go. It's a great lesson.

*Star Trek* world is a whole different muscle. It's somewhere between Shakespeare and film work is where you have to hit the tone. You can't get hysterical every time you've seen a world explode because it's happening every week. So you have to get to that Shakespearean place in your acting. Comedy is very close to tragedy – you amp it up a bit and it becomes comedy, so you have to be careful. You have to be really careful that you maintain the dignity of the piece.

For my character, because it was military, it was easier for me, because I was an archetype to begin with. The way I saw the world was so well-defined – I would see people suffering and it would be a political agenda for me. Right away, you're talking big thoughts. That takes you to that place. You're not talking about someone slighting you at the PTA meeting – it's worlds being at risk, and people that you love. Ideas.

*Arguably, the most important addition to the* Star Trek *team with* Deep Space Nine *was with the hiring of Ira Steven Behr as showrunner. Unlike* The Next Generation, *where showrunners would come and go,* Deep Space Nine *would maintain the creative guidance of Behr from beginning to end.*

**LISA KLINK (screenwriter, *Star Trek: Deep Space Nine*):** Ira Steven Behr was a lot of fun. Ira had toys in his office. He was really into westerns and military movies, and he'd have little toy soldiers everywhere. His writing room was always fun. He was very open to everybody's ideas – it was all about throwing out pitches. It didn't really matter if you were the senior person in the room or the junior person – a good idea was a good idea.

**NANA VISITOR:** I had such respect [for the writers], that when I approached them, I chose my battles. I fought when I thought my character needed it. It was rare. Ira was as passionate as I was – even though he doesn't like to remember that now – when we would get into it. Two New Yorkers going at it about a script point. Especially about when it came to Kira and Dukat being lovers. That was a big one. I couldn't. Another Cardassian – great idea – but not Dukat.

**LOLITA FATJO (pre-production coordinator, *Star Trek: Deep Space Nine*):** I can't say anything bad about Ira. He was my boss and mentor, but ultimately he's my friend. We're still very close. We had an amazing time working on the *Deep Space Nine* documentary a couple of years ago. It really brought us all very close again. That was a blast. Just to work with Ira in that capacity again was so much fun. I can't say enough about Ira. I love him to death.

**PENNY JOHNSON JERALD (actress, "Cassidy Yates," *Star Trek: Deep Space Nine*):** Ira is a gem. Ira with his blue [beard]. Ira is a very special man. He's genuine, he's so understated – humble in every sense of the world. I was very fortunate after *Deep Space Nine* to get a call from Ira to work on *The 4400*, but at the time my mother-in-law was dying and I couldn't go and do it. But I thought, "Oh, I'd love to go work with Ira again…" Ira is borderline genius.

**RONALD D. MOORE (screenwriter/co-executive pro-ducer, *Star Trek: Deep Space Nine*):** Ira's very much about bonding the writing staff, and we're all going to have lunch together. There's a comradery and team effort to it. On *Deep Space Nine*, there was very much a team effort to the show. Ira was very committed to the show. Loved the show, and was pouring his heart into it. Third season of *TNG*, he was doing it almost as a favor. He was a big fan of the original *Star Trek*, but was frustrated by the limitations of *Next Gen*, but cared about the show. By the end of the season, he was like, "I'm done." But the thought of him walking off of *DS9* was unthinkable. He was so committed.

*Filming of the first episode of* Deep Space Nine *commenced on August 18, 1992.*

**DAVID CARSON:** I loved directing "Emissary" for *Deep Space Nine*, because there was a lot of ideas in it. I know there was a lot of exposition in it and we had to establish all the things that had to be established. But for me, that was okay because it was rich in ideas and rich in characters and full of actors who could really embody their characters.

**NANA VISITOR:** When you walked on the set, you were enveloped in this world. There was no doubt that we were doing something really interesting, and that the writers had such a hold on the thing and such an interest. I didn't have a doubt at all.

**DAVID CARSON:** [The first scene shot] was the scene when they come into the bridge with Kira and O'Brien. It was to do with them getting the Cardassian [equipment repaired]. There was a lot of movement in the scene. So I thought this is a great way for us all to get to know this bridge. I followed her and followed them around. Started with a very high shot, establishing shot over the bridge and followed them around on a crane. And that was the first shot.

The first scene was problematic. It caused David Livingston to come and say, "What are you doing? You're still shooting this shot at

lunchtime?" (laughs) It was the first day. David was always immensely supportive.

**LISA KLINK:** "Emissary" was a terrific pilot. It did a really good job of introducing the characters and showing kind of a different world within *Star Trek*. Being on the space station at the edge of nowhere, in the *Star Trek* universe and introducing all these new characters — I thought it was really effective.

**DAVID CARSON:** Michael [Piller] was very concerned that *DS9* should be different.

**DENISE OKUDA (scenic artist, *Star Trek: Deep Space Nine*):** "Emissary" establishes the key points of *Deep Space Nine*. The Bajorans being very spiritual, and that's a theme that carries through the entire series. Of course, the introduction to all the characters – Kira Nerys is this badass person who wants to get things done. Doctor Bashir is this wide-eyed Starfleet officer who comes in. It hit all the buttons of introducing the characters and the universe and so on.

**MICHAEL OKUDA (scenic artist, *Star Trek: Deep Space Nine*):** *Deep Space Nine's* "Emissary" had a much more complicated storyline than "Encounter at Farpoint." "Encounter at Farpoint" was much more, "Here's a ship, here's a crew – go." There was a lot of backstory with "Emissary" – the Bajoran/Cardassian conflict, Sisko's backstory and his antagonism towards Picard, tantalizing things about Odo and the freedom fighter coming in from the cold. It had a much more complicated story to it.

**DAVID CARSON:** You've got freedom fighters trying to clean up the mess left by the Cardassians, you've got a commander who's just lost his wife and he's bringing up his son. You've got all these things going on. At the same time, we're establishing the layout of the station itself. So we're showing the audience the galleys, the walkway outside the bar, the bridge, where everything is. We're having to walk through the whole thing so it'd explain itself to the audience. In that case, when I say it was difficult, it was complex. In an enjoyable way.

Deep Space Nine *is also notable for being the first* Star Trek *show where "humans" are the minority amongst the mostly alien ensemble. Michael West-more and his makeup/prosthetics department had their work cut out for them.*

**NANA VISITOR:** [Early in the show] — it was a little bit of rain, and iron stairs, and I had my sneakers on. I had my makeup done, because that's how they wanted it – to do the makeup first and then you change into your costume – because it was best for the costumer. I opened the door to the makeup trailer and fell down the stairs and couldn't move. I thought, "Here I am, finally got on a TV show, and I broke my back." They took me to an urgent-care place. I'm sitting there in jeans and a shirt, and my hair and makeup done, and this young doctor comes in and goes, "Okay, I see you – OH MY GOD!!! YOUR NOSE!!" He truly believed for that moment that I'd accordioned my nose. The makeup was that great.

*The budget for the pilot episode of* Deep Space Nine *had one of the largest budgets ever seen for television with a startling $12 million ($23 million in 2021 dollars) put into the two-hour episode. $2 million of this was reportedly spent on sets. Herman Zimmerman's work on the production design strove for new heights.*

**MICHAEL OKUDA:** When we did the *Next Generation* pilot, it was still a significant risk for Paramount. Nobody knew if it was going to work. Fast-forward five years to *Deep Space Nine, Star Trek* is a solid hit. We had resources we didn't have on *The Next Generation*. Para-mount was willing to fund us having video monitors – which is not cheap. Herman Zimmerman built the largest, up to that point, standing set ever made – the promenade – a massive two-story structure with alien shop windows and perspective paintings and spiral staircases and a bar. It was huge.

**DENISE OKUDA:** I remember being with Doug Drexler on set when Sisko's wife, Jennifer, dies on the U.S.S. Saratoga. The amount of emotion Avery Brooks brought when he found his wife, Doug and I were shocked. I get goosebumps right now just thinking about it. You could feel the grief in this man. Doug and I looked at each other and

were like, "Do we have an actor or what?"

**LISA KLINK:** The pilot of *Deep Space Nine* didn't strike me as all that drastically different. I think it became so as the series went on. They certainly went to darker places. They had a lot more shades of gray. *Next Generation* was a lot of good guys and bad guys and the Federation with the good guys and other people were the bad guys. Whereas in *Deep Space Nine*, we had a little more blending of not all of our characters were perfect and not all of the bad guys were totally evil. That's what really distinguished it from *The Next Generation*.

*The pilot episode of* Deep Space Nine, *"Emissary," debuted on January 3, 1993, and received 18.8 percent of the ratings for syndicated television stations. According to Jim Benson in an article from Variety on January 24, 1993, "Emissary" became "the highest-rated series premiere in syndication history."*

**NANA VISITOR:** [I knew we had something special] when I saw the pilot. They sent it to me because I had the flu [and couldn't go to the screening at the Paramount Theater]. When I saw the pilot, when I heard the music, I couldn't believe it. I thought it was beautiful. I became a huge fan of the show. I loved what we were doing. I had the opportunity to play a person that I wouldn't get a chance to play anywhere else. I had such a range that I could do – from being a Cardassian to the Intendant – all the different aspects. What is it, 12 archetypes? I almost got to do them all! It was crazy.

**RONALD D. MOORE:** When I first heard of the concept, I didn't like the concept. I was a *Deep Space Nine* skeptic at the beginning. There was an overlap period where I was on *Next Gen* for the last two years of its run while *Deep Space* was doing the first two years of its run, and all of us on *Next Generation* kind of felt threatened by *Deep Space Nine*. Who was the new shiny object? We felt like they were getting all the money and they were getting all the attention. So those of us at *The Next Generation* staff would make fun of it and disparage it and didn't think it was as good as we were and blah, blah, blah. Then *Next Gen* ended, and I was invited to go over to *Deep Space Nine* and took a harder look at the first couple of seasons. I started to see things

**261**

there that I hadn't really noticed before. I saw that there was a deeper commitment to developing the characters. That the characters were in a lot of ways richer and more complex than the *Next Generation* characters were. It was really breaking away from some of the constraints that Gene had put on *Next Generation*. *Next Gen,* Gene felt very strongly that there was not supposed to be any internal conflict among the Enterprise crew. They could not really have differences. He would call them petty fights and jealousies and rivalries and all that, which to me was bread and butter of *The Original Series* was the conflict between those characters, especially the big three. So *Deep Space* really exploded all of that. These were much more complex characters. They had arguments, their own internal rivalries, and jealousies, and loves, and all that kind of stuff.

There was a richness to the mythology that Michael and Rick created in the pilot; of Bajor and the Cardassians and the post-Holocaust of it all; the occupations and terrorism and the Federation coming in and trying to soothe the waters. I started to see that there was a huge opportunity in this show. That staff was really dedicated towards exploiting those characters and pushing *Star Trek* as far as it could. Over my tenure on *Deep Space,* the mantra was, "How far can we push this franchise? What are the places we can go that none of the other shows can go? What can't they do in *Star Trek*? Is there a way we can do it?" It was wonderful. If you think of it in college terms, *Next Gen* was my undergraduate studies in TV writing and production and *Deep Space Nine* was graduate. It's a longer-running story. Let's do bigger, longer arcs. Let's make the characters not always the good guys in every episode. Let's see how they make mistakes. Let's have them angry at each other. Let's break up pairs that you seem to like and put them back together. Again, it was just a great, great experience.

*Due to the high cost of the pilot episode, (an estimated five times the budget of "Encounter at Farpoint" from just five years before) the first season was plagued by the continual need for lower-cost episodes to offset the expense of the first.*

**MARK A. ALTMAN:** *Deep Space Nine* was a show that struggled

to find its identity at first. At first they didn't quite know what the show was. They made a huge mistake because they spent so much money on the pilot — which is beautifully directed by David Carson — that they didn't have a lot of money after that. So they did a bunch of bottle shows on the space station and it fed into this mythology that this was a show that boldly goes nowhere. Because people felt, "Oh, it's on a space station and it's not going to be adventurous, and they're not going to boldly go." That was not true because *Deep Space Nine* was the most adventurous show of all.

**LARRY NEMECEK:** The entire first season suffered from the pilot going over budget. As the first season landed, and this big broad scope started to open up for what we would do with this series, the question became: What's going to be our arc? What's going to be our main mission here for Sisko in this crew?

*Beginning with the first episode, and carrying through the first season, it became clear* Deep Space Nine *would differentiate itself from previous* Star Trek*s in two ways –* Deep Space Nine *would have a more serialized structure than* The Next Generation, *and the series would tackle darker stories.*

**CIRROC LOFTON:** We were aware of the criticism. They called our show "The Dark Show." We didn't really get the warm welcome. We got the kind of criticism about not being a "mobile show," since we're a stationary space station. But there was also the criticism about it being dark and about Avery's look always being under fire. When you look at all those things, *DS9* actually was really ahead of the curve, as far as doing that kind of a show. A serious drama with a black lead, father, family man. There weren't too many examples of that prior. So this was kind of groundbreaking and I'm glad that they did take that initiative. Had they done this now, I think the show would be welcomed a lot more. It would get more acclaim and people would be more willing to receive what they were seeing. But this was before there was a black president. This was before a lot of the imagery that we've seen lately, good, positive black imagery. This was groundbreaking at the time. There weren't too many black people on television that were not doing comedy, trying to make people laugh, speaking in

an articulate way, talking about really meaningful subjects, and telling stories that are meaningful and relative for people to watch.

**DAVID LIVINGSTON (producer, *Star Trek: Deep Space Nine*):** In terms of the drama, I think *Deep Space Nine* is the most interesting. Because of the character interaction, because everybody had wants and desires that conflicted with other people's wants and desires, and that makes for great drama. When you don't have that and everybody gets along, the only way you get drama is by going outside. I don't think that's as interesting as having the conflict in your own home.

**DENISE OKUDA:** I very much believe in Gene Roddenberry's *Star Trek*. I am an optimist and I hold the ideals of what Gene was trying to say about us as a civilization. So sometimes when they did things like Section 31, I did not like that at all. And anything that calls itself, *Star Trek* that goes away from that basic Gene Roddenberry vision, to me, is not *Star Trek*. However, I think that it took a lot of guts. You mentioned serialization -- that was huge. I think that a lot of people back then didn't like *Deep Space Nine*, but it's really interesting now to listen to those same fans say they love it. I know that Mike and I both agree with them.

**RONALD D. MOORE:** We were attracted to doing darker stories. We were attracted to doing stories that had much more conflict in them. That were more morally ambiguous. That were tackling difficult subject matter with our characters. We all felt that we were pushing *Trek*, but none of us felt like we were breaking it. We all felt that it's fine to do *The Next Generation* version of it. It's also fine to do *The Original Series* version of it. It's also fine to do *Deep Space Nine* that all these could coexist comfortably in the same *Star Trek* universe and that it didn't all have to taste the same. The fact that our story took place in a specific corner of that universe and had darker more difficult overtones to it and it took audiences on trickier journeys. To us, that's fine. Why can't both exist? Why can't the Enterprise be out there holding up the torch of utopia and really be this eternally optimistic idea of the future. But also say that over here in a different corner of the same universe, they're having some real problems, you know? So all these kinds

of things just felt like they could fit together.

I think that creatively, [Paramount] kind of gave up on it in terms of "Let them do what they want, because they're not taking our advice. They're not putting engines on the space station and flying it through the galaxy," which is really something they suggested. Sisko is Sisko, and he's not going to be Picard and Kirk, and they won't give up this Bajor thing, and they're still depressing, but the show's doing good enough.

**RICK BERMAN (executive producer, *Star Trek: Deep Space Nine*):** Ira Steven Behr got very involved with wanting to do long strings of continuing episodes. The studio absolutely said no. Because these shows were going to be syndicated, they were not necessarily going to be syndicated in order, and they wanted standalone episodes. I was often blamed for that – I was told, "You won't let us do an eight-part thing on the Federation wars." But it was purely coming from instructions from the studio, who didn't want serialized episodes. Ira wanted more warfare, Ira wanted more violence in certain ways. Which he had every right to want. My feeling was it strayed a little far from Gene's ideals.

**RONALD D. MOORE:** The serialization of the show was something we just kind of did over Paramount's objection, to be frank. *Deep Space* was again another syndicated show. There was no network. Paramount was really the only governing authority and they pretty much left us alone through all those shows, but the one thing that they were adamant on is they wanted the episodes to be standalone because this was at a time of television when binge-watching was non-existent. Nobody did that. The best you could do is maybe eventually buy the VHS box sets and watch them. But that was kind of rare. And people's home recording methods were archaic and didn't function very well. So Paramount and the syndicated stations would say, audience members have to be able to watch these in any order. If people feel like they've missed an episode and they're lost, they're never going to tune in again.

That was their mandate. We really hated that because it prevented us

from really doing a more serialized story. However, the nature of that show lent itself towards having to be a serialized story. Cause you were on the same station every week. The station didn't go anywhere. Bajor was still gonna be there next week. The Cardassians were going to be there next week. All the stories propelled you into picking up plot threads you had established last week or week before. You can see the evolution of the series and the first couple of seasons, it's very episodic. It's trying to be episodic and serialization just keeps creeping in. Cause it just does. But by the end of the run, we just didn't care anymore. The Dominion War arc was a flat-out serialized story. At that point, Paramount had given up and they just threw up their hands and they were like, "ah, let's just go do *Voyager*. And these crazies will finish out this show."

**CIRROC LOFTON:** I didn't feel like I needed to do any more work. The times that I felt like I needed to do more work, they gave me more work to do. That was around the fourth, fifth, sixth season when I was getting older and starting to really have more abilities as an actor, to be able to just nail certain scenes and be able to deliver pages' worth of dialogue. Once I was able to be comfortable with that, they started giving me more of that to do. The other thing is that *Deep Space Nine* had probably one of the largest ensemble casts in my memory of television. When you talk about all the ancillary characters that were involved, there's just so many people to talk about. There were so many guys that were really worthy enough to have their own shows and their own *Star Trek* series because they were that good.

**NANA VISITOR:** I went to a convention, and that happened pretty early. I had no concept of what that would be like, and yet it was incredibly important to me to understand what it meant to them. That was part of the loop that I had been missing. I mean, I had been told it, but there's something way different when you're signing autographs and an old woman goes, "Your part means something to me." Now, she's in my heart, and I'm going on set, and no matter what's going on in my life, this is for you and you and you.

Unbelievable things happen [with the fans.] One guy was in line at

a convention with his computer and I thought, "He's done something that's like *Deep Space Nine* or something, and he wants me to see it." And he had his kids with him. Sure enough, he opened his computer, and showed me something landing on a planet. And I said, "My god! Those special effects! What you did here is incredible." He said, "No, I landed that on Mars."

Deep Space Nine *also sought to put real-world issues onto the screen far more than previous* Trek's *had. Sometimes the cast/crew unfortunately had to confront real issues in the real world as well.*

**IRA STEVEN BEHR (showrunner, *Star Trek: Deep Space Nine*):** We didn't go in with that attitude. Actually, what we talked about in the writers' room is, "Let's explore faith." They told us we couldn't do politics. They asked us not to do Bajoran politics, so we said, "Okay, we'll do religion." So we didn't go in to be down on religion, if anything we were looking for ways to give Kira more stuff and more of a personality. You have a culture that went through some seriously hard times with the occupation. Whenever a culture goes through hard times, that's where you see the rise of fascism. So people, after they've gotten their asses kicked enough, they want someone to tell them, "I'm going to take care of you. We're tough, we're strong, and we're going to see that you're okay." People will buy into that and it doesn't matter what they do.

**CIRROC LOFTON:** Three or four years into the show. I was sitting in my trailer, waiting for production to call me for the next shot, and somebody who I have never seen before comes walking up to my trailer door and opens it. I'm sitting there looking and they start questioning me. "What are you doing in here? Who are you?" I'm like, "Who are you? My name's on the outside of this trailer." "You're not supposed to be here! I'm going to call security!" So, I'm like "Who is this guy? I've never seen him before. He's not one of our ADs or our usual production staff." I was really disturbed by that. Then I went to the stage and found Avery and I told him, He stopped everything and said, "We're going to find this guy, who is it?" We started walking to find this guy, and sure enough, we found him in there. Avery reversed

it on them and stood up for me. "Who are you? What are you doing here?" I can tell you, that's how he stood up for me. I was a kid. I didn't know what the course of action was. He's an adult, he took the initiative to say, "I'm going to fix this. We're going to get to the bottom of this." There's all kinds of little incidents like that, where you are reminded that you don't necessarily belong. People are looking to put something on you. What are you doing here? He had a little bicycle that I would borrow to go around the Paramount lot. I remember one day being on his bike and security stopping me while I was on the other side. And then they started accusing me of stealing the bike. To be even accused of stealing the bike, it's kind of ridiculous. I'm on the Paramount lot, not out on the street, I'm walking around the lobby, driving the bike around a lot, but to be singled out and accused of it is discriminatory.

**PENNY JOHNSON JERALD:** Speaking on the character [of Sisko], watching a black man with this voice where he could play God – this man who commands respect when he just walks into a room – it was spiritual. I say that as a person of color, because we don't get that opportunity often. Now, it's a floodgate happening, but then, it just didn't happen. Here you see Avery Brooks, this power, and not only is he powerful, a talent who's untouched and unmatched by all the others. And I'm not saying African American people – allllll the others. He is playing this father – which you don't get to see a black man playing a father, for some reason America doesn't get the fact that black men can run their families, mentor their children.

I came on the show because I had an instant chemistry with Avery Brooks. And I respected him and I respected his performance from *Hawk*. He was a hero in my community. I felt privileged to take the stage with him. So I came with my A-game.

**ANDREW ROBINSON (actor, "Garek," *Star Trek: Deep Space Nine*):** The very first episode where I was introduced, they wanted to give Julian Bashir a storyline. So they figured, put the young doctor together with the old spy. When I first saw Siddig on set, I thought to myself, "This is a beautiful guy, really good looking." I immediately

said, "I'm turned on by him." Myself, I'm a boring heterosexual, but I thought "This is great. Here's this alien, who knows what the hell the sex life of an alien is, you know?" I thought, "Okay, it's not so much that Garak is gay, he's omnisexual. If there's anything that's attractive to him, that's fine, whatever it be." That first scene between the two of us — I adore that scene. I must say both of us played it perfectly. Sid got what I was doing. His reaction, especially at the end of the scene when I put my hand on his shoulder, his reaction is fabulous. I thought, "That's it, we've got to take it from there." I was certain that the writers would have picked up on that. They didn't, and I don't fault them for that at all. The times are the times.

**PENNY JOHNSON JERALD:** I get a lot of tweets and comments in regards to Cassidy Yates – because she was a captain. She was Captain Cassidy Yates and she stood her ground, but she was still a woman. And that to me is very hard. I think that Cassidy Yates was truly three-dimensional, or all-dimensional if you can get any more dimensional than that, in terms of that she was a woman, a mother, a lover, a wife, but she always remained a captain and true to her cause. She went to prison for that, because she didn't fold under the power of the man, she stood her ground, went to prison, and she made a comeback. In terms of gender, I think it represented what we're actually trying to get to today for women to be powerful and represented.

**NICOLE DE BOER (actress, "Ezri Dax,"** *Star Trek: Deep Space Nine*)**:** A lot of stuff [with the character] didn't hit until later. The stuff with Ezri being a character that transgender people look to, that certainly was not something that was on anyone's mind necessarily at the time. Now obviously, yes, Dax has been a man, then a woman, and understands that – and they did look into that with Jadzia, when she had that same-sex kiss on the show, which was a big deal at that time. But now, I get a lot of transgender people coming up to me saying, "Do you know how important this character was to me? Someone I could turn to who was like me." And I thought, "Wow, of course. That makes sense." But was not on my mind at the time.

**PENNY JOHNSON JERALD:** There was a script that LeVar

Burton was directing, and the scene was the two captains, Cassidy and Sisko, in bed and they were not married, and they were making love. Now we weren't naked or anything like that, station didn't allow for that. But we were hearing rumors that the moment that we wanted to share – which was tender – I think we were rolling over or something to indicate we had just made love – rumor was that that probably wouldn't be accepted, and wouldn't make it to the final cut. In the end of the day, it didn't make the final cut. I don't know why, but I felt cheated. Because that was a moment that, being a person of color, it was important to show that in this black family, that we're normal people and we do this thing that you all do and it's tender and it's beautiful. I felt cheated from that moment, that we didn't have that opportunity for you the viewer to see.

*Possibly the pinnacle episode for* Deep Space Nine's *progressive efforts came from the episode "Far Beyond the Stars," which saw Benjamin Sisko wake up as a sci-fi pulp author in 1950s New York – and experiencing all the racism and bigotry that unfortunately went along with the era. The episode, which was directed by Avery Brooks, culminates with a heart-wrenching monologue by Brooks.*

**PENNY JOHNSON JERALD:** "Far Beyond the Stars"… Woosh… that was an emotional shoot. It took us to a place that was true to the history of what went on during that time. But to be directed by Avery and at the same time for him to be in it, was an extraordinary thing. I must say, out of my entire career, and knowing when I'm involved with a piece of work that should be recognized and given certain accolades, that is one that Mr. Brooks should have been nominated as best director. Because that was something else.

*Despite excelling in terms of story and performance,* Deep Space Nine *found it difficult to take hold in the syndicated television landscape.*

**LARRY NEMECEK:** *DS9* never got the numbers. Never in first-run that *Next Gen* had. *Next Gen* had the explosion that was "Best of Both Worlds" – *DS9* never had a moment like that. A moment in culture. Now, in hindsight, and thank you Netflix and Paramount plus, the

whole binging phenomenon has been so kind to *Deep Space Nine* and *Voyager*. There are so many more fans now than there were in first-run.

The syndicated model had worked so well for *Next Generation*. They had built up this model with the stations. But it wasn't like they owned their own network and they can say, "Okay, everyone running *Next Gen*, now you're going to run *DS9* right after." Because some stations were running *DS9* on 6 pm on Saturdays, or 6 pm on Sunday. After football, but before network programs, or after local news. And there's not a two-hour window there, it's a one-hour window. So when you're going out to sell *DS9*, where are people going to put it? A lot of those same independent stations that were so great for *TNG*, there might not have been the window to put *DS9*. So you're looking at the lower-level stations. If you're there, some poor schmuck in 1995, trying to watch what would end up being the most serialized *Star Trek* show ever, and you're trying to keep up with the show, who knows when you're going to be able to see it. Much less record it. A lot of the audience gave up in frustration back then. Because that was the model, that's how we watched.

**NANA VISITOR:** A lot of us came from Broadway, where they would put the notice up on the call sheet backstage, and you got two weeks' notice. You have two more weeks of employment, and you're moving on. So we all had that, "Well, we have two shows at least before they pull the plug." I was on *Hotel*, the Aaron Spelling show, when Aaron Spelling came in and literally pulled the plug. I was doing a guest spot, and he came in and pulled the plug right there. Boom. So it happens, and it could happen to us. So we had that mentality. Armin Shimerman would go, "How much longer do you think?" "The rest of the year?" But we never took it as a given that we were getting a next season.

**IRA STEVEN BEHR:** We were so lucky that no one was waiting to cancel the show. We had the time to investigate the characters. The actors brought so much to our understanding of the role. You come in, you have a pilot, you get yourself into those characters and who they can be, and then they become so much more interesting because

they're played by actors. Every major character on the show, [the actors] brought so much more to the show, it enabled us to just write them better.

**LARRY NEMECEK:** So here's three to four years gone by with *Deep Space Nine*. They've launched *Voyager*, but *Voyager* is a network show – it's UPN. They've still got this syndicated *Deep Space Nine*. Here's *Deep Space Nine* getting the Defiant, amping up the action/drama quota, the narrative of the Dominion is starting to ramp up – and yet the numbers aren't going up. The viewership ratings aren't going up. They're losing fan numbers.

So we get to season four, and you've got the people running the studio saying, "Guys, how about we do something to shake this up a little bit? How about we bring someone in from *Next Gen*? What about Worf?" There's levels to this – will Michael do it? Can we pay him for that? And there'll be the studio saying, "Make that work." So here's Ira and the team making this wonderful Dominion story – and then they throw Worf in. You have to have some momentous reason for why Worf would show up.

**IRA STEVEN BEHR:** I thought the Klingons were pretty good in *TNG*. When they said we had to bring the Klingons on, no one was happy. We were doing our thing, and they were doing the other thing. But we knew it was going to happen. It would take some getting used to, but it'd be good for the show. Putting the Klingons and the Cardassians together, I thought was really good for the series – plus it bought us Martok, the greatest Klingon out there. Ron Moore was obviously the point man with the Klingons, but by that point we were a writing staff with one mind. All we did was play off of what was done before us.

**NANA VISITOR:** I found out about it from a question at a convention. "How do you feel about Michael Dorn joining the ship?" It's like, "What?!" We had no idea. I thought, "This is it. He's going to be number 2. And I'm going to be pushed down to delivering them coffee." That was my big worry. [Learning that wasn't the case] was a

process, but enjoying Michael was pretty much immediate. That happened immediately. He's just so wonderful. He quickly became a regular at Sunday dinners, because I love to cook. And I didn't feel moved off from my character at all.

**RONALD D. MOORE:** Worf came in because the studio felt that *Deep Space* needed a boost. They wanted a ratings boost. They wanted something to grab a bigger chunk of the *Star Trek* audience. I think the ratings were good, but they weren't great. And they were looking for a way to reenergize the show. It was a flat-out kind of commercial move. Who could we bring from *Next Generation* over here? Rick and Mike talked through the various possibilities. Ira Behr, who was running the writers' room at that point, had talked through the possibilities and Worf was really the only choice from that cast that made any sense. That would actually add something to the puzzle. Here's the war-like character coming into a situation that's a war-torn environment. So that made a certain amount of sense.

It was a difficult mixture. I think everyone on *Deep Space* felt the nature of what it was — that it was a naked ploy to get more ratings. So I think there was some resistance when the character first arrived. Everybody loved Michael, like everyone loved Michael Dorn an actor. He was one of the most popular members of the show and of the cast internally. But it was just the sense of "Why do we need help from over there? We're doing fine. They should leave us alone." But we found ways to work it in and he became more and more part of the fabric of the show as time went on. Especially once you kick up into the bigger Dominion War arcs, and now you're dealing with the Klingon Empire and you're really dealing with a lot of those things, he had a more natural fit once the show went to war.

*Another casting change came at the end of season six, with the departure of Terry Farrell and the death of her character, Jadzia Dax.*

**MARK A. ALTMAN:** The Terry Farrell thing is really sad because of course she brought so much to *Deep Space Nine*. The thing that was great about her was when they realized they should stop writing her

like a scientist and just give her technobabble that she had so much life. She was so good with comedy, obviously Paramount realized that because she got cast in *Becker* with Ted Danson, that she was so facile with comedy. When they started writing to her strengths – which is banter, she's almost like a 1940s Katherine Hepburn type – you realize she's really smart and really funny. Suddenly, the character of Dax really comes to life. The relationship she has with Bashir is very different than the relationship she has with Sisko, and the relationship she has with Kira – it's one of the most three-dimensional female characters that have been on any of the *Star Trek* shows. She's terrific.

**RONALD D. MOORE:** It was a shock and a surprise that Terry Farrell didn't come back for the seventh season. We were just in denial about it up until the very end, so we made no accommodations to where we would pull Dax as a character completely out of the show. I don't think any of us were ready to do that. We just wanted Dax to continue, so viewed it as an opportunity to do different Dax stories, and different relationships. Now she has a different host and how would that change things, in her relationship with Sisko and Worf. We embraced it as an opportunity to expand.

**MARK A. ALTMAN:** It's really sad, because you get to the end of the sixth season, and the budgets are going up and the actors' contracts are about to expire. You're going into your seventh season and you know it'll be your last season, and the network isn't about to start throwing money at you because this is it. She got squeezed in negotiations. I think she felt she was undervalued and at the same time, they were really playing hardball with her. For someone who had been such a part of the ensemble for so long – there should have been more respect there. More of a conversation. Ultimately, people were talking at each other, not to each other. As an agent, you sometimes get the "last and final offer," which sometimes is and sometimes isn't – and she got a last and final offer, and I think to protect her dignity and self-respect, she couldn't accept it. It was heartbreaking for her. I think they were very dismissive in the way they dealt with the negotiations. You want to tell people how valued they are – because actors often want to feel appreciated, and I don't think she felt appreciated. She was being told

she wasn't a great actress, and she didn't bring that much to the show and all this other stuff. In a way, I think she had no choice.

**RONALD D. MOORE:** Yes. She left voluntarily, but there's definitely a complicated backstory. I wasn't involved in the negotiations directly. And so everything I was hearing was from the writers' office, which was also a bit of a rumor mill of what you heard or what Ira heard from Rick who, this or that. So it was all through various filters. It definitely seems like it was her choice in the end, but the reasons why are… I think, complicated. Terry can probably speak to them better than I could. I think it was about money. It was about her role in the show. It was about respect. It was a very complicated dynamic and I don't really know what the short answer is.

**MARK A. ALTMAN:** She didn't deserve that. There are many conflicting stories of whose fault it was. I do know that Ira Behr was not involved – and he was mortified, appalled and angry when he found out Terry wasn't coming back, because he felt the production had somehow betrayed her trust.

**NICOLE DE BOER:** For me coming in, I was only really hearing from Hans Beimler [supervising producer], who was the whole instigator for me to even audition for the role in the first place. So I was only getting positive feedback and that they were all excited to have me. I didn't even know any details about why Terry was gone. I knew that she was on *Becker,* which sounded great. She must be happy. Everything's great. I was told to look at it as a new character, although I would have the memories of Jadzia as well as all these other people before with the symbiont. So everything was very positive that I was getting. I didn't hear anything about hesitations on anyone's part, or on the writers' part. Why would they do that to me? That would freak me out.

I was brought to Paramount to do a screen test, and I was quite nervous. What really didn't help me that day was – as I waited outside of Rick Berman's office, this minivan pulls up, the door slid open, and out comes this silver leg, and in full Seven of Nine regalia is Jeri Ryan. And

my mouth just opened. To see her there in person, she's just stunning. Completely drop–dead gorgeous. And I'm thinking, "That's what they want? Who am I kidding?! I'm not going to get this part!" Of course, that's when they open the door and say, "Nicole, we're ready for you."

**IRA STEVEN BEHR:** I thought Nikki had the toughest job on the season years of the show. I really did. And she pulled it off. None of us wanted to lose Jadzia. None of us wanted Terry to go. And when she went, it was a shock. We really had to regroup and figure out what to do. We decided to stay with the Dax character, we had to figure out a way to make it work. Piller, once we had Ezri up and running, came to us and said it was the smartest thing we ever did, by making her not having studied how to become a Trill. He loved it. We threw her into the deep end big time. She played it differently, but there was a continuity there, and we finally found someone who Julian [Bashir] could… I don't think she gets enough credit.

*A major high-point for* Deep Space Nine *came from the Dominion War – a serialized story involving a growing conflict between our familiar heroes of the Alpha Quadrant, and the Dominion, a villainous group from the other side of the wormhole. This serialized war arc would bring the Alpha Quadrant to the edge of destruction and permanently change the landscape of the* Star Trek *universe.*

**IRA STEVEN BEHR:** The whole idea of the Dominion came about in season two. Which is kind of a forgotten season. We were still in the act of "becoming" the show. It was myself, Robert Hewitt Wolfe, Peter Allan Fields, and James Crocker – these are the guys who created the concept of the Dominion. We did it over lunch for basically the entire season. Mike and Rick didn't know – Mike, I might have mentioned in passing that we were creating some villains for the series. Some *DS9* villains.

*Unbeknownst to Odo, the Dominion was created by his own long-lost people, known as the Founders. They had genetically engineered an army made up of the Jem'Hadar, and their masters, the Vorta.*

*The Dominion War managed to straddle both lines of sci-fi action, and philosophical intrigue, which many presumed would not be possible in previous iterations of Trek. This is possibly not better emphasized than in the landmark episode from the sixth season, "In the Pale Moonlight."*

**IRA STEVEN BEHR:** Mike [Piller] and Rick [Berman] laid the groundwork by having a captain who was also a father. That was different right off the bat. We had these two parallel streams going on throughout the life of the show – the dark, non-Gene Roddenberry, *Star Trek* (supposedly) – and on the other hand we had this very character-driven story about people with very intense relationships. Whether it's Sisko and Jake and Cassidy Yates, whether it's Odo and Quark, whether it's Quark and Rom, whether it's Odo and Kira – there was a lot of them. To me, that's where the heart of the series always was, and always felt that way. That's why we were never fazed by all the negative comments that were made about the show not fitting in with the franchise. We were an outlier for sure, but we were about as positive a view of the 24$^{th}$ century as you could possibly have.

**RONALD D. MOORE:** What we were trying to do was very different. We were going deeper into character, we were making the show smarter, and wanted to push the boundaries of what *Star Trek* was. That was our goal. On *Next Gen*, it was all about staying within what was "*Trek*." At *Deep Space Nine*, the mandate was, "Let's push. Let's see what we could get away with. Let's redefine *Star Trek*. What happens when they face this kind of crisis? What about this? What are the flaws in the character?" We were starting from a very different place and it was exciting and exhilarating. It did not feel like an extension of what I had just done. It felt like a new show. It was a brand-new show that I was working on that was set in the same universe.

**MICHAEL OKUDA:** One of the things *Deep Space Nine* did was go beyond what Gene Roddenberry was trying to do. Roddenberry very much wanted his characters to be a symbol for what humanity could become. *Deep Space Nine* was designed to say, "Okay, you have Starfleet people. But the galaxy is more complicated than that." An ingenious way to be faithful to what Roddenberry wanted to do, but

bring in conflict from others. "In The Pale Moonlight" was one of the times we see this deeply principled Starfleet officer, trying for all the right reasons, doing horrible things for the right reasons. Because we have the heritage of *Star Trek* – these people are ethical and compassionate and what we all aspire to be – to see him driven by the horrors of war to do the awful things made it such a profound episode.

**RONALD D. MOORE:** "In the Pale Moonlight" is a story about Garak and Sisko deliberately putting out disinformation, fake news, in an effort to draw a neutral power into a war. It is the morally corrupt thing that they're doing and they're doing it with knowledge of what it is and knowing that it's wrong. But they feel that the stakes are such that they have to. The stakes are the fate of the galaxy. It's a story about the sacrifice of personal honor and personal ethics in service of this greater idea. And what's the cost of that? How far are you willing to go down that road? They were willing to go pretty far, which I thought was the really interesting question.

**MARK A. ALTMAN:** One of the most ambitious stories that *Deep Space Nine* ever told was "In the Pale Moonlight." "In the Pale Moonlight" is the story of – the war is not going well for the Federation. It looks like we're going to lose, and we're desperate to get the Romulans in the war. In a perfect universe, in which our characters have worked with complete ethics and morality, Sisko slowly makes decision after decision to do "the wrong thing," to do the right thing. Basically, Garak drags him down this path where he is going to convince the Romulans that the Founders and the Cardassians have destroyed one of the Romulan ships and killed one of their diplomats. It's a pressure cooker of an episode. There is a denouement which has a tour de force of a speech by Avery Brooks, where he records a captain's log, explaining what he did, "but I can live with it." And he deletes the log. It is, if not the best episode of *Star Trek*, it is up there with "City on the Edge of Forever," and "Balance of Terror," and "Yesterday's Enterprise." It's a remarkable hour of TV.

**IRA STEVEN BEHR:** We live in a society where we think the social contract is forever. The rules of a civilized society – America

– is just in stone, and nothing is going to unravel it. Well, that is not true. Because in order to keep that social contract alive, people have to behave in a certain way. We had an episode where a Founder said, "There's only four of us on Earth. Look at all the havoc that we've reaped on Earth." It takes very little to unravel that social contract. Yes, love and relationships help that, but you also need something you believe in. Not just in the most blasé way – "we stand for this, we stand for that" – but in something that really means something, that really matters to us.

**LARRY NEMECEK:** "In the Pale Moonlight" for the darker grittier series of *Star Trek* is the darkest grittiest of all *DS9*. It's still disturbing to watch it. The plot is disturbing in the way they filmed it, with Avery doing a personal log. He's hardly the first character to do a personal log. O'Brien does it all the time. All the characters have done it at one point, but for Sisko to be staring at the camera where the audience and that final, "I can live with it, I can live with it…" Where you're not sure if he's sure about it or not. But for him to reveal all this and didn't erase the tape… Or did he erase the file? Did he keep it? It's all superfluous. It's all meant to blow you away, wherever you're watching the show and go, "Oh my God."

If you're the good guys and your survival is very close to being snuffed out, you have to get one thing done. You have to get over one hurdle. In this case, it's we have got to get the friggin Romulans off the hump and get them in on our side. Even if you say, "Hey, you know if they wipe all of us out, they'll turn on them eventually."

**RONALD D. MOORE:** I love "In the Pale Moonlight." It's one of the shows I'm proudest of. It's dark, ambitious, a great episode of television. It's surprising, goes to places I don't think we were expecting it to go – it pushed the boundaries for what *Star Trek* was. It's the one that's really emblematic of the promise and the potential of *Deep Space Nine* in that it was willing to take the characters to places you could not imagine other *Star Trek* series taking. I could not imagine any of the captains on any of the series doing this episode, other than Benjamin Sisko. And doing it with a character like Garak, who could

only really exist in *Deep Space Nine.*

*"In the Pale Moonlight" began as an episode given to freelance writer Michael Taylor. His initial draft featured prominently the character of Jake, with Sisko as the voice of reason to run into conflict with.*

**RONALD D. MOORE:** You're using freelancers because you're doing 26 a year and it's just so much, there's so many stories. It's really hard for the writing staff to churn out that many episodes. We needed ideas and we needed material and you were desperate to have another episode. Sometimes someone comes in and pitches you a crazy idea, and it's not something you've thought of.

*As the first draft by Michael Taylor was read, it became clear more work was needed on a fundamental level.*

**RONALD D. MOORE:** Michael Taylor wrote the first draft, and we were having trouble making it work, so it was handed to me to do the rewrite.

*Out with the family dynamic, and in with espionage, moral stakes, and murder.*

**RONALD D. MOORE:** I was introduced to a lot of espionage thrillers by Ira and the other writers, especially on *TNG* and that third season, my first year there, they were huge fans of Le Carre. I hadn't read any of it. *Tinker Tailor Soldier Spy* was a common reference point in the writers' room, which I didn't understand. Hadn't read the book and had not seen the Alec Guinness miniseries, and they started referring to me as young Peter Guillam in the writers' room, that was my moniker for quite a while. I didn't know what the hell it meant. But by the time we get to "Pale Moonlight," we've been talking about Garak and Le Carre and all that. Now, I had read it and was much more steeped in it.

**ANDREW ROBINSON:** Thematically, "In the Pale Moonlight" deals with realpolitik — do the ends justify the means, and how different systems of government deal with their problems in their own ways.

We're a democracy, so we're supposed to be open in our dealings with the world. But we don't know what's going on. Nobody knows what's going on. I remember loving that episode, simply because it was Garak schooling Sisko on how things go. If you really want to get something done, sometimes you have to do ugly things so that other people don't know about it. It was a metaphor for basically Americans and the rest of the world, and that there is a real split in this country of people who want to be open, fair, show that we are the shining city on the hill, and that we do things correctly and treat people well. Yet there is a whole other thing that's going on in the world.

When we were shooting that episode, and when I was shooting any episode as Garak in that makeup and in that costume, what I was thinking about as an actor is, "Do I have my lines? Do I know what I'm doing? Can I work with this makeup, under which I am sweating like a pig? Am I making sense?" That takes a while, then the cameras start to roll and you start interacting with the other actors. Especially Avery Brooks, who is a powerful actor and a joy to work with. He's present, he's there, very much in the moment. Once that gets going, it becomes this duet. In the sense of "In the Pale Moonlight," it's a duel between a character that was a very powerful commander, Captain Sisko, but who's naive about the way things work politically in the universe — certainly that Garak inhabits. On the other hand, there's Garak, who was groomed all his life to be a spy, a very brilliant spy, and who knows how to work the underground in the underworld and the machinations of getting things done. Not in a democratic way, but getting things done practically, efficiently, and without a lot of hoo-ha. That's the dynamic of that episode. Because Avery is a great actor, and it's really a joy to work with someone who's as powerful and as present as Avery, it was a complete joy. It was really like a dance that we did.

**RONALD D. MOORE:** Andy and Avery really brought their A-game with this one. They're really good at playing off of each other. They always enjoyed playing off of each other, and I think their scenes together are some of the best scenes in the show. When you go back and look at all the Sisko/Garak scenes, there's really good stuff in there. This episode really put them together and dig into each other and

themselves. I think it was a dynamic performance.

**ANDREW ROBINSON:** That moment at the end of the episode, "In the Pale Moonlight," when Sisko comes in and he's so furious and clocks Garak and knocks him over his sewing table... it's a wonderful moment. It encapsulates that whole dynamic between them. That yes, by agreeing to Garak's methods, they solve the problem with the Romulans, and yet it is so offensive and repulsive to Sisko's ideals that his fury just overtakes him. You notice Garak's reaction. He doesn't say "You son of a bitch," and it doesn't turn into a primetime fistfight, Garak says, "Okay fine, hit me. Hit me. But we got the job done, right? We did what we needed to do." In the sense, it's an unbridgeable gap between them, because Garak will never get what it is that Sisko is committed to and deeply believes in, and Sisko will never understand. There is that gap between them that is unbridgeable. Sisko is the one that came to Garak and said, "I have a problem, and I need your help." Sisko knew that Garak wasn't going to say, "Let's get the Senate and the House of Representatives together, vote on it, and see what happens." That's not going to happen. Sisko knew that Garak's methods were not going to be diplomatic at all. There's that tension within. That's that tension within Sisko that, when it all goes down, he comes bursting into Garak's tailor shop and knocks Garak over the table, that's the tension that he's releasing. That's the tension that any leader in a democratic situation is facing. There's a generosity about Garak. There's an understanding that Garak has. Believe me, he's not a perfect creature at all, but he does understand some things. He understands from his point of view that the Federation are handicapped in a sense by their democratic system, by their rule of law. That there are certain procedures and structures that the Federation has to observe that Cardassians don't.

*Notably, the episode also features a cold-blooded murder committed by a main character — who gets away with it.*

**ANDREW ROBINSON:** There's a scene where that rod that Garak is supposed to be able to get, and Sisko says, "Well, how can you get that?" and Garak says, "Well, don't worry about it," and it's not discussed... that's so Garak. Even though it may be, on one viewing,

Garak's papering over a fault in the plot and the writers skipping a step there, on the other hand that's Garak. I think it's "Garak's business is Garak's business". There are things that he's able to do that's extraordinary.

**RONALD D. MOORE:** Yeah, it was definitely an off-screen murder by one of the leads. At that point in the show, I knew the places where I had to be careful. I did not want to set off the Rick Berman or Michael Piller alarm. I didn't want to have a whole giant thing. I was already pushing a lot of buttons with this episode, and I was trying to keep my head down, and "let's slip this one by" was more of my feeling. I remember thinking, "If Garak kills this guy on camera, it's going to be the straw that breaks the camel's back." I knew intuitively, make it off-camera.

**ANDREW ROBINSON:** Having that advantage of playing a character over several years is a gift. Especially when the writing maintains its high level, which it always did with *Deep Space Nine*. There is a depth and a breadth of character that you are able to achieve. There is no question about that. So when I got a script like that, I'm reading it and thinking, "Yes, this is so quintessentially Garak." The joy of playing Garak was derived so much from his lack of human morality. What we think as being moral or ethical. That means nothing to him. He's an alien, for Christ's sake. A Cardassian. But for me, I created a Cardassian world for myself. In that world, human morality means nothing to me. So what you're able to do is you're able to explore your responses to someone like Captain Sisko, who represents human morality. I was able to just use my imagination and go with that.

**RONALD D. MOORE:** It was important that Sisko had many opportunities not to do what he did and that it wasn't a story of circumstance where Sisko was boxed in and never had a chance not to do this — that it was inevitable and like, "Oh, it's a tragedy, but what else can I do?" That's one version. I wanted the version where here's a man who had many choices and he made his choices and he always knew what he was doing and he chose not to take those off-ramps and he chose not to bail out at this point. He just kept going.

**LARRY NEMECEK:** "In the Pale Moonlight" is just the cherry on the whole ice cream of the fact that *DS9* as a series was all wrapped and done two years before 9/11 and everything we have lived through since — all this civil-liberties-versus-government stakes, protecting the public, this rise of the fierce individual against the goodness of the state. And now the rise of fake news.

**RONALD D. MOORE:** I don't have the writing credit on the show — it's Michael Taylor is writing credit. It was the one time I was very tempted to put my name on a script that I didn't write the first draft of. There was a philosophy; there were two schools of thought on credit. Michael Piller believed that the credit should reflect every-one that worked on the show. And Michael wasn't shy about putting his name on an episode he had rewritten or adding a staff member's named. I had put my name on scripts — I rewrote the final draft of "Data's Day" and I'm credited on it. But there's another writer who wrote the first draft, right? This other philosophy was Ira's philosophy. And Ira's philosophy was, you're on staff, you're a producer on this show. You have so much more power than any freelancer, every day you'll come in here and you're going to do all kinds of things to their work. And all they have is that credit. You should not take that from them. This time I was really tempted, cause I loved it. I was like, "Oh man, maybe I should do that." And Ira said, "It's a personal decision everyone has to make it for themselves. But just remember, you have all the power in this and he doesn't, and you should think about that." Ultimately, I decided not to, because I, at that point I started to believe in Ira's philosophy of credit. It was a turning point for me in terms of that, because ever since, whenever I'm rewriting a script to this day on any of the shows, I won't put my name on it.

*The title of "In the Pale Moonlight" has stirred interest over the years, for being the only direct reference in* Star Trek *to... Batman. Despite the fact that no one knew it at the time.*

**RONALD D. MOORE:** I thought it was a real phrase – "Dance with the Devil in the Pale Moonlight." Then no one could track down where this phrase came from except for the Tim Burton *Batman* movie.

And I was like, "Is that true?" I sort of refused to believe it. I was like, "No, I've heard that phrase before." And people were like, "No, that's just from *Batman*." "How could that be?" Sure enough, I had never seen a reference other than a *Batman* and I just loved it, but I thought it was a more common phrase.

**ANDREW ROBINSON:** I never knew that the quote came from *Batman* and the Joker, and that idea that you can't make an omelet without breaking a few eggs. To dance with the devil in the pale moonlight, that is such a wonderful image. It really is. And the paradox is you have to dance with the devil sometimes in order to promote good and to move forward. That's where it gets complicated and sophisticated. That's what a lot of people don't understand. They really don't understand, it's either one thing or the other. White or black, the good or the bad. That's the thing about *Deep Space Nine*, and because of writers like Ira Behr and Ron Moore. *Deep Space Nine* stayed in that gray area, but it was never starkly white or starkly black. It was never good or bad, it was always mixed. Garak is a perfect example of that character. They made him and they wrote him, and I went with that to make Garak an appealing character.

**MARK A. ALTMAN:** "In the Pale Moonlight" tells you everything you need about the show. These are characters trying to do the right thing in the wrong circumstances, and sometimes they have to compromise their conscience and their morality for the greater good. It's wrestling with big issues and deep philosophical issues and features some sensational performances. That's why that's such a special episode.

*"In the Pale Moonlight" aired on April 18, 1998, during what many consider the best season of the series, season six. Though unlike* TNG, *the creatives behind the scenes on* Deep Space Nine *felt they could keep going for many more seasons.*

**RONALD D. MOORE:** It was a totally different world than the one we were working with in "Yesterday's Enterprise." More than halfway through the sixth season, it's a well-oiled machine. We're going into the Dominion arc, the war thing, we know pretty much for

certain that season seven is going to be our last season. You could see there's an endgame. It was definitely firing on all pistons – the writing staff was loving the show, we were all happy, there were lots of ideas. We knew that if we did get an eighth season, there'd be plenty of story for an eighth season. We had no qualms of our ability to keep doing this. So it was a joyful time.

**LOLITA FATJO:** I know for sure the *Deep Space Nine* actors would have gone for 20 years if they were allowed to. That cast was so tight and so good and were all such good friends. That show had such a good vibe to it all the way around, from the crew to the cast. That was tear-jerkingly sad when that show ended. It was heart-wrenching.

**ANDREW ROBINSON:** When you get a script like that, you get an opportunity to work with someone like Avery, and a script where the story is as strong as it is, you're grateful. You are absolutely grateful. When I got hired to play Garak on *Deep Space Nine*, I had no idea that I'd be doing interviews like this, or that there would be conventions. I'm an actor, I got a job, I thought, "Great. I can pay the rent this month." Then you read the script and you think, "Oh, this is really interesting. I have no idea what a Cardassian is, but the writing is interesting." It evolves that way. Basically, I'm just working on the character called Garak. That's my job. Then later, when the series is over, suddenly...

**NICOLE DE BOER:** I think that *Deep Space Nine* has definitely stood out over time, more so than the other shows, which is ironic because at the time, it was thought of as the lesser show. The whole idea of trying out the serialization at the time was like, "Ugh, that's really risky people. Don't like that.". So it was controversial at that time. And now look, that's the norm now. And that's how people consume shows: They sit and they binge-watch. They're used to the serialization. So that's really worked in our favor.

**LOLITA FATJO:** No features for *Deep Space Nine*, and the reason is it was just too expensive. Those sets were phenomenal. They made the *TNG* sets look not so spectacular. It was never even considered.

Believe me, that cast would have loved to have done it.

**NANA VISITOR:** There was no gray area – it was always, "No. It's never going to go into a movie. This is it." I never really understood why. We weren't given an explanation – that's just the way it was. So none of us expected it.

*The final episode of* Deep Space Nine, *"What You Leave Behind," aired on June 2, 1999, and featured the end of the Dominion War, and the fulfillment of Benjamin Sisko's spiritual mission to become the Emissary of the Prophets.*

*At the wrap party, showrunner Ira Steven Behr commented, "I started to think about the title of this final episode, which is 'What You Leave Behind', and I started to think, 'What have we left behind?' I think I leave behind a lot of good memories of a lot of talented people. I leave behind the* Star Trek *franchise that will forever be different because of what we did on* Deep Space Nine.*"*

# THERE'S COFFEE IN THAT ~~NEBULA~~ STAR TREK
## *Voyager and UPN*

"I couldn't help it, said the scorpion. It's my nature." ~Commander Chakotay

*Discussion of yet another* Star Trek *series began before* The Next Generation *ended.* Deep Space Nine *had barely premiered, yet the success of both and the lucrative appeal of the franchise convinced Paramount that multiple* Star Trek *television shows could exist at the same time. This series would feature a more traditional take on the franchise, and involve a starship exploring strange new worlds, as opposed to the more stationary* Deep Space Nine. *Rick Berman and Michael Piller began toying around with the idea in July of 1993 – a full year before "All Good Things," and just seven months after the premiere of* Deep Space Nine. *Early on, the decision was made that the new show would be led by a female captain. Though not the first woman captain in* Star Trek *canon, this would mark the first* Star Trek *series to have a female lead.*

**RICK BERMAN (executive producer, *Star Trek: Voyager*):** As we started *Voyager*, I thought it was important – especially as we were going to have a female captain – to have a female executive producer. So we invited one of our writers, Jeri Taylor, to join us as one of the three executive producers on that show. Michael, Jeri, and I could not have been closer. Worked together very well.

**JERI TAYLOR (executive producer/co-creator, *Star Trek: Voyager*):** Rick said to me, "We're going to do a series about a female captain, do you want to be a co-creator?" That was it. I think we were working on it during the seventh season of *Next Generation*, because we'd go into Rick's office at lunch, and develop *Voyager*. We'd do that four or five times a week for a long time. Nothing was decided except that it would be a female captain. That was the idea.

*With* Voyager, *however, Paramount would dispense with the syndication model, in favor of finally doing the thing they'd hoped to do nearly 20 years before – start their own network.*

**MARY JO TENUTO** (*Star Trek* **historian, startreknews.net):** Paramount [still] wants to start a new network, and they do this with UPN (United Paramount Network), and *Star Trek* would be a flagship show. Rick Berman, Michael Piller, and Jeri Taylor set up a number of secret meetings to flesh out what the show would be and what the characters would be. It's interesting to see how the characters change from those initial meetings. Tuvok was originally going to be Vicon, and be 160 years old, with more of a grandfatherly presence on the show. They changed the character because they really liked Tim Russ. B'Elanna Torres, we know her as half-human/half-Klingon, but the original intention was that she would be half-Bajoran/half-Cardassian. That would have been an interesting mix to deal with. Kes and Neelix were originally thought to be one character, named Mayfly, because mayflies have such a short lifespan. Mayfly would have been androgynous and only lived seven years.

**JERI TAYLOR:** When you're writing and producing an episode, you really have tunnel vision. You're only thinking of writing and producing the episodes. How it filters out into the universe is another issue. So I don't think any of us were thinking, "Oh god, we're launching a network. We better make this good." We wanted this to be good on its own. It wasn't our network, but it was our series.

*Voyager* was made with a lot of expectations, because it was to launch the new UPN network. It had a big budget, a lot of hoopla, a lot of publicity – but those are elements that exist outside of our world as writers and producers. We wanted to launch a series that would be exciting and interesting and provocative on its own. We looked at the script, the production, wanting to make it the best it could possibly be. What impact it had on the other things, that was not our problem.

**MARY JO TENUTO:** It was great to see a woman. We saw in the '60s Nichelle Nichols on the bridge, and now we are seeing women in more prominent positions. So, captain, chief engineer with B'Elanna Torres, and then later Seven of Nine being a scientist and in astrometrics — that really opened people's minds up to the possibilities that you can have women in these positions. Just like what we saw with NASA

and females in space, it gives you a role model. It opens doors and opens up your mind to the possibility that I, too, can do that.

**MARK A. ALTMAN (creator, *Pandora*; author, *The Fifty-Year Mission*):** The two-hour premiere of *Voyager* had a lot resting on its shoulders, because of course, *Next Generation* had just gone off the air at the height of its popularity and *Deep Space Nine*, despite being probably one of the best *Star Trek* series, was underperforming. So, *Voyager* was carrying the entire franchise on its shoulders at the time. It needed to work. It had to work.

*Over the course of several lunch meetings, and eventual real meetings, Rick Berman, Michael Piller, and Jeri Taylor honed in on the story for* Voyager, *and its first episode, "Caretaker."*

*Speaking with Star Trek Magazine in issue 119, Michael Piller commented, "The thing about* Caretaker [the Voyager pilot] *that must be remembered in all discussions, is that it was created in the shadow of* ST:DS9."

**JERI TAYLOR:** We started with characters. It was getting very, very difficult, because there had been *The Original Series*, *Next Gen*, *Deep Space Nine* – every kind of combination of character or alien species had been done. So how do you come up with something unique, that feels fresh, even though you're the fourth iteration of this franchise? That took a long, long, long time. We came up with some crazy, crazy ideas. Eventually, Rick just said, "This is crazy. Let's stop and get real." So eventually we came up with the characters, then we had to figure out what to do with them.

It was Michael who came up with the idea of losing them in deep space. He said, "I swear to you, this is what makes it original, different, fresh, this is what makes it work." And I think he was right. It was radical enough that it made me a little nervous. I think it might have made Rick a little nervous. You're completely broke away from the familiar. It's possible to perceive that the popularity of *Star Trek* had a lot to do with the familiar – the Klingons, the Romulans, that area of space we all know and love. Now we're going off to where there aren't any of

those things. Is the audience going to accept that? Or resent us? How will we come up with new alien species? It's not as easy as it sounds. It was unsettling. But everything Michael said rang true, so we went with it.

*The* Voyager *pilot picks up numerous threads that were initially laid out in* Next Generation, *and* Deep Space Nine — *conflict with the Cardassians over annexed Federation space and the rise of the Maquis — freedom fighters who deemed the Federation departure criminal and stayed to fight the Cardassian occupation. While the* Voyager *pilot can be seen in many ways as a fresh start for the franchise, it can also be seen as the most dependent on pre-existing knowledge. The world of* Star Trek *is now so familiar to longtime fans of the saga, there is no need to go over the basic fundamentals of the galaxy. On the other hand, because the show departs the known galaxy after merely 20 minutes, perhaps grounding the viewer in the* Star Trek *world was deemed unnecessary.*

**JERI TAYLOR:** I think we probably just wanted to check off the checklist. It wasn't a conscious thought, but that's what you want to do. You have the characters, you need to establish the premise, you had to make it sound exciting and challenging. I think it worked for our purposes.

*The pilot for* Star Trek: Voyager, *"Caretaker," begins with Captain Kathryn Janeway assembling a team to go on a dangerous mission into the Badlands near Cardassian space to track down a lost Maquis ship — which was run by many former Federation officers. Inside the Badlands, the U.S.S. Voyager discovers the Maquis ship, but just as they do, both ships are teleported thousands of light-years away to the other side of the Galaxy by a being known as the Caretaker. Members of both crews are taken, and Janeway must team up with the Maquis captain, Chakotay, to recover them. The crew meet some allies in Neelix and Kes, and also some enemies in the rough, gangster-like race of the Kazon. After Janeway recovers her missing crew, she learns the Caretaker is dying, and cannot send them back home. The crew of Voyager must work together with their Maquis enemies, in order to make the 70-year trek back home.*

*As quoted in* Captains' Log Supplemental: The Unauthorized Guide

to the New Trek Voyages, *by Mark A. Altman and Edward Gross, Michael Piller commented on the more straightforward approach to the* Voyager *pilot. "When we started the pilot, I felt that after all the psychological stuff we had done on* Deep Space Nine, *we could let loose and have a wild ride and adventure with this. My push on the pilot was to let it all hang out in a real old-fashioned adventure story."*

**BRANNON BRAGA (screenwriter/executive producer, *Star Trek: Voyager*):** My first exposure to *Voyager* was sneaking into Jeri Taylor's office and pulling a draft out of her drawer because it was top secret. I had to see what they were doing.

*The writing process on "Caretaker" took over a year, from the first secret lunch meetings to finalizing the script. From there, the pre-production process was fast and quick. The first draft of the teleplay, written by Michael Piller, with extensive input by Rick Berman and Jeri Taylor, was read by the network in June of 1994 – though the script would continue to be rewritten even during production.*

*Casting for* Voyager *began in the summer of 1994. By this time,* Star Trek *had become a ratings behemoth, and as such, there were many more options. Robert Beltran* (Night of the Comet [1984], Eating Raoul [1982]) *was cast as the Maquis leader/first officer, Chakotay. Robert Picardo* (China Beach [1988-1991], The Howling [1981]) *was hired as the curmudgeon holographic Doctor.*

**ROBERT BELTRAN (actor, "Chakotay," *Star Trek: Voyager*):** I auditioned for Leonard Nimoy before *Voyager*. I got three pages for a scene as a Klingon captain. I had to go over to Leonard Nimoy's house in Brentwood – I live way on the other side of town. I didn't have a whole script, just my three pages. I walked into this room and there's like 20 producers all at this round table, with one seat in the middle for the person who was going to be auditioning. So I sat down, tried to be amiable, and one of them asked, "Do you have any questions?" And I said – because I had never watched *Star Trek* – "Yeah, uh, what is a Klingon?" It was a sincere question. And Leonard just goes, "(sigh), Shall we just read?" So I did the stupid scene, and I walk outside. A

buddy of mine is getting ready to audition for the same role and saw me fuming and said, "What happened?" I said, "I asked a question! They got so pissed off at me. WHAT IS A KLINGON MAN?!" And he busted up laughing, "You auditioned to Leonard Nimoy for *Star Trek* and you don't know what a Klingon is?!" So I was like, "F Klingons, F *Star Trek*, F Leonard Nimoy!" The screen door was wide open and they were all looking at me like, "…."

**DAVID LIVINGSTON (director, *Star Trek: Voyager*):** [Robert Beltran was] very contrarian. And he was never really part of the group. That was his nature.

**BRANNON BRAGA:** Having a Native American on the show was a cool idea. I think we almost cast Graham Greene who was in *Dances with Wolves* (1990). He was one I think came very close to getting that part. Chakotay suffered for a little as a character. The actor was a really, really high-end quality actor, very cranky, a little cranky, but with good reason, because his character had first officer syndrome a little bit, which is -- you're sitting next to the captain, but you're not the captain. I was never fully comfortable writing about his Native American culture, because I'm not Native American, and I don't really know a lot about it, and I didn't want to misrepresent it. So I leaned into what he meant to Janeway. To me, he was someone who kept Janeway honest, because Janeway was a risk-taker in a way that Picard was not.

**ROBERT BELTRAN:** It was one of the easiest auditions I've ever had in my life. I come back from the third one from the network, I come back home, the phone is ringing, I answer it and my agent said, "You've got the job." It was amazing.

**ROBERT PICARDO (actor, "The Doctor," *Star Trek: Voyager*):** I remember when my agent sent me to the audition. This was pre-internet, so we literally mailed scripts. The *Star Trek* script I was probably sent in the mail to read. I was doing a play at the prestigious Mark Taper Forum. I'd always wanted to work there. I was in final rehearsals, which means 12-hour days where we're setting all

the technical cues of the show. My agent said you have an audition tomorrow for the new *Star Trek* series. I said, "I can't do that, I'm in tech week." He said, "Well, go over during your lunch break." I said, "But I have a job, I'm not free to shoot the pilot." He said, "Well, lie." I went and lied, but I didn't want to read for the holographic doctor. The character description said, "a computer program of a doctor. Colorless, humorless," which didn't sound like a bucket of fun for seven years to me. I was going to pass on the audition, put the script aside and concentrate on the job I already had. But an actress friend who was reading for Janeway said, "Oh, you must read it. It's really terrific." She said, "if you don't like that doctor character, there's a wonderful character named Neelix, who's an alien." So I read Neelix, it seemed funny and charming. But I knew he was an alien, so before I went in, I asked my agent how long the makeup process will be every day. My agent called and they said "more than 15 minutes." Which is true, three-and-a-half hours a day is more than 15 minutes. But they don't tell you that because they don't want to scare the actors away.

Long story short, I went in and I read for Neelix, and I read so well that I ended up testing for the part. My competition was Ethan Phillips, who's a longtime friend. I went in, I read, I came very close, but I did not get the part. I thought, okay, it's probably for the best. But my agent called back that day and said "They would like you to come in and audition for the original part that they were interested in you for." I didn't get the joke, but I was impressed with the fact that they wanted to see me again in a completely different role. So I say to my agent, "I'll do it." I'm the only actor in the series who read only once for his role. Everybody was there, the whole room, the new UPN network executives, all of the heads of Paramount Television, and all of the producers of *Star Trek* — 16 people watching me. The wonderful, now passed, Michael Piller said, "Bob, we've already seen you for this other part. Do you have any questions?" I said, "No, I'll just take a stab at it, and if you want me to make an adjustment, I will." I had heard they'd seen 900 actors and wanted someone funny, but I didn't think the part was funny on paper. So I ad-libbed a final line, which got me the job.

The last scripted line in the audition, the Doctor has been left active

in sickbay and he has nothing to do, right? He's talking to the computer, and he says, "I believe someone has failed to terminate my program." After that last line, I took a long deadpan look at the 16 people watching me, and I said, "I'm a doctor, not a nightlight." They laughed, and I was hired that day. Did I realize I was channeling DeForest Kelley? No, I didn't know. When I finally met 'De Kelley' a few months after we started shooting, I said, "Mr. Kelley, my character pays homage to your doctor character all the time." And he looked at me and he said, "Oh, you're mean you steal from me?" "Yeah, pretty much." Then we got along great. It just shows how ignorant I was of *The Original Series*. Had I seen a poster in college with DeForest Kelley going "He's dead, Jim."? Maybe, but I had never seen "I'm a doctor, not a blank".

**LISA KLINK (screenwriter, *Star Trek: Voyager*):** Everybody liked writing for the Doctor, because Robert Picardo would just knock it out of the park. He would make something funny whether it was written as funny or not.

**ROBERT PICARDO:** When I was cast in *Voyager*, I was coming off of a series called *China Beach* (1988-1991), which was a Vietnam drama. Back in those days, the network edict was that I had to have a hairpiece, because if I was going to be a long-term romantic interest for Dana Delaney, I had to have hair. You couldn't kiss a beautiful woman on American television without hair. Thankfully Patrick Stewart changed all that. When I was cast in *Voyager*, I said to the producers "I sometimes work in a hairpiece. Would you like me to?" They said "No, no, we want you just the way you are. We've had a great deal of success with bald actors."

*Early on, the Doctor would take on the role of "non-human commenting on humanity" that was such a staple in* Star Trek.

**ROBERT PICARDO:** I remember early on I had an idea for a B subplot for the Doctor. I think they were understandably confused that I wasn't looking for writing credit or anything, I just thought it was a funny gag. I wanted to do one where the Doctor was so certain that if had the capacity to be ill as an organic crew member, that he would

be a better patient under the circumstances. Meaning that he thought a lot of these members of the crew were acting like babies. So, of course, when they changed his program so that he has a programmed flu, he is a terrible patient. It was so much fun to play. What I love most about my character was this kind of Humpty Dumpty aspect. He was up on a perch and full of self-importance and this overinflated sense of his own worth to the crew with his own body of knowledge. It was fun to see him pushed and to fall off from his high horse. That was what really was delightful about playing the Doctor; that he had that arrogant air about him, but then as soon as you nudged him, you could see that he had a vulnerable underbelly.

I feel that when I was cast in the pilot, I didn't understand the character. I didn't realize his potential. I had no idea that he was going to be the outsider character that Spock had been in *The Original Series*, or that Data had been in *Next Generation*, that Odo was in *Deep Space Nine*. I thought, "Well, we've got a Vulcan character." Tim Russ was going to be the Spock role. That's how uninformed I was when I took the part. I thought "I do nothing in the pilot. I don't see what the potential is, but if I take this job, my two young daughters will likely go to college." That's the way I felt as an actor. This is a good job for the future. Then a few episodes in, it was like a light went on in my head. I finally started to understand what they wanted out of the role. What the joke was that he was a willful piece of technology. In the intervening years, since *Voyager* premiered, we're used to willful technology that we think we understand, and then it gets a virus and you just can't make it work. It's the conflict between hardware, which is data, or software, which is the Doctor. That whole thing about "what's the problem with your system."

The moment I think that I had the insight was when Kes comes to sickbay because she wants to make a hydroponics bay and grow vegetables to save replicator power. She wants soil samples to experiment with how best to grow her vegetables. So the Doctor says, "I have the combined medical knowledge of 5,000 medical textbooks and the individual personal experiences of 27 Starfleet physicians. But sure, let me get your dirt." He says it with a very huffy attitude, like he's the

star relief pitcher who's pitching girls whiffle ball. That feeling that he wasn't being given the respect that he felt he deserved. The ultimate example of that was, with the power of the knowledge that he had, they would leave him running when he had nothing to do in sickbay. So he on the one hand had this enormous power of information and knowledge, and then any idiot could forget to turn them on or off because they didn't flip the switch. That dichotomy between "I'm very powerful" and "I have no power" is the source of his bad attitude early on. Once I got that memo to myself, then it started to make sense that was my hook, my key into the character. The fact that the Doctor, like in Milton's *Paradise Lost*, Lucifer has a sense of injured merit that leads to his downfall. I decided the Doctor had that same sense. "Why don't you give me the respect that I am due because I am so brilliant."

*Tim Russ, who previously had a small role in* Star Trek: Generations, *as well as* The Next Generation *and* Deep Space Nine, *and was shortlisted for the role of Geordi La Forge in* Next Generation, *was cast as the Vulcan security officer, Tuvok.*

**TIM RUSS (actor, "Tuvok," *Star Trek: Voyager*):** I was introduced to the *Star Trek* franchise by having an opportunity to read for Geordi La Forge in *Next Generation*. I came in and read for Roddenberry and Rick Berman, or one of his other producers. I did not get that role subsequently — obviously, LaVar got it. But they brought me back to read for the doctor in *DS9*, and I did not get that one either. By the time the shows were up and running, they brought me in to read for guest-star roles on both of those shows. That took place over a period of about three years. Finally, I was able to book a role on a *Next Generation* and then I booked a role on *Deep Space Nine*, and then they brought me in for a role on the feature film *Generations*. From that point forward, Rick Berman was the executive producer of the franchise, and he told me, "Look, we're developing a new show called *Voyager*, and I really want to have you come in and read for it." He told me a couple of times, and the second time I started taking him seriously. I realized that if that's going to happen during a certain time of the year, I wanted to be available for that read and/or for the project and be able to book it. I don't want to be off doing an episode of *Baywatch*

and miss out. I cleared my schedule for that chunk of time they were doing the readings, which was basically the summer. They called me in to read for it.

**JERI TAYLOR**: When people say things like, why is the Vulcan black? There are no black Vulcans. My answer is "Who says?" And as the creators of the show, we say. So there are. Tim Russ was just a delight to work with. As a human being, he is absolutely wonderful. He's grounded and sincere and stable and, and he brought exactly the right quality to that. Vulcans — I don't think they can be a lot of fun to play because there's not much wiggle room there. But he managed to exude — a funny word to use, but — humanity through the Vulcan exterior that made him, for me, a very appealing character. And I think it was just a reflection of who Tim is.

**TIM RUSS:** The casting process for *Voyager* was very simple for me, because Rick Berman had me in mind for that role. So when I went in to read at Paramount, it was a room that didn't have more than five or six people in it. I read for that part and that was it. They gave me a call that next day. I talked to other actors about working in this business and reading for roles, and wanting to play parts on projects, and I say, "You have to be right for the role. It's a picture business, that's what it is. If you're not part of the picture, it's not going to happen." I just happened to be right for that role, pure and simple. I wouldn't have gotten it had I looked different, had a dialect, had I been the wrong shape and size, it wouldn't have happened.

At the time I went in to read, it was just the sides. They weren't about to let that script out before we did this. That's pretty much the way it is nowadays. I had a pretty good read on that role, obviously because I grew up watching [Spock] over and over and over again. So I simply based my character on his. You've got to portray this already established character; it wasn't like I was making it up from scratch. That would have been trickier. I could base it on that character and know what the feel was going to be for him going in. Because I had the right attitude, I might've had the right voice, the right height, and weight, all of those things came into play. Rick Berman, right along the same lines

as what Gene Roddenberry had established, was going to diversify the cast. That also opened the door for me as well.

*Tuvok, unlike Spock, would be the first 100 percent Vulcan character to be a series regular on* Star Trek.

**TIM RUSS:** I formalized him and made him pretty strict in his behavior as a foundation. I think I kept that all the way through. I never really lightened it up that much. If you watch Spock's character over the years, he became a little less formal. You could see some of the other side creeping in, and that was brilliant the way he did that. My character actually never really changed that much from front to back. He's a hundred percent Vulcan, and that was the difference between the two of us. That's what I wanted to play as far as the series went, to keep a focus on all of that so that anytime we did break out of that mold, it was extreme and it was noticeable.

*Newcomer Garrett Wang was hired as the fresh-faced and forever ensign, Harry Kim. Ethan Phillips* (Benson [1979–1986], Critters [1986]) *won the role of the humorous and sly trader-turned-cook of the Delta Quadrant, Neelix. Robert Duncan McNeill* (Masters of the Universe [1987]) — *originally considered to return to the role of Nick Locarno, a disgraced Starfleet cadet from* TNG *episode "The First Duty," but could not due to rights issues — was cast as disgraced Starfleet officer Tom Paris. Roxann Dawson — who would later go on to a very successful directing career which started during her tenure on* Voyager *— was hired as the half-Klingon/half-human chief engineer B'Elanna Torres. Jennifer Lien rounded off the cast as the young Kes — a race with just a seven-year lifespan.*

**ROBERT DUNCAN MCNEILL (actor, "Tom Paris," *Star Trek: Voyager*):** I got onto *Star Trek: Next Gen*, it was a year I had gotten a TV pilot for a show called *Going to Extremes* – the pilot had been pushed a little, so I had a few weeks of waiting around before the TV pilot, and my agents called and said, "Hey, there's this role on *Next Generation*. You should go audition." Honestly, I remember telling my agents, "Uhh, I don't know if I want to go do a sci-fi show right now." I had this fancy pilot I'd been cast in. They said, "No, go do it, keep

working." So I auditioned and got it. Even if it hadn't led to *Voyager* –
Wil Wheaton was in the episode, Patrick, and the other actors on the
show, created such a family environment – it was such a defining mo-
ment for me. The professionalism, the sense of humor and enthusiasm
they had on the set, I had never been on a set that felt quite like that.

I heard [the creatives] were very happy with the [*TNG* episode I
was on], "First Duty," and they had talked about bringing Nick Lo-
carno onto *DS9*. And it just didn't pan out. But when *Voyager* was in
development, they went back to that well and said, "Well, maybe he
could be here." Ultimately, they decided to create a new character –
very similar to Nick Locarno, but they wanted more of a blank slate.

**GARRETT WANG (actor, "Harry Kim,"** *Star Trek: Voyag-
er*)**:** I walked in on my first audition – and I'd just finished a callback
audition for a movie called *Glory Days* – I got to Paramount studios
and got a page. I called my agent and they go, "You booked the film." I
said, "Oh wow, that's great!" So I walk into the audition with Amanda
and begin reading the sides for the audition scene with her, and she
stops me and says, "What are you doing?" I said, "I'm… auditioning."
She goes, "You didn't prepare for this?!" I said, "To be honest with
you, I prepared for a callback audition for a movie that I just booked."
"What movie?" "*Glory Days*." "Never heard of it. You know what?
You're so unprepared, I hate you actors." She literally berated me for
the next 20 minutes. She said, "You know who Andy Garcia is?" I go,
"Yes, Andy Garcia, the actor." "Yes, I was the casting director on his
first movie. When he came in on his first audition do you think he was
unprepared?" "Uhh… no." "That's right, when he came in on his first
audition, he was prepared. And that's what makes him a star and you
not." At that point, after being verbally berated, I had had it. She said,
"You know what, get out of my office, go study the sides, memorize
it, and come back in 15 minutes. Do it the right way." I walk outside
and talk to the casting assistant and say, "Your boss is mean. She yelled
at me, and then told me to leave the office and look over the audition
and come back later." [The assistant goes] "Wait, she told you to leave
and come back?! Oh, she loves you."

**ETHAN PHILLIPS (actor, "Neelix," *Star Trek: Voyager*):** I got
a call from my agent saying, "They're going to do a new *Star Trek*, and
would you come in to audition for the Doctor." So I said, "Okay."
Then he called back and said, "No, they decided they want you to
audition for the role of Neelix." I said, "Okay, what's a Neelix?" He
said, "He's an android." I didn't know what that was, but I figured it
was a guy that had like an oid or something hanging off his chin. I read
for Bonnie Finnegan – they put me on tape and sent the tape off to
Los Angeles, and a week later they called me and said, "We'd like you
to read for the Doctor now." I went in and read for [the Doctor], they
put it on tape and sent it off to LA, then I didn't hear anything for two
months and completely forgot about it. Then they called me and said,
"They'd like you to fly to L.A. and read for the network and the stu-
dio." So I flew out there and read for them. There were 40 guys in the
room, one was Winrich Kolbe, who directed the pilot. Everybody was
really stern, except for Winrich, who was in the back of the room and
was smiling. So I said, "I'm going to [read] for this guy." After, I didn't
hear anything for three weeks. I was standing outside of a pay phone
on the northeast corner of Washington Square Park calling my agent
to find out if anything was going on – and he said, "We haven't heard a
thing. Hang on Ethan, I've got a call." He came back and said, "You've
just got the part."

**ROXANN DAWSON (actress, "B'Elanna Torres," *Star Trek:
Voyager*):** I lived behind William Shatner. It's so funny and just a co-
incidental story, but his daughter, Leslie, and I shared an alley, basically.
We would play after school, and she'd always want to sit down and
watch her dad on TV. I didn't like *Star Trek*. I didn't understand why
she would want to watch that, I wanted to go play basketball or do
something else that was fun. But that was the first time I really was in-
troduced to *Star Trek* was sitting on the rug. I had no idea that I would
ever be a part of that world, not even a little bit. It was wonderful
meeting her later on and talking to Bill about it. It was such a full cir-
cle. I didn't connect with the idea of science fiction. I did like the show
*Dark Shadows*, but for some reason, I didn't connect with *Star Trek*.
Even when I auditioned, I didn't know much about *Star Trek*. I had no
idea really. On that first day when they gave us a tour of the sets, and

I walk onto engineering to see this three-story set, I go, "I guess they don't think we're going to get canceled. They must be invested in this *Star Trek* thing." I think it also gave me an advantage, to give the role maybe a fresh approach and not feel that I was part of a universe that was so well-defined, that I could find my own way in it.

**MICHAEL WESTMORE (makeup supervisor, *Star Trek: Voyager*):** Neelix was a Talaxian and they said, "Design something that we could make a doll out of. Something that kids could have." So I thought, "Well, what better than Disney?" So my Talaxian is a combination of the warthog and the meerkat. [Like from *The Lion King*.] He had all these little fluffy little eyebrows like that. He had the mohawk. In fact, the mohawk was made with goat hair, which is very strong.

**ROXANN DAWSON:** I'm Puerto Rican, and as I was growing up, I didn't really see anybody that looked like me on TV. I wanted to be an actor, and the [roles] coming up for me were either maid, drug dealer, coke addict, and maybe if I was lucky, the best friend of somebody, but only with an accent, and mine was not good. There are now roles for all kinds of Latinas of every kind, from different countries, from the United States, from Neoricans to Colombians, you've got all sorts of people now that are able to work in lead roles. I think that's great to be able to look at the TV and see that, but it didn't really deter me. I think the biggest, hardest part for me was that I didn't fit into "the family." So when I would go for auditions, they'd go, "We love you, but we're putting the family together now, and you're not quite fitting in."

**GARRETT WANG:** Spending fifth grade through high school in Memphis, Tennessee, I experienced a lot of racism and it was very difficult for me. So when I did get to Hollywood and I did start acting, I really wanted to portray a non-stereotypical Asian role, so the kid walking down the street in Memphis, Tennessee, or anywhere in the south, would not be picked on for his ethnicity. I remember when I was first cast in *Voyager*, they said, "Do you have any concerns that you want us to keep in mind?" I said, "Yes. Please don't have Ensign Kim going into the mess hall, going to the replicator, and ordering noodles

or fried rice. Let's not do stereotypical stuff. Let's keep him Starfleet first, Asian second."

**JERI TAYLOR:** The cast fell into place fairly easily, except Neelix and the Doctor. We read each of the actors for each part. We felt strongly that Ethan Phillips should play Neelix, and Robert Picardo should play the Doctor.

**ROXANN DAWSON:** It was an audition like any other. I had no idea how it went or how it was going, and then they called me and they wanted to know if I had any Indian blood in me. They were thinking at that time, if they didn't go with a female captain, that maybe I could be Chakotay. They were playing around and sort of figuring out how to move all the different characters around. I was either the first or second person cast in the show, and at that time they didn't have anybody else. I think they were trying to figure it out as they were auditioning Chakotays, "Well, maybe she could be that role instead." They were just examining all the possibilities. I don't think it had to do with Geneviève Bujold and the fact that she ended up not playing the captain. Beltran and Picardo were cast, and I had been cast as well, but we weren't on the bridge, so we didn't work with her.

*The most significant element for Roxann Dawson was the role would require her to join the lexicon of heavily made-up characters in* Star Trek.

**ROXANN DAWSON:** I was scared out of my wits about having to wear heavy makeup. You finally get a role that you're excited about, you're in the prime of your acting career, but nobody's going to see your face? Plus, the first incarnations were pretty awfully ugly, and they did make me cry. It was more Klingon than human. Then we found the beauty makeup for it, and they did a great job. Both Greg and Valerie were my makeup artists through the years, and they did just a phenomenal job of finding the beauty in it. In the beginning though it was pretty ragged, I have to say. My first makeup test, it was pretty bad. It was not something I'd want to live in for seven years. It was definitely difficult on my face, and the time I had to spend in the chair and the removal of it made for a very long day. But they found a

good compromise with the makeup. So I was pleased. When I used to go to conventions, people wouldn't recognize me unless I covered my forehead. Then they would kind of get it.

It didn't restrict me acting-wise, but it did restrict my face. I did have to learn how to work with the forehead. When you get an itch under there, it's awful. It was hard to learn how to work with makeup and also seeing myself like that. I often don't like watching myself in my work, but to see that half-alien thing, I had to get used to it and I had to learn how to work with it. It was a learning curve.

**ROBERT PICARDO:** The *Star Trek* producers have always been partial to theater-trained actors in our cast, I think at least four or five of our original cast had all been on Broadway, and if not Broadway, they had extensive regional theater credits. *Star Trek* is not shot just in closeup, so you really have to use your whole body and especially your capacity for gesture as well as a certain amount of size in your performance. I used to say that the three most important things about being a *Star Trek* actor were, you had to have interesting hair, a good butt, and a good voice. I think that's true. I think you have to look good in the outfit so you have to have a reasonably good-looking butt, you have to have a good voice, and if you don't have interesting hair, they're going to wig you to death, which they do with all the women. But if you're a man and you're bald, the great thing is your interesting hair doesn't require hours in the chair getting something glued on.

*While the process of finding the crew for the U.S.S. Voyager went fairly smoothly, the casting for the lead, Captain Kathryn Janeway, would prove another matter. Early auditions for the role took place in June and July of 1994, with names such as Erin Gray (*Buck Rogers in the 25th Century *[1979-1981]), Lindsay Wagner (*The Bionic Woman *[1976-1978]), Patty Duke (*The Miracle Worker *[1962]), and Linda Hamilton (*The Terminator *[1984], Terminator 2: Judgment Day *[1991]) all considered for the role. Ultimately, producers Rick Berman, Michael Piller, and Jeri Taylor settled on French-Canadian actress Geneviève Bujold (*Dead Ringers *[1988], Anne of the Thousand Days *[1969]) for the role of Kathryn Janeway.*

*Filming for the pilot began on September 6, 1994, with scenes on the Voyager bridge. Early strife arose with Bujold's performance as Janeway, however, with the actress preferring a more subdued, thoughtful approach to the character – one which may have worked well in a low-budget indie movie, but was difficult to appreciate in the fast-paced world of Star Trek. Bujold too, felt the rigors of television – with its 16-hour days and endless discussions over hair design – to be a strain. The mutual decision was thus made after only a few days of production for Bujold to resign her commission as captain of the Voyager, and for production to go on hold for a week while another lead actress was cast. After a frantic search, the initial runner-up for the role, Kate Mulgrew (Mrs. Columbo [1979], Ryan's Hope [1979–1989]) was cast. With just one week off schedule, production resumed on the filming of "Caretaker." Footage of Geneviève Bujold's time as Captain Janeway can be seen on the special features of the Voyager DVD set.*

**MARY JO TENUTO:** The first time fans would see a female captain on screen would be in *Star Trek IV*, onboard the U.S.S. Saratoga. We would see the first female captain on screen. But the first time we have a captain leading his show would be seeing Captain Kathryn Janeway on *Star Trek: Voyager*. They had auditioned Susan Gibney, who had played Leah Brahms on *Star Trek: The Next Generation*, but she was deemed too young for the role. They considered Lindsay Wagner [of *The Bionic Woman* fame], but her agent had said no and didn't even pass the offer on to her. Then the role went to Geneviève Bujold.

**JERI TAYLOR:** We struggled to find an actress. We must have seen hundreds of people, none of them felt right. Then it became known to us that Geneviève Bujold was interested, and I think everybody was excited beyond belief. This was an Academy Award-nominated actress. A feature film player. So we called her in and talked to her. We asked her to read part of the script, and she didn't want to do that. She and I discussed it, and I think she felt it was demeaning to her that an actress of her stature and caliber be asked to read a part. So we made the decision not to ask her to read, convinced that it would be wonderful. After one day of shooting, we were a little dismayed. We talked to the director, Winrich Kolbe – she was very passive in the role. Looking back, I think this was a very conscious choice on her part, that, she didn't need

to be strong, imperious, or controlling, because the crew was capable. She didn't need to be firm or tell them what to do because they knew what they were doing. So her role was to really sit back and let people do what they're good at. Dramatically, this did not translate well. She lacked any energy. It created the effect that she did not want to be there very much. She was withdrawn, passive. We talked to the director, Winrich Kolbe, and said, "We need to have a bit more passion from this woman." And he said, "I know. I've tried. And it's not happening."

**RICK BERMAN:** I hope this doesn't come across as mean-spirited. Geneviève Bujold was an Academy Award nominee; she was a very famous French-Canadian actress. Her agent introduced us, we had some lunches together, and I remember very clearly telling both Michael Piller and Jeri Taylor, who were both enamored with her, that this isn't going to work. This is a woman who had just done feature films, had never done television. She was used to doing just one page a day; we do seven. She was used to getting to know her director, having dinner with her director; we don't do that in television. I just sensed it wasn't going to work. Both Jeri and Michael felt we had to give it a try. But I couldn't win. The three of us were executive producers on that show and it was two against one. And on the second day, Geneviève Bujold basically went into her trailer and wouldn't come out. I forget over what. The studio got incredibly upset. There was an insidious feeling of "I told you so," from my point of view. We shut down for a few days, and our second choice, who was Kate Mulgrew, happily accepted the job, and within a week we were filming again and we had ourselves a new captain.

**ROBERT PICARDO:** I had a big crush on Geneviève Bujold after I saw her in *King of Hearts* (1966). I think the *Star Trek* producers, since their enormous success with Patrick Stewart, loved the idea of having an international film and/or stage celebrity playing the captain. First of all, she comes entirely from a feature film background. I think she was used to shooting a page a day, not eight to twelve pages a day, so I think there was a certain amount of "I didn't know what I signed up for." But also, she did not have that theatricality that you need to play a *Star Trek* captain. She was very internal, and there's a certain

responsibility when you're in command that everybody hears "Okay, let's go fellas." She was making Janeway very interior and conflicted about going off on this mission that made it seem like she was not joining the world of *Star Trek* that we were familiar with. That's my own assessment. I was not there, I only heard things, and that doesn't take anything away from the fact that she's a great actress. I think she wasn't happy. She took the job and they weren't quite happy that she took the job either. So I think it was fairly mutual.

The great thing about Kate [Mulgrew] was she was so immaculately prepared. I've never worked with an actor who never brought the script to the set and yet carried the show. Kate, once she stepped on the set, she knew every line. I carry my script like a security blanket, and I constantly check every word to make sure I'm doing it precisely, even from tape to tape. Kate never had to do that, and I was completely amazed by that. She knew it from the moment she left her trailer. I just thought that was extraordinary. The fact that Kate had it all there, no matter what had just happened, the moment they rolled again she was back in, and in a way that I deeply admired.

**TIM RUSS:** If they were not able to come up with a female captain that they really liked for the show, they were going to recast one of the other principal roles and make them female to keep the cast balanced. They definitely would have done that had they not cast a female captain. Just looking back on it, I don't know why it would have been that difficult to come up with an actress. Kate was one of the earlier people that they read. She's the best one. She plays that role because that's the way she is. I worked with her for seven years, I know her personality, and that's what she is. What you see on the screen is Kate Mulgrew. She's perfect for that role.

**ROBERT PICARDO:** I was one of the last people cast before the Geneviève Bujold incident, but the rest of the cast were all in place and shooting. I had not shot as the Doctor, but I heard that production had shut down because Geneviève Bujold, by mutual agreement, had left. So then they were looking for a captain again. There were all these rumors that if we didn't find the right woman to play Captain

Janeway, that the studio might make it a male after all, and therefore one of the other male characters already cast might be turned into a woman. So we were all a little nervous about losing our jobs before we began. Then Kate came along and saved the day. From the moment she walked on the set, there was never, to any of our eyes, a moment's pause or hesitation. I think she was under a tremendous amount of scrutiny, and she has joked in many places afterward that she felt that everything she did was being dissected. From the way she looked, to her hair, to how much emotion should she have, and should Janeway ever express romantic interest in a male — everything was under a microscope because she was the first female captain. But I never saw in Kate's performance any lack of confidence. If she was under that kind of stress, she hid it completely.

**TIM RUSS:** Number one, [Kate Mulgrew] has frighteningly good memorization skills for the dialogue that we had, and the amount of dialogue and revisions we had in the long, long hours and days, she could handle without a blink. She is a nuclear professional. You had better be ready when you come onto the scene with her, because you're going to be playing catch-up ball if you're not. She's not going to miss anything, not a single blink, not a word of dialogue, nothing. She is a consummate professional and sharp. She can goof off every once in a while, but working with her personality is very much like the captain's. I was really amused by it, stunned by it, and it was fun to watch. Knowing the way she was off-camera and on, I was like, "Yeah, that's Kate." All those elements they gave her character as a captain was just the way she is.

**KATE MULGREW (actress, "Kathryn Janeway,"** *Star Trek: Voyager***):** Before I started, I said to Patrick Stewart, "I have to confess to you, Patrick, I'm scared. This thing is really daunting. I feel like I'm shot out of a cannon." He said, "Don't worry. After seven years, you'll walk away and you'll be so proud of what you've done, if it's anything like I've done." And he was proud. And guess what? He was right to be proud – and so am I.

**DAVID LIVINGSTON:** I had my issues with Kate Mulgrew.

There was one occasion when I was doing a split-screen with her, where she had to play against herself when there were two different Voyagers. I did my best to explain to her technically what was going on, but I failed miserably because she never got the idea of having to play to an extra, looking at her and saying, this is really you over here. And then you're talking back and forth. And I regretted that I wasn't always able to communicate to her what I wanted. I knew what I wanted, but sometimes I wasn't able to get it across to her. She's a very technical actress and she really needs to understand exactly what the beats are and where it is.

**JERI TAYLOR:** I like to think [Janeway is based on me] quite a bit. I don't know if that's true. I'm the one who felt very strongly that she shouldn't just be a man with breasts. That she should be allowed to have her female components. By that I mean, her compassion, sensitivity, maybe a maternalness. In other words, she should not be acting like a man all the time.

**LISA KLINK:** We did talk about Janeway a lot and about whether her gender made any difference whatsoever — and we decided that it did not. That in this idealized future, nobody gave a crap whether she was male or female. That was a world that I wanted to live in, where it was completely irrelevant because it made no difference to how she did her job. As an individual character, obviously, you bring in her gender and her background as a science officer, and you can bring in more individual traits. But as a captain, she was just in charge.

**KATE MULGREW:** Janeway first and foremost is a scientist. Her rank notwithstanding, her passion, her longing, her essence, is to explore, to discover. It was terrible we got lost in the Delta Quadrant, and I've spent my life apologizing for it. I don't think Janeway felt so bad about it. She had the opportunity to discover whole new worlds. And that I think is really what makes her beat. I love that about her.

What Paramount does is a harbinger of what will come to pass. Janeway was the first female captain, and a scientist, was no mistake. It was well-intentioned, it was clear eyed, and it was obviously prescient,

because science is the field that Janeway most impacted I believe. If I could take that to my grave, I will be a very privileged and honored person.

**TIM RUSS:** When it comes down to the captain on a ship, when you're the head of an operation, all the responsibility is automatically on your shoulders as the character. So whatever comes down, whatever challenges are faced by you or your operation, your company, your ship, it's a tremendous responsibility, and it's a lonely job. It's just you that has to make those decisions, and if it goes wrong, you're the one to blame, even if it's not your fault directly. There were some episodes that they worked in where [Janeway's] decisions were challenged. One of the classics is the "Tuvix" episode. She had to make a decision to destroy this lifeform in order to bring back her crewman. In the very, very last moment, when she walks out of the sickbay and down the hall, she doesn't say a word, but her face tells you everything. It's like a book on how she's feeling about what she just did. People will argue whether that was the right decision or not, and yet that character has to take the responsibility. We ended up halfway across the galaxy, lost, because she made a command decision. Who carries that burden? The last two episodes that we ended the season with, the whole show with, were based on her. They made those episodes around her because it was her decision to take us there. A command decision that she could be faulted for. There's infallibility everywhere. In her operation, she is, however, the captain. If she has a weakness, a moment of doubt, it's nice to be able to play that once in a while, just as a nuance. I think there were times and moments when that did play out. You're in command, and that's what command is. Even if the decision is right or wrong, you have to make it, and that's command.

**MANNY COTO (executive producer, *Star Trek: Enterprise*):** Well, it's funny – I never looked at Janeway as the first female captain. I just thought she was a great captain. She was a perfect balance of compassion and force and smarts. I really loved her as a character.

*Since Voyager's initial run, Captain Janeway has inspired generations of people. But that didn't stop severe hesitation and questioning to exist behind the*

*scenes in the creation of Voyager – specifically over her physical appearance.*

**RICK BERMAN:** Kerry McCluggage, who was chairman at Paramount Television for most of our tenure, was a wonderful guy, but he did have an obsession about hair. A classic example was Kate Mulgrew – constantly, constantly, I'd get calls requesting hair changes. And I would be the one who'd have to bring in our hair person and the actor to discuss hair changes. But never once was that precipitated by me. They were instructions.

**KATE MULGREW:** In the first season, they were so upset by the fact that I was a girl, they couldn't get over it. I had bosoms and you know… hair. "What are we going to do with all that hair…" So they were always touching me. Fiddling me around. Really, how many haircuts did I have in the first season? Ridiculous. Captain Janeway was really busy trying to get out of the Delta Quadrant – "Oh, just do my up-do." So I went to [the higher ups] and said, "Please, can I just command?" I think they were all just so tired by then, they said, "Yeah, give it a shot…" And it worked. It all sort of relaxed and took off. Had a great time.

*Such constant flip-flopping on hair led to another batch of reshoots ordered for "Caretaker," to accommodate the redesign. Recently, behind the scenes photographs of the initial shoot have surfaced, which show Captain Janeway with a hairstyle much more akin to the later seasons, but somewhat sleeked back and shorter on the sides. Why the decision was made for the "bun" look of seasons 1 and 2 may never be answered.*

**ROXANN DAWSON:** *Voyager* spent a lot of time considering hair. I don't know if it was *Voyager*, or Paramount, or Rick Berman, but I fell into the hair trap too. My hair changed throughout the years — went straight, went curly, we did braid things, we were trying different things, but I didn't mind it. I didn't feel like I was under a microscope because of it. We were just trying to find some natural changes through the years. I had more flexibility because I'm not the captain. I think they were really trying to find something for Kate that would just work from beginning to end. To her dismay, she did not like

the attention that was paid to her hair all the time. Not at all. But they were trying to do it right. They reshot quite a bit because they didn't care for her hair in the "Caretaker" episode. They were long days. It was reshooting with the entire cast on locations, all to redo it just for her hair. Rick Berman did sometimes take the heat for all of the questions about the women's hair. The men's hair didn't seem to matter, which I thought was very interesting. The hair was for some reason a very, very big deal.

**JERI TAYLOR:** The only entity we had to deal with on *Next Generation* was Paramount, because we were syndicated. They gave their notes, and that was that. With *Voyager*, we had to get notes from the studio and from the network. I suspect there is an intrinsic distrust among writers and producers, both with a studio and particularly with a network. The people who are giving you notes from those two entities are not writers, they're not producers of television, they're executives. I think it's fair to say there's not a lot of respect among writers and producers for those "suits" who are giving us notes. There are times when a studio or network gives you notes on an episode that are perceptive or helpful, I would say there are many, many more times where the reverse is true.

**TIM RUSS:** The first female captain, the first Hispanic commanding officer, the first Asian regular cast member. As a matter of fact, there weren't even that many Asian cast members on any series as a regular before Garrett. We broke three or four molds on that show and rightly so. This takes place several centuries in the future, so I'm assuming that several centuries from now, it won't be like it is now, I can only hope. I'm glad that I was there for that ceiling breakthrough as well, and they could not have picked anyone better than Kate Mulgrew for that role. They were screen-testing a number of actresses. Geneviève Bujold, and another actress from New York that they brought in. Garrett, Roxann, and I were already cast. The captain was the last role, and they weren't sure if they were going to get a female captain or not. They weren't sure so they were hedging and thinking they may have to go with a male captain, but it was back and forth. They brought in Kate much earlier, then they read some other actresses, and they brought her back.

I screen-tested with the actresses in between, where we actually shot the scene that they wanted to shoot. I read with all three of them and it was great. Honestly, when Kate walks on the bridge, I said, "Yep, that's the captain." I knew that she was right for that role.

**KATE MULGREW:** My very first walk on the bridge, I was so scared. That was nerve-racking, with all those suits standing at the lip of the bridge, just waiting. They were waiting to watch me do something wrong. We were in my Ready Room, and I was making the entrance, and [director Winrich] Kolbe said to me, "This is your living room – you can't do anything wrong; you own it." And then the doors open and I went in. He gave me the first big push. He was an excellent companion to have during that period of time.

*Michael Westmore's team, meanwhile, was working double-time, literally, with the* Voyager *pilot – for not only was this the start of a new show, but also a whole new set of alien creatures never before seen in* Star Trek.

**JERI TAYLOR:** It is harder than you might think to think of alien species that are unique and specific, but haven't been done before in some way, shape or form. We had to come up with them, but it was not easy. I am intrinsically drawn to certain kinds of stories and aspects of stories and the characters and the relationships. People's stories were much more to my liking.

**MICHAEL WESTMORE:** I would have two shows – I would have *Deep Space* starting up at the end of *TNG*, I would have *Voyager* starting up at the end of *Deep Space*, and the same thing with *Enterprise*. And at the same time, a movie.

*The recurring villains for the first three seasons of* Voyager *was the gangster race known as the Kazon.*

**MICHAEL WESTMORE:** Kazon was based on a turkey. They have this thing down here that's like a wattle from a turkey. The fore-heads on them had a top like a turkey on there – and we even painted them red. They had wild wigs, and there'd be sponges in the wig to

make it seem like there's lumps in there.

**MARK A. ALTMAN:** Shooting on the *Voyager* pilot, "Caretaker," went extremely smoothly from there on out. They did some location shooting, the new sets worked out great for them, and Kate Mulgrew immediately made the role of Captain Janeway her own. She went on to inspire an entire generation of young women with that character of Janeway.

*The* Voyager *pilot, "Caretaker," premiered on the new UPN network on January 16, 1995, and was viewed by 21.3 million people. An impressive start to the new series.*

**GARRETT WANG:** We premiered January of 1995 on a Monday. Tuesday, they came to the production office, and the voicemail was full of people who were channel surfing, came across *Voyager*'s premiere, and decided to leave a message on the voicemail. The messages were different people saying the same thing, "How dare you allow a woman to be in command?! We're going to come down to Los Angeles and blow up Paramount Studios and kill all of you!!!" Just anger. What's amazing is, having the only show with a woman captain, a strong female lead, it really is the most empowering show for any young lady to watch.

**MANNY COTO:** I like the "Caretaker" pilot better than the *TNG* and *DS9* pilot. I thought it was smoother and more interesting and better acting. But again, there was a sense that it was pulling away from its best ideas. The Maquis and things like that. The idea was that you had these people who were the opposite or against each other onboard the ship, so you were entering a fiery situation – but that was never really played out. It was pulled back from. In the same way that the *Enterprise* concept was pulled back from. So with the Maquis and the conflict aboard the ship, "We're against each other – but not really!" They kind of brushed over that very quickly. It felt like a pilot that was reaching for something and pulled back from it at the last minute.

**ROXANN DAWSON:** I loved the "Caretaker" script, our pilot,

when I first read it. It's what made me want to audition. I loved this character and everything she was going through. She is pretty salty, you know? There were just these great scenes and that ran the gamut. I just went, "Okay, I got her." I also just love the whole idea of it. I'm a huge *Lost in Space* fan actually, so there was something that reminded me of that. It seemed to open the universe to so many possibilities where this could go. I loved the different characters and I was totally impressed.

**DAVID LIVINGSTON:** The Maquis setup should have been the central conflict on the ship. Outside of going and visiting aliens, every week. Having conflict on the ship would have been much more compelling than what it ended up being on *Voyager*. It was the original intention. It was in the bible. The Maquis were put on board the ship specifically for that purpose to have that conflict, but it never panned out. Everybody in *The Next Generation* on the Enterprise got along famously, nobody ever said a negative word to anybody else. *Voyager* was supposed to be different. And the writers simply didn't pull it off.

*Over the next seven years,* Voyager *would have a number of different showrunners, but most would agree the "soul" of* Voyager *lay with co-creator Jeri Taylor. Taylor was born June 30, 1938, in Evansville, Indiana. She worked extensively as a screenwriter in the '70s and '80s for shows like* The Incredible Hulk *[1977-1982],* Magnum P.I. *[1980-1988], and* Jake and the Fatman *[1987-1992], before joining the writing staff of* Star Trek: The Next Generation *in the show's fourth season. She would go on to showrun* TNG *in its later years, and before devoting her attention 100 percent to* Voyager, *wrote three episodes of* Deep Space Nine, *which specifically set up the Maquis storyline that would later be paid off in* Voyager. *In addition to her work on the series, she also wrote two* Voyager *novels, which gave further insight into characters' backstory and motivation – as close as you can get to an unreleased episode of* Star Trek.

*Jeri Taylor ran the writers' room, which would see some of the great names of* Star Trek *and science fiction television pass through – from Brannon Braga, to Ronald D. Moore, to future* Hannibal *creator Bryan Fuller. Continuing in for its third series was the Michael Piller-instigated open submission policy for screenwriters.*

**LISA KLINK:** Jeri was terrific. She was my mentor. She called me into staff, and when I walked in, she told me that all they expected was for me to do my best and contribute to the room. She kind of eased me in, while also teaching me what I needed to know.

**ROBERT PICARDO:** I have very fond memories of Jeri Taylor. She's very bright and very un-show-biz-like. She seems like your really smart aunt or college professor. She just does not seem like someone from the entertainment industry. She's more literate, like a novelist, than a television writer. It really is her voice that brought Janeway to life, but Jeri seemed to be keyed into the emotional hook for each of our respective characters in a way that if you had a question for her, it was very easy to communicate with her. So I would go to Jeri first, and if I had a suggestion that she liked, then Michael Piller might be invited into the room.

**JERI TAYLOR:** When I became an executive producer and co-created *Voyager*, I did have more responsibilities [than on *TNG*], but mostly it's running the writing staff and getting the script into production. They shoot the script in seven days. It takes months to develop the script from beginning to end. And then they expect another one to be ready. So it's stressful.

**ROBERT BELTRAN:** I really liked my conversations with Jeri Taylor. We talked about Chakotay and where we'd like to go with that. She was great, and I really hated to see her go, and hated to see Michael Piller go. Those two were really good.

**ROXANN DAWSON:** As far as Jeri Taylor's concerned, it didn't affect me at all that she was a female. These kinds of things didn't really occur to me back then, but she was obviously a talented and super great person that I could go talk to and sit down with, discuss the fact that I was interested in directing, she heard me, and she made it happen for me. She brought my request to Rick Berman, and I always felt support from her. It was just wonderful, but I don't think I honestly ever thought about the whole woman thing. They did make a big deal of the captain, and I thought that was cool. I loved Kate. I knew her

work from earlier on. I remember her coming in for her screen test, because I was stepping out of my trailer and I saw her walking to the makeup trailer to get ready for her test. I was thinking, "She'd be just awesome. It would be so fantastic to have her." I'm so glad that worked out because she was just great.

**ROBERT PICARDO:** [The writers] were very particular about the dialogue. I understand that, because they did not want any contemporary expression, any regionalism of speech, anything to creep in the actor's performance that would take the audience out of this mythic future. If an actor uttered a slight turn of phrase that sounded 1996, that's what they didn't want. So they were very particular that the lines were said precisely. To the point where I actually would call and say "This is grammatically incorrect." They'd say, "Yes, but it's a matter of expression." And I'd say "But I'm the only character in your show who has programmed grammar. My grammar is out of the grammar book because I have been programmed with that information."

**TIM RUSS:** The dialogue was not going to sound as though it was 1994–95. You couldn't speak in those terms, in that kind of phrasing and style. It had to be a certain way, and that's just the way they did it. A lot of guest stars came on and they were very unpleasantly surprised at how specific the dialogue had to be. They had mountains of it because they were the guest star, and the script supervisor would come over to them and correct literally one word. They were like, "Are you kidding me?"

The reason why they were so strict with the dialogue, and this is since the beginning, it's a television show with characters who have this outrageous-looking makeup, yet what they are saying and doing is very serious. In order to take them seriously, they have to speak a certain way, and you cannot have them speaking in a casual manner the way we speak today and colloquially.

**LISA KLINK:** To be honest, taking pitches from new writers was a little bit of a chore. Typically, it would be two days a week. It would be maybe Tuesdays and Thursdays in the afternoons that I would be

taking pitches from maybe three or four writers. It often felt like an interruption, because I would be in the middle of like trying to get a script done or something like that, and I would have to take time to go and hear these other pitches. But having been on the other side of it, having been the pitcher, I think I had a lot more sympathy for people who were sitting on the other side of the chair and tried not to make it apparent that maybe I was being impatient.

Sometimes people would come in and be very impressive. Most of the time, unfortunately, it was not the case. Pretty much as soon as they pitch their first idea, you get the idea that this is probably not going to go so well. But the thing is you always go in with some optimism because you want them to pitch a good idea, because we did 26 episodes a year and somebody had to come up with all those ideas. So every time somebody came in to pitch, we were hoping that they would bring us something good.

**ROBERT PICARDO:** The writers, they know what they want to do. I think they write to the strengths of the actors that they cast, but they pretty much know what they want to do. To their credit, if I had an idea, they always listened to me. They didn't always take them, but I did go in and made two or three suggestions that they did take that ended up influencing the arc of the career a fair amount.

*As the show progressed into regular production, and subsequently into seasons, much became business as usual for the* Star Trek *crew. However,* Voyager *would be under new scrutiny. Still haunted by the ratings success of* The Next Generation, Voyager *had big shoes to fill. And even though the ratings and critical reaction were good, eyebrows rose because they weren't better.*

**MARK A. ALTMAN:** There was a risk-averseness in *Voyager*. The feeling was, *Voyager* needed to be *Next Generation*. They took all these risks on *Deep Space Nine*, and there was a sense internally, especially from the network, that it didn't pay off for them. So now with *Voyager*, they were going to be a lot more conservative. The idea of exploring this whole conflict they set up with the Maquis and the Federation and how to find common ground and work together – immediately

becomes everybody working in perfect harmony. Which is disappointing, because that was a really interesting idea to explore, and it doesn't really pay off.

*A decision early on was made that Janeway should avoid romantic entanglements – because with the limited crew, and the ship being constantly on the move, a romantic element with a subordinate would be inappropriate and compromise her command. That, of course, didn't stop fans from seeing romantic possibilities between Janeway and Commander Chakotay.*

**JERI TAYLOR:** I don't know how it got started, but I wrote some of the episodes where Janeway and Chakotay seemed to be feeling out a relationship with each other. It was very tempting. He was such an attractive man, and a man of depth and quality. You could see him being a worthy partner for her. But it's not a good idea dramatically, not a good idea for a captain on a ship to have a relationship with one of her crew. That's stupid. So we just decided that's not going to go anyplace. It just had the feel of, "What can we do that people won't expect?" [It] didn't seem to follow our flow organically from what had gone before, but it was just imposed on the situation.

One of our ways of addressing [Janeway's lack of an emotional confidant] was her relationship on the holodeck with Leonardo DaVinci. For which I took a great deal of crap from a group of very strident women, who were infuriated, absolutely infuriated, that we would have her have a "relationship" with a mock-person rather than a real person. Somehow that lessened or denigrated her as a person. In my mind, it was the perfect solution, because she could have this wonderful interaction with this character who wasn't real, it didn't provide any political, romantic, or sexual problems. It was just a place she could go when she needed to talk about something and needed a friend who would talk about it with her. But boy did it make some people mad.

**ROXANN DAWSON:** I think it's difficult to [write] science fiction. Even when you're got the label of *Star Trek*, it's hard to tell these stories. But when they're told "you're doing 26 episodes a season." You're not gonna hit it every single time. I think there was a flux in

terms of the storytelling, but that's part of it. Overall, if you just look back at the number of episodes that were good for each season, there were strong episodes every single season. We somehow maintained the storytelling and the development of the characters to a point where it was still intriguing for the audience.

**MARK A. ALTMAN:** Part of the problem also was that UPN was competing with the WB channel – the fledgling WB channel. And they were getting much better affiliates. The stronger stations were going with the WB, a lot of affiliates felt it was better to go with WB in the long run. *Buffy*, *Roswell*, a lot of those shows – WB was able to build a prestigious network quicker. So, *Voyager* was kind of coming out with one hand tied behind its back.

**TIM RUSS:** Back in the day, we used to get our revisions at 12 o'clock at night. They would be hand-delivered to our places at night, for the next day. So we would be in the makeup chair trying to learn whatever the revisions were for that day. On one season in particular, we just somehow got behind in terms of the scripts for shooting, so we started shooting some of the episodes before we had the rest of the script written. We only had the first two or three acts, and we didn't have the last act or so because they simply couldn't get the stories done that quickly. It was a tremendous amount of work.

You've got costumes that have to be made, you've got the make-up that's got to be designed and molded for each episode, and as the episode's going on, you've got a plan for the one that's the following week. We were shooting these episodes in seven to eight days; we'd have a couple of units shooting at the same time trying to finish up bits and pieces of the previous episode. You have special effects and post, but that's another mile and a half. Just the shooting, they have to build sets on a swing stage. You have to build a whole alien planet, with dirt and trees. I'd walk onto the soundstage, and it's a giant 20-foot-high alien lab that they built together, all to scratch. We had to build things, the props, the costumes, the makeup, the sets, every single week. Other shows shoot in ten or eleven days for their episodes, we're shooting eight. It was crazy what the producers managed. You work as a

showrunner on a show like that, you can run anything after that. When you can handle and bring a *Star Trek* series franchise, 26 episodes a year, on an eight-day schedule — it's impossible to pull off. We were there, we were filming every day, and the shows were on the air on time.

**KATE MULGREW:** In a nutshell, discipline. Real discipline. And a kind of ardor, I would say. I was passionate about it – unflaggingly, unstintingly, passionate about it. I wanted to endow [Janeway] with a new kind of humanity. I wanted to imbue her with a new kind of sensibility. I was crazy about Janeway. And as I fell in love with Kathryn Janeway, I really wanted to pick her up and give her new wings. Wings that the *Star Trek* community had not seen before. Having said that, I had two small children at home and I was a single mother, so I would tell you that I had a rigid schedule. To which I adhered for seven years. I never went into that soundstage cold. Not one day. I learned my lines every single night. That was number one. Number two, I determined to endow the technobabble with as much meaning as I could. That was hard. I could've faked it – and perhaps it's meant to be faked, but I doubt it. So I went to the Okuda Bible, and the Okuda Bible led me to Richard Feynman, who is a physicist, but an imminently readable physicist. I learned from that how to couch these terms in an understandable and sympathetic way.

**ROXANN DAWSON:** We jelled as a group right away, we really did, and we kind of jelled the whole time. It's a family; you go through seven years, there's going to be some moments of friction and people growing in different directions and want different things from their experience at work. But yes, they still make me laugh. That was such a formative period for me. When I entered *Star Trek*, I was newly married. When I left *Star Trek*, I had children and I'd started directing. A lot of things happened in those seven years that were very pivotal in my life.

**WENDY NEUSS (producer, *Star Trek: Voyager*):** *TNG* and *Voyager* were so different. I love the cast of *Voyager* and I thought they were all really lovely people, but there wasn't the same coherence, the same family feeling. I knew everyone on *Next Generation* so closely, and they

become a family unit. They really hung out together and did everything together and were so open. They would come onto the looping stage and just say everything that was going on. *Voyager* wasn't like that. It's certainly understandable, partly because I was seeing Patrick at the time, but I think they weren't that kind of people. They were prouder of it, and the atmosphere on *Voyager* wasn't quite as warm. I think there was a little more tension. I didn't know how much tension there was between Kate and Jeri [Ryan], it didn't filter back to me that much. There was a whole different vibe. A great group of people, terrific people, funny, lovely, but it wasn't a cohesive family unit in the same way. People were more private.

**ROXANN DAWSON:** It felt enormous, like they were taking it, us, and the show very seriously. Not happy with Kate's hair, reshoot the full day. They were really trying to nail it down the first time and with no regrets. So a lot of attention to detail, and we were all just starting to get to know each other as a cast and sort of see where our characters could go and how they would interact. It was just a great ride. I felt like we were being treated really well by everybody and that the show was given a lot of respect.

**BRANNON BRAGA:** My peak creative years went on in *Voyager*. *Voyager* was the most creatively satisfying show. Looking at everything as a whole, there was just something about *Voyager* I really hooked into.

**MICHAEL OKUDA (technical consultant, *Star Trek: Voyager*):** I think it would have been fun if over the course of the series you saw the ship starting to deteriorate. Now the studio doesn't want to do that because they want the symbol of their show to be this very cool, powerful thing, but I think that that would have given the show more character. I would have liked to have seen the ship started to get dirty, and on the exterior especially, maybe some meteor strikes, or if we get in a battle to have the battle scars remain. Now, that's the problem with that, of course, is you can't. It's difficult to do because a lot of the ship shots are stock shots. So, asking the producers to be in a position where every few episodes, you threw out all the stock shots and have to shoot new ones, that becomes a much more expensive proposition.

**ROBERT BELTRAN:** *Star Trek* tradition – you have to add scenes on the bridge. I always hated them, because they took so long. It was always this concocted drama/crisis, that everybody knew we'd get out of because we had to be back next week. So, I always managed in some of the takes, right before they say "cut," I would sneak something to Kate in on the side like, "Don't worry about it, Kathryn, we'll be back next week." The tradition I felt could've been shortened a little bit. The shields never went down below 12 percent.

**ROXANN DAWSON:** Rick could be very warm, but he can turn it off and on at will. It was always very interesting. I was hanging a lot around the production offices when I was studying to become a director, and he would sometimes forget I was in the room. I'd be in there sometimes for the screening of the director's cut of an episode. I'd be in the back of the room, and I think he would forget that I was there, because I still remember the day he was commenting on me and my work, and referred to me as Frankenstein. I'm thinking, "Oh my God, that's not very helpful for me to go to work tomorrow." There were definitely some moments that were interesting since I did spend a lot of time in meetings, was able to see the behind the scenes, making of the sausage. But he was always very kind, and like I had mentioned before, after my first episode that I directed, he offered me a second one by saying to me, "I'm gonna give you another opportunity to fail." And I took up the challenge.

**MICHAEL WESTMORE:** There was an episode that was a race of dinosaurs, and the humans landed on the planet, but the dinosaurs were basically like humans and that's what made this whole thing so neat. All of us when we were doing that show were going, "Emmy, Emmy, Emmy." Another show actually got nominated instead of that one. That one should have been a winner.

*Struggles with the ratings and critical appreciation continued to plague the series during its seven-year run. The season two finale saw the episode capture just an 8 percent share of the night's audience – a far cry from the 19 percent of the premiere. While today, we can look back and observe that the nature of television itself was changing at the time – with networks like WB, HBO, and*

*Disney Channel competing for viewers in ways* TNG *did not have to worry about — at the time, this downtrend in ratings was a cause for concern.*

*One solution suggested was to bring on a new cast member — one who could shake up and liven up the show. The other was to allow* Voyager *to finally enter Borg space — something astute fans would have been expecting given Voyager's location in the Delta Quadrant. The villain that had seen great success in enlivening* The Next Generation, *had recently made their big-screen debut in what is widely considered the best of the* Next Generation *movies,* Star Trek: First Contact (1996). *This would also serve as a cost-saving measure, as costumes, sets, sounds, and visual effects could be repurposed from the movie — thus giving* Voyager *a more cinematic feel.*

*All of these discussions would coincide with an unfortunate situation behind the scenes — one which would lead to the mutual decision for series regular Jennifer Lien to leave the show at the beginning of the fourth season.*

**ROBERT PICARDO:** I don't know exactly, but Jennifer was extremely quiet and private and really monosyllabic. Writers would chat with us, we'd get invited out to lunch often at the beginning of the season, by Brannon Braga and other writers. I think they wanted to get our ideas about our character, because when you're writing 25 scripts a season, that's a huge responsibility. Jennifer could never be her own advocate. You'd say, "Is there anything that you'd like to see Kes do next year?" She'd go, "No." But I think primarily it was that Jennifer was very quiet. She was a terrific, natural talent as an actress. She had great range and always delivered very well, but it was really hard to have a conversation with her. So I don't think they felt that they knew what to do with her beyond a certain point. That's my perception.

**ROXANN DAWSON:** Jennifer Lien was extremely talented, and I thought an excellent choice for that role. I think that when she left the cast, I actually missed the role of Kes. She was a part of the cast that we never got back, you know? A facet of the diamond was missing there. I thought she was fantastic. She definitely was going through some personal things, and at a certain point I guess it was decided that she wouldn't continue on with the show, but not at all because she wasn't

excellent. It really had nothing to do with her performance. She was a pro; she always knew her stuff when she was on set. She was great.

**JERI TAYLOR:** I think the reason people don't talk to you about it is, they don't know what to say. It was a mystery to everyone. Jennifer Lien, who played Kes in *Voyager* — a very, very good actor, and the relationship between her and Neelix was working wonderfully. She began to become distracted, inattentive, there was just something off. I asked her to come into my office and probed gently to see if there was something going on in her life, something I could help her with, and she simply wouldn't speak at all. This is what happened to everyone who tried to reach out and help her, including her agent. To this day, I don't think anyone knows what was going on, but clearly, there was something emotionally upset about her. She would not open up about it, she would not consider getting help about it, but clearly, it was more powerful than she was. And she was incapable of continuing. It's such a loss when someone with that kind of talent who could have gone on to such heights was unable to overcome her demons.

**RICK BERMAN:** On season four of *Voyager*, the studio came to me and felt that a couple of characters weren't effective. The writers weren't giving them quite enough to do. They mentioned two characters and mentioned that it'd be a good idea if we lost one of them. Since the Borg were introduced — the idea of having a Borg on the ship, and having it be not just a member of the hive, but a character that was human and as a child kidnapped by the Borg [was intriguing]. We had lots of casting sessions. We needed a good actor and the thought was, "Why not get a babe?" We got it down to three actors, and Michael Piller, Jeri Taylor, and I all agreed on Jeri Ryan. She was a character that the writers loved to work with. She was quite an exceptional actor. We hit a home run with it.

**JERI TAYLOR:** I don't know where that came from. It might be Paramount had their voice in there, and if so, they would have only spoken to Rick. The feeling was, something needed to give some "umph" to the show. With Jennifer leaving, we felt another female would be a good idea. We wrote the character because we thought

it would be an interesting one. Many, many people read for it. And it truly was not Jeri Ryan's appearance that got her the job — she read it the best of anyone. I remember the first day she was on the set, I went to the set. I had seen the rehearsal for the first scene, and went up to her and gave her one little note that I thought might help, and she had "it" like that. She could absorb input and reflect it back. The take was so much better than the rehearsal. She was a good actress.

*What culminated in this end of season 3 discussion was a soft-reboot of sorts, in the two-part episode "Scorpion." The U.S.S. Voyager has finally entered Borg space. The crew sees their chances of traversing Borg space as slim — until sensors detect a passageway that is devoid of Borg activity. While en route, they discover a destroyed Borg ship, and an odd spacecraft sticking out the side. Upon transporting over, the team discover bodies of Borg, and are attacked by a three-legged alien species. Janeway learns that the entire Borg Collective are at war with these beings — known to the Borg as Species 8472 — and that they are losing. Janeway determines the right course of action is to form an alliance with the Borg, to combat Species 8472, and in exchange, earn safe passage through Borg space. In Part II, the Borg send a representative to speak for them, Seven of Nine. Together, Janeway and Seven develop a weapon to fight the invaders, and instigate a plan to deploy it. But in the process, Janeway is betrayed by the Borg. Unbeknownst to the Borg, Janeway expected a betrayal, and instigated her own plan — severing Seven of Nine's connection to the Borg, and making their escape.*

**BRANNON BRAGA:** I never got tired of the Borg. I always seem to find some angle. You mentioned "Scorpion Part II." Well, the angle there is it turns out they're not all powerful. Someone's kicking their ass. At the time that was a big concept. Someone's kicking the Borg's butt? Holy shit, who's that? Species 8472. One of the first all-CGI. It looks terrible now. All due respect to Dan Curry.

*The following episode, Seven of Nine has had her Borg implants removed, but the psychological damage of a life spent with the Borg will continue to haunt her. Meanwhile, Kes's fledgling psychokinetic powers have suddenly sky-rocketed, and are at the point where she can no longer safely remain on Voyager. She departs the ship, but not before teleporting Voyager beyond Borg space.*

*All while this was happening, showrunner Jeri Taylor was making plans to retire and hand the reins of showrunner over to Brannon Braga. The man who had started as an intern on* The Next Generation, *wrote the* TNG *finale, and two* TNG *movies, would now steer the ship for future* Star Trek *voyages.*

**BRANNON BRAGA:** I saw "Scorpion Part II" as the second pilot for *Voyager*. I was transitioning into taking the reins of the show as a showrunner. It's something I never asked for or even thought about, it just started happening. I felt like the show needed some kind of infusion of fresh energy. I was waiting to be allowed to use the Borg. We cleared a path for the movie *First Contact*, and now I could use the Borg. I wanted to start doing bigger, crazier stories that really pushed the limits of what we could produce. [To test] the nerves of the characters. I wanted Janeway to start having to take more risks and I wanted to do little movies. If I couldn't do a seasonal arc, I'm going to do a bunch of two-partners. I had an idea of one, I was at home and I thought, "What if there was a Borg crew member that had become disconnected from the hive?"

**ANDRE BORMANIS (science consultant, *Star Trek: Voyager*):** I always tell people when I'm doing talks at conventions and such, when we talk about the Borg, the thing that's most appealing to me about the Borg is that we're already there. We are the Borg. If the internet went down for a week, society would come crashing down. We are totally dependent on our technology. If you turn the clock back 50 years – society would collapse. It's astonishing how dependent we are on technology that didn't exist when I was a kid. That's what I think is so frightening about the Borg – we are all vulnerable. It's technology or destruction.

**BRANNON BRAGA:** I called Rick Berman after I brainstormed with Joe Menosky about Seven of Nine, and Rick suggested that it be a Borg woman. Maybe a statuesque, Grace Kelly demeanor. That's how Seven of Nine was born. Initially, I thought she'd have more Borg stuff on her, but once we cast Jeri Ryan, you probably don't want to drone her up too much.

*After a short but extensive casting search, Jeri Ryan was selected to play Seven of Nine. The actress had previously done guest spots and recurring roles on* Matlock [1986-1995], *and* Dark Skies [1996-1997].

**JERI RYAN (actress, "Seven of Nine,"** *Star Trek: Voyager***):** Seven was a really rich character, and was very beautifully written. I was very, very lucky. My favorite thing about it was, they were not afraid to show the gray area. They were not, "Starfleet is great, Janeway's on a horse, and they're all perfect, perfect, perfect – and the Borg are all evil, evil, evil." They showed the gray area. Yes, the Borg took away my choice, but Janeway did the same thing. They showed that. Everything's not black and white. That's when I really started to appreciate it.

**ROBERT BLACKMAN (costume designer,** *Star Trek: Voyager***):** The designing of the Seven of Nine outfit was all done undercover. I had a photograph they sent me in secret of Jeri Ryan, and I was to come up with something. They told me she was going to be a Borg, and she was going to be regenerating into being a human. I came in early for the fourth season of *Voyager* to design that outfit, then fit it. It looks so simple but it's the most structured garment I've ever done. It was technically a miracle. When I talked to Berman, he said, "It can't be a Dabo Girl, but it's got to be really sexy." And I said, "Well, I can do that. I can do that amazingly. She will be covered from neck to the soles of her feet – and the 18-43-year-old fanboys will go wild."

I thought, if she's regenerating, she should have some indication that something is helping her regenerate. I wanted to put an understructure under it, some kind of rib structure – tubes that will look like she's regenerating. So I drew a picture. [Later] Rick called me up, and showed me the picture, and it had a red mark drawn in by one of the executives that went down here and up here – in other words, falling out cleavage. And I said, "I can't do that. It's not the character, it's nothing to do with who she is, and we'll look like two of the biggest panderers in the world. Pimping her. I can't do that. But I can do this suit that will look sexy." Rick clearly agreed, because we did what I wanted.

**JERI RYAN:** I had no problem with the costume. Honestly.

Because it was the antithesis of anything this character was about. It was the complete dichotomy between this character and this physical appearance. So I had no problem with that. Because in real life, there are incredible smart, incredibly capable, incredible strong women in every potential physical representation. So I had no problem with it at all. Because it could have been very gratuitous and very... That's why I didn't like that one scene – the Harry Kim, "Take off your clothes," scene. That was so on the nose for me. But that's the only one – out of four years, 103 episodes, that was the only scene that I can point to. The rest of it she was so beautifully written. And so strong, cool and smart. I was proud to play her.

*After a few episodes of that silver suit though, the suit was changed to an easier to apply brown one-piece suit.*

**BRANNON BRAGA:** The concept of Seven of Nine, we thought, could infuse Janeway with a subsidiary mission of sorts, which is the wild child. I thought about the Truffaut film, *The Wild Child* (1970), where you want to make her human again, but you never really will. It's a fragile mentorship where they kind of need each other. It's a wonderful relationship. I wanted Seven of Nine to come on and freshen up each character. Now, some caught on better than others. Janeway and the Doctor were probably the best.

**LISA KLINK:** The introduction to Seven was really interesting because we had treated the Borg just as this mass. That they specifically did not have individuality. And yet we had to develop this individual character who had been assimilated when she was a child, and so had not grown up as an individual herself. That's a really interesting backstory for a character. Once we freed her from the collective, against her will, then she almost had to go back to being a child again, in a way to define her own personality and voice. That was an interesting journey for a character.

**MANNY COTO:** I think the character like Seven of Nine, and Data and Spock, have a function of being able to step outside, observe human behavior and comment on our human behaviors.

They're striving to be human, not in Spock's case, but in Data and I think Seven of Nine's case. But at the same time, they are able to look outside humanity and comment from an extraterrestrial point of view. Seven of Nine as somebody trying to regain her humanity was just irresistible concepts that were science fiction based. She was definitely a character that was lacking on that show before her appearance. Her popularity wasn't just because of how beautiful she was. I think it was a great character.

**MICHAEL OKUDA:** *Voyager* didn't really find its legs until we brought Seven of Nine as the Borg. The wild child coming in and discovering humanity, turned out to be really the heart of the show. Then for our heroes to go up against the Borg in "Scorpion" was almost a second pilot for us. I was happy when we brought the Borg in, because we'd established that they lived in this part of the galaxy, but in doing so, they kind of robbed *Voyager* of its identity.

**MICHAEL WESTMORE:** In "Scorpion," Jeri Ryan is introduced to Seven of Nine. She is made up just like we did the Borg on *First Contact*. We did a lot of work in designing those Borg. The bald heads and the implants that go onto the heads and the eyepieces. Her suit is a bit more feminine. Jeri sat through that makeup, that must've been a three, four-hour makeup and dressing session.

**RICK BERMAN:** I think it affected the ratings positively. Seven of Nine became very popular. It was hard on Kate Mulgrew, because Kate was the first female captain of a starship. Kate was very popular amongst women groups and things, to put a woman front and center in a TV series. After three years of Kate being this symbol of a woman in charge, and extremely popular, all of a sudden a new woman arrives, who's younger and stunning, and the press put a lot of focus on her. Certainly, in the beginning, it was hard on Kate. But it eventually worked out.

**BRANNON BRAGA:** It upset the cast. Look, the show had been on for three years, and was working. I think Jennifer Lien's departure upset people. Naturally. Kate Mulgrew was very protective of her

people, and to see one leave had to be upsetting. And here comes this new person – I think there was definitely friction with some of the cast members. I don't know how well Kate got along with Jeri at first, I think Kate was just upset by what was happening. All that settled down, but I wasn't surprised by it.

**JERI TAYLOR:** It's always tricky dealing with actors, by definition. They have all at once egos that are inflated and fragile. And I understand that. The acting world is a perilous one. So I suspect what happens when they get a job that's somewhat long-lived is that they want to exercise a little bit more control than they have felt at other times in their lives. So they want to begin assuming control, and making choices, and deciding what scripts are brought to them and what happens in their character arcs. That way lies madness.

**KATE MULGREW:** Actors are by nature skittish. We get fired a lot, we lose jobs a lot, we get rejected a lot. And when we get a good job, we want to hold on to it, so there's a wariness, a carefulness. But I've never felt that. I just don't. It's a wonderful thing to play a great part.

**MARK A. ALTMAN:** It seemed like the recipe for success, because she was getting on the cover of TV Guide, she was getting a ton of press. There's only one problem with that: The lead of the show, Kate Mulgrew, is not happy. Because all of a sudden, she's being usurped by this newcomer, who's the new hot thing. Literally and figuratively. And she lashes out. *Voyager* becomes a more unpleasant place to work because Kate is becoming more sarcastic and unpleasant to work with. She's very mean to Jeri Ryan. And to Kate's credit, I have to say, she has acknowledged it, she has owned her behavior, and she has apologized for it. But this was a real issue at the time. It definitely wasn't Jeri Ryan who was the problem – she was doing everything she could to assuage Kate's issues. It wasn't her choice to be the resident sexpot. Also, she was the bright shiny penny, so she was getting the best storylines. So some of the other cast was starting to resent the focus on her character.

**JERI TAYLOR:** I don't think that because someone is beautiful

or has an amazing body, that lessens them as a female role model. It's irrelevant. It may not be to everyone, but I did not see that just because we had a strikingly beautiful person, that does not lessen the attitude the series was trying to propagate.

**BRANNON BRAGA:** I felt, and this just may be my narrow perception, that the character of Seven of Nine was judged unfairly from the get-go. They had ads and posters and stuff of this form-fitting outfit on a statuesque blonde. She was marketed as this new character and was getting a lot of attention before anyone saw who she was. I remember people being critical, even within the ranks of the people I was working with, like, "Oh, you're bringing T&A on the show. How low do you have to go? How low are you going? That you're just turning this into *Baywatch*." I was really very offended by it because I knew what Jeri was doing because we were filming at that point. This was a great character and Jeri was bringing it to life. I'm like, "Can you just wait until you see the character and not…You're the one being sexist by judging her appearance and thinking we're just turning this into *Baywatch*." Yeah. We really embraced her looks. We did. I mean, that outfit was something else. But I thought it was okay because there was depth to the character. And I thought it was a good counterpoint to how she looked.

**ROBERT PICARDO:** When Jennifer Lien was going to leave the show at the end of season three - I felt really bad about that. They were breaking up our original cast. The Doctor had a very unique relationship with Kes, because ostensibly he was mentoring her as his medical assistant, but she really was mentoring him in his developing sense of entitlement as an artificial intelligence. When Kes was leaving, I went in and spoke to Brannon Braga and I said, "I'm concerned that the Doctor will revert to being a joke, a windbag character, because he doesn't have the sounding board. He doesn't have the crew member that he shows the other side of himself to that he doesn't show to any of the other crew members." He said, "Try to think of a way to relate uniquely to our new character that Jeri Ryan is playing." Well, Jeri Ryan is a very beautiful actress, way younger than the Doctor, so it didn't seem appropriate that he interact with her in a way that most

men would love to. So I thought about it, and I went, "Well, here's an idea. Since she's a human turned into a Borg and is now going to be reclaiming her humanity, what if the Doctor thought he was a better teacher of how to be a human?" It appeals to the comic side of the character that he has such an overinflated sense of his own self-worth, that he would be a better teacher than the real thing. I said to him, "It would be fun to develop role-playing scenes where I'm teaching Seven appropriate behavior under these circumstances by playing a character with her." There would be great comic potential in that. And that ended up turning into a four-year arc with Seven of Nine, which was really, really fun.

**MARK A. ALTMAN:** The introduction of Jeri Ryan's Seven of Nine did briefly help the ratings. It was a short-lived phenomenon. It certainly got a lot of attention. Entertainment Weekly and TV Guide – all these publications were scrambling to have Jeri Ryan on their covers. It did get the show a lot of attention. But they never reached the heights of "Caretaker." *Deep Space Nine* and *Voyager* were never going to get what *Next Generation* had. *Next Generation* was a very unique point in television. Also, you have to remember, *Next Generation* was first-run syndication, so it was on a lot of really strong channels in some cases and got a lot of promotion. Whereas *Voyager* was spearheading the new United Paramount Network (UPN) which in a lot of cases was some bad UHF channels and local independent channels that had been rebranded as UPN. They were competing with the new WB channel. So there was a lot of industry reasons why the show was at a disadvantage.

*Despite this, many fans and modern reviewers highlight the Janeway/Seven of Nine relationship as one of the best of* Trek *history – becoming a defining feature for the show during its final four seasons.*

*At the end of the fourth season, Jeri Taylor retired from* Star Trek *and Hollywood in general, moving to northern California, where she currently resides.*

**JERI TAYLOR:** I had made the decision before season four started that I was going to retire. My husband had already retired, and was up

here [in Northern California], so it was time and I was ready. But it did not have anything to do with what was going on with the show.

**ROBERT PICARDO:** I remember specifically Brannon Braga asking me to have lunch with him early in one season. The writers were already back working and we had not started shooting yet. I think it's a friendship thing too, but they were going to get their job done no matter what. I always thought of the writers' room like the really smart kids in college who waited too long in a semester to do their term papers and then stayed up all night and wrote them. They were great, but it was chaos until the moment they had to turn it in.

**ROXANN DAWSON:** Brannon Braga was always extremely gracious, inviting the actors to give their thoughts, their ideas on character development and arcs. I thought he had a pretty open-door policy. Very easy, and good to talk to. He was a great addition to our show. *Voyager* was constantly evolving. I don't know if anything felt different at any single time, because it always felt different as we were moving through the series, because things were changing, from the cast changes to the showrunners changes to people moving into directing. We were always in a state of flux. I didn't notice that there was anything one way or the other, but when Brannon came in as showrunner, that was drastically different.

*A few years later, Ronald D. Moore joined the writing staff. Fresh from his time on* Deep Space Nine, *he was about to learn times had changed in more ways than one.*

**RONALD D. MOORE:** It was a difficult chapter in my *Star Trek* career. *Deep Space Nine* had come to an end, and they had asked me to come to *Voyager*. It was the easiest thing to do – it was a lot of money, I got to keep my office, I love *Star Trek*, and I just decided why not keep going? The other *Deep Space Nine* writers all were like, "I don't know Ron. We're out of here." And I was like, "See ya…" It turned out to be a very unhappy experience. I was not the right person to go to that show. It was problematic with the relationship between Brannon Braga and I, and I just wasn't happy. So I left. Ultimately, I do think it was my

mistake. I should have left, it was time to leave, and should've left on a high note after *Deep Space Nine*. But I just wanted to hang on and keep doing *Star Trek*. It wasn't a good fit.

When I left *Star Trek* after 10 years and I was looking for another job, my agent told me, "You should spec out another series." And I was like, "What? Write a spec for another series? I have 50-60 episodes of television and two movies written?!" And he said, "No one will read a *Star Trek* script. No one takes it seriously." I was shocked. We felt that on the show. At the beginning, we weren't even considered real *Star Trek*. So we were a sub-category of a sub-category.

Voyager, *like* The Next Generation, *and* Deep Space Nine *before it, would also see some of its actors direct episodes. Possibly the two most successful of the "Rick Berman School of Directing," were Roxann Dawson and Robert Duncan McNeill. Both have gone on to wide success, directing shows like* Foundation *and* Turner & Hooch, *respectively.*

**ROXANN DAWSON:** I approached Jeri Taylor, I tell her I'm interested in directing, she passes it on to Rick, we get a sign-off on that. Then I get put onto all of the communications, invited to all of the various production meetings, access to the editing room, and access to almost anywhere I wanted to go. The Paramount lot became my school. I just ate it up. I loved it, I loved being a fly on the wall and watching the directors work, I would come up with my own plans and watch them work, then I would go into editing the next day and watch that work be assembled. I also approached other shows on the lot, like *Buffy* and *Angel*, I would observe and shadow as many directors as I could. I was also taking a private course and doing my own little mini things. I was reading a lot and I loved it. It was literally like going to school for me, and I loved school. I come from the theater, and I di-rected a little bit in the theater, but I always thought I would act. I'm a very controlling person. I just really always liked to tell people what to do. I directed a little bit in the theater world, and always knew I wanted to try it in film, but I didn't know if I'd like it, to be honest with you. I think my background in choreography as well allowed me to really get that other dimension of being able to move the actors with the camera

and tell a story. Suddenly, I realized that was exactly what I wanted to do. It was so clear to me. But when I started, it was really just a test. There was a question: Do I want to do this? I was very willing to walk away from it if it wasn't the right thing for me.

*Voyager ended its seven-year run with the U.S.S. Voyager making it back home, but only after a nearly fatal battle with the Borg. The finale, "Endgame," proved not just an end for* Voyager, *but also for the mythology of the Borg first set up in "Q Who" with Janeway and Seven of Nine successfully destroying the Borg from within.*

*The* Voyager *finale aired on May 23, 2001, and was viewed by 8.8 million people for a 13 percent audience share. While perhaps not the numbers of the* Next Generation *finale, "Endgame" still showed there was life in* Star Trek — *but that didn't stop the questions of "how much life?" from being asked.*

**JERI TAYLOR:** I think there are some series that quit when they're ahead and you feel like they could have gone on for a little longer. I have the feeling that *Voyager* was done when it was done. There was not anything left to mine in it.

**BRANNON BRAGA:** I thought Seven of Nine should have died. My pitch — because I worked out the story with Rick and Ken — and I said, "You know, we set up this tragic character who can't ever be a Borg again, she can never really be human, and she is leading a really hard existence." We had just done an episode where she started to develop a love for somebody, and an implant activates — we learn that if she falls in love, her Borg implants will kill her. What a tragedy. And if you can't love, what's the point of living? This is a tragic character. I thought Seven of Nine should have died getting the crew home. There would not have been a dry eye in the fucking house. To me, the finale was missing something potent like that.

**DAVID LIVINGSTON:** On the very last episode I directed at the end of the series, [Kate Mulgrew] called me into her dressing room and said, "I know you and I have struggled over the years, David. But I want to tell you that in the end, the work was good. And what we did

together was valuable." That was a huge relief to me.

**JERI TAYLOR:** I was what you might call a consultant [on seasons 5–7]. They sent me all the stories and all the scripts, and I would give notes — yet another layer of notes they had to deal with or not. It was horrible. When you're involved with production and developing scripts and working with the staff, it's a very stimulating kind of life. It's creative and artistic. When you just read something, and then write some notes and send it back, it just feels lifeless. I felt a certain obligation to the show. I was one of its parents, and I thought I should participate through to the end in some way.

I remember toward the very end, every story, I felt like giving the same note. Which is we've simply developed too many stories and it seems tough to come up with something fresh. They began to have a repetitive feel. They did what they had to do, got people home. They had some relationships in there that paid off or didn't. It was probably how it should have ended. But it just sort of seemed to end.

**GARRETT WANG:** I thought the final episode would be a great one to redo — because I remember reading the script and thinking the first hour was amazing, but the second hour tied everything up too quickly. So I called up the executive producers and said, "You really want to make this amazing, film the first hour, then air that on TV and say at the end, "To be continued… at a theater near you…" Then a two-hour movie of us getting back home. We didn't even step foot on Earth! The episode ended with us in orbit.

**ROXANN DAWSON:** There was quite a bit of change. We were all aware at the end of the seven seasons that *Enterprise* was coming in. I think some people felt neglected because all the eyes were on "What is the *Enterprise* going to do?" I remember finishing the show, and the sets being torn down before we could even reach the doorway of the soundstage. There was very little applause, there wasn't a lot of goodbye, and that I found unusual. I would have expected that after doing seven years on a show that there would have been a little more acknowledgment on the last days of people working. You would think that there'd

be a little bit more recognition of the work that had been done, but there wasn't really. I think that was the one disappointing thing of the entire experience, which I loved, was the goodbye wasn't ever really a goodbye. I think we all shared that as an opinion.

**KATE MULGREW:** [At the end of the series] one by one people were released, and then it was just me. I was kept for five days of close-ups and pickups for the entire season – just in case. I swear to god, I sat in my Captain's chair and I delivered every single line they gave me. I did it standing, I did "engage," and "Red Alert" and I did it sitting – for five days. And just as we were about to wrap, a crew guy came with this screwdriver and started to undo my chair. The chair is being dismantled, the console is being ripped from behind me, and I'm trying to do… And nobody's there. Berman didn't come, none of the producers came – I was all alone. Finally, I heard, in from the darkness, "Well that's it, Kate. Thanks for a great seven years. And that's a wrap." I stood there, I'm not kidding, I started crying. "Oh my god… is this it??" When I saw silhouetted in the briefing room door, Robert Picardo, the Doctor, "Come here, Captain, give me a hug. Let's go have a drink." And that's why I say, the memory is — friendship.

## *"IT'S BEEN A LONG TIME…"*
## *(YOU KNOW WE HAD TO DO IT*
## *EVENTUALLY.)*
*Star Trek: Enterprise*, and the end of an era.

"We are all explorers driven to know what's over the horizon, what's beyond our own shores. And yet the more I've experienced, the more I've learned that no matter how far we travel, or how fast we get there, the most profound discoveries are not necessarily beyond that next star. They're within us, woven into the threads that bind us, all of us, to each other." ~Captain Jonathan Archer

Deep Space Nine *ended its seven-year run in the spring of 1999.* Voyager *ended its seven-year run in the spring of 2001. For the first time in 14 years, no* Star Trek *series was currently on the air. However,* Star Trek *was still a success in ratings. Movies, home video, and merchandise sales were still high, and there was every hope that the film franchise would continue on. Therefore, it was inevitable that Paramount would look for a new entry to the* Star Trek *franchise.*

**RICK BERMAN (creator/executive producer, *Star Trek: Enterprise*):** We were a few seasons into *Next Generation* when the studio said, "Let's get another one going." And that became *Deep Space Nine*. When *Next Generation* ended, they went into the movies and they said, "Let's get another show," which became *Voyager*. My feeling was, "Let's take a break. We're doing this too quickly." Their feelings were, they have a time slot, ratings — do it. And the same thing happened when *Deep Space Nine* ended, and we had two or three seasons of *Voyager* left. Again, I said, "Let's wait." "No, we have the time slots, let's go." Brannon and I had developed a very close relationship and decided to do it together. Unlike Brannon running the writing staff and I running everything, we decided to write it together. We worked together beautifully.

**BRANNON BRAGA (creator/executive producer, *Star Trek: Enterprise*):** *Enterprise* or *Star Trek: Enterprise*, as it would come to be known. I got a call one afternoon. I was working on *Voyager* and, Rick Berman called me and said, "What do you think about co-creating the

next *Star Trek* with me." Rick and I had become close colleagues over the years. He had a concept for a prequel. [Prequels] weren't a huge thing at the time, I think *The Phantom Menace* had come out. But he wanted to set it in *Star Trek*'s past closer to our time. We came up with a concept to set part of it on Earth while the Enterprise was being built and really do a "How did Starfleet get it on its sea legs?"

*With the new series, franchise producer Rick Berman, chose to take more of an active hand in the writing of the show.*

**RICK BERMAN:** When Brannon and I decided to create *Enterprise*, we decided to write the pilot together. With a Mac sitting on a desk projected onto a big TV. We would work three hours or so every day. I would say, of those 19 years, that was the most fun for me, and the most rewarding.

**MANNY COTO (executive producer, *Star Trek: Enterprise*):** Rick Berman on *Enterprise* was more like the Dick Wolf position, where he oversaw everything. There were things that were his domain, like post-production and visual effects and all that, but also story. He approved the stories and was very much creatively involved in every season. Everything had to go through him. I always enjoyed working with Rick. He had a sarcastic sense of humor, and I enjoyed that. He would go through your scripts. You'd sit down with Rick and he'd go through your scripts and give notes and do little marks. That rubbed [some writers] the wrong way and they were irritated by Rick's notes. I always thought they were funny and he was very wise. I have a thin skin when it comes to that stuff. I'm happy to sit in and hear his stuff. I enjoyed hanging out with Rick simply because I can get him to talk about Gene Roddenberry and the old days. He would tell me great stories. I mean, fantastic stories, which I can never get enough of. I really loved Rick and I thought he would come up with great stuff. I have great fond memories of going into Rick's office with Brannon and just sitting there. And first of all, bullshitting about the news of the day, but also then talking *Star Trek*. It was great.

**BRANNON BRAGA:** I thought the prequel idea was cool. I

immediately understood what he was going after – something with a slightly different tone to it, but was still *Star Trek*. Rick had the idea to call it *Enterprise*, which is probably the only word that says "*Star Trek*" without actually saying *Star Trek*.

**MANNY COTO:** I think Rick felt he was the torchbearer of Roddenberry's vision. And I think people working on *Voyager* and *Deep Space* probably got more of that than I did. By the time *Enterprise* was in play, the show was what it was. I didn't get much from Rick about Roddenberry's vision and we couldn't do certain things. Rick was wary of too much sci-fi goofiness.

**BRANNON BRAGA:** One of the things that I thought was the coolest aspect of *Enterprise* was, we were picking up right where *First Contact* (1996) left off. Rick and I thought, "Well, what happened between *First Contact* where we meet the Vulcans for the first time, and Kirk's era?" And we thought, "Well, what if the Vulcans had a heavy hand, and they didn't think we were ready?" The Vulcans were stern mentors. This was a phase in their relationship with humanity. I thought it gave us a lot of good stuff in *Enterprise*. But a lot of fans were like, "Why are you doing that?"

**MANNY COTO:** You need one person who is in charge, who has a vision. And that doesn't exist for *Star Trek*. It used to with Rodden-berry, and for a while it was with Rick Berman. Rick was the one with the vision. There were four series under Rick that were very good, and then when Rick left… You'd have to have someone who loves the franchise to oversee it, but who also has good taste and is smart. You can get somebody who's running the franchise and then running it into the ground. It's a lot of moving parts, but I just think these franchises cannot be controlled by groups of executives who don't like them and are just simply looking for what's hot. You can't run a franchise that way, you can't grow a franchise that way.

*Development on the new show,* Enterprise, *and its pilot episode, "Broken Bow," began in late 2000, with Brannon Braga handing over his showrunning duties on* Voyager *to Ken Biller so he could devote himself fully to the new*

*venture.*

*Original plans were to have the whole first season set on Earth – in the spirit of* The Right Stuff *(1983) – as humanity prepares to boldly go for the first time. The ship would not be the traditional starship design we all know, but a shape reminiscent of '50s sci-fi rocket designs. The crew of the Enterprise truly would be the first humans in space, and also vastly behind the technology of the alien species they would encounter. However, the feeling by the studio was that the audience wanted the reliable and familiar stories, not a reinvention of the franchise.*

**MANNY COTO:** Brannon's idea [originally], which was an interesting idea, was that he wanted to do the series more about how the minutiae of traveling in space, the little things that our characters might experience that had never really explored in other episodes. It didn't give us momentum. And I think audiences were expecting a little more with a sci-fi adventure series. But it's a cool idea. I think to do that, you really have to embrace it. Meaning if you really want to do something about the minutiae of exploring new worlds, then you have to go all the way. You have to deal with gravity. You don't have the viewscreen on the bridge.

Brannon's original idea by the way — which was slowly, the studio interference — it was kind of whittled down to ultimately became the same kind of *Star Trek* scenario, but he wanted to do something much more like *Run Silent, Run Deep* (1958), which was a real submarine [feel.] We don't have viewscreens, we're cramped, and we have limited technology. Which I thought would have been much more tense and scary and new. Ironically it was done in *Battlestar Galactica* (2004-2009), the Ron Moore series, where they didn't have the classic viewscreen and you had characters sitting around and kind of bumping into each other. Much more a warlike feel. I always found the submarine scenario much scarier because even exploration being inside a vessel where you don't know what's going on outside, or you have limited capabilities, would have made for a much more tense series. If you want to go more realistic then go all the way.

Brannon never really got to go as far as he wanted with everything. He had a lot more radical ideas than people realize. And then because of studio pressure and what-have-you, they would put the box back in its regular place. But if Brannon had gotten all his crazy ideas in *Enterprise* – I think it would've been a lot more interesting.

*The story that ultimately made it to the screen centered on Captain Jonathan Archer, put in command of the newly minted Earth ship,* Enterprise. *The first ship scheduled for deep space exploration, the* Enterprise *is given a Vulcan science officer to "observe" their progress – without being too forthcoming about technology and what lies in space in the process. Meanwhile, a Klingon has been discovered on Earth, injured while fleeing from unseen attackers. It is decided that the Enterprise should take the alien back to Klingon space. On the journey, the Enterprise is hunted by an alien race known as the Suliban, who infiltrate and kidnap the Klingon. A rescue mission is mounted, and Archer and the crew learn that the Klingon was carrying vital information to the Klingon Council – information that told of a temporal war involving the Suliban and a plot to start a civil war within the Klingon Empire. The Klingon safely back with his people and communication with an alien race secured, the Enterprise sets out on its journey of exploration and discovery.*

*Casting for "Broken Bow" began in the late spring of 2001, mere weeks before filming was to begin. Unlike* Voyager, *which was plagued by difficulties in securing the lead,* Enterprise *had only one choice for the role of Jonathan Archer.*

**BRANNON BRAGA:** Rick and I had an archetype we wanted to hit with Archer – Harrison Ford, Tom Skerritt from *The Right Stuff* (1983). Kerry McCluggage, who was the head of Paramount television at the time, suggested Scott Bakula. We met with Scott, and he just seemed like the perfect guy. He had a certain affability, you liked him, he was a good captain but you believed he was in over his head at times. It was interesting because he was more famous at the time than Patrick Stewart or Avery Brooks was when they came into their roles. But I really love Scott.

*Scott Bakula, born October 9, 1954, in St. Louis, Missouri, was already*

**343**

*a household name from his earlier lead role in NBC's science-fiction show,* Quantum Leap (1989-1993), *and was a fixture on made-for-TV movies throughout the '80s and '90s.*

**MARK A. ALTMAN (creator, *Pandora*; author, *The Fifty-Year Mission*):** I really love Scott Bakula in most things. I'm not a huge fan of him in *Enterprise*. There's a certain charisma and larger-than-life quality that a starship captain needs to have – that Shatner had, that Brooks had, that Mulgrew had — that Scott just doesn't have. He's a great actor, but… That whole ensemble, I wouldn't say bland, but there's not a sparkle that a lot of the other ensembles had. There's not a lot of characters I find super memorable in that series.

**MANNY COTO:** Bakula was a huge "get." I tried to get him for *Odyssey 5* (2002-2004). I was starting up [the Showtime TV series] *Odyssey 5* the same time *Enterprise* was starting up. So I was trying to get Bakula for my show. Then I found out they were doing *Enterprise*, and Bakula had been given an offer, and I'm like, "Well, that's that." So he was a huge get. Everybody was talking about it.

**JOHN BILLINGSLEY (actor, "Doctor Phlox," *Star Trek: Enterprise*):** One of the great things about Scott was he could remember everybody's names, birthday, their wife's name, and their children's names. It's funny. You don't really see the extent to which number one on the call sheet sets the tone for a show and whether or not it's a fun set or horribly unpleasant. Scott and Mark Harmon are the two actors that I've bumped into in my career who I think set the most extraordinary tone as number one. They both had that kind of quarterback mentality. This is the team; my job is to make sure the team plays as a team.

**MARK A. ALTMAN:** At the time that they cast Scott Bakula, not only had he been a big success in *Quantum Leap* for NBC, but he had a somewhat successful movie career. He'd just done *Lord of Illusions*, and done some supporting roles. He was someone Kerry McCluggage had had his eye on and wanted big time for the show. They wanted a lead that'd have queue value. They weren't just going to cast somebody that

nobody had heard of. And they didn't want a repeat of the Geneviève Bujold disaster. They say the tone of the set is set by number one on the call sheet – and the one thing you can say about Scott Bakula is he's one of the nicest guys in Hollywood. So he set a great tone. A great work ethic. That's why I hate to say anything bad about [Archer].

*Other actors hired were model-turned-actress Jolene Blalock as the Vulcan T'Pol; John Billingsley (The Others [2000]) as the alien Doctor Phlox; Dominic Keating (Jungle 2 Jungle [1997]) as Lt. Malcolm Reed; Anthony Montgomery as Ensign Travis Mayweather; Linda Park as the translator, Ensign Hoshi Sato; and Connor Trinneer as Commander 'Trip' Tucker.*

**MARK A. ALTMAN:** On the original, you had Kirk, Spock, and McCoy, and with *Enterprise* you have Archer, T'Pol, and Trip, played by Connor Trinneer. And Trip is good – he's kind of this good ole Southern boy and an engineer. It's a good performance. But again, it's not incredibly memorable. He has some good episodes, and they end up killing him off in the end, which I guess is a gutsy move.

**JOHN BILLINGSLEY:** I'd watched some of *The Original Series* as a kid in syndication, but intermittently. I certainly wasn't a big fan, I couldn't quote it chapter and verse. When I got this, I was certainly aware of the phenomenon of *Star Trek*. I was aware of the fan base, the long history of the show, how the movies revitalized it and *Next Gen* and the conventions. The way that it could be a life-changing experience because you are entering a familial situation. I never even auditioned for *Star Trek* before. I had just auditioned for *Alias*, and I was up for the part of the tech nerd that went to Kevin Weisman. That fell through. It was towards the end of pilot season, so I thought "Oh well." Then *Enterprise* came up very late in pilot season.

In the audition, they don't give you all the materials sometimes. I just got a scene and it said, "Come in with a slight alien accent." I said to the Mrs., "A slight alien accent? I don't know, let's just fuck around." We tried this, we tried that, and after some experimentation, I thought, "Obviously he's somebody who's kind of delighted with life. Somebody who's delighted with life, they can't contain their exuberance. So

maybe he's a bird? And on his own home planet when he's exuberant, he squawks." I went in and I squawked a few times and they gave me a callback. I go in, I squawk again, and I get the job. I'm at the table read, and nobody's really said anything. I squawk a few times at the table read.

At the end of the table read. I turned to Rick and Brannon and say, "So am I a bird?" Rick and Brannon were practiced inscrutablists, so they didn't give me an answer. On the first day, the makeup doesn't make me look like a bird, so I think I'm probably not a bird. First rehearsal, first scene, I squawk. Jim Conway, who's directing the pilot, says, "John, quit fucking around!" At which point I knew I was not a bird. The path that led me to that choice was right, which is that Dr. Phlox was somebody who carried a tremendous amount of exuberance and enthusiasm around with him. It wells up and it manifests itself. People who are full of joy, they express it in their bodies and faces and gesticulations and vocals. To me, that was always part of Dr. Phlox. Of course, you play the scene as it's written.

**BRANNON BRAGA:** You know… John Billingsley as Doctor Phlox. You're telling me right now he thought he was playing a chicken, and suddenly it all makes sense. His mannerisms… He was playing a chicken. Never heard that before. And I'm thinking right now, his weird head movements he was doing… He was a fucking chicken.

**MANNY COTO:** The problem with the presence of the Vulcans in *Enterprise* is that you had a group of characters who already knew everything we were trying to find out, but were holding back that information just because they were grumpy and didn't like us. We were trying to explore new worlds, but you got the impression that the Vulcans had already been to all these places. So it's like, "Oh great. We're number two!" We're just following in their footsteps. To me, the simple fix would have been — because I really liked the Vulcan showing up at the end of *First Contact*, it was terrific – [to have the Vulcans] show up and then go away. They weren't interested in helping us.

Humanity should have gone out on its own further exploration and

surpassed the Vulcans very quickly. Just because of our nature, whatever you want to call it. You can't have a show that's about exploration when another race has already explored all this and we're just catching up. No one wants to see that. What's the point? Why explore what's already been explored? We'll just ask the Vulcan. "Hey, so what did you find out there?" You undercut everything. So that was the part that was one of the major problems.

For whatever reason, by the way, [the Vulcans could not have explored much space and we surpass them very quickly]. It could have been political. It may not have been in their nature. A million things could have been going on there so that the Vulcan showed up. We happened to make first contact. Terrific. But they had no interest [in us]. It makes the humans the center, we're the intrepid [explorers].

I love the idea of aliens have left something behind, that we're seeing their presence, but we don't know [what it is], and we're puzzling out what they were like. It makes the idea of exploration go hand in hand with the mystery and solving a mystery and what's out there. What are we going to find? I think that could have been, that should have been, much harder hit.

**JOHN BILLINGSLEY:** If the show was about the first human ship out there, either there shouldn't have been aliens, or our presence should have been infinitely freakier, which is what I would argue. Vulcans in the eyes of *Star Trek* fans are not even aliens anymore, they've been part of the cosmology for so long. To me, the biggest problem with *Star Trek* is that most of the aliens are just guys with rubber heads on. The true alien experience, to have a real alien creature, I think it could have been a complete freak-out for everybody. How they eat, how they sleep, how they defecate, their social mores and their customs, how they speak. I don't know how to solve this problem, but the idea that anytime you meet an alien, they're speaking perfect English because you've got a little device that you hold up and you push three buttons. But you can't tell this that you can't tell a story about what's broken in 43 minutes. As soon as you introduce a problem, you gotta start having the solutions to the problem. The reason that you have

the universal translator and the little medical tricorder and every other technological quick fix is because you gotta be able to solve the problems fast. I get it, but some of what's scary is just that. We all experienced it in life.

**MARK A. ALTMAN:** It was a mistake to do a prequel. *Star Trek* is at its best when it's boldly going. It's right there in the narration. By going backwards, you're being more tepid. People don't want to go back; they want to go forward. So while there is a certain appeal to seeing how it all began, I think it's misguided.

*Shooting on the pilot began on May 14, 2001, with exterior locations. Meanwhile, production design was underway, presenting a unique problem for Herman Zimmerman and Michael Okuda: How do you make a prequel to* The Original Series, *when so much of our real-world technology has already superseded it?*

**MICHAEL OKUDA (scenic art supervisor, *Star Trek: Enterprise*):** What we were trying to do was take the 1960s show on one end, and the NASA space shuttle on the other end, with switches and meters, and try to find something in the middle. Not to look more advanced than the original *Star Trek*, but to have the original *Star Trek* stand as a model of elegance and simplicity. We were trying to do some clunkier, busier, and harder to use, to show what they've grown into in *The Original Series*.

**BRANNON BRAGA:** Being a prequel, there was a lot of discussion about what the art direction and production design would be. Uniforms? Easy. But the ship… Rick and I and our production designer, Herman Zimmerman, took a tour of a nuclear submarine. Which I had a panic attack almost in there – it's very cramped. And we went with that vibe. Very high tech, gleaming, but touches like, in Archer's Ready Room, he has to duck under a beam. They haven't quite got that spacious Captain Picard Enterprise yet. Which looks like a resort in comparison. We went with a more rudimentary sensibility.

**MANNY COTO:** I think Herman Zimmerman's sets for *Enterprise*

were just the best sets I've ever been on. They were just gorgeous. The engine room was spectacular. It was all there. It was all beautifully painted. When I'd take breaks, I used to go walk up and down those corridors in that set. So, I'm not surprised that he thinks it was his best work, because it was still one of the most beautiful sets I've ever seen.

*With the production crew behind the scenes entering their 15th year of* Star Trek, *the process of pre-production and eventual filming went smoothly.*

**DOMINIC KEATING (actor, "Malcolm Reed,"** *Star Trek: Enterprise***):** You do read the pilot and go, "Pshh, I wish I was in it a bit more." But I realized early that the classic *Trek*-thrust was the triumvirate, and the triumvirate was Scott, the Captain; Jolene, the vixen; and Conner, the heartthrob blonde. (laugh) But it was a good solid start. They spent a lot of money on it.

*Speaking for the Enterprise Season 1 Blu-ray special features, James Conway, director of the pilot episode, recollected a phone call he received from Rick Berman: "He says, 'I'm gonna ruin your weekend. I want you to direct the Enterprise pilot. It's a $12 million production.' Biggest production they've ever done, biggest production I would've ever done. They spent a fortune on the pilot."*

*"Broken Bow" premiered on September 26, 2001, to a respectable 12.6 million viewers. Despite receiving positive reviews from both critics and fans, the ratings saw a steep decline over the course of the season — with the season finale garnering only 5.28 million viewers.*

**BRANNON BRAGA:** When *Enterprise* came out, there had been a lot of *Star Trek* on. It didn't benefit from that. I think people were like, "Tell us why this has to be on the air?" We felt we were still mid-stride. Still had lots of stories to tell, and had found a slightly new way to do it. We were just doing what we've always done. But instead of having this glorious moment of having Kirk and Picard on the cover of Time magazine, we were scrutinized.

**RICK BERMAN:** The expression that I heard was "franchise fatigue." Which today is a joke, because I think they have 260 *Star Trek*

shows on the air now. But this was our fourth show and I think there was some franchise fatigue. It could've been the quality of the show, it could've been franchise fatigue, but it all came down to the ratings.

**MARK A. ALTMAN:** If you look at *The Original Series*, it was a little weird and creepy – you're always coming across things you've never seen before. "Strange new worlds," if you will. But with *Enterprise*, it was all things that had been already encountered. The Andorians, or the Vulcans – but there didn't seem to be anything that was fresh and new. It didn't feel like they were the only ship out there – going boldly where no one has gone before. And by the end, there were multiple ships from Earth.

*Despite the perception of franchise fatigue –* Enterprise *is not short of interesting science fiction concepts – aided by the advancements in computer technology.*

**MANNY COTO:** The Temporal Cold War [established as the continuing story element in the pilot] was a really cool idea, but it was just never fleshed out. It never jelled. I think it became a lot of exposition with crewman what's-his-face showing up and talking and showing the map and all that stuff. Really interesting stuff, but you never really got a sense of a real Temporal Cold War – a real war of time. It was never fleshed out because I don't think any of us really knew what it was. We never sat down to really think it through.

**MARK A. ALTMAN:** They had tried to establish a mythology with the Temporal Cold War – which I thought was a really interesting idea executed poorly. Brannon had this idea of it would be a prequel and a sequel – because you'd have this race from the future who were trying to change the past. It was a really great concept for the show, but it was never explored in an interesting way. They didn't really know where they wanted to go with that, because they never resolved that arc.

*And then there's the song… Breaking with tradition that the* Star Trek *opening credit sequence should play over a timeless symphonic track,* Enterprise

*would employ a pop song sung by a person, something that many fans at the time felt burst the illusion of a 22ⁿᵈ century tale of science fiction.*

**BRANNON BRAGA:** The *Enterprise* theme song, my personal opinion, I didn't like it. I really wanted to do — for a long time we had "Beautiful Day" by U2 in there. That title sequence was specially designed, and against "Beautiful Day" it was badass. We couldn't get that. I don't know how we got the theme song for *Patch Adams* (1998). I mean, some people love it.

**MANNY COTO:** Much discussed. Yes. It's a theme song. It's strange. At the time everybody was hating on it. I think it's grown on people. I don't know if I'd like to see it without the theme song now. I've kind of gotten used to it. I kinda like it. That's all. I think it was an interesting idea to do something like that. It probably was a little glam rock, was probably the wrong feel.

**MARK A. ALTMAN:** If you have the volume muted, it may be one of the best *Star Trek* title sequences ever done. The problem is, even though they tempted it with U2's "Beautiful Day," which was marvelous – you can see why people got excited about it – they couldn't afford U2's "Beautiful Day." So they found this Diane Warren tune from *Patch Adams* that Russell Watson covered, called *Faith of the Heart*. It's a joke! It's awful. I know certain people defend the use of that song to their grave – but it just diminishes the show. It leaves you completely vexed.

**RICK BERMAN:** If anyone is to blame for the theme song, it's 100 percent me. It seemed to me that after four series, including the original, of "These are the voyages," and some beautiful music and some opening credits – we should get a song. I went to Diane Warren, who was one of the top songwriters in America, multiple Grammy and Oscar wins. She had written a song called "Faith of the Heart," which was just perfect for the show. I thought the song was great. Peter Lauritson and his people put together an astonishing visual – putting together visuals from all the Enterprises in history. Shots of real astronauts. Beautiful montage. And I was accused of heresy. "How dare you

put a song in front of a *Star Trek* series?!"

**MANNY COTO:** One of my favorite episodes of *Enterprise*, which I guess is controversial, is "Dear Doctor." That's the one where they go to a planet, and it's all told through Phlox's journals. Phlox is writing to somebody – a friend. They go to a planet and learn there are these two species, and one species is dying from a plague, and [the Enterprise is] hopefully there to help. But then Phlox discovers it's not a plague, but it's an evolutionary marker. It's basically natural selection. So now the question becomes: Do they have the right to interfere with the natural evolutionary processes of this planet? Because if they save this one species, they'll eliminate the other one, because the species are fighting. So it becomes a really interesting dilemma. Because there's no right answer. The answer that they ultimately make, many people have said is the wrong answer. What I like about the dilemma rather than good and bad, in the end… there's a dilemma. You're screwed no matter which way you come in. I find that much more interesting.

*While the ratings may have been low, the faith in the franchise was still high.* Enterprise *was renewed for a second season, and eventual third season, though the writers were aware they hadn't quite gotten the rhythm of the series down yet. The constant struggle between the network and the creatives regarding how to do a prequel while still making it feel like* Star Trek *persisted – with the network tending to come out on top.*

**ANDRE BORMANIS (screenwriter/co–producer, *Star Trek: Enterprise*):** Twenty-six episodes a season was insane. I remember when I started *Enterprise*, that was my first time as a full–on staff writer, [inside] Brannon's office, the walls were covered in dry-erase calendars. For the entire year. April of 2001–April of 2002. And on those calendars was when every episode was supposed to start shooting. Episode 1 through episode 26. We knew we had to have a script ready, or we were in trouble. That really puts the fear of God in you. "Howwww are we going to do this?"

**MANNY COTO:** I don't know how we did it. I just did a series that's 10 episodes and I barely got through that. Maybe it's just that I'm

older, but I mean, doing 26 episodes on *Star Trek* was daunting, but now it would be insane. And we had a regular staff. It wasn't a giant staff. We had like a regular group of people. I honestly think part of it was we had to do 26. So that's what we did. You know what I mean? I do think when you know what your goal is, you're able to do it.

**JOHN BILLINGSLEY:** *Enterprise* was the fourth iteration of the Rick Berman era. I jokingly say "the show that killed the franchise," although the franchise of course did come back to life. At the time, I think we suffered from *Star Trek* fatigue. There had been overlaps between *Next Gen* and *Deep Space Nine* and *Voyager*. *Voyager* went off the air and we immediately came on. Although there was the promise of radical re-interpretation — it was going to be riskier and more dangerous — I don't think we really quite lived up to that hype. For the most part, a lot of people said, "I've seen this before." We were the one show that did not last seven seasons.

**MANNY COTO:** If you're going to do that show, then it has to be the only human ship out there. Alone! You know? So when the series is starting, you're watching, and suddenly Anthony Montgomery is talking about being a boomer and being on a ship that is transporting cargo. What, wait a minute, we're already out there? So, what's the Enterprise? It's just kind of going further out? It was vague and it lessened the whole drama of it. [Brannon's original idea was right], they should have been the first and the only and all on their own. The drama would have been heightened tremendously because we just have no one to depend on. By the way, I would have included the Vulcans with that as well. I think the Vulcans as backup really kind of undercut the whole thing.

**JOHN BILLINGSLEY:** I had a source who would slip me the first draft of the script, primarily because I was number seven on the call sheet. I thought, let's find out if I'm going to be in this next episode; if not, I'll go fishing for another gig. They were very nice about letting me do that. In one episode early on, maybe the third episode, a crewman had transported down to a planet and we were terrified of the transporter, because it's new technology. In the first draft, when he

transports back, his head is where his ass should be, and everybody's terrified. By the time it gets massaged by the network and we get the eventual playing script, he's got little twigs sticking out of his ear. I thought "This is the problem." It's still got that network tamp-down. Everything that the show potentially had going for it -- first crew in space, doesn't know its ass from its elbow, doesn't know how to play nice with the bad aliens and keep out of trouble, doesn't know when it should go forward or go back, doesn't trust the technology — they softened all that stuff. They lost a lot of what was potentially edgy.

**MANNY COTO:** Everything changes dramatically once production begins, because now you're dealing with production issues, as well as writing. As a showrunner, that's when things get really harsh. You're rewriting stuff that's being shot. You are dealing with actors' problems, notes, you're going to production meetings. You're going to set, in addition to having to beat out and come up with episodes for the rest of the season. So on every show, the season get harder as the season progresses. Now on *Enterprise*, one thing I didn't have to do was go into the editing suite or post-production. Rick did all that, which was a great relief and helped get us through the season. But on other shows I worked on, where I had to do post-production as well, then it becomes almost... I don't even know how it's possible. We managed to do it. We have to do editing and writing and breaking stories.

On *Enterprise*, the beginning is heady days. You're getting the episodes written and stuff, but then as the production wears on, and you're spending less time in the writers' room because you're dealing with other things... That's why you like to start on a series with four or five episodes already written. By episode 17 or 18, you're behind and you're out of story and the show is shooting and you have to really scramble. You get to the point where you're like, "This idea is good enough, let's go with it."

Whereas that idea probably wouldn't have passed muster at the beginning of the season, in the middle of a season when you're desperate — it's like you're running in front of a train. And if you trip, the train is going to run over you. You can't not write an episode. There has to

be an episode for them to shoot. You get to a point where some stories are not fully worked out. You get them as good as you can so that the show can go on.

**MICHAEL WESTMORE (makeup supervisor, *Star Trek: Enterprise*):** On *Enterprise*, the production literally wanted to see a sketch. I would do that at four o'clock in the afternoon, I would put together 10 sketches, take them up and they'd just check off what they wanted and give it back to me. But even then, it was keeping with the variations on the theme. Inspirations from Earth.

**MANNY COTO:** Brannon Braga is great. I liked him so much, I brought him on *24* the year after, and we wrote every script together for that season. [On *Enterprise*] we would flesh out the bare bones of the story – this was in season 3, before I was running the show – and then we would go to Brannon's office during the break. There'd be a guy [taking notes] and Brannon dictating the outline off the top of his head. A ten-page outline. Off the top of his head. He would unfold the story in real time in front of you and that's what would go out as the outline. It was amazing. I can't do that. It'd take me three days to do an outline – Brannon would do it in like two hours. He's one of the best writers I've ever worked with. Brannon's a riot. We had a lot of great times together. Great collaborator.

**MARK A. ALTMAN:** First two seasons, *Enterprise* is really an anthology, stand-alone, mission-of-the-week series. The ratings are not growing – in fact, there's an attrition of the ratings. They need to do something to right the ship. So at the time, *24* is huge – which was really the first successful heavily serialized TV series. Of course, this was in the shadow of 9/11. So they constructed a story where Earth was attacked and millions of people were killed. It's very on the nose, which is weird for *Star Trek*, because it's more about metaphors. So they come up with a story where the Enterprise is sent into the expanse to stop potential annihilation of Earth. The first attack was a test run. Which was also kind of weird – if you're going to do Pearl Harbor, why would you, three weeks earlier, say "Hey, we're going to attack Hawaii in three weeks! Just wanted to let you know!" It was very ambitious – some

successful, some less.

**ANDRE BORMANIS:** With the third season of *Enterprise*, we did something different – we did a serialized season. I'm not sure who's idea that was ultimately, but the idea of doing serialized storytelling was becoming more and more common in television. We thought with 9/11 still being in our memories, an attack on Earth would call for a big canvas to service it. So ultimately, whoever made the decision, it was decided this season would be all about the Xindi and the attack on Earth. I think it was very successful on its own terms, but it did take us away from the premise of the show, being the foundation of the Federation.

**BRANNON BRAGA:** Season three of *Enterprise*. We had aired two seasons and the show was doing good, but not great. I think, and Rick would agree, it was franchise fatigue. We got called into one of the big bosses at Paramount, Jonathan Dolgen's office. He was a huge *Star Trek* fan. He called us in and said, "You got to do something. Shake things up. Do something new." Back on *Voyager*, I had had this idea called "Year of Hell." I wanted to tell a season of *Voyager* where they're down to the last bolt on the bulkhead, and I wasn't allowed to do that. I wouldn't be allowed because we were a syndicated show. The episodes made a lot of money selling around the world, and the idea of doing a serialized season was just inconceivable.

Now, here comes Season 3 of *Enterprise*, and I'd still like to do a serialized arc. Let's do this. I had this idea for a species called the Xindi. We took our cues from 9/11, which hit when we were producing the first season of *Enterprise*. So it was still on everybody's mind. We did a 9/11-like event — Earth was attacked. That was a big deal for us, in our minds, we always stayed away from Earth being in jeopardy. We conceived this season-long episode of *Enterprise*, and I thought it was very successful.

**ANDRE BORMANIS:** The interesting thing about the Xindi is that they were five different intelligent species that had all developed on the same planet. A lot of people wonder, "Well, is that really

plausible?" Well yeah, it is. There are at least five intelligent species on this planet, depending on how you define intelligence. So we wanted to explore that idea, show intelligent species that were not just humanoid.

*Enterprise was also the casualty of a major regime change within UPN's executive structure. Paramount had sold to Viacom in 1996, but various technical/legal matters kept UPN running very much business as usual for the following years. In 2002, Viacom president Mel Karmazin restructured UPN, which resulted in control of the network being taken away from Paramount Television division and put under the auspices of CBS. President of CBS Les Moonves sought to curtail UPN's programming to the younger generation, spending lots of money to secure the broadcast right for* Buffy the Vampire Slayer, Veronica Mars, *and* Roswell. *Rick Berman and Brannon Braga found themselves answering to a new group of executives, many of whom had no interest in* Star Trek, *or even science fiction.*

**MANNY COTO:** The network actually pitched with a serious face, "Can we get a boy band on the *Enterprise* to play in like the rec room? That was their pitch.

**RICK BERMAN:** In one of the first meetings I had with some of the new executives who were put in charge of *Enterprise* from CBS — and this maybe says something about them promoting their network for a different audience — one of the women suggested that we include "boy-bands." And she actually sat in this meeting and said, "Could we get a boy band that would be members of the crew and they could play music and we'd have music that we could promote in some way?" We laughed, thinking that would be the end of that.

In the same meetings, I explained to her that there were two characters that were going to go out onto the hull of the ship to fix something. A spacewalk. I described the sequence, and I remember when I got all done, that same woman said, "That's all great. What's a hull?" So that says a little something about what happened when CBS took over the show. Their understanding of science fiction and their interest in promoting the show was nothing like the previous three seasons.

**JOHN BILLINGSLEY:** I can believe that [Rick Berman and Les Moonves of CBS didn't get along]. My impression was that Les Moonves did not have a tremendous amount of affection either for the franchise or perhaps even the genre. Whatever the relationship was with him and Rick, I think that probably played a part. There were so many things that happened, it could never happen that way. There was fatigue, Rick and Brannon didn't get a break after *Voyager*. Consequently, the bible for the show was not particularly well thought through. The Sulibon arc didn't really go anywhere, yada, yada, yada. Victory has a thousand fathers, defeat only has one that claims it.

**MANNY COTO:** The ratings plunge happened, I believe, in between seasons one and two. When I got there in season three, I think the ratings were already down in the three million range or something. It was pretty low when I got there. And they continued to drop. Slower, in season three, if I remember correctly. They didn't drop much in season four. I think they steadied off, but it was very low anyway.

I had heard that there was talk about getting rid of Scott [Bakula]. I don't remember that. I know Rick didn't want to get rid of Scott. I think people may have thought that the flagging ratings were because of Scott. Which is a little silly, I don't think that's the reason. I remember at one point we were talking story about doing a season where Scott is, if not dead, then incapacitated or lost where you have a crew trying to function without a captain. This is an interesting idea, but that never went anywhere. Because Rick rightly was like, no, "Bakula's the captain." He's wonderful. But I did hear that. Rick was not going to have it.

The drop in ratings for *Enterprise* was quite dramatic. So everybody was scrambling and trying to figure out how do we fix this. I'm sure Moonves and their audience surveys or whatever, said, "Bakula's the problem," in Moonves's eyes. But I think that is ridiculous. Bakula's not the issue.

**JOHN BILLINGSLEY:** I was 40 at the time. I was a stage actor for many years and didn't have a pot to piss in when I moved to Los

Angeles. I wasn't rubbing pennies together, but [*Enterprise*] was a significant career milestone financially. That show was a life changer. When you're told by the executive producers, "you're in the clear for seven years" and the ratings out of the gate in the first season are bad, there's a part of you that goes, "I was going to buy a house." I was perfectly aware and candidly telling the Mrs. early on, "We may be lucky to go two." Third season was a surprise, fourth season was no small bit of a miracle. I thought everybody was selling themselves a bill of goods, because when we were canceled, "Oh my God!" What were you expecting? It's not that people weren't paying attention, but nobody wanted to pitch to UPN. Nobody wanted a show on UPN. UPN had no content. We would survive if UPN survived. And it was UPNs handwriting that was on the wall.

*With the third season, Manny Coto was hired to write for the show, and would eventually take over as principal showrunner during* Enterprise's *fourth season, as Brannon Braga elected to develop other projects.*

**MANNY COTO:** I had finished a series called *Odyssey 5* on Showtime. I guess Brannon had seen it and liked it and/or had read my pilot. My agent represented Brannon at the same time and called me up and said, "Do you want to meet? And I said, "Hell, yes!" I went in and met Brannon. He was in a state. I mean, on a lot of television shows, the fact is most of your writing staff is not going to work out. It's just a matter of, 70 or 80 percent of the writers just don't get the show. So you're left with a small group. And he, unfortunately, had put together a brand-new writing staff and a lot of them just weren't able to get the voice of the show. So he was really by himself. Himself and one other, Chris Black, was a terrific writer. This was the end of Season 2. Season 3 had just started filming when I joined. He pitched me the whole Xindi arc and he was in desperate need of someone who can write the series. But he didn't know that I could write the series. It's very possible that I couldn't. *Star Trek* is a very narrow band. You had to have a certain voice and get that voice, because you can deviate too far one way or the other. Too technical or too wise-cracky. It was a very narrow band of writing and you had to be able to find it.

Brannon handed me a scene to rewrite – I don't remember what episode. There was a scene he needed rewritten for an episode, and I rewrote it and he was happy with that. But then I pitched [the episode] "Similitude." I'm very proactive as a writer. Wherever I go, I don't just go in and go, "What do you want me to write?!" I consider it a failure if I don't come in with ideas. So I had this idea for "Similitude," I pitched it, and we wrote it. So that's the first thing we wrote. It was very well received. So that was the first thing we did.

**JOHN BILLINGSLEY:** When Manny Coto took over, I think we were very fortunate to even go four seasons. We were on UPN, a network that was itself on the verge of extinction, so they kept us on because they didn't really have a lot. Our numbers were in the toilet. Manny came on, and in a way, there was a certain freedom knowing that we weren't going to be saved, the numbers weren't suddenly going to skyrocket up. Manny had a little bit more latitude, particularly in the fourth season, to write episodes that were valentines to *Star Trek*. The fourth season was a ton of fun, and if it had survived and Manny had stayed at the helm, I think we would have had another wonderful couple of years.

**MANNY COTO:** When I got there, they thought there was a real possibility that Season 3 was going to be the last, because of the ratings. We all knew the show was on a limited time span. When Season 4 started, we all knew it was going to be the last season. I mean, there was a small possibility that if the ratings shot up, we would continue, but I knew well that this was the last season, they had cut budget. They had cut our budget. You could just tell Paramount was like, "This is it." So that's one of the reasons they let us do whatever we wanted to do. I think partially that was the reason why Brannon went off the development of the series for Season 4. I wouldn't say "jumping ship," because he was happy. I think he was done with *Trek*. It was like he had done 18 years, so many years later. So he wanted to branch off.

**BRANNON BRAGA:** I gave Season 4 of *Enterprise* to Manny Coto. I was working on other stuff and was just ready to move on at that point. Ready for a break, and not knowing whether *Star Trek*

would go on. I knew *Enterprise* was going to go on for seven years. I didn't know it'd be the last season, nor did Manny. But Manny had done just such a stellar job in Season 3 and was so clearly passionate about *Star Trek*. In some ways, maybe he should have been running *Enterprise* all along because. I have a deep love for *Star Trek*. I spent most of my adult life there. But I think I probably could have used more passion for *The Original Series*, which is what Manny had. I had knowledge of it and I did tie-ins, but Manny — he was going to do a tie-in with *The Animated Series*. That's how deep his insights went.

**MANNY COTO:** [When Brannon announced he was leaving] I was pleasantly surprised, and then completely bummed. Season 3 ended up with Archer waking up in World War II Earth. And then I learned that Season 4 was going to be all takes place in World War II. That's what Rick wanted to do. And I was like, "I don't want to do that." I mean… First of all, I was thinking, selfishly, here's an opportunity to run a season of *Star Trek* and I'm going to be stuck doing World War II stories? I like World War II as much as the next guy. I'm fascinated with history, but I don't want to do Archer and these guys running around Nazi Germany. It's not what *Star Trek* is. I mean, it's maybe an episode or two, but no.

**JOHN BILLINGSLEY:** [Brannon Braga was tired when it came time to make *Enterprise*.] I would agree with that. There's so many variables. Putting together a writers' room, it's really hard getting a group of people together. I think some of the issues revolved around the short-notice difficulty for a UPN show getting a good team of writers in the writers' room, and then having to tell them everything that's already been done. It wasn't just *Star Trek* fatigue so far as Rick and Brannon were concerned, but *Star Trek* fatigue in so far as the entire town was concerned. Who wanted to take the gig? Having taken the gig, who wanted to work under this impossible pressure of having to come up with something that hadn't been done before when *Star Trek* had been on for umpteen years? And frankly, the visual signature of the show. When you were surfing the channels back then, you knew when you landed on *Star Trek*. What if it was overlapping dialogue? What if you broke the visual signature that had always been attached to *Star*

*Trek*, and let that be part of a story that this is really not your daddy's *Star Trek*. They didn't do that. Because people who were at the helm of *Star Trek* on every design front had been there for many years.

**MANNY COTO:** I can't imagine being on any show for that long. On the other hand, if somebody told me now, "You're going to do *Star Trek* for the rest of your life," I'd go, "Okay!" Brannon was never a full-board Trekkie like I was. And maybe that's a good thing. Fans can get a little weird, and can get into fan service. I was accused of that in Season 4. I would argue differently, but… Brannon and Rick were not "Trekkies." They like movies and entertainment, but they weren't *Star Trek* fanatics. They would tell you. Which could be good or bad when you're writing a show. I just think you have to love *Star Trek* in any degree.

*When it came to the fourth season of* Enterprise, *the show's writers and crew were faced with a steep decrease in the budget – from averaging $1.7 million per episode in Seasons 1-3, to just $800,000 in Season 4. In an odd contrast to the budget cuts in the third season of* The Original Series *nearly 40 years before, the budget cuts on* Enterprise *surprisingly opened previously unseen possibilities for the show.*

**MANNY COTO:** The reason why Season 4 looks good, even though the budget was cut, was because I cleverly decided to do multi-episode arcs. So we were able to reuse sets for those episodes, and amortizing the budget. For example, the Vulcan arc, we were able to use the Vulcan set for three episodes, whereas before you would use it for one. The three-episode arcs actually helped save money, but in a way that you wouldn't notice because you're just watching the story. By the way, we actually came in like a million dollars under budget. So even on top of the budget cuts that they had given us, we came in under budget. But I think Rick and Brannon blew that on the last episode, they spent all of the extra money on the last episode.

*Manny Coto's tenure as* Enterprise *showrunner would also include more prequel elements – picking up numerous storylines first established in* The Original Series.

**MANNY COTO:** Some people said I was too much into fan service. I was simply exploring the *Star Trek* universe. There was this grand *Star Trek* universe, which is really kind of a miraculous thing. This is a franchise with over 700-plus episodes at the time that had managed a pretty consistent continuity. You had this old world that was created, pieces of it were laid there, and I felt there were many interesting avenues and places that we hadn't explored that could be expanded upon in an interesting and fascinating way. Why not explore the world that's there that we're all interested in? You can do that in a way that doesn't necessarily include people who don't know *Star Trek* that well. You can do it in such a way that they're introduced, they're just following the story. But at the same time, I do recognize that you need to go to new places. But I felt that on *Enterprise*, for example, we had not gone to any of the touchstones of *Star Trek*.

**MICHAEL WESTMORE:** Manny and I had some very interesting conversations on *Enterprise* because I said to him, "You know, I'd like to redo the salt monster from *The Original Series*." And he says, "We can do it." Cause we did, we did the pig people, where they pulled up the Tellarites and redid them. I thought we did a beautiful job in redesigning them. And there's still things from the old series that Manny wanted to bring back and let me redesign.

**MANNY COTO:** Michael Westmore was a particularly big, big thrill. First of all, because you can watch Hollywood movies all the way back into the '30s and see the Westmore name. So there's a whole lineage there, which is fascinating. His shop was just a glorious place, full of great makeup and stuff that he had done. Just a real pleasant, sweet guy who can handle anything that was thrown at him. He had a really difficult job in those days, with a limited budget of creating aliens with just prosthetics because there was no money for CGI and expensive makeup. Full-headed makeup was cost-prohibitive. So he had to come up with little solutions to do species here and there that were just almost human, but were still alien. And it fell on him. When I worked with him on Season 4, he was talking as if he was a little kid. By the way, everybody was like that. I never got the sense that this was a group that was on its last season. Everybody on that show really gave their all.

People who had been there forever.

**JOHN BILLINGSLEY:** The fourth season worked because I think that's when they figured out how that crew functioned. It captured more of the spirit of the original. It had more dash. In a way, I think Scott is more of a swashbuckler, as opposed to the dark, brooding, "They've screwed me on Earth and they've given me a ship that doesn't work." I think the current iteration of *Star Trek* is sort of trying to grapple with this, the idea that man is perfectible and that we go off into space, having solved all the problems of the world, and now we'll go out and teach the alien something. There's something about the white man colonizer to *Star Trek* that's always kind of bugged me. I think it's a really tricky thing in the modern world to play against, to figure out how to adjust. The pilot started early on by Scott saying, "We've conquered sickness and disease, etc." I thought, "This is not what *Star Trek* should do anymore. It's not 1966." To a certain extent, I just don't think the pieces fit.

**MANNY COTO:** On Season 4, and like on most shows, you start off with grand ideas and grand themes. Your first four or five episodes are difficult to write. But I had a great writing staff. Reeves-Stevenses were there and Alan Bernard and a bunch of other people who were really great. And Mike Sussman, people who knew the show well. We were all excited about what we were going to do. So we got kind of a heady run at it. Part of the thing that helped us was we were doing three-episode arcs early on. We had one story we're telling over three episodes, which helped make it slightly easier.

Season 4 was... I just wanted to do what I thought a *Star Trek* show should be. The potential of the *Star Trek* universe was there laid out for us. The history of the Vulcans and the Andorians – there were so many interesting cultures and stories to tell, I thought, "Why aren't we mining this for material?" The founding of the Federation – "Demons" and "Terra Prime" was my small attempt to show the beginnings of this. The character of Peter Weller – who was basically saying, "Aliens out. Earth for Earth." Which I thought was a great way to end the series – to circle back in that, "Here we've gone and explored other worlds,

and fixed problems – but hey, guess what? We still have some problems of our own to fix." Issues from the past. So I thought it was fitting we circled back to Earth with "Demons" and "Terra Prime."

I always thought a fascinating character was Colonel Green, which was mentioned briefly in one of the earlier *Star Trek* episodes, but who led a genocidal war on Earth. So I thought it was interesting to tie back to that, but have Paxton be a disciple of Colonel Green's. It seemed logical to me that if we ever did begin to meet alien species there would be a very virulent group of people who would be like, "This is wrong." I thought that was something that we could explore. Imagine if an alien culture was able to live on Earth, the first person to break out in any kind of a disease would be a flashpoint for, "You see?! You see?" That's them, they brought this, we're screwing ourselves. We've got to do something." And off you go because people are naturally hysterical.

*Lower budgets and continuing storylines afforded Season 4 of* Enterprise *more intimate character studies.*

**MANNY COTO:** My biggest regret with Season 4 – and this gives you an idea of where the brains of the studio were at. The Reeves-Stevenses [screenwriters and *Trek* novelists] came up with this fantastic idea to do a two-episode arc that would feature William Shatner. The idea was it was a mirror universe themed episode. In the original "Mirror, Mirror," the evil Kirk had a device that was called the Tantalus field, which you press a button and his enemies would vanish. Now, it was implied in there in that episode that they just kind of died, but what the Reeves-Stevenses were saying, "What if what this field did was transport, and everyone who was opposed to him into this pocket universe?" So, they were all on this planet surviving. At the end of that episode, it's implied that the good Kirk had convinced the evil Spock to take command from the evil Kirk. And Kirk told him about the Tantalus field. So you would have surmised that at the end the evil Spock would have sent Kirk to the Tantalus field taking command of the Enterprise. So you now have this pocket universe with the evil type. We were calling Tiberius Kirk kind of stranded with other

people who evil Spock has banished. But they've forged this kind of community in basically a prison. The idea was what if Archer and the Enterprise stumbled into this pocket universe and evil Tiberius. Kirk was now an older man, but still formidable, and wanted to take control of the Enterprise and escape. It was a prison escape. So it would have been evil Kirk, William Shatner, Tiberius, trying to take over the Enterprise, with other minions who had been trapped there.

I mean, I was dying. That was so much fun. And we met with Shatner. We had lunch with Shatner and pitched him the idea, and he really loved it. He was all in. But what happened was, studio didn't want to pay Shatner what he wanted. They did little reports. They were initially interested, but they decided it wouldn't have been a feasible [investment] and they wouldn't have gotten anything out of it. There's no point in doing it. They didn't want to pay the money. Shatner was asking, I don't remember, nothing exorbitant. It wasn't like a million dollars an episode. They didn't want to pay anything because they just didn't give a shit, to be perfectly honest. It would've improved the ratings; it might've saved the show. But even if it hadn't, it would've been a classic *Star Trek*, and a glorious piece of *Star Trek* that now would exist. But the studio didn't want to fork out an extra few hundred grand. It was ridiculous. I was so pissed.

I honestly think [Paramount] wanted the series to die. I honestly think Paramount didn't want to hire the Shatner for that two-parter. Not because he was too expensive, but because they might've saved the series. That's my conspiratorial thinking. I really think they just wanted it all to go away. I don't think they were the least bit interested in doing anything that would revive the series. You wouldn't jump on the idea of William Shatner coming onto the show for two episodes? You would grab at it. If you cared, you find the money. Please. I think it would have been like 400 grand. You can't find the money, Paramount, for two episodes for William Shatner?

*On February 3, 2005, while still in production on the episode "In a Mirror, Darkly pt. 1," the cast and crew were informed that* Enterprise *would not be returning for a fifth season. Rumors and discussion of cancellation had circulated*

*since early Season 2, so it was not so much of a surprise, but still a disappointment to fans and the crew.*

**BRANNON BRAGA:** *Enterprise* ending wasn't a shock. CBS had come in and – I don't remember all the business of it – but all of our bosses at Paramount had changed virtually overnight. And the person who had built this franchise with us were gone. We had new bosses. Yes, I did sense some friction between Rick Berman and Les Moonves. There were certain things creatively that certain executives were asking for. It was clear they didn't know what *Star Trek* was. A disconnect would be the right word – between CBS and us. The ratings weren't great, and the show was expensive.

I was with Rick in his office, I don't remember what we were working on. The phone rang. It was an executive from CBS who said, "Hey guys, so it's time to call it. I think we're going to call it a day on this one." And we said, "Okay."

**RICK BERMAN:** I remember the person who called me to tell me *Enterprise* was not going forward for a fifth season, was somebody I barely knew at CBS. I think *Enterprise* was a great show, with a wonderful cast. When Manny Coto became involved and brought in more of the canon and reminiscences of *The Original Series*, I think the show got even better. I was as disappointed as everyone.

*Because of the early announcement, the show's producers were able to craft the final few episodes with a "finale" in mind. However, the plan to put a cherry atop the 19 years of the* Rick Berman *era by giving a love letter to the devoted fans… backfired.*

**MANNY COTO:** My final episode was "Terra Prime." I looked at "Demons" and "Terra Prime" as the finale for *Enterprise*. As wrapping up the *Enterprise* storyline. Brannon wanted to do "These Are the Voyages" as wrapping up the entire 18-year run of Rick's *Star Trek* from *Next Generation* on. Kind of a coda. So I had nothing to do with that episode. At all. Rick and Brannon wrote that episode on their own, and produced it on their own separate thing. I'm a little baffled by all the

anger and hatred towards that episode. I thought it was a fun episode. Maybe you didn't like it, but the viciousness? Really? Fans get really carried away. I thought it was fun that the crew of the *Next Generation* was looking back at the events of *Enterprise* and using it as a tool.

**BRANNON BRAGA:** Rick and I wrote the final episode and that's a much-maligned episode. Rick and I had been working on *Star Trek* for a long time. Manny had just done some kind of spectacular three-part episode that we thought was a sensational finish for *Enterprise*. Maybe the last one would be an *Enterprise* episode but a little Valentine to the franchise? So, I had this idea of, "What if it's actually a *Next Generation* episode that we haven't seen and they're going to the holodeck to look at Enterprise?" Seemed like a good idea at the time. But I don't know that it turned out really well.

It wasn't right to kill Trip's character. The cast hated the episode. That was the only time I ever saw Scott Bakula mad – mad at me. I think the cast felt disrespected that it wasn't really their final episode. I'm sure we could have done better. But that was Rick and I waving farewell – because we both knew we were moving away from *Star Trek* forever.

*"These Are the Voyages," the final episode of* Star Trek: Enterprise, *aired on May 13, 2005, to 3.8 million viewers. With the final episode, an era came to an end. The crew, many of whom had worked on the* Star Trek *franchise for nearly 20 years, were let go. Michael Westmore's makeup and prosthetic design workshop was closed up. Paramount Stages 8 and 9, which had been used continuously for* Star Trek *productions since 1988, were put to other uses. And for the first time since 1978, there were no new* Star Trek *projects in development.*

**MANNY COTO:** Rick made a lot of enemies at the studio. I think because he was protecting *Star Trek*. Rick was protecting *Star Trek*. He was not going to have any crap coming from these people who obviously hated the show. That's fine when everything's going great, but when the ratings drop… And by the way, part of this was [*Star Trek: Nemesis*]. The movie came out and didn't do well, and I think that hurt the entire franchise. *Nemesis* and the movie before it, *Insurrection*, were

not good. The movie profits dying fed into *Enterprise* dying. When things start going badly, suddenly you have no friends left, and that's why he was thrown off of *Star Trek*. He was booted. The thinking was, "We need new blood."

**RICK BERMAN:** After 19 years of doing *Star Trek*, I had had enough. It was exhausting, and it was incredibly rewarding. I think more important than anything else is how important these shows meant to people. I spent years having people come to me saying, "This show has more of an influence on me and my family than any other show we've ever watched." The family would discuss it, the metaphorical aspects, the allegorical aspects of it – it meant a lot to a great number of people. A show like *Cheers* or *CSI*, much higher ratings, much more popular, but nobody sits around discussing these things. The number of scientists and astronauts who've said that *Star Trek* influenced where they finally got was incredibly rewarding.

**JOHN BILLINGSLEY:** One of the coolest things about being on [*Enterprise*] was the camaraderie. I loved my fellow castmates, but mostly being part of the experience with the crew, who had been together for that long. Although it's always an emotional experience to wrap a show, the real emotional experience was the crew's goodbyes. They'd been together for 16 or so years; kids had grown up, people had married, people had divorced, deaths, etc. I doubt I'll ever get to experience that again.

**MARK A. ALTMAN:** It was only after *Nemesis*, when [Paramount] started to look at developing other *Star Trek* movies, that Rick finds out what it was to be Gene [post-*Star Trek: The Motion Picture*] —because contractually, they had to keep Rick involved. They develop this script called *Star Trek: The Beginning*, with a wonderful writer, Erik Jendresen. This is the first *Star Trek* project in probably three decades that Rick Berman hasn't been involved with. He would have been a producer on it, but that was probably the last piece of the Berman era. Ultimately, his contract expires. He's given a development deal, but nothing really comes of that. It's sad, because he really kept that franchise going. He didn't always make the right decisions, but who does? If not for Rick

Berman, there's no way these shows would have gone on for as long as they did.

**MANNY COTO:** When *Enterprise* went off the air, [the studio] unceremoniously sent Rick off the lot. "Whelp, we're done." I predicted at the time, "They're going to find some hot filmmaker to come in and revive the franchise." And that's exactly what happened.

**MICHAEL WESTMORE:** I had to stay for another five weeks to close down the labs and everything. When that was done, I went to the telephone and called Marion (my wife) and I said, "Come get me, I'm ready." Closed my office door, walked out. Marion was so sympathetic to me, "Oh my god, how was it?" I said, "Let's go to dinner. I'm hungry." Never looked back.

*But this was not to be the final voyage of the starship called* Enterprise. *A group of creators would take the reins of the franchise and produce a whole new slew of motion pictures, television series, comics, and books. Streaming channels and home video allowed for* Star Trek *to be discovered and rediscovered — breathing life back into* Trek *of new and old. Ensuring that in whatever direction future* Trek's *will go, the heart of* Star Trek *will never die.*

**MANNY COTO:** *Star Trek* is a complete world and a concept. It's a concept that humanity will survive into the future and that we will have issues to overcome and we will overcome them as a species and as a people. But *Star Trek* is flexible in that it can change to whatever the times are. It can address whatever the concerns are at the time. Because it's so flexible and because it's a general concept, it's enduring. And it can endure to reflect our times and the times it was created.

**MARK A. ALTMAN:** *Star Trek* is an amazing franchise. The fact that is has endured 55 years and is still going strong after all of this time. What is it about *Star Trek* that fascinates me? I've sat here and talked to you about *Star Trek* for hours. Why is it so interesting? I have no idea! David Gerrold says it's about family, others say it shows a future where we all get along. I've talked about *Star Trek* for literally thousands of hours — on the podcast and interviews and books — I still don't know

why I love *Star Trek* so much. But I do. That's the wonderful thing about it. I've seen some episodes, conservatively, hundreds of times, but I never get bored of them. It's a wonderful vision of the future, it's a world we'd all love to live in and fear that we won't. So it's aspirational, hopeful, it shows us a path forward that's very appealing. At the heart of *Star Trek* is that optimism. It's most successful when it taps into that innate goodness and hopefulness – and that's why it will outlive all of us.

**LEONARD NIMOY (actor, "Spock," *Star Trek*):** [*Star Trek*] was what it should be. It was a story about a hopeful future. That was one of the mainstay reasons that it was successful. A story about a hopeful future made in a difficult time. At the time, the war in Vietnam, the racial issues that were happening — times with tough. Riots in the streets, riots at political conventions and times were tough. People were angry, upset, nervous, and concerned. And [*Star Trek*] was this thing that said, "In the future, we have a way of dealing with these issues. It's going to be okay." Here's a group of people who are solving problems together, and they're all different diverse people, not even all from this planet, working together -- successfully.

## ACKNOWLEDGMENTS

The author would like to make special thanks to Brian Volk-Weiss, Rich Mayerick, and everyone at Nacelle Publishing for their hard work and devotion to fandom and geek culture, and their conviction to bring this project to life. They are truly one with the Force, and the Force is with them.

To Mark A. Altman for his mentorship, friendship, and invaluable support during and before the writing of this book. The Trekspert to end all Treksperts, and a man a crew would follow across the galaxy.

While most of the majority of quotes in this book were taken from interviews conducted for *Center Seat: 55 Years of Star Trek* documentary series, we would be remiss if we did not acknowledge the touchstone authors of *Star Trek* literature that came before, including Mark A. Altman, Edward Gross, Terry Erdmann and Paula W. Bloch, Ian Spelling, Kerry O'Quinn, Fredrick S. Clarke, Preston Neal Jones, Michael and Denise Okuda, and countless others who have added invaluable scholarship to the history of *Star Trek*.

To research assistant Brandon Gale for his much-needed assistance when deadlines were looming. People should watch his career with great interest.

To my L.A. *Star Trek* Customizable Card Game group of Jon Callan, Rob Bozich, Matt Lubner, Graham Matuszewski, and all the others before and after — may a Borg cube never end the game.

To Gene Roddenberry, Lucille Ball, Rick Berman, Jeri Taylor, Ronald D. Moore, Dorothy Fontana, Bryan Fuller, David Gerrold, Peter David, and countless others who have written/created for the *Star Trek* franchise, and enlivened the imagination of a wide-eyed child who would one day write this book.

And lastly to my family, for only occasionally telling me to turn off the TV and "Get a life." Thankfully, I never listened.

## ABOUT THE AUTHOR

Peter Holmstrom is a television and motion picture writer who most recently wrote for the sci-fi adventure series *Pandora*, for the CW, and served as a co-producer for the documentary *1982: Greatest Geek Year Ever*. He also serves as an associate producer for the hit *Star Trek* podcast, *Inglorious Treksperts*, hosted by screenwriter Mark A. Altman, and *Star Trek: The Motion Picture, The Director's Cut* visual effects supervisor Daren Dochterman. Peter Holmstrom served as a researcher for *Secrets of the Force: The Complete, Unauthorized, Uncensored Oral History of Star Wars*, published by St. Martin's Press, as well as a forthcoming book on the *John Wick* film series. Holmstrom's previous work in journalism included articles for regional magazines in the Pacific Northwest such as Portland Monthly Magazine, SIP Magazine, and others. He received his MFA in screenwriting from the American Film Institute Conservatory in 2018. Peter Holmstrom was born in a small town outside of Portland, Oregon, and currently resides in Los Angeles.

CPSIA information can be obtained
at www.ICGtesting.com
Printed in the USA
JSHW030856150123
JK12248400001B/2